, 2003

Toronto, CA

For Nathan —

To A devoted contributor to & teacher f Moholy's visual literate credo.

I am pleased to add my Moholy book to your collection & ~~I~~ hope that there will be future opportunities for X-change.

Best wishes,

Louis Kaplan

# LASZLO MOHOLY-NAGY

**B**iographical **W**ritings

by Louis Kaplan

Duke University Press    *Durham & London 1995*

© 1995 Duke University Press
All rights reserved
Printed in the United States of America on acid-free paper ∞
Typeset in Sabon by Keystone Typesetting, Inc.
Library of Congress Cataloging-in-Publication Data
appear on the last printed page of this book.
Frontispiece: Lucia Moholy, *Laszlo Moholy-Nagy*,
1930, gelatin silver, gouache, 8.3 x 5.8 cm. (Collection
of the J. Paul Getty Museum, Malibu, California)

# Contents

List of Figures    vii

Acknowledgments    ix

Introduction: Signing on Moholy    1

1    Production-Reproduction    31

2    Forging Ahead: The Plague of Plagiarism    63

3    It Works    79

4    The Anonymous Hand    119

5    Moholy: The Significance of the Signature    157

Signature's Postscript: Moholisch/Like Moholy    191

Notes    193

Selected Bibliography    217

Index    229

# List of Figures

1. Lucia Moholy, *Laszlo Moholy-Nagy*.   Frontispiece
2. Lucia Moholy, *Constructivist and Dadaist Congress, Weimar*.   5
3. Laszlo Moholy-Nagy (or Lucia Moholy), *Laszlo Moholy-Nagy*.   27
4. Laszlo Moholy-Nagy, *Photogram*.   38
5. Laszlo Moholy-Nagy, *Stage Scene-Loudspeaker*.   42
6. Laszlo Moholy-Nagy, *The Diving Board*.   57
7. Laszlo Moholy-Nagy, *Play*.   60
8. Laszlo Moholy-Nagy, *Yellow Disc*.   86
9. Laszlo Moholy-Nagy, *Photogram: Self Portrait Profile*.   91
10. Laszlo Moholy-Nagy, *Self-Portrait, Photogram with Torn Paper*.   97
11. Laszlo Moholy-Nagy, *Self-Portrait Lighting a Cigarette*.   110
12. Laszlo Moholy-Nagy, *Bicyclist*.   115
13. Laszlo Moholy-Nagy, *Telephone Picture EM 3*.   120
14. Laszlo Moholy-Nagy, *Love Your Neighbor* (*Murder on the Railway Line*).   135
15. Laszlo Moholy-Nagy, *In the Name of the Law/Psychology of the Masses*.   138
16. Laszlo Moholy-Nagy, *Poster for Schocken Department Store*.   148
17. Laszlo Moholy-Nagy, *Light Space Modulator*.   160

18. Laszlo Moholy-Nagy, *A Chick Remains a Chick; Poeticizing of Sirens.*   175
19. Laszlo Moholy-Nagy, *The Hydrocephalus.*   178
20. Laszlo Moholy-Nagy, *City Lights.*   179
21. Laszlo Moholy-Nagy, *Space-Modulator L3.*   186

■

*Laszlo*

*Moholy-*

*Nagy*

# Acknowledgments

Published in the year marking the centenary anniversary of the birth of its Bauhaus artist subject, *Laszlo Moholy-Nagy: Biographical Writings* has had its own nine-year gestation period from inception to publication. This lengthy passage of life's writing has generated an appropriately lapsed situation in which the present signee finds it most difficult to identify (with) the originating author of the biographical writings and in which much of the editing has taken place in relation to an anonymous hand. Its biographical trajectory has coincided with two of Moholy's major life coordinates (Chicago and Berlin) and has wound up in the "Mo-holy" city of Jerusalem. (Here, by coincidence, the Moholy one dropped in during the last phase of this book's editing, thanks to a wandering exhibition of his photographs organized by the Goethe Institute in spring 1994.) In order then to roll the credits of this book in conventional terms, it is necessary to honor the tripartite division of its inscription.

This work began as a doctoral dissertation in the Department of History of the University of Chicago. I want to thank both Harry Harootunian and Chuck Krance for their steadfast support and encouragement of a work that crossed over many disciplinary borders in its pursuit of Moholy's life-writing. I acknowledge a great deal of indebtedness in this first phase of the project to an important exterior force, Tom Conley, whose "graphic unconscious" mobilized the writing and editing, and whose "vision in motion" perceived both the project's possibilities and possibilistics. I also want to acknowledge Scott Michaelsen for the valuable insights that he offered and for whatever might have been culled

from our other writerly collaborations that found a way into the Moholy text. I received a great deal of assistance from the Moholy archives at the Illinois Institute of Technology, the University of Illinois (Chicago Circle), and the University of Cincinnati. Finally, I acknowledge the help of the late E. Ray Pearson for opening up his personal archives on his life with Moholy in Chicago.

In Berlin, I want to acknowledge the assistance of the library and the archives of the Bauhaus Museum under the direction of Peter Hahn. Here, I was able to bring Moholy's Bauhaus period and the German linguistic register to bear upon *Laszlo Moholy-Nagy: Biographical Writings*. In addition, I also want to thank Moholy and Bauhaus scholars such as Andreas Haus, Lloyd Engelbrecht, Magdalena Droste, and Rainer Wick for their discussions on the biographical subject. Above all, I want to acknowledge the significant impact of Jeannine Fiedler on this work. Her friendship has left a deep and indelible mark on the body of this text.

In Jerusalem, I want to thank the many colleagues and friends (including Paul Mendes-Flohr, Stéphane Moses, Steve Aschheim, Hanni Mittelman, and Gabriel Motzkin) at the Franz Rosenzweig Research Center at the Hebrew University of Jerusalem where I have been based since fall 1993 and where I have found a supportive working environment to bring the Moholy project to completion amid my current preoccupations in German-Jewish cultural history and the discourse on the Jewish joke.

As to be expected, there are also those acknowledgments where the tripartite division breaks down.

Many thanks to Patrick Clancy for his invaluable feedback on both the theoretical constituents and photographic conditions of the Moholy subject at hand.

On a more personal note, I want to acknowledge the support of my parents, Leon and Sarah Kaplan, for their appreciation of the value of scholarship and its scripting through too many years of academic underemployment.

I would like to thank all of the institutions that have lent photographic materials for use in this volume: J. Paul Getty Museum, The Metropolitan Museum of Art, The Museum of Modern Art, George Eastman House, Davis Museum and Cultural Center, and the Harvard University Art Museums.

A special word of thanks goes out to a bearer of the proper name encountered in this work — Hattula Moholy-Nagy. She is

deserving of special credit for serving an anonymous stranger with much hospitality and in providing open access to her invaluable personal archive of Moholy materials when this project was in its early phases. I am also grateful to her for granting permission for the use of all of the illustrations in this book.

Acknowledgment must be given to the three anonymous readers for Duke University Press who provided insightful critical comments that helped to shape the editing of the work in its final phase. I also want to thank Jean Brady, Mark Brodsky, and Richard Morrison of the Press for their able assistance at many stages along the way toward publication.

Last but not least, I want to acknowledge the able editorial direction and steering efforts of Ken Wissoker, with whom I have been acquainted (on and off) through the twists and turns of this life narrative. It has been a long, strange trip of convergences and divergences starting from scratch in the phonographic studios of WHPK radio in Chicago to the publication of these scratches and marks in the biographical service of the Moholy signature.

<div style="text-align:right">

L. K.

Jerusalem

November 9, 1994

</div>

LASZLO
MOHOLY-
NAGY

# Introduction: Signing on Moholy

■

He wants to side with any writing whose principle is that *the subject is merely an effect of language.* — Roland Barthes, *Barthes by Barthes*

Free form! Marvelous! No hung-up old art history words for these guys. America's first unconscious avant-garde! The hell with Mondrian, whoever the hell he is. The hell with Moholy-Nagy, if anybody ever heard of him. Artists for the new age; sculptors for the new style. . . . — Tom Wolfe, *The Kandy-Kolored Tangerine-Flake Streamline Baby*

## Laszlo Moholy-Nagy: From Constructivist Tradition to Signature Effect

The overarching title of this study indicates that it belongs to the genre of individual biography as a subset of historical studies. The first part of the title announces the proper name of the visual artist, *Laszlo Moholy-Nagy,* in the starring role, cast as its object of study; and the second part of the title, *Biographical Writings,* declares that it will involve the writing of a life. To provide, in shorthand, the conventional facts and figures of the historical context at issue throughout this work: Laszlo Moholy-Nagy (1895–1946) was an abstract artist who grew up in Hungary, who turned to painting after the Great War, who moved to Berlin and came under the sway of the dadaist and constructivist movements in the flourishing international avant-garde scene of the early twenties, who taught under the direction of Walter Gropius at the Bauhaus in its middle period (1923–28), who moved to

Holland and then to Great Britain in flight from the ominous rise of Fascism, who was called to Chicago in 1937 to form a New Bauhaus art school, and who spread Bauhaus modernist art education doctrines in America for the next decade until his untimely demise in 1946. In his ever westward wanderings, Moholy's journey depicts the migratory pattern typical of so many artists of that era.

If this work were to be set up within the terms of the traditional historical narrative, the individualized Moholy biography would provide an easy outline of life chapters (a sequence of periods of settlement) and a constant vectorial direction (westward). Of course, there is quite a temptation to adopt this linear grid as a ready-made model of historical understanding and apply it to this particular case study. One could quite easily imagine a flowchart of chapters resembling the structure of an extended transatlantic voyage or a Moholy tour that, in a quarter century, takes the following urban route from start to finish: Budapest, Berlin, Weimar, Dessau, Amsterdam, London, and Chicago. As a matter of fact, one encounters such documentation in illustrated form in Stephen Bann's standard compendium, *The Tradition of Constructivism.*[1] The frontispiece of the book delineates a diagrammatic mapping of the movement that generates the "constructivist tradition" — the linearity of time along the vertical axis (from 1920 to 1965), and the geographical coordinates ranging from Russia on the eastern left to the United States on the western right along its horizontal axis. One of the squiggly lines travelling from the upper-left- to the lower-right-hand corner traces the trajectory of Moholy-Nagy and underscores the intersection of his path with a number of constructivist collectivities — the Bauhaus in Germany in the twenties, the Abstraction-Creation group in France in the early thirties, the Circle group in England in the mid-thirties, and the New Bauhaus in the United States in the forties.

However, due to technical (and technological) difficulties, this unproblematic chronological and teleological sketch of an artistic life and its art historical itinerary will not be charted in the present volume. For the fixed schedules and departure and arrival sites of the historical craft encounter a great degree of resistance and turbulence when flying in the face of what Moholy introduced in his posthumous overview of the new arts as "vision in motion."

*Vision in Motion* makes it quite difficult to tow the line of the

constructivist tradition. In the introduction to this work, Moholy asserts a compound view of his construct, vision in motion, with a bit of relativity theory shifting around in the background to open up new dimensions. In other words, *"vision in motion is a synonym for simultaneity and space-time: a means to comprehend the new dimension."*[2] The simultaneity that accompanies vision in motion or, synonymously, the overlaying and superimposition of space onto the axis of time, provides the extra dimension which shakes up the historical order and any integral claim to a proper sequence. Moholy goes on to link vision in motion with the rise of abstraction in the arts, for the ability to see objects on the move lies at the basis of the cubo-futurist revolution: "vision in motion is seeing moving objects either in reality or in forms of visual representation as in cubism and futurism."[3] While Moholy refers to these artistic movements as "forms of visual representation," their deformational strategies and multiple distortions (which, as will be demonstrated later, Moholy equates with vision in motion) provide a powerful critique of any fixed mode of representation.

However, the abstract revolution in the arts and the move towards vision in motion is only one side of the Moholy story and the active critique of traditional modes of representation. This study is also interested in demonstrating how the artistic practice of Laszlo Moholy-Nagy entails a set of operations and strategies that acknowledge the problematics of language for the visual arts and consider art as a signifying practice. Like vision in motion, this linguistic turn provides another source and resource of turbulence and resistance to an unproblematic form of historical representation, and this, in turn, impacts upon any biographical attempt to seize upon Moholy and render an account of his life. Both abstract art and theories of language in the twentieth century have problematized the representation of the (biographical) object of study and the claim to an immediate, direct, and easy accessing of the referent. The starting point of this study, then, is to consider how one can write artistic biography in the light of such abstract and graphic resistances.

Taking issue with modernist conventions, these biographical writings mobilize something other than a static or utopian reading of Moholy that would categorize the Bauhaus master as a geometrician of form or as a formal Constructivist. Instead, they demonstrate that there are great affinities in Moholy's work with the visual-verbal investigations and word and image plays of such

figures as Marcel Duchamp and Man Ray. Like these other van-guardists, Moholy devised experimental strategies of (un)naming such that his artistic practice has to be understood as a major attempt to pose signification as the problem for the visual arts of this century. This study reviews the significant contributions which Moholy made in this direction in a variety of media. Whether preoccupied with questions of photomontage, photo-grammatology, or other forms of light-writing, these practices problematize the transparency of the signifiers of visual art in the field of representation.

In the pursuit of a better understanding of the avant-garde scene of the twenties, this study wishes to recall the active com-merce and exchange among the so-called "ism's of art" before the imposition of the set labels and strict divisions of art histori-cal categories. For example, if one looks at the infamous photo-graphic group portrait of the International Congress of Avant-Garde Artists held in Weimar in September of 1922, one sees a rather serious looking or deadpan Moholy in the background flanked by Tristan Tzara, El Lissitzky, Theo van Doesburg, Hans Arp, Werner Graeff, Hans Richter, and others.[4] One year before receiving the call to the Bauhaus as master, the preschool Laszlo and Lucia Moholy (his first wife) travelled from Berlin to hobnob with these provocative pathbreakers of modern art. In the mix-up and the exchange of tendencies and media, this avant-garde joint venture was given the hyphenated name of the Dadaist-Construc-tivist Congress[5] (Figure 2).

But the recitation of related figures and intellectual affiliates interested in investigating abstract artistic languages goes only so far in constructing a working milieu for Moholy's project. The particular thrust of this biographical study is to review how the artistic practice of Laszlo Moholy-Nagy engages a primal scene of signification in the staging of *signature effects,* and further-more, to consider how this signature practice impacts upon the writing of his biography. In other words, these biographical writ-ings focus on questions raised by the inscription of the Moholy signature. The double-edged construct of the signature effect, which frames the issues raised in this biographical study, is the net result of an encounter between the subject and its scripting. The inscription of the signature always involves a splitting of the sub-ject into two parts. On the one side, the primal scene of inscrip-tion institutes an investment of the subject in the world as an authorial identity. That is why at the end of any letter or any piece

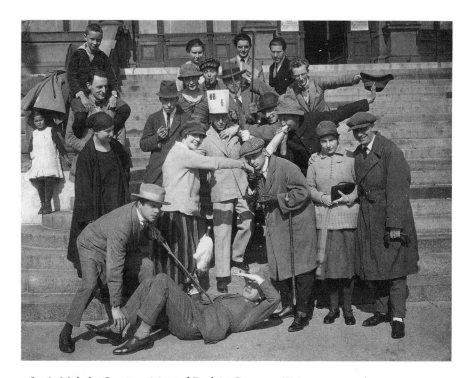

2. Lucia Moholy, *Constructivist and Dadaist Congress, Weimar,* 1922, gelatin silver, 16.7 x 21.6 cm. (Collection of the J. Paul Getty Museum, Malibu, California)

of personal correspondence there lies a signature. The signature signs off, authorizing what has come before. It connects the body of the work and the body of the person handwriting. In this act of self-possession, by marking one's own name next to the *X* or on the dotted line, the work returns to the signer. In this system of the proper name, the signature signifies the author and that is its meaning as well as its identity.

But on the other side of this procedure, the subject is constituted as an effect of the signature. The signature returns the subject to the material basis of language in its graphic inscription. Rather than a delivering of the subject, the effect is one of delivering the subject in name only. The graphic intervention of the signature blocks access to the subject as signified object and converts him/her into a textual effect. In this manner, the signature becomes a problem for history — not just the history of the signature, but the signature of history. For there is the risk that the history of meaning could be signed away (or resigned) in the

write-off of the signature.[6] From this perspective, history can no longer be viewed as a series of events which stand outside of language, but must be acknowledged within signification — that histories are organized through signifiers, chains of signifiers, the gaps between signifiers and signifieds, or even proper names and their signatures. History will then bleed into historiography.[7]

This double writing of the signature effect also conditions any consideration of the monster construct of modern technology and its impact upon the constitution of the biographical subject at hand. Moholy seconded Gropius's call of "Art and Technology: A New Unity" (*Kunst und Technik: Eine Neue Einheit*) as the appropriate motto for the Bauhaus when he burst upon the Weimarian scene in the summer of 1923.[8] In this light, Moholy's work with the photogram, the phonograph, or scratching onto film must be viewed in the service of forging the modern media personality. But it is also necessary to consider how these media technologies intervene and problematize the subject of biography. In other words, Moholy's deployment of technological constructs such as *production-reproduction* automatically leads to the consideration of a mediated Moholy subject encountered only via the *technology* of history. It is this technologizing of history that imagines the signature effect as an automatic writing machine for the scripting of the biographical subject.

### Derridean Warrants Out for the Arresting of the Signature

There is no denying that the formulation of the signature effect owes much to contemporary literary theory (to name-drop, deconstruction and poststructuralism) or to those post-Saussurean theoretical endeavors that have problematized any simple relationship between sign and referent. In particular, there is an indebtedness to those texts signed in the name of Jacques Derrida that have taken up the signature effect as another means by which to approach the writing of biography and thereby to acknowledge life's graphic dimension. Rather than trying to summarize and totalize a Derridean theory of the signature as a body of knowledge, it is more to the point to review a number of scenes of writing in the Derridean corpus on the effects of the signature that have strong resonances with the strategies that have been deployed in the present Moholy case study.

The basic thrust of Derrida's biographical encounters has been to locate the signature as and on the borderline between life and

text. This is why Derrida has been bent on associating the signature with a variety of figurations of the remains — with overflowing (in *Signsponge*), with the parergonal supplement (in "To Speculate On Freud"),[9] and with laughter (in "Ulysses Gramophone").[10] In *Glas*, Derrida asks this question up front and then, appropriately expropriating, leaves it hanging: "What remains of a signature?" (*Que rest-t-il d'une signature?*)[11] The two totalizing demands for the signature's appropriation are both bound to fail because they can not exclude what remains in the return of the repressed other. On the one hand, the historicist gesture seeks to move the signature outside the frame of the work — i.e., to understand it as the writ of authorization on the part of the author who signs for the totality of the work on the inside. On the other hand, the formalist gesture seeks to place the signature inside the frame so that "it is in the text, no longer signs, operates as an effect within the object."[12] In her study of Rousseau's signature (*Signature Pieces*), Peggy Kamuf summarizes the push and the pull of the demands of the signature that threaten to tear it into pieces: "At the edge of the work, the dividing trait of the signature pulls in both directions at once: appropriating the text under the sign of the name, expropriating the name in the play of the text."[13] Given these considerations, biographical writings that are constructed via the signature effect have to walk the (double) line — engaging both the formalist and the historicist positions as foils for one another in order to acknowledge the necessity of the signature's remains.

Derrida accomplishes this in *Glas* by juxtaposing the signature of Hegel (as the impossible historicist demand to make the signature disappear) and the signature of Genet (as the impossible formalist attempt to keep the signature completely inside the body of the text). This plays out the double band of the signature's writing. "Hence the signature has to remain and disappear at the same time, remain in order to disappear, or disappear in order to remain."[14]

*Glas* also considers how the structure of the remains inscribed in the signature "event" exposes the one who signs to a space of writing that is linked to death. As Derrida explains, this is how the writing of the signature exceeds the structure of the event: "When I sign, I am already dead, I hardly have the time to sign that I am already dead. I have to abridge the writing, hence the siglum, because the structure of the 'signature' event carries my death in that event. Which means that it is not an 'event' and

perhaps signifies nothing . . ."[15] In applying this model to the practice of Moholy-Nagy, the following study explores the relationship between the inscription of the signature and the "death of the author" under the rubric of the becoming-anonymous of the Moholy subject. To this end, it reviews the problematics of an artistic practice (photographic and otherwise) of an "anonymous hand" (writing) designed to deal in and with death's exposure.

An important Derridean venture into the theory of signature remains the essay "Signature Event Context" which takes on the language theories of J. L. Austin and their specific exclusion of the citability (or "iterability") of performative utterances as somehow a perverse, parasitic, and even non-serious language practice. In contrast, Derrida insists upon the iterability of signs and the impossibility of saturating their meaning within a single linguistic context as foundational to the structure of graphic inscriptions. This leads to a discussion of the enigmatic "effects of signature" in terms of the peculiar intertwining of the singularity and repeatability that is marked out in every inscription of the signature. Derrida discloses, "In order to function, that is, in order to be legible, a signature must have a repeatable, iterable, imitable form, it must be able to detach itself from the present and singular intention of its production. It is its sameness, which, in altering its identity and singularity, divides the seal."[16] The iterable function of the signature provides a necessary resource for biographical writings that are no longer bound to authorial intentions. Along these lines, these biographical writings will explore the iterable effects of the construct instituted by Laszlo Moholy-Nagy under the signature of production-reproduction. In postulating the productive function of reproduction (and vice-versa), this iterable construct maps out an alterity at the center of biographical identity.

*Signsponge* offers one of Derrida's most extended speculations on the question of signature through a study of the French poet Francis Ponge. It is here that Derrida explores in depth the "*double bind* of a signature event."[17] This is the push and pull that a signature experiences between its function as a proper name and its conversion into a common noun (as the remains of the proper name) — between "the need to become a thing, the common name of a thing," and "the contrary demand for a pure idiomaticity, a capital letter unsoiled by the common, the condition of the signature in the proper sense."[18] In the case of Francis Ponge, this turning of the proper name into a stony monument leads to the contradictory consideration of the signature sponge that both

soaks up and wipes out meaning. This Derridean signature strategy, decomposing the proper name into the common noun, is also illustrated in the text "Parergon" which frames the aesthetics of Kant in terms of the border or edge (*Kante*).[19]

In deploying this strategy, this antonomasia of the signature, the final chapter of these biographical writings reviews the decomposition of the Moholy signature into the common register. Its writing shuttles back and forth between the proper name of the artistic subject and its conversion into the things that would program the action of his artistic life (*holy, ho,* the hyphen, *hole/whole*) while, at the same time, investigating how these things approach the limits of meaning. As Gregory Ulmer has commented, the deployment of the signature effect in this manner is neither an attempt at historicist nor formalist explanation, but rather the generation of a life-text (bio-graphy) "as an *inventio*" — as another way of making history or writing a story open to "the convergence of necessity and chance marking the place of the impossible subject."[20]

The positing and positioning of the signature on the borderline and open to the invasions of the other problematizes the concepts of the *proper* and *property* that go along with artistic authorship. Indeed, it raises the possibility of forgery and plagiarism as essential risks in the inscription of any artistic signature. Derrida develops this stolen doctrine on the right side of *Glas* amid an analysis of the poet-thief, Jean Genet. To cite, or even pilfer, this passage, this investigation relies upon "resources which would lead into the interior of the system of painting, importing *into* the theory of painting all the questions and the question-codes developed here, around the effects of the 'proper name' and the 'signature,' stealing, in the course of this break-in, all the rigorous criteria of a framing between the inside and the outside."[21] In this particular frame-up, the signature that insures the link between the author and the work can also be forged and stolen. The following study investigates or joins a break-in (already in progress) that serves to contaminate the purity of the Moholy signature in the light of a system in painting and other artistic media under the constant threat and accusation of plagiarism and pilfering.

In "Otobiographies," Derrida challenges the genre of philosophical biography that is constructed upon the historicist maintenance of a rigid separation of the life and work of the philosopher. Of course, this is exactly the site at which the signature intervenes. Derrida speaks by means of a pluralizing negation of

this biographical distinction: "We say no to this because a new problematic of the biographical in general and of the biography of philosophers in particular must mobilize other resources, including, at the very least, a new analysis of the proper name and the signature."[22] Derrida emphasizes the importance of the signature for any project aimed at the dislocation of biographical identity exactly because of its dynamic position and borderline status between the body of the author (life) and the body of the textual corpus (work). He problematizes the fixed biographical subject by lending an (other) ear to the line of textual credit undersigned in the posthumous name of Friedrich Nietzsche on account of the dynamics of the eternal return. The substitution of the term (Moholyean) "artist" for (Nietzschean) "philosopher" in the aforementioned citation from *The Ear of the Other* will put the reader on the track of the aims of the present inquiry and its mobilization of resources in pursuit of an artistic biography organized around the problematics of the signature. In this way, it might be read as a direct response to the Derridean call for a new analysis of the proper name and signature as applied to the case of Laszlo Moholy-Nagy.

### The Signature Effect in the Key of Moholy

When one makes the case for Laszlo Moholy-Nagy, the consequences of the signature effect do not stop with cutting up the world into signifiers and signified. This study demonstrates how the double band of the signature effect (between signified subject and signifying matter) prescribes a series of tensions that are played out in the life writing and artistic practice of Laszlo Moholy-Nagy that shuttle between identity and anonymity, between originality and plagiarism, between necessity and chance, between authorship and its resignation. It is convenient to preview how different aspects of the signature problematic contribute to the constitution of our biographical subject in the five central chapters of the study:

1. "Production-Reproduction." As indicated, production-reproduction is the formula with which Moholy's experiments with a number of new acoustic and visual media technologies (the photogram, the photograph, and the phonograph) are preoccupied during the 1920's. Taking off from the assumption of the capacity of a signature to be copied, this chapter follows the ramifications of the preceding formula on Moholy's work and

writing. In other words, this formula poses issues which mark repetition with difference or production with reproduction. The effects of production-reproduction even open the possibility that another Moholy, a simulacrum of himself, might appear somehow in the recitation of his work.

2. "Forging Ahead." The signature which authorizes and guards against artistic duplication can also be forged by another. This chapter examines the charges of plagiarism brought against Moholy throughout his artistic career. It reviews how Moholy's art and writing operate in an economy that seeks to question the restrictions of copyright and individual property. The forging of the signature risks the identity of the biographical subject and his works of art.

3. "It Works." This chapter reviews how the signature makes its way into Moholy's works of art and the consequences therein. The signature is imprinted literally as Moholy's graphic works. Moholy focuses attention on the materiality of these visual signatures and on their loss of connection with the identity of the signer of the work. Moholy's abstract autobiographical photogram self-portraits are signature works which institute a practice of masking the subject. His photomontage self-portraits deploy tactics to "unname" or "misrecognize" the autobiographical subject. This chapter also reviews a few case studies where the mark of the signature confounds the proper assignment and identity of graphic works.

4. "The Anonymous Hand." The signature can be detached — removed from reference, author, or personality — and this puts writing in an anonymous hand. This chapter considers a number of Moholy's strategies of unnaming or of becoming anonymous and, therefore, a number of detaching practices which foreground the problematics of the signature. Sections are devoted to the telephone pictures, the detached-hand photograms, and the shooting photomontages, showing how Moholy raises the question of the anonymous hand and the "death of the author" through these practices. Moreover, this chapter exposes the paradoxical nature of writing a biography of one who seeks to become an anonymous agent.

5. "Moholy: The Significance of the Signature." The final chapter examines the significance of Moholy's proper name. It plays back and forth between the significance/necessity and the arbitrariness/chance of the encounter of the graphic and of biography. In sections on *ho, holy, hole in whole,* and the hyphen, it

establishes a personal correspondence between Moholy's auto-graph and the construction of his autobiography. It investigates the possibilities of meaning or significance out of the arbitrariness of a name. But it also demonstrates how the meaning of each of these terms risks significance and displaces Moholy's status as a fixed biographical subject. As a result, "The Significance of the Signature" wavers between the possibility that the (autographic) signature determines the (autobiographical) life of the bearer and the possibility that it removes and disposes of the self and its significance.

From this sketch, it becomes clear that the issues raised by Moholy's signature revolve around questions of identity, naming, and indication; of the functions of the author and authority; of the constitution of the subject in language; of the limits of the biographical subject; of the signature in surplus of meaning; or of the "graphic" in excess of the object of biography. Each chapter opens a new angle or constructs another frame from which to take up the problematics of the signature, a new keyhole that will subject Moholy, the biographical subject, to a peering and a peep-ing and will catch what he called "vision in motion" — change that will move with it.

This study works around the proposition that a new practice of historical writing can be styled that marks the problem of the signature for biography. In this way, it hopes to lighten the so-called "burden of history." This burden involves the traditional reluctance of Anglo-American historical studies to conceive of the possibility of using modes of representation that do not proceed via the late-nineteenth-century form of narration developed in the English novel for the organization of the materials which con-stitute historical writing. By means of the unstable border of the Moholy signature, this study hopes to construct a writing that problematizes representation as a closed relationship between signs and meaning, signifier and signified, language and a priv-ileged outside of the text called historical reality. It inscribes a practice which acknowledges exteriority, alterity, and disconti-nuity in the crafting of historical writing.[23] The need to write Moholy "otherwise" finds its warrant in the perception and re-ception of the biographical subject himself. In autobiographical reflections upon life at the Bauhaus, Lothar Schreyer writes a rather unattractive portrait of Laszlo Moholy-Nagy at the incep-tion of his teaching career in which the forces of a menacing and threatening alterity cling to the essence of his description. Schrey-

er's characterization cannot be explained away just because Moholy was a foreigner — i.e., a Hungarian with a funny accent teaching at a famous German institution. It has more to do with a clash of artistic world views — an old-line Bauhaus Romanticism and Expressionism being invaded by a technological unknown which could only be marked as something other, as a foreign body with Moholy taken as its abstract representative. Schreyer recounts, "Now it happened that with Moholy-Nagy a new and completely foreign world came into the Bauhaus which appeared to threaten us."[24] Schreyer's description continues, recalling the early rejection and isolation that Moholy faced at the Bauhaus in Weimar: "The teachers and apprentices rejected Moholy, not as an artist, but as a human being. It is horrible to say this."[25] However, one of the assumptions of this study is to take Schreyer's statement at face value. In other words, it is necessary to start from the premise that there is something alien in the artistic practice of Laszlo Moholy-Nagy and that this alien quality involves both an acknowledgment of the forces of alterity and a group of artistic strategies that displace the human subject from the center of artistic action. In contrast to Schreyer's horrified reaction, these biographical writings detail the artistic strategies of Moholy that serve to foreground these forces of alterity at work and to demonstrate how they transform the biographical accounting of his life.

In addition to this defamiliarizing strategy, the following study also deploys convergences on the level of the letter (homonymy) to detonate the transparency of the signs of historical representation.[26] Historical common sense, or the essentialist powers of the signified, insists that these moves operate only on the level of appearance in an attempt to dismiss such maneuvers as mere wordplays without any basis in anything other than linguistic substance. This is a traditional move that attempts to reduce writing to a transparent vehicle for meaning. But the theoretical armature of this study refuses to take naive historical representation for granted. Instead, it constructs or poses its readings in the interspaces and intersections of the plays of signatures and the undecidability of their chance/necessary meetings. These double plays are graphic demonstrations of the risking of a fixed biographical identity. Indeed, they force the reader to confront the intertwining of chance and necessity as applied to life's writing.

Given these considerations, *Laszlo Moholy-Nagy: Biographical Writings* does not take its object of study for granted. For

Laszlo Moholy-Nagy does not only constitute a history of events or the origin of a discourse. He is equally a resource of signifiers for the generating of textual effects to stage the problem of writing for history, the graphic for biography, the signature for the signified. Any nostalgia over the loss of the traditional subject of biography will be counterbalanced in affirming the plays and re-sourcefulness of signature effects staged in and through Moholy's name. Not obsessed by old art historical words and concepts, this approach might generate Tom Wolfe's marvelous and free-form style of writing of/on the artist for the new age. To achieve this end, the text will put into practice that which Moholy called production-reproduction, i.e., the capacity of every signature to be reinscribed and to undergo transformations on account of that reinscription. Production-reproduction opens the possibility that the biography of Moholy-Nagy will become "a matter of virtuosity"[27] in its reading, and that the graphic will get away from "Moholy." Or viewed in another light, Moholy's vision in motion affords the opportunity to take him on a journey to parts unknown. Following the patterns of graphic movement and moving beyond the so-called "tradition of Constructivism," it will uncover other maps and trajectories lodged within the body of his life, work, and signature. And so, in revisiting an unheard of Moholy-Nagy, the diabolical risk of the biographical writings will cast Wolfe's howling, infernal chant ("The hell with Moholy-Nagy, whoever heard of him.") in a new light.

Given these assumptions, the mobile terms of Moholy's biographical writing stand ready to form new chains of reading. This raises the question of the text, the "Where's the text?" effected by the graphic surplus of the signature — what is alternatively dubbed intertextuality. The graphics of the signature and the "nothing" to "go between" reiterate the dynamics and the staging of Moholy's *Spiral-bound Mobile Picture*. Perhaps, in the spiraling and bounding description of this intercontinental passage, we are reading the book to come.

> "Have the two leaves spiral-bound down the middle of the white background," Moholy told me when he left for America. "The leaves have to move like the pages of a book. Is that clear?"
>
> I thought it was, but I was in the minority. For days I canvassed the London binderies, carrying board and leaves like pieces of armor.

"Where's the text?" the foreman would ask after a disappointing glance at the designs. "These are covers, but what's to go between them?"

"Nothing. Just put them together with spiral binding and fasten it to the middle of the board. . . . To create new light effects, superimpositions."[28]

The hermeneutic question of the foreman as to the location of the text and the need to know what goes between the covers of the book unveils disappointment or despair in the face of the lost contents. But the author of *Experiment in Totality* responds with an off-handed and enlightening response ("Nothing.") which poses in the affirmative the generation of "new light effects, superimpositions." This superimposing response provides a way to understand both abstract visual art and a biographical writing practice where "the leaves have to move like the pages of a book." In both instances, the focus of attention will shift from the representation of the subject to the staging of demonstrable effects subject to "vision in motion."

### From Constructivism to Deconstruction: Recovering Future History Moholy Style

But constructivism that constructs nothing, and is of little visual attraction in itself, might better be called zeroism. — T. W. Earp, *The Daily Telegraph*, review of a Moholy exhibition

Future history will reestablish him as one of the moving forces on a new vision of this century. — Herbert Bayer, "about moholy-nagy"

While the "Derridean Warrants" were preoccupied with showing how the contemporary practice styled Deconstruction offers the theoretical constructs (e.g., the signature effect) that enable the biographical writing of/upon a constructivist artist, this section looks at this process from a reverse angle. In other words, it proposes to work from the past to the present and thereby to establish the historical and textual links between these two movements — from Moholy's Constructivism to Derrida's Deconstruction. This provides the pieces of a puzzle with which to construct

Moholy's "future history" through a genealogy of artists and movements whose intellectual lineage would pose a revisioning and refashioning of a conventional artistic/literary history of styles and disciplines.

Given the trans-European founding of the constructivist movement in art and architecture after the First World War and the rise of the deconstructive literary-critical movement in the early 1960's, this section seeks, if possible, to come to terms with these capital points — i.e., the exact relations between these movements (the terms of these movements and movement of these terms) as well as Moholy's relations with them. Assuming the conventional frame of art historical reference, Constructivism denotes the international art movement to which Laszlo Moholy-Nagy made a significant contribution. Indeed, this descriptive statement mimes a textbook definition or an encyclopedic cataloguing wherein one takes possession of the proper artistic name as "a leading exponent of CONSTRUCTIVISM [who] was a painter, sculptor, stage designer, photographer, and film maker."[29] Unfortunately, this descriptive formula represses the unsettling side of the artistic agenda of Constructivism, concerned as it was with questions of abstraction and exteriority, with questions that tested the limits of representation in painting. Indeed, this study hopes to demonstrate how Moholy's artistic practice provides a case study of a constructivist tactician at the crossroads between signification and the visual arts whose career runs parallel to many of the vanguard artists and art movements of the interim War period. Meanwhile, this study cites or deploys numerous theoretical constructs adapted from Deconstruction that take as their point of departure the texts of French writers such as Jacques Derrida. Deconstructive textual analysis has taken up the question of signature, the limits of representation, and writing's relationship to the other. While its legendary and legitimizing status has been achieved in texts between literature and philosophy, the strategy of the signature effect has been instrumental as the point of departure for this exercise in biographical writing.

Without a doubt, there is a direct link on the level of the letter between these two signatures, of the constructive and deconstructive call letters. But, one has to inquire whether the scripterly association is only a coincidence. Do these linguistic roots have historical significance? In other words, could one plot a history of movements from Constructivism to Deconstruction? While this section begins with an epigraph from Moholy's Bauhaus col-

league Herbert Bayer that asserts an overarching grid of the history of ideas and influences, it is in the service of a "future history" open to the posthumous dynamics of production-reproduction that this section charts the lines that connect these two movements as they relate to the biographical writings of Moholy. Two possible risks accompany this speculative inquiry, and these extremes offer variations upon the battle between chance and necessity that follows the tracing of Moholy's signature effects throughout the texts of his life and the life of his texts. On one side, there is the teleological risk embedded in the form of historical inquiry that would project a destinal subjecthood to the recovery of the move from Constructivism to Deconstruction. On the other hand, there is the risk of frivolity that comes in the form of the incessant demand of the arbitrary signature as somehow running the show when it comes to the history of these movements — a distracting history that would serve only to re-cover Moholy's tracks.

In any event, the road is winding and it offers a series of unexpected detours — technological and otherwise. The first stop of this historical sketch is a return to the Hungarian capital city of Budapest. The address is 3 Nagymezo Street, and the schoolhouse is named the Mühely. In terms of both the institutional name and the address, the dynamics of the significance of the signature return to Moholy's native Hungarian tongue. For it is most astonishing to learn that Mühely is the literal Hungarian translation of the German Bauhaus — the institutional supporter that would deliver to Moholy his international academic credentials and his artistic name. The director of this school of graphic arts, which was designed to be a pedagogical replica of the Bauhaus, was Moholy-Nagy's former Hungarian activist colleague Alexander Bortynik. Their paths crossed at the Bauhaus, with which Bortynik was affiliated from 1922 to 1924. Werner Spies recalls the association: "After spending the years 1920–1922 in Vienna, where he arrived at his first consistent geometrical abstractions, Bortynik moved on to Germany, though his eventual goal, he says, was not Weimar, but Jena. However, the atmosphere of the Bauhaus and the presence of other Hungarian artists, among them Moholy-Nagy and Andor Weininger made it easy for him to decide to remain in Weimar."[30] While the following evidence may be hearsay, there is also a personal letter that sets up an artistic lineage tracing its source to Moholy and his constructivist mates: "As [Bortynik] recalled in a letter to Vasarely, like many of his

Bauhaus comrades, he was 'strongly affected in his early work by the influences of *de Stijl,* Mondrian, and especially Van Doesburg, as well as by those of Moholy-Nagy and Herbert Bayer.' "[31]

From 1928 to 1930, the recipient of that letter, Victor Vasarely, studied at the Mühely at the very same time that Moholy, having left the Bauhaus, taught the preliminary course on existing and created forms. This encounter evinces both a historical conjuncture and its theoretical constituent. Like the teacher, Vasarely became interested in achieving optical and structural effects in graphic design and he soon became a leader in those art movements obsessed with movement, Optical and Kinetic art. Indeed, Otto Stelzer in his postscript to *Painting, Photography, Film* cites "Vasarely (another Hungarian)" as one who followed directly in Moholy's footsteps. Using the generic labels of twentieth-century art history, Stelzer traces Moholy's departure from Constructivism in terms of the pathbreaking role that he played for the new movements:

> Moholy always saw himself as a Constructivist, but he passed quickly through the static Constructivism of his own time. In a few moves he opened a game which is being won today. His light-modulators, his "compositions in moving colored light," his leaf paintings [*Blätter-Bilder*] of the forties, represent the beginnings of a "kinetic art" . . . which is flourishing today. Op Art? Moholy did the essential spadework of this school (the old expression is in order here) in 1942, even including the objective, important for Op artists, of an application: with his pupils in Chicago he had evolved studies for military camouflage. The display of these things . . . was at once the first Op exhibition, *trompe l'oeil,* and its theoretical constituent.[32]

In the blink of an eye, Moholy passed quickly through the static Constructivism of his time. He moved to the beat of kinetics, "even the term is his" — whatever such terminology means for such a movement. Meanwhile, before it even had a signature to call its own, one learns that Moholy was staging op effects and playing at camouflage. To expand further upon this role of playing the forerunner in terms of Op and Kinetic art practices, it might be worth considering that, somewhat later on, the members of the German avant-garde movement Group ZERO would invoke the importance of Moholy's example (even if in inverted or paradoxical form) for their anonymous artistic practice of painting/

writing with light in the late 1950's and early 1960's.[33] They even staged an exhibition in Antwerp in 1957 under the title *Motion in Vision*.[34] Ironically, this posthumous artistic development gives another twist to T. W. Earp's critical epigraph denouncing Moholy's work as a transmutation of "constructivism" into "zeroism." In the light of future art history, this reads "Moholy style" as an unintentional prophetic pronouncement of Group ZERO.

Following the international weave of the patterns of this kinetic history, Vasarely moved on to Paris in the 1930's, and he crossed borders and paths with Moholy again as a fellow contributor to and supporter of the Abstraction-Creation group. Still living and working in Paris in the 1950's, Vasarely in turn influenced a number of young graphic artists working under the acronym of GRAV (Groupe de Recherche d'Art Visuel), including such figures as Julio Le Parc and Francois Morellet.[35] While the GRAV group issued manifestoes, plotted tactics and strategies, and organized their exhibitions, Jacques Derrida began to write what instituted his own version of "Op Writing."

Such is the title and the argument of an essay by Gregory Ulmer that draws a direct connection between the theoretical concerns of the Constructivism of GRAV and Vasarely on the one hand and the Deconstruction of Derrida on the other hand. Through the superimposition of a moire effect and its linguistic transduction, Ulmer makes the case for another "anti-formalistic" way of reading that rethinks literary deconstruction in the light of the aims of constructivist visual art and vice-versa:

> What I want to show is that the syntactic movement which Derrida opposes to form is in principle a linguistic version (a "transduction") of the moire phenomenon being researched by the Constructivist artists in Paris about the same time as Derrida was writing his first book — on the philosophy of Geometry. That Derrida names his soliciting procedure "deconstruction" may, in this context, be taken as both an acknowledgment of his affinity with Constructivism, and his caveat that his use of the moire figure . . . is not itself another concept of form.[36]

To hypothesize for yet another generation, one might consider this study as a direct response to Ulmer's viewpoint that undertakes not the "comparative study of the relations of Derrida to GRAV," but of Derrida's Deconstruction to Moholy's Constructivism. Thus, it might be read as an exploration of the acknowledg-

ment of this affinity. To reinscribe the Ulmerian terms, it might then be understood as an intellectual history that plots "the general analogy between their interests [i.e., Moholy and Constructivism] and those of Derrida having to do with framing, grids, networks, movement, and double bands."[37]

A parallel case study locating a relationship between the two movements can be found in the field of contemporary architecture where so-called "deconstructive architecture" has claimed both a historical lineage and a theoretical linkage with the Russian constructivist movement of the 1920's and 1930's. In the foreword to the architectural omnibus *Deconstruction,* Andreas Papadakis states this relationship in the unproblematic language of direct influences and artistic continuity. Whether fully conscious or just intuitive, the analysis goes so far as to argue for the unthinkability of the latter movement without the former — and not just in name only: "At the beginning of the century, a conscious theoretical development within architecture took place in Russia and Deconstructive theories owe a debt to the Constructivism of that time. Indeed, much of the present work stems from earlier, often intuitive moves in this direction."[38] This new "theoretical development" instituted the use of such architectural motifs as rotated axes, disrupted grids, slanted walls, disjointed edifices, etc. To cite just one example of historical continuity, the element of "scalelessness" in the *Prouns* of El Lissitzky — those interchange stations between painting and architecture which had quite a powerful effect on Moholy's own intermedia explorations — resurfaces in the spatial articulation of the *Landscape Superimposition* of Bernard Tschumi in his design for the Parc de la Villette in Paris.

Of course, there are other critics who argue that the deconstructive architectural movement cannot stand on its own terms as something radically new and different from the past. But these allegations by no means impair the positing of a historical or theoretical linkage because the conflation of the contemporary architectural scene with Constructivism only underscores the dependency of this historicist filiation — even to the point of a parasitic relationship in good deconstructive fashion. Thus, in his proposal that deconstructive architecture is a rehashing of constructivist tropes, James Wines bridges (and marks) the gap by referring in a hyphenated manner to today's "pioneers of the new fragmentation, the new Constructivism-cum-Deconstruction."[39] Derrida affirms this conflation qua contamination of the terms of the de-

bate with the rather open-ended assertion that "deconstructions would be feeble if they were negative, if they did not construct."[40]

In addition, the collaborations of self-professed "deconstructive architects" such as Bernard Tschumi and Peter Eisenmann with Derrida on such projects as the *Folies* in Parc La Villette or on the *Timaeus* designs demonstrate how the strategy of "philosophical" deconstruction has intervened directly into the field of architecture.[41] These specific projects have attempted to explore an "architecture of the between" or one that would pursue a logic of supplementation and interruption as applied to the art of building in order to deconstruct traditional dichotomies such as figure and ground, form and function, or abstraction and figuration. Furthermore, these architects have expressed an interest in undermining the privileging of shelter as the foundational goal of the architectural project. As Andrew Benjamin indicates, this opens "the possibility of an architecture that takes place within that space of interruption that holds within it sheltering, but, at the same time, deconstructs shelter."[42] It is interesting to point out in this context that the depriviling of the centrality of the concept of shelter in architectural design is already a concern of the "new vision" of Laszlo Moholy-Nagy in the guise of a constructivist theoretician. Arguing for an "experience of architecture" based on an understanding of spatial articulation, a discriminating Moholy diagnoses the essential and essentialist problem: "A symptom of our time is that this lack of discrimination is also common in architects, who look for the essence of architecture in the meaning of the conception of *shelter*."[43]

"From Constructivism to Deconstruction," here is the title of a history of events that link up, of biographical facts and figures, of the ideas and influences of artistic and philosophical personages handed down in a linear succession, of intersections and coincidences that appear to be untainted by the problematics of signification. But this narrative passes by all too quickly for it overlooks the *syntactics* of the signature and its line of fire which "in a few moves" — even in the simple movement from construction to deconstruction — "opens a game which is being" played, if not won, today. The formalist critique that embodies the syntactics of the signature in the most literal way possible raises a dissenting voice on the level of language in an interrogative mode. After all, who is to say that the homophony of the signature might not be the sole basis for the movement from construction to de-construction? In other words, what had been defined as the outside of significa-

tion—the joint history of Constructivism and Deconstruction—would be reinscribed as effects of their signatures. Paradoxically, what they have in common as historical projects—their attention to the issue of signature effects and to the posing of limits of the representational frame—also divides them, and this, in turn, would undo the possibility of any historical link between them. There, it is spelled out, spelling in the way of the words.

What to draw from the overlay of two words, two movements, with two letters of difference? On the one hand, there is that which insists on the chance meeting of linguistic materials so that these are merely plays on words independent of the work of history—i.e., the historical linkage between Constructivism and Deconstruction. On the other hand, there is the possibility of the necessity and significance of this signifying link, that which constructs history as an effect of these movements—the event of and from these signatures. In between, there is writing. It is a game, shuttling, playing between chance and necessity, shuffling two words, in order to induce a moire effect—a wavering and a blurring between them. For the flickering graphics of the moire effect is what links construction to deconstruction, and also what divides them, or superimposing them, de*construction*—*"like the two overlapped but not quite matching grids that generate the flicker of the moire effect."*[44]

Moholy's artistic practice also involved the dynamics of op effects to induce those wavering movements where a certain indecipherable vibration steps in to blur the image. As he writes in *Vision in Motion,* "This painting introduces a psychologically determined motion if one tries to define whether the black or the white arc is in front of the other. There is the feeling of a definite movement of the arcs forward and backward."[45] It produces a queasy feeling, a *seme-sickness,* a disturbance adrift, a movement making waves, back and forth, that blurs definition. One imagines Moholy at the Biograph airing a film presentation on this topic entitled *DECONSTRUCTION/CONSTRUCTION.* The first frame (DECONSTRUCTION) is followed by the second (CONSTRUCTION) featuring a black-white reversal with the remainder (DE) of the first frame still haunting the screen. This is how he would present it, or rather perform it, the "so-called after-image." Moholy describes the phenomenon, "At the cinema, the eyes often react to the white title on a dark background by reversing the lettering to black on a white background. This is the so-called after-image."[46]

These wavering moire patterns generate graphic effects in writing. Here, it serves a strategy designed to superimpose and set off these two words with so much in common in their construction, a marginal difference in spelling, a mere prefix affixed to one, and yet not quite the same, like the two overlapping but not quite matching grids that generate the flicker of the moire effect. The double band of this slightly distorted, offset writing would displace Construction, writing in the signature of Deconstruction, and then doubling back over again.[47]

In the autobiographical essay "Abstract of an Artist," Moholy comes to terms with the schematics of the double band through the figure of the strip shuttling back and forth throughout his career between a form of interpretation and something else which has been misrepresented or distorted as the "original departure."

> In analyzing "distortion," in these days I find that during the last twenty-five years, since I began my abstract paintings, I did not paint any shape which was not the interpretation of the original departure, the strip, used in my first collages. By slight distortion, although I had not been conscious of it, I continuously changed this shape on each occasion believing that I was inventing something completely new.[48]

On each and every occasion, the iterable strip functions as the "constant variable" in Moholy's artistic signature that resurfaces, repeats, and reinvents the artistic fallacy of the "something completely new." This myth of origins departs in and as the "original departure" and this is what produces collages from the first ("first collages").

The movement on the paper strip shuttles between Construction and Deconstruction. With this ever so "slight distortion" on the level of the letter, this unconscious wordplay, meaning has played out — a text and a biography. In the margins of the text, if and since that is not enough, Moholy weaves the autobiographical scene of "Abstract of an Artist" with a double writing on the doubling strip. It is a surprise when everything strips down to the play of repetition and difference. Here, the double band of Moholy's autobiographical writing is reshaped in the variant and variable form of the textual ribbon. To quote, "All the shapes which I used in the last twenty-five years surprised me one day as being variations of a ribbon (strip)."[49]

Not to be taken as formal concepts, moire effects and double bands move over, folding over. The signature strip and its capac-

ity for removal and reinscription have posed the problem of identity. All of the terms fold over and in the fold rests the possibility of production-reproduction, a repetition marked by difference. The flicker takes effect when language, in the very act of representing, folds over on itself — as a homophone breaks up identity, as the materiality of the signature points to itself as the limit of meaning, or as a pseudo-concept is marked in quotations. Repeating, the signature folds back on itself (quoting) from the source of frivolity, "folding back on itself in its closed and non-representative identity."[50] In this manner, threatening to touch upon that which goes under the name of parody, "de-construction" performs an optical illusion that might "construct nothing." Therefore, as its necessary risk, these biographical writings, as well as the practice of "de-construction," will have been generated in a double space where it is impossible to determine whether these terms have everything or nothing to do with each other.

At this indeterminant juncture, one can turn to two alternative histories of the dadaist-constructivist legacy composed by Kurt Schwitters that are derived in similar fashion out of the double band of the signature and its significance. Schwitters constructs his history of Dada as a "pataphysical" patrimony, the patronymic in the name of the forged father and, impossibly, its origin and destiny. It passes around the plays of language at the point where the risks of nonsense and the necessities of meaning shake hands. It confounds the discussion of whether the signature resides in history or history is an effect of the play of the signature. It is a long story, but this comparative and comparable history may shed some light upon these biographical writings:

> Here I must mention Dadaism, which like me cultivates nonsense. There are two groups of Dadaists, the Core- and the Shell-Dada, of which the latter reside mainly in Germany. Originally, there were only Core-Dadaists, the Shell-Dadaists under their leader Huelsenbeck shelled themselves off from this core, and in the splitting tore away parts of the core. The shelling took place to the accompaniment of loud howling, singing of the Marseillaise, and the dispensing of kicks with the elbows, a tactic Huelsenbeck employs to this day.[51]

Schwitters advances the necessity of chance and poses the historical significance of the wordplays. He plants Huelsenbeck's signature to flower on the surface, on the level of the letter, a level that

is skin deep. The husk, the *Huelse,* of Huelsenbeck effects his history. It moves the origin along, and the splitting of the shell shocks the relationship of inside to outside, taking away pieces of the core with it. The signature of Schwitters's MERZ movement also follows the logic of this materiality of the signature. After all, it is nothing but a piece of rubbish, a scrap of paper torn off, cast off on concrete, the loss or surplus of exchange value, that which was left over from the term *KOMMERZIELL.* In experimenting with photogrammatology, that ghostlike apparition of a medium, Moholy picks up the scatterings, the shellings, or the rubbish pictures of Kurt Schwitters so that the economics of waste plays an important part in Moholy's own brand of photogrammatological Constructivism.[52]

In addition to this dadaist history, Schwitters takes on the history of Constructivism in a singular manner and in the affirmation of a signature. It is simultaneously the history of a letter and, yes, the biographical subject, his signature, has carved out a most important part in it. The history of influences transforms into the replication of the letter which is caught in the middle. In the essay "Mein Merz und Meine Monstre," Kurt Schwitters proposes an alphabetical history of the modern art movements and their fashioning. Moholy's elementary search for the abc's of artistic expression returns in a perverted form with Schwitters's musings on the history of art as being subject to a strict alphabetical development:

> I would suggest to the critics that it would be better to write that I was influenced by Moholy, Mondrian, and Malevich, as we live in the age of the M, compare Merz. This is called Monstructivism. A few years ago, this meant "Kandinsky, Klee, Kokoschka." Everything with K. Before that, it was Lissitzky with L. We are going through the entire ABC of development. Today we are accustomed to M being in fashion, because, after all, that's the way the alphabet goes. And one day, when we arrive at the letter S, it will suddenly say, "Schwitters." Yes, yes, art is fashion.[53]

In the *Merzzeichnung* (that accompanies the piece), Schwitters illustrates this modern art history of the *M* with a parodic quadratic drawing that mimes the styles of Moholy, Mondrian, and Merz in three of its four quadrants, and he pencils in a Kandinsky clone for good measure. The enterprising Schwitters is able to move the terms of significance in the art historical debate to the

magic of a displaced letter in his insistence upon the acknowledgement of the art of "Monstructivism." One must translate this term as a constructed monster, a monster of a construct, a monstrous aberration of a name and its meaning coming from within the name itself, the rotting of a signature from its core. In the slippage of an extra term, one has moved the *"ism's* of art" from Constructivism to Deconstruction to Monstructivism. Schwitters's inventive narrative demonstrates the monstrous effects that come to avant-garde art history when given the slip and slippage of the signature.

### Multiplying Moholy's Signatures

There are multiple other routes to travel with signatures and some of them also enter into the life-writing of Moholy and the introductory ways and means of "signing on." A few of these strategies deserve some special mention. For instance, there is evidence that the biographical subject is quite interested in graphology. He writes, "People's characters are judged by their handwriting."[54] And it is a little-known fact that handwriting is a problem for Moholy from the very beginning and marks a snag in the school records. From the following account, handwriting, from the first, makes him second best: "In his first class he had top marks in everything but handwriting where he was given a 2."[55]

On the other hand, the quest for Moholy's signature can be as personal as the lines traced on the palm of one's own hand. Perhaps one should become a palm reader and study the writing of the hand itself to examine the markings of the subject in question that foretell his destiny; in other words, stop and look at Moholy's palm. This explanatory mechanism is not to be palmed off lightly for the subject at hand, not to be slighted as a mere sleight of hand. A quick look at Moholy's presumed photographic self-portrait seems to invite this reading[56] (Figure 3). And in Moholy's filmscript *Dynamic of the Metropolis,* one shot, with some extra emphasis, fills up the frame and delivers a similar punch line, "Close-up. ONLY the HAnds with the boxing gloves."[57]

For Laszlo Moholy-Nagy's School of Design taught that signing on and palm reading and writing go hand in hand. In its second school catalogue, the upraised palm shows off its signature. It prints and imprints the palm in the recording eye. "THE EYE OPENS. . . . We begin to see, with our own eyes. Our own signature, lines in our palms, veins of a butterfly wing, light on a

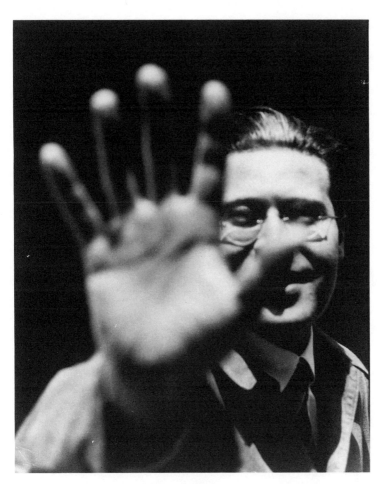

3. Laszlo Moholy-Nagy (or Lucia Moholy), *Laszlo Moholy-Nagy,* 1925–1926, gelatin silver, 25.7 x 20 cm. (Courtesy of The Metropolitan Museum of Art, New York, Ford Motor Company Collection, Gift of Ford Motor Company and John C. Waddell, 1987.) (1987. 1100.69)

surface, all are seen with a primal wonderment."[58] Opening the fields of representation and education, and as the first stage in the study, the eye pauses for signatures, writing from the very beginning, the "primal wonderment."

The next catalogue of the School of Design describes a new type of educational practice that, through the aid of (holding up) the signature, takes things even further: "The best way to achieve this is by observing objects not yet stamped in everyone's memory in worn-out formulae of the past. Instead of a face, tree, or human figure, which are always connected with traditional art, un-

usual objects and records are substituted. As the first stage in the study of line signatures, fingerprints, woodgrain are introduced."[59] The illustrations for both of these passages could be used as close-ups for Moholy's presumed self-portrait. On the left and right they offer the palm, raise it as the question of writing, magnify this issue, conflate the writing on the palm of the hand and the writing traced by the hand. Already in these introductory comments there will be straying and crossing over in the play of these signatures — in the finger(print) and in the wood(grain), in the writing of nature and of auxiliary instruments, from hand-written signatures ("our own" or on "line") to the writing of "light on a surface," (dubbed, following Moholy, *light-writing*).

In a sense, it is possible to say that this study of its founder and his signature puts into practice exactly what Moholy's school (and Moholy, himself) preached. It might be said to be written in the tradition of his school of painting, but the quotations from the School of Design catalogue disconnect the writing of the signature from tradition, from traditional art, and call for "unusual objects and records" found neither in art nor in schools. The research into "our own signature" (i.e., Moholy's) must ferret out what is so unusual about this written record, how the signature "de-signs" even as it is stamped on, how it raises questions for identity in the close-up of an (anonymous) hand held up to stop, how it contests what is signed by the authorities with the extra edge of its writing, how the signature is in the position of being "substituted" in and for teaching. The question is posed: What is it about the writing of the signature which would render it beyond the bounds of the book of life, where it is inscribed? How does it stamp upon "worn-out visual formulae"?

If the signature of and in palmistry is not esoteric enough, it appears logical to try a hand at astrology. Moholy certainly thought in astrological terms and believed in the signature of the stars and its writing of destiny. There are three extended horoscopes in the Moholy archives, one of which was collected one week subsequent to his death. This posthumous account comes back from the future and reads, "A typical premature personality, his 'character' early acquires a profile, and correspondingly 'destiny' assumes early clear definition."[60] Finally, character can be plotted through the lens of a prism. Using a spectrum, one can find the correspondence between the color wheel and the wheel of fortune. In addition to handwriting, Moholy believed that one could chart the finest gradations of personality through the signature of

color: "People's characters are judged by their handwriting. I'd know anyone by his relationship to color. In laymen as well as in artists it is the unfailing test for sensitivity and refinement."[61]

These practices of the signature are mysterious sciences — connecting a palm's lines to its owner's life, handwriting or a favorite color to a person's character, drawing a correspondence between the stars and a character's destiny or between a few markings on paper and a person's identity as in the authoritative signature. Graphology, palmistry, astrology, and color coordination are all ancient disciplines which link up the biographical subject and the question of the signature — hand-writing, palm-reading, star-gazing, etc. But the present study mobilizes different resources to research the mysteries of the signature. It concurs with the astrologer Ferdinand Ostertag that destiny is writ early in a man's life with "clear definition," but suggests that these effects might reside in the double play of the signature itself rather than in the stars above.

Signing on, the pen point that puts signature to paper institutes a double scene that frames Moholy, his signature, and the works he signs. On one level, the signatures are his own. This is the proper function of the signature connecting signifier and signified. For instance, the subject Moholy employs production-reproduction in his artistic practice. But on another level, the graphic movement works against this relationship like the raised palm that stops the flow of trafficking in meaning. Could Moholy know or foresee this event? When he is made an effect of language or when he stands at the point of being removed by his signature, the subject — miming *The Fool* of Moholy's photomontage self-portrait — will speak only in ignorance. This scene traces the anonymous space of a writing dispossessing the signer from himself.

In the complex generated by the signature effect, *Laszlo Moholy-Nagy: Biographical Writings* hopes to find the graphic means to stage a singular artistic biography. Or, to phrase it another way, it hopes to use the signature effect as a means by which literary theory and the visual arts can inform each other in the recreation of a life-writing that acknowledges the problems ensuing from the poststructuralist "death of the author." To reinscribe Barthes's initial epigraph for signing on and to post it in alignment with this Moholy experiment working with and playing off of the competing demands of subject and signature: "he wants to side with any [biographical] writing whose principle is that the subject is merely an effect of" the signature.

# Production-Reproduction

## Starting from Scratch: Gramophone, Film, Photogram

The story starts by mapping out the scene of what Moholy labels production-reproduction — that which structures the production of a signature for repetition and, in its repetition, difference. In other words, it will illustrate that a signature, any signature, has been copied in the first place. And in the second part of this odd equation, upon being photocopied (or reproduced in general), it will become another original (i.e., a production). Always already, there follows this thesis: production-reproduction, flowing from one to the other — an absorption of characteristics, but not the same, not "totally" the same on account of *re*, or because of the return, or to superimpose the two — (re)production is the only formula adequate to figure the original difference at work in the question of the signature whether photographic or otherwise. Moholy stumbles upon this magic formula very early in his artistic career. By 1926, he is already writing in retrospect about his total absorption in the problematic: "For some years, I was totally absorbed by the importance of the equation 'production-reproduction.' I almost tried to control [*meistern*] the totality of life under this aspect. Specifically, it led me to an analysis of all reproductive 'instruments.' . . . A supplementary idea brought me to a basic knowledge of the photographic field."[1] This statement splits the subject of production-reproduction. On the one hand, the author and Bauhaus master tries to control "the totality of life under" the operations of production-reproduction. But

through "a supplementary idea," Moholy is led back towards a total absorption of the subject by the signifiers, "of the equation 'production-reproduction'" and, whether sonic or photographic, this absorption of Moholy converts him into a signature effect. For the production of reproduction and the reproduction of production turn the "totality of life" to the service of the modern media personality. The reproductive "instruments" of these broadcast systems turn Moholy around in the process. Reproduction lodged in production, or the essential space generation of a writerly technology, opens the displaced space for the articulation of the Moholy media subject. It moves over, hence moving him over.

Keeping this shift in mind, it is important to take issue with Tilman Osterwold (even though he is one of the few writers who has emphasized the importance of the media problematic for Moholy) when he states, "While an artist, such as Moholy-Nagy, revolutionizes the media in terms of its content by opening up unutilized possibilities (with the implementation of fantasy, ideas, feeling, and intellect), he does not, however, alter the function of the mass media."[2] In this decidedly anti-McLuhanesque analysis that ignores the medium as message, Osterwold keeps matters squarely in the control of the revolutionary artist and the emotional range of his electronic palette which can be switched at will from channel to channel. But before one can criticize the artist's inability to transform how the mass media functions and can hope for its possible mutation, one has to take into consideration the thesis that the problematic of production-reproduction has already conjured up the artistic subject on its screen as an effect of the electronic transmissions of the mass media.

In the first movement of production-reproduction, Moholy constructs media experiments which transform the instruments of reproduction, and perhaps even the entire apparatus of representation, for productive purposes. The first and foremost goal of this research program is construction to serve and to service the human: "Since it is primarily production (productive creation) that serves human construction, we must strive to turn the apparatuses (instruments) used so far only for reproductive purposes into ones that can be used for productive purposes as well."[3] Three areas of research into this media "turn" are detailed throughout Moholy's writings. They involve the use of modern media technologies which double production over into reproduction: the writing of the gramophone, the film, and the photogram. Through the switching on of these inscription devices, the chart-

ing of Moholy's biography becomes the history of the graphic in his life. But this investigation into Moholy's life also maps how these reproductive devices generate recordings that get in the way of the subject of biography. Played back through these technological media channels, Moholy is subjected to another type of biofeedback. In the battle of purposes inscribed in the above quotation, the striving after the genuine (human) product unintentionally constructs the distant and distancing strife of (technological) reproduction.

The first Moholy experiment which uses reproduction for productive purposes entertains a new musical signature that turns about, a *phonographic*. The stylus of the gramophone cuts a new musical style of writing. Starting from a scratch, the operator produces through the dismemberment of wax or vinyl copies.[4] Moved by Edison's phonographics, Moholy's "esoteric graphism" rewires the invention of the wizard of Menlo Park: "An expansion of the apparatus for productive purposes might make it possible for scratches [*Ritzen*] to be made in the wax plate by a person and without the aid of mechanical means."[5] Previously recorded, the record becomes productive again. The record player no longer reproduces sound as a mere tone arm for the machine or as its "mechanical means." The dead copy springs to life in Moholy's live scratch mix. The player of records becomes a *bricoleur* who plays off of preexisting materials and exposes their productive possibilities for replays and reinscriptions, that which feeds back into the system.[6] In such re-creation, according to Moholy, there comes the "creation of music."[7]

Yet, through the production of reproduction, the record cuts both ways. Flipping between its passive and active voices, the disc jockey has become the operator of the system. This enacts a double phono-writing set up between the player and the played upon. By producing in reproduction, the musical *monteur* (i.e., "person") writes anew through the scratch marks. And in writing, through the musical signature of "self-produced" scratches, he is scratched out. This scratching onto the record, cutting back and forth, raises a racket, causes a noise and an interference in the sound track. It resounds in a deafening roar that rocks the Bauhaus, shatters Moholy, and jams — in the thrust of the matter — the subject of biography. Moholy calls this scratch work — a marking, a "making scratches" — "this kind of handwriting." This is the investigation of the self produced when starting from a scratch. It is time, he says, for the investigation of this double-

edged signature effect, ". . . the investigation of self-produced scratches, and finally mechanical and technical experiments to perfect this kind of handwriting done by making stratches [*Ritzen-Handschrift*]."[8] This mechanical and technical practice carves out the lines and writes out the phonographic symbols and signatures that constitute Moholy in the turning of its tables, in the motion of a hand, or nowadays, it can be added, in terms of word-processing, with a slip of a disk (copy). With the flip of the disk, the *Ritzen-Handschrift* (scratch handwriting) switches the subject into an effect of a scratching signature.

But the perfectionist Moholy wants to go one step further in the attempt to systematize his scratching. In order to constitute the rules of this new scratch system, Moholy turns to the system of alphabetization from which to draw the necessary resources that would allow for a transposition of media. Therefore, Moholy calls for a new scratch music alphabet, a *scratch ABC,* to take its place among the languages of art which he taught and, through the transformation of the letter, gets caught up in. In so many writings, Moholy makes reference to any number of these fundamental alphabetical systems in a variety of media — "language[s] of optical expression,"[9] Eggeling's "ABC of motion phenomena in chiaroscuro and variation of direction,"[10] "an ABC of architectural and projective space,"[11] or a *Sound ABC* that scratches onto film.[12]

This sonic material — ABC's in a jumble that supersede the subject and its meaning — scripts the subject as he (Moholy) scripts the score in "establishing a groove-script alphabet [*Ritzschrift-ABC*]" by "the incision of groove-script lines" and "graphic symbols [*graphischen Zeichen*]." Having gotten into the groove, "for the time being" — the time of writing or of production-reproduction — Moholy moves "in a graphic way." This is a special time and a special language where, over and over, one listens to a record skipping in the programming of meaning. The programming of the Moholy playlist lays down two basic guidelines for its listeners:

■

*Laszlo*

*Moholy-*

*Nagy*

**34**

1. By establishing a groove-script alphabet (*Ritzschrift-ABC*) an overall instrument is created which makes superfluous all instruments used so far.

2. Graphic symbols (*Die graphischen Zeichen*) will permit the establishing of a new graphic and mechanical scale (*graphisch-mechanischen Tonleiter*). . . . From these, at-

tempts to devise — for the time being, in a graphic way — a special language.[13]

But the conductor of the scene of production-reproduction is not content to stop at this juncture. The media program will be repeated again and again. Conducting bodies, it presses on for another layer, one more time and signature. When stuck in the groove, production-reproduction can function like an infinite tape loop. For Moholy's next move aims for even more feedback. He re-records the production of reproduction to press and repress that wax plate for replays and for a re-sounding of effects. This is what Moholy's scratch orchestra sounds like now: "This sound, when reproduced, might result in acoustic effects [*Schallwirkung*] which without any new instruments and without an orchestra, might signify a fundamental renewal in the production of sound (i.e., new not yet existing sounds and sound-relationships) for the purposes of composition and the very concept of music [*Musik-vorstellung*] itself."[14]

The conditional aspect of this paragraph must be stressed in demonstrating how the phonographic medium envisioned here would subvert the traditional concept of music in its every performance. In risking significance, this sound — reproducing the production of reproduction of production, etc. — might result in echoes and feedback ("acoustic effects") which, without any new instruments, overload "the very concept of music itself." This sound might signify for the purposes of composition, but then again it might not (for the purposes of decomposition). The scratch work brings a fundamental renewal in the production of sound and in significance. This renewal of the new, similar in texture to the reproduction of production, deploys a second layer of text which works against the grain of the concept. One must listen very carefully, ear to the ground, as the mixmaster Moholy rubs against the grain of a voice and scratches out static meaning, the not yet existing or meaning.

Moving sound around in a transposition of the new media, Moholy also moves the scratching, the "acoustic alphabet of sound writing," onto film. This enables him to write out the second scratch signature as a "counterpart" to phonographics. In this inter-media experiment, the production of reproduction takes the film strip as its material base in order to rub out the "unheard of" or even the "nonexistent" for both visual and sonic purposes. As was the case with the record, this production of reproduction can

happen without any recourse to recording. Moholy writes of an "opto-acoustic alphabet": "We can write acoustic sequences on the sound track without having to record any real sound. Once this is achieved the sound-film composer will be able to create music of a counterpart of unheard of or even nonexistent sound values [*hörspiel*] merely by means of an opto-acoustic alphabet [*optofonetischen abc*]."[15]

Written this way on the silver screen, "all types of signs" are liable to crack and crackle as they break the sound barrier. As Moholy records it in writing: "In an experiment, *The Sound ABC*, I used all types of signs, symbols, even the letters of the alphabet, and my own fingerprints. Each visual pattern on the sound track produced a sound which had the character of whistling and other noises."[16] Moholy's mention of "my own fingerprints" returns the reader to the primal scene which holds up the autographic signature. At the crossroads of psychophysical self-testing and the origins of the sound film, this is perhaps the most peculiar experiment in the scratch history of Moholy-Nagy. In the control room, an avant-garde sound engineer tunes in and turns on to the frequencies of his own fingerprints. He listens into his corporeal remains and residues as they transfigure into a celluloid experience. He overhears the body, the alphabet, the sign systems, the symbolic order, everything and noise. And as the sound is tracked in this way, each character writes out a sonic signature—aleatory to the thing itself, to the representation, to the meaning and which only insists upon its own singular scratch-noise.[17]

*The Sound ABC* (*Tönendes ABC*; 1932)—an unheard of or nonexistent piece in that the actual filmic record has been lost—registers a Moholy wrapped up in aleatory experiments which reduce to a whisper or raise to a ruckus each and every visual object. Piercing in their effects, these noises—from the low pitch to the shrill whine or whistle—pierce the status of the object. These noisy experiments between sound and vision even alter our sense and organ of smell: The wondrous playing of a nose is recorded in Moholy's scrapbook. In this transposition of media, the breaking of the nose comes running from and through the ear. "'I can play your profile,' he would say to a friend, sketching the outline of the face in his notebook, 'I wonder how your nose will sound.'"[18] In scripting this movie scenario, Moholy cracks a joke which manipulates media—an olfactory organ into a sonic wave.

The third signature of production-reproduction is written in

the key of the photogram for an automatic writing with light. The photogram also institutes the supplement at the origin of production-reproduction in the form of a *photogrammatology*.[19] The photogram starts from the scratch as well, but the incisive instrument is neither stylus nor pencil. Instead, the photogram reveals how visual experience owes its constitution to the writing, recording, and tracing of light. In order to speak of the site free of signification which the new language of the photogram represents and, therefore, in order to be given a clean slate ("*tabula rasa*"), Moholy, taking and making notes in his scratch pad, refers to another effect of the signature — the subtle stroke of light-writing (*lichtschreiben*):

> The photosensitive layer — plate or paper — is a *tabula rasa,* a blank page [*unbeschriebenes blatt*] on which one can make notes with light [*man mit licht so notieren kann*] in the same way that the painter works in a sovereign manner on the canvas with his own instruments of paint-brush and pigment.
>
> Whoever obtains a sense of writing with light [*lichtschreibens*] by producing photograms without a camera, will be able to work in the most subtle way with the camera as well.[20]

Following the dynamics of the graphics of the signatures which record the production of reproduction, photogrammatology also risks the conversion of Moholy into a light-writing effect. When placed into this scene of photogrammatical inscription, the term "sovereign" recalls the impossible investigations of Georges Bataille who defined the sovereign moment of his general economy as "this loss."[21] Even as Moholy works in a sovereign manner by means of a writing with light, photogrammatology traces a signature that stops meaning in its tracks and exposes the problematic master of the "gram" to a loss of meaning (Figure 4).

But the double writing of photogrammatology does not only embroil the Moholy subject in the web of production-reproduction. Moholy captures how photogrammatology contaminates even the Kantian categories of space and time. It is conventionally assumed that photograms exist in space and time. Nevertheless, the signature of photogrammatology acts as if the case were otherwise. It no longer has anything to do with the recording of the fixed object of study nor "with the record of an existing space (or space-time) structure."

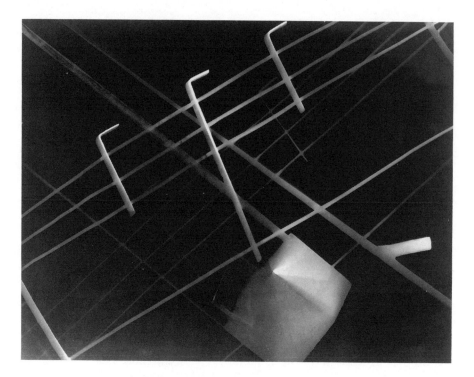

4. Laszlo Moholy-Nagy, *Photogram,* 1927?, 17.5 x 23.1 cm. (Courtesy of The Harvard University Art Museums)

Cameraless pictures, photograms, however, bring a completely new form of space articulation. It no longer has anything to do with the record of an existing space (or spacetime) structure.... The photogram for the first time produces space without existing space structure only by articulation on the plane with the advancing and with the radiating power of their contrasts and their sublime gradations.[22]

Through its spatial generating, the light-writing of the photogram opens the space for the articulation of subject and object. Through the institution of a reproductive technology, "for the first time [it] produces space without existing space structure." Photogrammatology articulates a curved space that follows the curious logic of production-reproduction. One might even posit that photogrammatology constructs or advances the shifting and radiating space of the biographical writings and their modulating effects.

The writing of the photogram follows the formula of produc-

tion-reproduction. Instead, in place of, "taking place," it steps in and reuses the apparatus. The double take of photogrammatology turns photography into a new (productive) medium. Through this trick of photography without a camera and a "reevaluation" (*Umwertung*) that involves a greater sensitivity to light, the reproductive apparatus produces. Upon reflection, this brings the "secondary level" into the forefront. We form and formulate in response to the devices that set up a field of optical perception. Moholy looks into this mirror image and a silver alchemical transmutation commences as follows:

> The photographic camera fixes light appearances by means of a silver bromide plate positioned at the rear of the camera. So far we have utilized this capacity of the apparatus only in a secondary sense; in order to fix (reproduce) single objects as they reflect or absorb light. In the event of the re-evaluation [*Umwertung*] taking place in this field, too, we will have to utilize the bromide plate's sensitivity to light to receive and record various light appearances (parts of light displays) which we ourselves will have formed by means of mirror or lens devices.[23]

On the flip side of this magic formula, another conclusion will be drawn which extends the scratchy start of the story to reproduction in production. This is the first law of the modern god of reproduction, Xerox. From the very first impression or imprint, a space has opened for doubling, infinite replication, and the dissemination of the copy. Originals or copies aside, it marks production as reproduction. An extra sign steps in between (identity) to multiply matters in photographic multiples.

These mechanics bring Moholy into a lively debate over the status of art and the art object in the age of technical reproduction. In a letter which criticizes Moholy's encroachments on Bauhaus pedagogy, the painter Lyonel Feininger raises the specter of mechanical reproduction in reference to Moholy's art in order to disown Moholy from art: "But actually it is a question of mass production, technically very interesting—but why attach the name of art to this mechanization of all visual things?"[24] Feininger's traditional argument follows to the letter the terms of the debate which Walter Benjamin sets up in "The Work of Art in the Age of Mechanical Reproduction" a few years later. While Feininger dabbles in photography himself, the painter refuses to make the move from the individual aura and its cult value to the mecha-

nized multiplicity of exhibition value.[25] In Feininger's scheme, it appears that only the former can take on artistic value.

It is clear that Feininger is insisting upon the romantic position in defense of individual expression by setting up Moholy as a constructivist straw man or, better yet, as a type of mechanical robot in flight from the individual. For Moholy's part in this confrontation, one might recall his retort to Lothar Schreyer, providing insight into Moholy's quick diagnosis of an outdated romantic disease at the Bauhaus and the remedy that might be derived from techniques such as production-reproduction, as equally applicable to Feininger's criticism: "In the short time that I've been at the Bauhaus, I have already recognized that you are all suffering from Romanticism and Naturalism. That should have belonged to the long forgotten past, and I never expected to find at the Bauhaus especially a world which I considered to have been surpassed a long time ago."[26] By restricting the name of art to individual objects alone and by refusing to acknowledge the possibility of a mass reproduction which moves exteriorly to the identity or uniqueness of the thing or of all visual things, Feininger excludes the artistic possibility of photogrammatology and photographics on account of their graphically repeatable aspects. Attached to the objective aura of old, he ignores the mass reproduction of effects. He refuses to acknowledge the possibility of artistry in the play and displacement of the mechanized or in the performative staging of multiple effects. But if art it is — in "the name of art" — then what is being called into question in Feininger's criticism is already a sign that mass production masks reproduction. Technically speaking, mechanization renames "art" in repetition by virtue of the mark and the re-mark of the signature. Or from another angle of the equation, the name of art, having gone into reproduction in the modern age, detaches from itself and signs itself (its signature, "art") in the guise of a duplicating (if not duplicitous) name in the writing machine.

Yet despite Feininger's early ideological reservations, he participates as one of the six Bauhaus masters (along with Moholy, Schlemmer, Klee, Kandinsky, and Muche) in the birthday portfolio presented to Walter Gropius that is initiated by Moholy only one year later. This project takes the construct of production in reproduction as its artistic basis.[27] Moholy asks each of the masters to present a painting based on a photographic reproduction from a magazine showing a crowd being addressed by a loudspeaker. Moholy's organizing gesture transforms the painterly

medium from individual expression to reproductive variations. And furthermore, Moholy's photographic selection of a phonographic thematic is an extension of his own mechanical preoccupations illustrating how the sounds of reproduction have been inserted into the space of the live performer. For this move is further amplified in Moholy's contemporaneous photomontage entitled *Stage Scene — Loud Speaker* (1924–26) which puts a bidirectional turntable and a loudspeaker in the center of the performative action (Figure 5).

From the perspective of reproduction in production and its logical culmination, the photographer in search of authenticity will print — correction, reprint — nonsense. For to repeat Walter Benjamin's reflections, "to ask for the 'authentic' print makes no sense."[28] In the writing of photography and the photogram, there is the loss of both authenticity and identity. It is as if a carbon copy had been laid down in every click of the camera of the clock of photo-writing. The technical magic of instant replay "instamatically" lands the image in the gap of production-reproduction, or rather, it exposes the subject in the play of an infinite series of signatures.[29] With such replication, identity becomes unfocused. Lost in the drift of copies and signatures assembled with no locus of identification, the subject will no longer be able to link up with anything like biographical authenticity. The picture has changed and the canons of art with it. Multiplied again and again, Moholy — "the thing itself," or what is dubbed his signature — comes back around to the "essential structural element[s] of the whole," that which is added on or subtracted from the whole, or the *hole in whole* that opens the possibility for reproduction in production. "Photography culminates in this. The series is no longer a "picture" [*bild*] and none of the canons of pictorial aesthetics [*bild-ästetischen massstäbe*] can be applied to it. Here the individual picture loses its identity as such and becomes a piece of montage [*montageteil*], an essential structural element of the whole which is the thing itself . . . a photographic series can become a most powerful weapon, the tenderest lyric."[30]

The work of the multiple confirms Feininger's worst fears. On the assembly line of this mass produced photo-writing or television (*Telehor*) series, "none of the canons of pictorial aesthetics," or of aesthetics in general, "can be applied." Now the artistic field has been transformed to make way for the staging of graphically repeatable effects and montage fragments. As such, the photographic medium has become a strategic battleground of potent

5. Laszlo Moholy-Nagy, *Stage Scene–Loudspeaker*, 1924–26, gelatin silver, 16.9 x 12.4 cm. (Collection of the J. Paul Getty Museum, Malibu, California)

weapons and tender lyrics. All in all it might be said that *monteur* Moholy deploys the lyrical weaponry of the photogram, the scratching stylus, and the photographic multiple to pierce holes in the subject of aesthetics — and, by extension, in the subject of biography — in order to question "identity as such."

### Re: Intervention of the Photogram

I was always the lowest in the history class. I was a disgrace to my instructor.

He kept me in school one day after the examination which I had failed misera-

bly. He gave me a list of questions, told me to look them up and write down

the answers. He passed me to save his own skin. — Man Ray, "Interview"

Now that the terms of production-reproduction have been recorded to illustrate the dynamics of the photogram, it is necessary to review the catastrophic effects these dynamics have on the attempt to delineate any history of the photogram's invention. In the time of production-reproduction, will there still be a place for invention? In traditional terms, the question of invention gives original credit where it is due, wherever it falls. In the history of technology, it is always a question of coming first, or of successfully establishing the claim of coming first. The credit of originality is attached to a proper name, an author, or an artistic practice. The inventor obtains the patent by putting down the primordial signature and receiving a copyright. The legalistic economy of invention focuses on the terms of authorship, paternity suits, and intellectual property disputes. In composing the narrative of how and when it happened, the history of technological invention serves this discourse of identity.

Now this is where and how the problematic invention of the photogram can spark an intervention. Who invented the photogram? Or for that matter, who invented the signature, the name, that pinpoints photography without a camera and puts it into the dictionary? Like many things that have been "in the air" (and here one might recall a parallel case pitting Bell against Gray in the race to secure the telephonic patent), these are controversial issues and there will be many parties to stake the claim. But this is not to suggest that the answer will lie in any multiple invention. The following analysis reviews how the unusual logic of the photogrammatical signature makes the question of an original inven-

tion and inventor (whether singular or multiple) inapplicable or even gratuitous. This is not a history of invention in search of a copyright, but the construction of the photo-grammar of intervention that ends by issuing a general right to copy.[31]

Indeed, the first rule of photo-grammar writes out the irony of its invention. No one can lay claim to the invention of the photogram because it is an automatic process where all one has to do is place something — or nothing for that matter — in front of a photosensitive sheet and watch light write before one's eyes. Independent of the need for an inventor, this practice of writing without a camera becomes a matter of technics alone, "without recourse to any apparatus."[32] From this angle of vision, the photogram and its invention remove the human element from the picture. Automatically, then, Moholy's independent assertion crosses out the significance of any debate over the invention of the photogram or the names of any of the claimants to its invention. But the photogrammatical position is not to be taken up as mere technological determinism. As the stories of Man Ray and Moholy are exposed for the reader, they will demonstrate how the technology of the photogram (a.k.a., writing inside out) *risks* the certainty of what belongs to the realm of chance and what belongs to the realm of necessity.

There are at least four pretenders to the photogrammatical throne — El Lissitzky, Man Ray, Christian Schade, and Moholy.[33] The documentarians vie to cite the proper place and time — the earlier the better — that will enable their candidate to take home the individual honors. But the cryptographic site of the originating photogram has been sealed away in some other darkroom. Sibyl Moholy-Nagy plays arbitrator of the undecidable origin in this way: "In spite of a long and bitter battle it has never been decided conclusively which photographer first put an object directly on light sensitive paper in the secrecy of his darkroom."[34] However, Sibyl's intervention is limited because it falls back upon a multiple or simultaneous invention rather than turning the photographers over to the alchemical secrets of the darkroom that place both invented object and inventing subject directly onto the light-sensitive paper.

Among the contestants, an adamant El Lissitzky writes to set the record straight on the impossibility of any claim to originality on the part of Moholy. While the attempt to discover an inventor or originator of an automatic technique which questions the terms of originality, creation, and inventiveness might seem to be

misconceived, El Lissitzky, speaking out of this photogrammatical blindspot, argues for the value of artistic meritocracy and lets it be known that Moholy — that "filcher" — knowingly copied the art from Man Ray. "The *artistic merit* of the discovery is something completely created by Man Ray. . . . What has Moholy contributed to it?" El Lissitzky insists further that he and Raoul Hausmann were the first ones to turn Moholy's attention to abstract photography and to the program which returns in the production of reproduction ("dealing with *productive,* not reproductive, achievements").[35] Ironically, this is the same program (or re-run) wherein is ruined the title of inventor or first-comer for Moholy as well as for El Lissitzky.

The argument over first inventions and intentions and, in a literal sense, impressions, fails to convince in the search for the proper signee. Even if the individual inventor could be found and crowned, there is no desire evinced to go back to the archive and break "the secrecy of the darkroom" in order to figure out exact dates or to reward the first-comer with an artistic merit badge. This is not the style nor the signature of the photogram which, citing El Lissitzky (against himself), deals with the productive achievements of reproduction (and vice-versa). In this move, the rules of photo-grammar contest the historical search for origins and the romantic concept of the artist or inventor, the original or authentic producer, the man of genius. Therefore, the contamination of the equation of production-reproduction and the damage of the gram problematize the concept of invention.

Moholy-Nagy writes on this issue exchanging invention for sweat at the root of that which resembles genius. He wipes himself off of and denounces the name of genius and its self-revelatory practices. But he also refuses to totalize the opposite theory, and one notes that there will always be a trickle of inspiration or the slightest possibility for the inscription of the creative artist and for the signifying and significant author (1%) in this passage. To become a photogrammarian or light writer entails strictly hard work in the production of these refuse pictures on light-sensitive paper. Adopted for art, Moholy's (re)saying copies from the inventive sweater who holds the patent for the light bulb, the phonograph, and the kinetoscope. It is most amusing to note how Moholy re-cites the American techno-wizard normally associated with the discourse of technological invention in order to access a rhetoric that downplays or demystifies the inventor as an inspired artist. Edison's profusely modest rhetoric about the perspiring

inventor draws upon the raw materiality of constructive labor and mixes it with the work-ethical demand of a Biblical injunction that lauds all labors by the sweat of one's brow. In *Experiment in Totality,* Sibyl Moholy-Nagy narrates the scene: "No artist held less to a mystical belief in the automatic self-revelation of the genius. When he had learned English, he adopted for art Edison's definition of genius, 'one percent inspiration and ninety-nine percent perspiration,' as one of his favorite sayings."[36]

Apropos of the photogram and its proper copyright, Moholy deploys a very different language than El Lissitzky. He writes of *re-invention,* marking the name with a hyphen and setting up another equation, *invention-re-invention,* to stand side by side with production-reproduction. This prefix *(re)* affixed as the mark of copying, the papers placed on the photocopying machine "independent of each other," removes the photogrammatical signature from the lure of originality in every instance. Moholy writes his own signature (or the personal pronoun "I" in this case) and Man Ray's, re-signed, independent of the terms of the debate or of "standard means" or time. The fabric of the discourse of re-invention exposes the problem of the proper signature through the use and abuse of the first person singular joined to the double subject of the sentence. "Around 1920, *Man Ray and I,* independent of each other, re-invented the photogram. This technique has since become a standard means of visual expression [my italics]."[37]

"Re-invention," like reproduction stepping into production, problematizes the concept of the proper time for photogrammatic invention as well as the possibility of an inventor. In his letter to Beaumont Newhall, Moholy, still under the spell of re-invention "at this time," states the "first" otherwise and pleads general ignorance: "I made my first photograms in 1922. . . . I did not know at this time about Talbot's and other's shadowgraphs nor about Rayographs."[38] Moholy's sweeping rediscoveries in this medium were first printed in the magazine *Broom* in the same year. As Andreas Haus discusses, the style of these abstract compositions in the photogrammatical medium shows the influence of the so-called *refuse pictures* produced by Kurt Schwitters in the "painterly" medium. But to return to the curious system of dating encountered in the letter to Newhall, Moholy's move of deferral may appear curious to anyone attentive to historical precedents in that it reverses the assumption that an artistic creator would seek to take credit for the invention of the photogram. If Moholy

hopes to distort this time sequence in order to bring greater honor to himself, he might push the clock back a bit. But in this passage, Moholy states the "first" two years later. Unknowingly ("I did not know at this time"), Moholy has entered into the time warp of the photogrammatological machine, of the photogram, writing himself. He has been given the slip of the photogrammatical signature in the production of reproduction. For this scene repeats the performance of the imbalanced equation of production-reproduction when 1920 equals 1922.

Every signature reinvents, every signature is the time for re-invention. Another place, another time, and the names and dates have been changed again. There arise new trade names and signatures to protect the secrets of the darkroom from the possibility of disclosure and from the innocence of the original. At this new intermediate time for re-invention (1921), the graphs have become grams when given another printing: "Man Ray calls his cameraless photographs, 'rayograms,' Schade his photos without camera, 'shadograms.' When I started in 1921 with my camera-less photographs I suggested the name 'photograms' which has been adopted since by most people."[39] Moholy mentions two other modes of light-writing with different names attached to them. In contrast to the photogram, one wonders whether these cameraless photographs were somehow invented. However, the *gram* which has been tacked on to both these signatures indicates that they, too, follow the odd equations of production-reproduction and invention-re-invention which ruin the purity of origin in their inscription.

It is curious that both of these other terms attach proper names to their signatures; specifically, the names of two of the pretenders to invention. In both instances, the question of the signature and the significance of the signature has come into play. From the historical perspective of the "self-revelation of the genius" and his authority over language, Man Ray and Christian Schade might be accused of self-aggrandizement, naming after themselves in the process to immortalize their signatures as artifacts. But rather than supporting the historical terms of invention, these signatures step in and subject their namesakes to the impersonality of language. At this juncture of the biographical writings, the chance of a name and the arbitrariness of signature touch upon the necessity and significance of a signature to confound these naming matters.[40] Like the photogrammatical practice itself, this initial-

izes effects which undermine or displace control from the hands of the inventors. They are caught unawares by the processes that work them as such.

For Christian Schade moves in a shadow play of puns and wordplays and is, as Sibyl Moholy-Nagy relays, "quite unaware of the double meaning in the English language."[41] This constitutes a wisecrack of language at the expense of his ego. Schade claims to have invented shadograms; and yet, he has already been exposed by the text or translated into an interplay and interweaving of light and shadow. This signifying coincidence registers the warp and woof of the light values of the shadogram. When Moholy discusses the name, the supposedly "better name" for the "re-invention" of the photogram, he too takes Schade literally and exposes the signature of invention to the shadow play and impersonality of language without giving it a second thought. In a personal letter to the historian of photography Beaumont Newhall, Moholy drops the name of his competitor. First, he tacks on a silent letter (*w*) to it, and then goes on to argue against the propriety of this newly minted name and its significance: "I would think that photogram is a better name than 'shadowgraph' because — at least in my experiments — I used or tried to use not alone *shadows* of solid and transparent and translucent objects but really light effects themselves, e.g., lenses, liquids, crystal and so on [my italics]."[42]

Meanwhile, from the perspective of the signified of biography, Man Ray "devised a similar process he egotistically christened[43] 'Rayographs.' "[44] But the play of the signature undergoes further biographical complications in this case in terms of the question of the proper name. After all, Man Ray is a staged name, a prop not unlike Moholy and his modulator, but a moniker chosen *before* the man's supposed invention of the process with the apropos name: the *rayogram*. Subjecting the self to the play of the signature, Man Ray's invention works through the textual plays of light, of rays, and illumination. There are significant doubts that a pseudonymous surrealist like Man Ray would stake out a claim "egotistically" to the invention of this technique — as involved as Man Ray is regarding production and reproduction in an ongoing projection of questioning beams of light upon the humanist author. For Man Ray already writes of the photogram as a ready-made or found object. No matter how one looks at it, it is an automatic process independent of invention. When he follows its

motions through, he does so absentmindedly, by rote, specifically "mechanically." Invention comes like Lautreamont's fortuitous meeting of an umbrella and a sewing machine, or in this case, a piece of paper and a ray of light. As the accident in the photographic grain connects, a stumbling intervention or even a gratuitous "in vain" form the fallout from the "waste of paper." The following text reads as a parodic re-invention of photography circa 1839 in that it mimes Louis Daguerre's purported discovery of mercury as an active photochemical agency after some accidental toxic leakage and spillage in his laboratory. "Distorted"[45] before Man Ray's eyes, the regret of the loss of the object or the loss of the negative has turned into the affirmation of the rayogram, the signature and its "waste of paper." Here is Man Ray's autobiographical allegory of the photogram set onto paper:

> One sheet of photo paper got into the developing tray — a sheet unexposed that had been mixed with those already exposed under the negative . . . and as I waited in vain a couple of minutes for an image to appear, regretting the waste of paper, I mechanically placed a small glass funnel, the graduate and the thermometer in the tray on the wetted paper, turned on the light, and before my eyes an image began to form, not quite a simple silhouette of the objects as in a straight photograph, but distorted and refracted by the glass more or less in contact with the paper.[46]

The light-writing of the rayogram, in the production of reproduction, marks him. *Re,* the prefix discussed earlier in the chapter, comes back to haunt again. To return to the epigraph, it haunts his learning and his history lessons. It returns to the production of reproduction, the copying of marks and the writing of the signature for the advancement — also in advance of — history. It sheds new light on the biographical incident in Man Ray's life. Man Ray confesses that as a boy he had the lowest marks in his history class and that he was a disgrace to instruction. Even at that early point in his life, this copyist failed miserably at names, dates, and origins and seemed to demonstrate the effects of production-reproduction. Man Ray recalls this historical moment in passing: "He [the instructor] passed me to save his own skin." Man Ray copied from the book; he grafted in order to pass. He produced, in the act of reproduction, a "regraphting" that seems to surpass history. The autobiographical narrative has been re-

■

*Production-*

*Reproduction*

**49**

written so that, "He gave me a list of questions, told me to look them up and write down the answers." The quotation has been copied again and, as a result, this self-denigrating appraisal rewrites El Lissitzky's defense of Man Ray (the inventor) contra Moholy (the photocopier).

After the retelling of these haunting darkroom tales, it seems logical to turn to Moholy's and Man Ray's mutual acquaintance Tristan Tzara and his impressive reversible poem on the latter's photo-grammar: "inside out photography: man ray."[47] Tzara's account is a post-invention, post-catastrophic inventory of cameraless refuse pictures that takes sides with the magical sweep of a wind that may have blown away all the "little swindles" that go under the names of knowledge, sensibility, and intelligence. It is in this light that Tzara declaims, "After the great inventions and storms, all the little swindles of the sensibility, of knowledge, and of the intelligence have been swept up into the pockets of the magical wind." Unlike the account of *Experiment in Totality*, this impresario inscribes intervention in the give and take of the darkroom operator as the translating tradesman, as "the negotiator of luminous values [*der kaufmann in lichtwerten*]." Like Man Ray's description, Tzara's inventive language describing the momentous occasion of the first photogrammatic illumination places the name of art on the sickbed, relegating the artist to ushering functionary at a candlelighting ceremony where the absorbing action has moved elsewhere. "When everything that people call art had got the rheumatics all over, the photographer lit the thousands of candles in his lamp, and the sensitive paper gradually absorbed the darkness between the shapes of everyday objects."[48]

On the question of the name, on the signature of invention, on the sign of the photogram, it does well to double back to a statement of Moholy's that has passed by without any commentary. While written with a first person pronoun, it moves its composer further away from the subject of biography and from the history of the photogram's invention and closer to the matter of photogrammar, to the technological effects of the gram and the graphic. It recalls that all talk of causes (originals) and effects (followers) comprises a secular variant of history, and that this secular history functions only as a diversionary tactic overlooking the technology of these matters.[49] This involves the move from the logic of cause and effect to the techno-logic of *effects themselves*. It is necessary to overhear the words of an avant-garde engineer once

more: "I used or tried to use not alone shadows of solid and transparent and translucent objects but really light *effects themselves,* e.g., lenses, liquids, crystal and so on [my italics]."

The reader stumbles again on the material (and materiality) that Feininger excludes from the "name of art," in other words, questions of technics and artistry that link the effects of the photogram to the work of art in the age of mechanical reproduction and that ruin the original inventor. "Effects themselves": such are what the photogram achieves; what the name, photogram, achieves; what production-reproduction, set back to back, achieves. This is what thrusts forth the technology of these matters — lenses, liquids, crystals. The abstract writing of the photogram abandons the field of the historical representation of the fixed object. In the production and reproduction of their effects, these signatures, marked down as they are on the page, incur the loss of objects (solid, transparent, or translucent), identities, and concepts. Put into operation, the abstract photogram and the photographic grain gain in chains of connections and these strategic concerns have a way of recalling Moholy's "and so on."

The "lasting name" for photography without a camera is given to "photogram." Ironically, this happens to be the only name without a last name as part of its signature, refusing to turn the signature into the signified in order to send out, for example, a "moholygram." Leaving no trace of himself in the name, Moholy's "designation" of light-writing is remembered.[50] However, the credit for the name photogram does not belong to Moholy by any means. Andreas Haus cites the previous use of the term in scientific journals, in "technical jargon," and even in the writings of Albert Einstein.[51] In the latter part of the nineteenth century and the beginning of this century, the so-called photogram allowed scientists to examine the structures of nature in finer detail whether in terms of botanical and animal specimens or in the astronomical visions of telescopic spectroscopy. But one cannot rely too heavily on the logic of historical precedents which are put into question by production-reproduction. After all, neither artistic nor scientific genius is at stake. For all predecessors aside or included, when Moholy suggests the name "adopted by most people," he is indebted to a semantic field and a performative effect for his adoption. He gives the name of and to the photogram by giving in to writing, the photogram; and to light-writing, the grammar of the photogram.

As a young painter I often had the feeling, when pasting my "abstract pictures," that I was throwing a message, sealed in a bottle into the sea. It might take decades for someone to find it and read it. — Laszlo Moholy-Nagy, "Abstract of an Artist"

This autobiographical reflection puts Moholy both at his most profound and perceptive and at his most unwitting, unknowing, and exposed. In a nutshell or a seashell, the act of throwing a message sealed in a bottle into the sea mocks the desire for a totalizing narrative which is always the goal of the authorized or authoritative biography. It writes out the ways and means of the graphic and abstract resistance of the bounding of the biographical analysis to the intentions of the author or to the circumscription of the subject within the message as unit. What Moholy foresees in the throwing of a message sealed in a bottle is a split structure that makes it possible for a statement to continue to produce effects beyond the presence of its author and beyond its "intended" meaning. Following the logic of production-reproduction, the bottled message points to a structure of an originating repetition.[52] It allows for the unforeseen and exposes Moholy to the unintentional consequences of the signature effect.

The scenario of the message in a bottle raises a number of issues about the status of Moholy, his autobiography, and the future of Moholy studies. In sending out the sealed message in a bottle, Moholy glimpses the open-ended structure of the autobiographical text as it comes back to him from the future of history. He entrusts himself to a writing — to what is belated and unknown, to what turns out to be decades away from the scene of Moholy's send-off. The "testamentary" structure of Moholy's autobiographical signature from the "Abstract of the Artist" inscribes the anterior belatedness of the historical text.[53] It is a memory of and from youth. For the scene is imagined by a young man, recalled and further projected into future history as an old master. It is something from beyond the grave and yet still not born — a still to be filled in blank or black hole which constructs the Moholy text as such. The projective and retroactive interplay of the bottled message generates the biographical text, used and abused, but still to be read for the first time.

With the throwing of the message, sealed in a bottle, floating

■

*Laszlo*

*Moholy-*

*Nagy*

**52**

on the sea, carried by the winds and the waves of chance, one wonders where the present biographical writings stand. To put matters quite bluntly, have we found Moholy's message in a bottle and broken its seal? An unproblematic account of Laszlo Moholy-Nagy would assume that it had deciphered the message and the historical contents of a life and was in the process of delivering to its readers the biographical object of study. That particular point of view is not far from that of a conventional journal article covering Moholy in the "Art" column of *Time* magazine which appeared just at the time of his retrospective exhibition in the Cincinnati Art Museum in 1946. The favorable press coverage overlooks the retrospective dynamics of Moholy's message in a bottle. Entitled, appropriately enough, "Message in a Bottle," the anonymous report concludes emphatically with an unveiled reference to the city on the shores of Lake Michigan where Moholy spent the last decade of his life: "In Chicago, at least, Moholy's message in a bottle has washed up on a favorable shore."[54] But one cannot be so sure that either Moholy or his message is or has ever "washed up." For openers at least, there are some risks, open to that possibility in the bottled message. The risks enter in the uncertain demarcation of production-reproduction — that which might or might not take (as Moholy "often had the feeling"), but which always remains open for the retaking. The bottled message cannot be anchored in a set context once and for all, nor deciphered once and for all. With the seal of occlusion and the throw of dispersion, the biographical writings follow the testamentary structure of a Moholy message which resists historical closure.

With a closer reading, there are even doubts about what constitutes the exact nature of this message in the first place. What of this message, if ever a found object, what of "a message" with so many different layers? Moholy's epigraph unfolds the polymorphic logic of his abstract pictures and he, in turn, cuts and pastes over the message so that it becomes difficult to locate. Is the message contained in the abstract picture which needs to be deciphered? Is it the epigraph itself which has been put into a bottle? Or is it, perhaps, the present biographical text which is spreading Moholy's message decades later? Given the cryptographic structure of production-reproduction which always seals a part and piece of itself away — and over again somewhere else (as writing) — in a cryptic encryptment, the text of the message and the message as text stand to confound.

But even if the message were to be found, there is no guarantee that it possesses the structure of a simple communication. There are a host of misinformational traps which have been built into Moholy's musings. There is the chance that one will find the message but not be able to read it. It will be written in some secret code or a bizarre sign system that is difficult to crack open even if and when — or because, considering the cubist perspective — the bottle lies broken in fragments. Moholy comments upon the challenge of a transformative reading amid the shifting sands of cubist perception and the warped history of its reception: "What seemed only yesterday to people as bizarre and meaningless reveals itself today as a part of the pathway to the larger connections of our form of life which are to be grasped only in transformation."[55] Or one may find the message torn up in fragments. Like the young Moholy, the reader will attempt a rearticulation for a pasting over of the past, but will never be quite certain of having put everything back together again.

The open-ended dynamics of production-reproduction allow for other chances and missed opportunities that are implied in the act of throwing. There is the chance of finding and reading an intercepted message. In other words, this is somebody else's bottle, but it has been mistaken for Moholy's. This substitute may have slipped in between the times the message was being signed, sealed, and delivered. Or more subtly: Somehow, even in the name of Moholy, the (re)productive reading transforms between the one time and the other. One can posit any number of these interference patterns, discontinuities, and feedback systems in terms of an entropic information theory that tunes the reader of the text into an aesthetic of distortion (*Verzerrung*). For Moholy, this aesthetic marks the rise of abstract visual systems based on the dynamics of the sealed message in the bottle in which, as in the pictorial laws of Cubism, "there occurred images, in which the stereometrically bound objects were presented as distorted."[56]

More drastically, there is even a chance that if and when the message is found, it will turn out to be a blank sheet. It will be sealed up in the same way that is described in Moholy's utterance. Amid all of these scenarios which lack any clear-cut resolution of the message, the reader, drawing a blank, may feel duped. This response exposes the desire for the message as the desire for the historical signified at the expense of the signifying materials. In other words, it exposes how the ruling assumption and the founding purpose of the code of biography lies in the successful delivery

of the personal message. But again, it is necessary to insist upon a writing practice that follows the consequences of Moholy's formula, production-reproduction. In this way, the sealing of the seal may be seen, or at least acknowledged, in its detaching from/in every scenario. This type of biographical project writes through the blank space that both enables and encrypts, that is, constitutes and removes every message. It leaves a remainder behind and ahead in every cast-out signature.

Given the sealed or thrown character of the bottled signature, these scenarios spell out the demand and responsibility placed upon interpretation and reading. This raises the question of the addressee or receiver of Moholy's statement—the unknown "someone" of some other time. The other risky component of the bottled message lies in the multiple trajectories of its readers' receptions. The found receiver will recite the unknown message and will be throwing a message sealed in a bottle into the sea with this recitation. Then, according to the topos, it might take decades for someone to find and read it. But when that someone reads it, he or she will repeat or recite it with a difference. It will double back on Moholy's utterance, whatever it was, or whatever he might have intended, in order to demonstrate the lodging of a difference in the same. The structure of the biographical writings, following production-reproduction, alters the tide of history. This pre-recorded message washes ashore to a Moholy on the beach still another time. It returns to him when the tide comes in, and still, as the tide goes back out again, it might take decades, etc. Somehow, thanks to the slips of the signature that put anchors away in this seascape, Moholy and his message — no matter how marked, torn, or tattered—remain unscathed. The finding or the reading will not settle his biographical account with the world, wash him up, nor put an end to reading. For from the very beginning (later on) it is reiterated, "it might take decades."

In his photographic albums, Moholy accumulates many beach snapshots. For the most part, these photographs are informal pictures taken by Moholy on the beach as a photographing tourist or taken of Moholy on the beach during summer vacations in the 1920's and the early 1930's. These latter shots document Moholy carrying on with other *Bauhäusler* on the shores of the Elbe or the Wannsee Rivers. In a couple of these photos, our beachcomber sports a wild floppy hat as he joins in a group impersonation of a vaudeville showgirl chorus line.[57] At first glance, these shots are quite refreshing because they take one out of the rarefied

air of avant-garde experiments and into the candid rush of photographic activity and the everyday life. If one investigates the topic further, one will ascertain that beach photography (*Strandfotografie*) constitutes a photographic genre in the twenties and thirties in Germany and that this hobby spawns practical guides and handbooks for the salt and sun worshipping amateur and professional alike.[58]

But the social context of this photographic practice does not explain away Moholy on the beach. For there is a set of relations foregrounding how the beach functions as a privileged site of production-reproduction. In terms of its topographical position, the beach occupies an intermediate zone between land and water. Following the logic of the borderline which demarcates Moholy's artistic practice, the beach mimics the photogram, positioned as a border zone (*Grenzgebiet*), and the hyphen that joins and divides production-reproduction. Nevertheless, this rationale might be understood only as a dialectical maneuver. The analysis also has to explain what happens in the beach encounter in photographic terms. In the ebb and flow of the waves and in the turning of the tides, something happens on the beach that impresses the photographic structure of the trace. Serving Moholy as a topographic emblem, the beach becomes the staging ground for a series of snapshots that inscribe the same testamentary structure as the message in the bottle. These vacation momentos participate in the odd structure of past into future that follows from production-reproduction and that partakes of the trace structure of photo-writing in general.

It is the figure of the footprint in the sand which serves as the first emblem for the testamentary structure of Moholy's beach photography. The footprint registers the fascination for the trace of the non-present remains which follow from production-reproduction's (surpassing of the) event.[59] These photographic footprints demonstrate the indexical character of the *snapshot effect*. The production and reproduction of the photographic print bear an indexical relationship that quotes or cites the real as an effect of the framing of the graphic signatures which are depicted. The footprints trace the indexical operation of the photographic sign itself. In foregrounding the indexical relation of the photographic sign as a structure involved in leaving traces, *The Diving Board* counterposes a waterstained footprint with the heel of a foot (Figure 6). *Footprints in the Mud* also finds the haunting trace in the print of the imprint abandoned. Like the message in the bot-

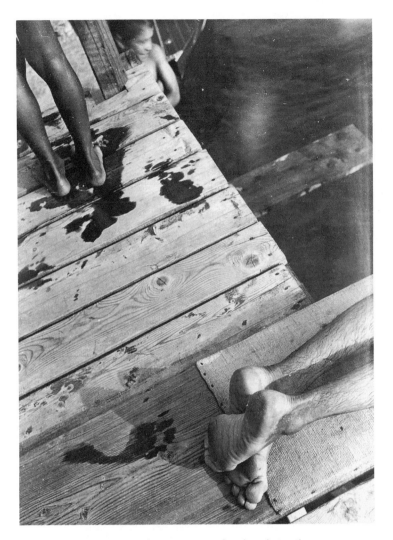

6. Laszlo Moholy-Nagy, *The Diving Board*, n.d., gelatin silver, 28.5 x 20.9 cm. (Courtesy of The Museum of Modern Art, New York)

■

tle, these footprints snap or snatch the trace of the past which comes back (tracking) from the future. Meanwhile, in *Painting, Photography, Film* (1925), Moholy reproduces a beach photograph of another type entitled *In the Sand*. In the dizzying and defamiliarizing perspective, the dislocated viewer turns over the twisted woman of the dunes. From ground level, the perspective might appear as a distortion. But there is a caption which has been written by Moholy (himself) that offers an invitation for the

"Umwertung des Sehens," the reevaluation of seeing in the production of reproduction, that mixes up the sands of time and startles experience. It reads: "Formerly regarded as distortion, today a startling experience! An invitation to re-evaluate our way of seeing. This picture can be turned round. [*Dieses Bild ist drehbar.*] It always produces new vistas."[60]

This photograph and its caption allude to a couple of biographical anecdotes in which Moholy insists upon a reevaluation of photographic seeing. First, there are Moholy's antics in the studios of Edward Weston where the roles are reversed, or even turned round. In a visit to Carmel, California, Moholy horrifies Weston by constantly turning his reproductions around in order, it is presumed, to produce new vistas. Ignoring the wishes of his host, he receives the invitation from the distorting demands of production-reproduction which (re)produce without any regard for proper perspective.[61] Then, there are Moholy's self-imposed twists and turns as recorded by Siegfried Giedion during a joint beach holiday in 1925. Moholy's peculiar posturings take aim at unusual perspectives and surprises. In this particular story, Moholy casts out his message in a bottle to the future of photographic history by evading the conventions of his time and foreshadowing its future practice. "i well remember how, during a holiday we spent together at belle-ile-en-mer in 1925, moholy-nagy consistently ignored the usual photographic perspective and took all his snapshots upwards or downwards. a few years later the surprising artistic effects of foreshortening and of converging vertical lines had become part of the stock-in-trade of every up-to-date photographer."[62]

Moholy refers to a number of these beach prints as his *Sand Architect* series. These photographic architectures recall the image of a child on the beach who constructs his sand castles in the air. These constructions register their transience in the rush of a new wave or a new vision. The shadows in these prints also double the indexical nature of the photographic sign. For instance, there is one photo taken at twilight entitled *The shadows are becoming longer. The actress Ellen Frank on the beach at Sellin.* On the beach with movie actress friend Ellen Frank, Moholy offers us his *beached methodology* which describes the relation of photography to the excesses of production-reproduction. Somewhere in between, the game of photo-writing surpasses authorial intentions. This operation signals a space which moves back and forth between chance and necessity. Moholy meditates upon a

mediated approach. "In my photos I have nearly always worked without a premeditated plan. But all the same my photographs are not the result of chance. . . . This beach picture is the result of this method."[63]

Between the premeditated plan and the chance results, a mode of photo- and biographic inquiry that plays the line is called for. The text plays, not unlike the little children in one of these photographs who have been caught in the middle of their minor beach party. With shovels and buckets in hand, they are exposed throwing sand around, framed refusing to box it in. This beach print was named simply *Play* (ca. 1929) (Figure 7).

As already hinted at, the scene of the send-off of the message in the bottle also helps to elucidate Moholy's connections to Cubism. *Vision in Motion* illustrates some of the more famous bottles of Cubism — Boccioni's sculpture *The Bottle* in which "the bottle is dissected and its component parts used for a composite view," a 1903 Paul Cezanne *Still Life* which features a "peculiar distortion" of a jug as well as a bottle, and a 1913 Picasso collage which features a bottle cutout.[64] Like Moholy's message in the bottle, cast adrift and ready for the retaking, the cubist bottles of these abstract pictures — cut out, distorted, dissected — demonstrate a plasticity of form. They describe collage as another form of or a deformation of the logic of production-reproduction.

Appropriately enough, Moholy reflects upon the collage logic, or "collogic" of Picasso and the cubists in terms of the broken and cut-up bottle. Fragmented and dismembered, these bottles have been recycled for abstract pictorial purposes. They take (apart) the secondhand possibility of iteration and alteration in everything. Moholy describes the cubist *monteur* at work: "He cuts them apart, looks into their insides, and lays the dismembered parts parallel to the plane of the canvas, one beside the other, giving a cross-section, an oblique section." As in a cross-section, this collage generates an intertextual density in the web of the canvas and in the spin of the bottle to be used over and over again. The "oblique section" brings both an endless depth and a manifold interpenetration to the surface. As Moholy relates: "The dismembered parts are placed one behind the other, to endless depths, many times again woven together so that they interpenetrate one another, but always in the manifold variety of an exciting visual arrangement."[65]

In collogic, where things register as reproductions from the first production, the natural (beauty) has been banished along with

7. Laszlo Moholy-Nagy, *Play,* ca. 1929, gelatin silver, 35.8 x 26.3 cm. (Courtesy of The Museum of Modern Art, New York)

the "actual" and other such "immutables." Instead, there will be only shades of differences, the cuttings and pastings that come with Moholy's collages. Following Moholy's directives, the photographic or biographic monteur will take certain privileges or licences, comparable to those of a surgeon on the operating table, as his textual operations and schemes graft the graphic — incising, splicing, lifting, and laying it down. "But after all, face lifting and beauty surgery are commonly practiced today and one should not wonder that the painter may desire . . . those privileges of the surgeon. There is only a shade of difference between 'distortion' of a color scheme and of actual parts of the human face, or other such 'immutables.' "66

As cited, Moholy connects the cubist movement with his own modulating phrase, vision in motion. He is able to achieve that connection through an expanded use of distortion. *Vision in Motion* enacts this visually, side by side: "**distortion equals motion** (distortion equals motion)." The quasi-construct "distortion" appears in quotation marks or in boldface because in the revisions of vision in motion and in the move from the study of the object to a consideration of its effects (in reality) there is no such thing. "The result was a *composite view,* a 'distortion' if judged within the convention of the vanishing point central perspective, but in reality it was 'vision in motion' (rendered on the pictorial plane)." And further, "Its practical consequence was a revision of our visual perception."67 Distortion — another name for what is at work in production-reproduction or in the play of signatures thrown across the canvas and on the page — will be seen in this revision as the defamiliarization of the conventions of the center, or of a central perspective, or, perhaps, its vanishing point.

In order to achieve these effects, the cubists were able to introduce a new and peculiar grammar that shifts the signifiers of painting around and parts with speech. In the letting go of a central perspective, the signatures are recast and permutated. Moholy employs the terms of language, switched around, in order to suggest the new bent. In short, Cubism informs an alteration. One might have to rethink "Cubism" itself (or any subject) as an active verb. This new grammar simulates the syntax of a Gertrude Stein literary portrait. With cubism seeming to be a verb and with prepositions after words, the art historian following Moholy's directives will learn something to the effect of, "Picasso cubisms canvas on." *Collogic* is the new grammar of the cubist painting: "The cubists introduced a new grammar into painting where the old

rules of bending words, declension and conjugation, changed; where prepositions were used after the words and where the adjectives and nouns became verbs."[68]

Moholy sees with his own eyes that cubist painting acknowledges production-reproduction through a dash of exteriority, making the picture pause—a move or removal that will not be gathered into sense, into the superficial sense of "logic." Or, better put, it only makes sense when it is sensed. With the addition of the prefix, col-logic links the faculty of aesthetic judgment to sensation. This entails a mode of appreciation that no longer has meaning in mind. The materiality of this visual project subverts whether "it makes sense" or not. "To appreciate the painting of a cubist one should see it with the eyes, not with the mind. . . . Unfortunately, people do not dare to judge a painting until they are sure that 'it makes sense,' until it satisfies a superficial insistence upon 'logic.' "[69]

On a larger scale, Moholy's message in the bottle and its logic of (re)production shift the ways and means of biography and implicate (complicate) the writing of the historical account. Like the artistic practices of the Cubists and the beached Moholy, this groundswell shifts the sands of historical time. It shipwrecks the solid state of historical meaning and rewrites distortion as vision in motion. It is hoped that this particular study and its signifying practice can serve as a beachhead or foothold for future research into the overall issue of the signature effect and its regraphting of historical time. Following Moholy and his writings, it would be akin to throwing a message in a bottle, constructing another scene of writing, welcoming other such scenes. Following the currents, the bio-graphic designer would give the switch to relations. As Moholy interprets it, the process of interpretation and its de-signing work (*gestaltungsarbeit*) has little to do with a "comprehensive knowledge of characteristics and elements." Given the extra turn of interpretation, Moholy's beachcomber mentality will be reiterated in light of the redoubled work of design—i.e., with "the capacity and the courage to build up new relations among the elements of expression already at hand [*vorhandener ausdruckselemente*], to raise them above the commonplace by giving them a new interpretation [*einen neuen sinn*]—through switching their relations [*beziehungsschaltung*]."[70]

It journeys in a cultural space which is open, without limits, without partitions, without hierarchies, where we can recognize pastiche, plagiarism, even imposture — in a word, all forms of the *copy*, a practice condemned to disgrace by so-called bourgeois art. — Roland Barthes, "Masson's Semiography"

In the flip and theft of a signature, one moves from production-reproduction to the problematics of artistic plagiarism. Among its many ruses, the Moholyean algebra of production-reproduction threatens to steal or sign away the proper authorities and the self-possessed author of the work of art. It opens the space for forgery, fakery, and the doubling of the artistic signature. This productive-reproductive capacity of the signature delineates what has been dubbed plagiarism, what has been banned and censored by the possessive logic of originality and identity. Of course, the condemnation of plagiarism does not constitute an unchanging essence. The Barthesian epigraph specifically frames it as an experience of art dubbed bourgeois, an experience of art as property and commodity. But if one studies sixteenth- and early-seventeenth-century French history, there is quite a different valuation of plagiaristic activity. In the essay "On Pedantry," Montaigne undermines any notion of copyright which would posit a legal or moral right to an original possession and speaks in turn of a transporting procedure of general citation, of "picking" and "culling" from "this and that book." To cite the French author:

Is not that which I do in the greatest part of this composition all one and the selfsame thing? I am ever here and there, picking and culling from this and that book the sentences that please me, not to keep them (for I have no store house to preserve them in) but to transport them into this, where, to say truth, they are no more mine than in their first place.[1]

In contrast to the "all rights reserved" mentality of the bourgeois copyright, nothing is for keeps in Montaigne's accounting. "I have no store house to preserve them in." Instead, Montaigne's motto might be read as "all rights reversed" in the enunciation of instantaneous reinscription and the reduplication of xerography. The copyright has been replaced with the right to copy. For his texts are no more his "than in their first place."

Whether the historical interpretation employs Marxian or epistemic categories, it would situate the negative evaluation of plagiarism as a specific effect of both the idea of private property and the concept of the individual or self-possessed subject. If Montaigne stands on one side, one might be able to posit an artistic figure like Laszlo Moholy-Nagy on the other side of this discursive space at the point where it begins to rupture or splinter into something else as yet unnameable. Indeed, the epigraph to Moholy's *Von Material zu Architektur* addresses the problem of possession as it relates to art and its experience. Moholy encourages his readership to take a skeptical attitude towards the linguistic means at hand when it comes to claiming the experience of art as one's own or taking possession of it (*zum besitz*). Moholy writes, "The experience of an art work can never be appropriated through description."[2] It is unclear from this description whether Moholy believes in a privileged nondescriptive means of appropriation or whether, properly speaking, the abstract artist believes that, as far as possession goes, there is none to be had at all.

While it might appear at certain junctures that the following reading sets up Moholy and his artistic practice as a heroic contestation and undoing of the condemnation of plagiarism, one also must recall the double bind of the forged signature which undoes the subject of a history as well. For the forging of the signature questions the idea that there is a pure and self-possessed subject capable of such defense, that is, capable of escaping the signature's ruinous and reproducible inscription. The forgery business delimits any attempt to give an apologia or pay homage to an author who supports plagiarism since the forger contests his

status as an authoritative author or subject when playing this supporting role. As the plague of plagiarism spreads, one must locate Moholy's position as author even as one reveals how the forging of the signature risks and rends him.

Therefore, in the matter of the signature, this will not be an inquest but the staging of a wandering question. It is marked not as an interrogation but as an interrogative model of the meaning of language and the language of meaning as such. In other words, the forging of the signature writes out the brief that poses the limits for the laws of property and its bounding of the biographical subject in terms of the copyright of ownership, possession, and the concept of plagiarism. Forging ahead, evidence will stack up in favor of the redoubling of the signature — that which makes meaning slide and takes the origin away. This is what cannot be labeled (as Moholy will ask of the author, "Who needs labels here?") but what has been banned and censored by meaning and dubbed with the (false) name of plagiarism. For it might be the case that this and any courtroom drama — its biographical remarks and the passing of its judgments — are able to convene or go into session only on account of the capacity of the signature to be copied and forged. In this inverted way, the plague of plagiarism demonstrates how the passing of historical judgment relies upon the signature's forging.

Taking up a linear history of Moholy's life (and putting aside how production-reproduction problematizes this frame of reference), this chapter proceeds in chronological fashion, the order which founds plagiarism, the stealing of the before, after. In every facet of his artistic career, Moholy is charged with plagiarism, and to such an extent that one hesitates to speak of his career if nothing is to stand as his own. The case stacks up against Moholy. The charge is plagiarism and even as it throws the book at him, one must consider how it also throws the problematic of the forged signature at the book.

At the beginning of a career in the visual arts, the naive student has not learned to discern differences. He has eyes but he cannot see. Indeed, his visual faculties are so unattuned that it is as if he were only listening to the story *behind* the painting. He cannot separate the beginnings ("originals") from that which dissimulates the beginning ("copies, or fakes"). When an artist like Laszlo Moholy-Nagy recalls his earliest visual speculations, he also loses that distinction: "My approach was more that of 'hearing' the picture's literary significance than of seeing form and visual ele-

ments. . . . I would not have been able to distinguish between originals, copies, or fakes."[3]

Moholy claims that, while at one time, at the beginning of his career, he could not distinguish the original from fakes or copies, he learned later on. Following the logic of production in reproduction, the knowledge of the origin, set off from the copy, comes belatedly. Of course, it is assumed that when he writes this passage he knows exactly what he is talking about.[4] But this is not the only way to read or hear, especially anything that has to do with copying or fakery and a knowledge of them. Something else lurks in the shadows, mimes the first reading, gives the semblance of a meaningful scheme that, perhaps, this too is a dissemblance, similar to the forging of the signature and its Promethean theft of the origin, its gift of fire.

With the forgery in the fire, the scenarios spread and two are posed here: (1) He never learned the difference between original and copy and remains confused at the time of the writing. A naive Moholy still persists in this conditional tense of the future perfect so that he "would not have been able" to know nor to distinguish himself. (2) He has learned the difference between another signature and his own and become a faker after the fact — something that it would be very difficult for a reader to know. Therefore he is lying about his past (he knew) or about his present (he does not know). Dealing as they do in forgery and fakery, these sneaking suspicions place doubts in the subject, in everything that is written — especially if and when that work, the *oeuvre* of Moholy, is littered with accusations of plagiarism and lying.

Following Moholy's autobiographical narrative in the retracing of his individual artistic signature, there comes a period of feverish activity. He describes a relatively short span of time that goes from reproductions and experiments "under the influence" to originality and private property. In the turn of a second decade and with his arrival in the dynamic metropolis called Berlin, he begins to produce pictures with a "character" — his own — "of their own." Moholy stages his own break with the Hungarian Activists (MA) in the following dramatic terms: "At this time I spent all my money for books of reproductions and I was continually studying pictures: old ones, new ones, whatever I came across. Up to 1920 my works were experiments under the influence of 'MA.' From 1920 on, my pictures, plastic art, and other works developed a character of their own."[5]

In 1921, only one year after this supposed character develop-

ment that separates "old ones" from "new ones," Moholy reproduces this scenario when he takes issue with the charges of plagiarism leveled by an old associate in the Hungarian activist group, Ivan Hevesy. While access to Hevesy's letter may be denied, Moholy — a good copier, even though the substance of the letter denies such charges — fills the reader in on the accusations during his reply.[6] Moholy admits that, in the past or at the beginning, he was a man under the influence. Once upon a time, he was a trash disposal unit, a recycling plant that rehashed others, or in his own words, "a receptacle of a man." But within a few years, he can claim that there is not a "trace of alien influence" in his work. He has become a new man, his own man, standing on his own, a "somebody," a "personality," someone possessed with "individual thinking." In this letter, Moholy attempts to speak in the authoritative authorial voice signing on for a form of creativity that overlooks the forgeable status of the signature — that which surpasses the originality of the author (whether "I . . . say a word or think a thought") and renders the alien or dispossessed character of a writing that surpasses influences.

But on the level of the authorial function alone, the claims of originality in the previous quotation are so extravagant, "unbelievable," to quote Moholy, as they bend over backwards and overreact in a self-righteous and defensive manner that they will have to be taken with caution or even with a suspension of belief. If such is the case, then attention will be redirected to the question of their reinscription, i.e., the possibility of being taken or of taking them that comes with the forgeable status of a signature. Thus, this approach seconds the motion that accuses Moholy of lying and, doubled to that, plagiarism.

Indeed, the evidence is to be taken from his own words, if only such a liar could be believed in this confession that stands as self-incrimination, or if only the following statements could rightly be attributed to the thief in question. The year is 1927, well after the first commentaries and many of the accusations which followed. It comes in the form of an art interview published in English which contains autobiographical responses and reflections that bring to the forefront the questions of mistrust, lying, and the stealing away of the author and his property. In it, Moholy recalls a tale from his youth and offers something like a "true confession": "In that confession-book we all lied in chorus. This memory still makes me happy; the world is a ball; the questions of the confession-book again roll around to me. I shall rise to my

heights — a chance to lie. One thing however I know today better than in my schooldays; if I now wish to lie, it is because I am still unripe."[7] With the world figured as a ball, the questions raised in the confession book return at the next roll. They come back to the subject in question who uses the autobiographical confession book against truth telling. This radical reversal and revaluation of values offers a chance to rise to levitational heights or experience an incredible lightness of being. For in the vertigo opened by the "chance to lie" — the possibility of stealing a signature and of lying when affixing it — how will Moholy, accused of taking things away, be taken? This statement, if one believes it, its seductive force, would double back on every single thing Moholy wrote before 1927 and turn these words into bold-faced lies. Following the linear logic that institutes plagiarism, if, as Moholy claims, he is "still unripe" in 1927, he was even more unripe before this time as he coated and coded the fruits of his wisdom with a pen or paintbrush poised for the poisons of plagiarism.

If employed as character witnesses, many more of Moholy's artistic compatriots only serve to reconfirm his own lying confession. The next defamation of character is delivered by Alfred Kemeny, a former associate of Moholy. The two coauthored the "Dynamic Constructive Energy System" as a joint manifesto with their signatures standing side by side. In an issue of the avant-garde periodical *Das Kunstblatt* in the early part of 1924, the critic Paul F. Schmidt writes a summary review of the new constructivist tendencies in the visual arts. For some reason, Schmidt's review informs the art world that Laszlo Moholy-Nagy represented (or had converted to) the suprematist variant of nonobjective art and that this work advocated the electronic switchover from manual painting to technological light display. Schmidt writes, "Suprematism, principally represented by Moholy-Nagy, works with colored light displays on a white plane and attempts to make the technics of the cinema (such as electricity) serviceable."[8]

In a subsequent issue, Kemeny submits a letter to the editor of *Kunstblatt* where he uses the Schmidt article as a springboard to rail against Moholy. Here, he brings allegations against Moholy and his originality and charges him with eclecticism and derivativeness, even accusing Moholy of being a copy of himself. After their breakup, Moholy has taken Kemeny's signature with him and inserted his own. Taking issue with Schmidt's conflation of Moholy with the "genuine" Suprematist movement, Kemeny of-

fers the reader an art history lesson cast in the ranting language of invective and diatribe as he attempts to set the record straight along the following lines:

> On the contrary, it must be noted that Moholy-Nagy has nothing to do with Suprematism. Suprematism is the life-work of the Russian artist Malevich and belongs among the most significant artistic movements of today. Suprematism has attained a maximum of creative potential, of the inherent necessity of creation; Moholy-Nagy has achieved a minimum of creative potentiality and one sees in his work the maximum of non-creative aesthetics [*Maximum an unschöpferischer Äesthetik*], of external and contrived hollowness [*Hohlheit*]. It is worth noting that Moholy, who thus far has employed Constructivism for objectively unwarranted self-promotion, now, in 1924, makes his appearance as a Suprematist, whereas genuine [*wirkliche*] Suprematism in Russia came to an end once and for all in 1919. Moholy, however, who is eclectic and derivative [*als Eklektiker und als Epigone*], has a similarly insignificant role within the essential outcome of new Constructivist Art as within Suprematism.[9]

On the side of the forging of the signature, the double dealings that take the work out of the control of the author and his creativity, these words reverse themselves in their unlimited reserve and work against Kemeny and his criticisms. Instead, there is the affirmation of a "non-creative aesthetics" in the age of technological reproduction — of the externality of the signature that carries it through every contrivance and, contrary to Kemeny (or Moholy), undertakes a demotion of the self. It affirms the "insignificant," the forging of the signature cast in the role that risks significance and sidesteps essences and origins and whose ingenuity and seemingly unlimited resourcefulness risk the genuine. Finally, from the perspective of the significance of the artistic signature in question as filtered through the German linguistic register, it is fascinating to note how Kemeny's critique of Moholy deploys the derogatory term "*Hohlheit*," equating Moholy's art with a tendency towards hollowness. However, the course of this narrative unravels how the Moholy signature is able to reverse Kemeny's negative criticism into a positive confrontation with the powers of emptiness (cf., *Holy*) and the cavernous (*Höhle*) as artistic burrower (*Nagetier*) (cf., *Hole in Whole*).

Naturally, Kemeny's commentary raises the ire of Moholy who replies by repeating all of his accusations put down in quotes:

> To accuse me of eclecticism, plagiarism, and self-promotion under false creative pretenses. He analyses my 'sterility,' the lack of 'economy' and precision in my work, and the 'general incompetency of my artistic efforts.' But this is irrelevant to what I have to say. . . .
>
> . . . I am totally uninterested in whether or not Mr. Kemeny questions my originality; whether he or anyone else labels me Suprematist, Constructivist, Functionalist, etc. Many years ago, at the very beginning of my life as an artist, some comrades and I warned in an article in *MA* against these catchwords. Classifications are born by accident, through a journalistic quip or a bourgeois invective. The living force of artistic development changes the meaning of the term without giving the artist a chance to protest his false identity.[10]

There is no denying that on one level this response shows a bruised ego battling back to regain some artistic integrity. But there are other lines of indirection in the rhetoric of self-defense that move the debate elsewhere. In this response, one notices how Moholy avoids the head-on confrontation of pitting the original against the copy. For the practice of production-reproduction, which goes under the bad name of plagiarism, renders the authorial *I* irrelevant and questions his originality. ("This is irrelevant to what I have to say," "I am totally uninterested in whether [he] questions my originality . . . whether he or anyone else labels me.") Therefore, Moholy delimits plagiarism as the construction of a property-born culture and as a bourgeois invective that maps out a restricted artistic economy. He seeks to avoid these catchwords by acknowledging the accidental and contingent status of these classifications and labels. Caught in "catchwords" or in the *isms* of art, one cannot leave things open for the taking — whatever one may come across. Instead, with the forging of the signature, one will be caught in a word, in the copy, in other words. All of the artistic movements classified under the headings of "Constructivist" or "Suprematist" or "Functionalist, etc." do not stand a chance in the face of the faceless force of the forging of the signature (doubling for "artistic development") that "changes the meaning of the term without giving the artist a chance to protest his false identity," his stolen idea, or his misquoted catchword.

In the mad circulation of rumor and gossip, it is not surprising to find out that Kemeny's charges are repeated in other artistic forums. There is a perverted form of borrowing that seems to be transpiring in these critiques written against Moholy matching the plagiarism for which Moholy is being condemned. The editor of the avant-garde journal G, Hans Richter, gets into the accusatory action with his own cynical commentary on the state of the art, "An den Konstruktivismus." Unlike Kemeny, Richter accepts Schmidt's report that Moholy has shifted gears from the constructivist to the suprematist camp and he takes this as a sign of Moholy's trendy artistic opportunism and excessive fashion consciousness. "As long as the catchword is fashionable. By the way, it appears already to be finished with all over again. At least, the leap-frog Moholy-Nagy, who has a fine nose for such things, has allowed himself to be called a Suprematist in the *Kunstblatt*. Perhaps, he will have more luck with that appelation than he did formerly with the Constructivists."[11] But the accusation of avant-garde leap-frogging on the part of Moholy must be seen in light of its context. Richter's castigating column is itself a review of the contemporary art scene in an avant-garde journal obsessed with the documentation of the latest artistic styles and the revelation of the latest artsy gossip. This journal owes its very existence to the idea of keeping up with what is "in." From this perspective, the negative condemnation of Moholy for following the trend might also be viewed as a positive evaluation of his ability to be flexible enough to latch on to another new movement (whether he actually did or not), thereby demonstrating admirable vanguardist attributes.

If these allegations of plagiarism are not enough, El Lissitzky adds his name to the list of accusers and more fuel to the fire. For the period when Moholy claims that he stood alone and out on his own, this Russian Constructivist finds his own guiding hand. In essence, El Lissitzky announces himself as Moholy's "self-constructor": "I turned his attention to photography. He was just preparing his first exhibition for *Der Sturm*. Neither [Raoul] Hausmann nor I took him seriously."[12] At the gallery, one ought to remove the name of the subject in question from under all of the Moholy's and replace it with El Lissitzky's or Kemeny's. It is clear from the following letter that El Lissitzky has been keeping up with the wave of Moholy-bashing in the art journals and that he cannot resist making a few snide remarks too:

I thought that Moholy would be more careful after the remarks by Kemeny in *Kunstblatt* and *G* and would only deal privately with stuff he has filched, but he is getting brazen. . . .

. . . What has Moholy contributed to it [the photogram]? Light? It has been left in the air. Painting? Moholy doesn't know the first thing about that. Theme? Where is that to be found? In order to concentrate, you've got to have a focal point. Character? That's the mask they always hide behind. It's idiotic of me to be taking this Moholy business so seriously, but this plagiarism is already getting to be too bare-faced.[13]

The second paragraph returns to the controversy over the invention of the photogram or "abstract photos." Even if written as a diatribe against the filcher Moholy and his stealing of the photogrammatic techniques of Man Ray and El Lissitzky, El Lissitzky's comments also work in reverse. Throwing off the onus of plagiarism, it affirms Moholy in relation to the non-originative production of photogrammatical reproduction. It follows the strange logic instituted by the doubling of a signature and turns back against its critical author. Light? For the dematerializing photogram, it *will* be left up in the air with its abstract signals going up in smoke. Painting? If in the beginning comes the sign, the record of its reproduction, then one would not care to know the "first thing about that." Theme? There never has been nor will be abstract photogrammatical writing on the order of thematic foundations. Character? There is the rub. "That is the mask they always hide behind." That is the mask they always show. That is where the signature — under the pretense of showing — hides, forges, and burns. Then adding another layer of dissimulation and an emptiness at the center, under the cover of the mask of the forging signature, "this plagiarism," this lying, "has become too bare-faced."

As he himself admits ("It's idiotic of me . . ."), El Lissitzky's comments read in a no less idiotic fashion through their unqualified investment in the "me" problematized by the risks of the forged signature. In venting his indignation, he falls into the trap of the forge and the crucible. Here is the signature's abyss. Indeed, to avoid the pitfalls of the argument, he should never have taken this Moholy business so seriously, this funny business of a signature which, by taking, puts into question the clear-cut distinc-

tion between original and copy or between the serious and the ridiculous.

From the avant-garde scene of Berlin to the Bauhaus educational institute in Weimar and Dessau, the accusations of stolen properties continue to mount without any beginning in sight. More names belonging to contemporaneous Bauhaus masters, colleagues, and apprentices — e.g., Josef Albers, Herbert Bayer, Joost Schmidt, and Xanti Schawinsky — are drawn into Moholy's forgery racket. In the act of naming, they come into Moholy's own and bear another signature. Shortly after the untimely death of his Bauhaus colleague, Xanti Schawinsky wrote an apologia of Moholy in the form of a letter to his widow, Sibyl Moholy-Nagy, wherein the onus of plagiarism is reframed in terms of the fostering of another artistic movement:

> His enemies hated him particularly because of jealousy or because they suffered from a persecution complex thinking that Moholy had stolen their ideas. In particular, Albers, who came up rather slowly with his ideas and wrote with difficulty; he was angry when he thought that his ideas were publicized by Moholy. Schmidt and Bayer were also suspicious of this and sometimes a dispute surfaced. Only a natural scientist could clarify historical priority. Gropius protected Moholy most rigidly, since — as he said — the important thing was that new ideas were fostered instead of having them mould in the drawer. Moholy always thought of the movement as a whole and perhaps did not always take seriously the author of a keyword. . . . My own idea with respect to a new educational theatre first appeared in the writings of Moholy. Naturally, I, too, was surprised but certainly could not take it in the wrong way.[14]

If the author of a keyword cannot be taken seriously, if he already bears another signature, this stealing away of the idea will surprise the naturalized subject ("Naturally, I, too, was surprised"). In turn, this careless attitude towards authorship impacts directly upon the biographical project itself for it proposes to place at the center of its narration an author who disavowed or "did not take seriously the author of a keyword." From this skewed perspective, the invocation of a persecution complex and any attendant sufferings has been reframed as the last ditch efforts of the authorities to erect walls around the permeable (Moholy) subject. Unlike El Lissitzky, Schawinsky "could not take it in the wrong way"

because the taking and retaking of these signatures elude the judgments of morality and its indictment of plagiarism — the right way and the wrong way, the good copy and the bad copy. They are lodged in an arena or in a theatre of education where in the beginning comes the rehearsal. Their parasitic actions draw upon the mould in the drawer in every instance and put at risk the attempts at a proper historical ordering of what "first appeared in the writings of Moholy." Put under a microscope or under glass, even a natural scientist would be very hard pressed to clarify historical priority when studying the improprieties and contaminations of these moulds, these multiple generations fostered from the beginning of time.

In America, these accusations return and come under the purview of another code of law and its authority. In 1938, Moholy is taken to Cook County Circuit Court by the same group of people, the Association of Arts and Industries, who had brought him to Chicago to teach at the New Bauhaus. It is this incident which forces Moholy to reconstitute his Chicago art school without its famed European name from 1938 to 1946 in the form of the School of Design and, later on, the Institute of Design. The documents state that Moholy "lacked 'poise, balance, diplomacy, patience, and teaching experience'; *that he copied other people's ideas* . . . ; that he 'alienated people, firms, and corporations'; created unrest, dissension, and turmoil among the students; 'undermined the school's effectiveness' " [my italics].[15] Perhaps the risks of copying, after the first term, provide industry with the alibi it needs to withdraw its support for Moholy and the New Bauhaus experiment on the American prairie. They can only condemn the scandalous effects of the forging of the signature within an educational institution licensed to support the original work of art.

Is it possible to mount a defense for Moholy, that is, to line up signatures or gather a petition to counter all of these charges? But how could he win? In a silent plea of no contest, Moholy, subject to the effects of production-reproduction, would have to acknowledge tacitly that all the words that he speaks have been put into his mouth by others. Or that if he were to speak for himself, it would be the words of others spilling out of his mouth, or even worse yet, no one would believe a word of it. Is there a saving grace for the one who did not take seriously the author of a keyword? But it is at this point that the oncoming death of the

author and his keyword gives way to the affirmation of the signature without regard to source materials or to the original author. Losing himself and his work, he would take offense in his defense, in a call for quotation, for the receipt of a general citation, to borrow a phrase, pass it around, "it's the entire text, through and through, which is citatory."[16] In citing, it would abolish both the author (substitute Moholy) and the authority of the keyword. It would throw away the lock on the keyword and its origin and return it to the impersonal pool of an artistic language ready to be retuned and retooled. Once this can of bookworms has been opened, these parasitical agents of plagiarism spread like the plague. Ironically, one way in which to defend Moholy would be through cases of the plagiarization of his art. But these other examples would only demonstrate that the prosecution stands as guilty as the defendant and that everybody seems to be implicated in this signing away of originality. This approach would further contaminate the notion of the unique artistic signature. The case of the Russian Constructivist Alexander Rodchenko offers a parallel. In 1928, the journal *Sowjetskoje Foto* accuses Rodchenko of plagiarizing Moholy's photos and includes a number of back-to-back illustrations as evidence. Naturally, given the labyrinthine structure of the signature effect, Rodchenko's retort also charges. In this regard, the Russian photographer makes the claim that he had "repeatedly requested" photographs from Moholy over the years.[17]

There are some lecture notes left by Moholy that address the abyss opened up by this obsession with possession in the best way possible: "Influences: Chains of infinite regress."[18] On second thought, through a radical reversal, at the sign of meaning's egress, the regress of influences is seen to forge ahead with the play of the signature in the uncontainable field of citation and the intertext of indeterminable origin which extends artistic (re)production indefinitely.

Using her own terms in her own way, Sibyl Moholy-Nagy recalls the "friction" ignited by the (Moholy) signature that has been placed under the charge of plagiarism. Thanks to a most magnanimous mode of reasoning, she sets herself up as a staunch defender of the plague and of the democratic powers of its levelling. But unlike the other accountants of his artistic thievery, Sibyl Moholy-Nagy emphasizes the *give* over the *take* in Moholy's artistic economy:

Much of this friction resulted from charges of artistic plagiarism, leveled against Moholy by some of his colleagues. He was accused of taking someone else's concept and developing it into a new form, a new theory, a new workshop exercise. But there was nothing less comprehensible to him than the tight grip on an idea. Throughout his life he flung projects and suggestions into the arena, not caring whether anyone else would claim them. He lent carefully compiled lantern slides, his vast collection of prints and clippings, even his own manuscripts, to any friend who had to make a speech or wanted to write a book.[19]

At the limits of comprehension (at the limits of the "comprehensible to him"), these signatures undertake a journey, enact the passage of the idea, anew — "nothing less comprehensible to him than the tight grip on an idea." As (s)he writes, this exchange of signatures, the call for a generalized citation, eludes the tight grip of and on the idea, its origin, and its author.

Given the undetermined origin and author of this passage, this chain letter passes from Moholy to all the *Bauhäusler* who have been named, to his students, to those who would come to write about him, to future history, to anyone else, any other, even to a plagiarizer, a pasticher, or a forger. In transports, the forging of the signature traverses a rousing space without critical hierarchies, losing track of historical foundations and chronologies. Unless considered as a pastime to move past the one-track irreversibility of historical time, the anxieties of influences can arouse only contempt. The cause-and-effect models of the art historical discourse are epigonic tactics that sidestep the complexity of the temporal issue because they refuse to acknowledge the retroactive force of production-reproduction which invades the past from a time immemorial. Or as Sibyl Moholy-Nagy covers for her late husband in the posthumous *Experiment,* "The hunt for epigones, the pastime of so many art critics, only aroused his contempt."[20]

To Moholy's account and in his handwriting, there is a loan receipt that Sibyl uses as part of her case to fend off his detractors. However, this piece of evidence, put into circulation, seems only to reconfirm Moholy guilty as charged. Inverting the borrowing act, here the signator is caught in the act of lending with nothing to call his own: "Loaned to the School all my paintings and drawings, watercolors, lithographs, photomontages, photos, color re-

productions for teaching as demonstration material. [signed] L Moholy=Nagy 1942 December 1st."[21]

For this author does not seem to take seriously the meaning of the keyword, plagiarism. In the world of production-reproduction that this loaner practices, a practice condemned to disgrace by the contemporary art market and the idea of originality, a practice of unlocalizable signatures, there can be no room for plagiarism and its segregated housing system of original and copies. Unknowingly, Moholy's move calls attention to that which exceeds the gripping economy of the idea—that this idea or that meaning is lodged in signification as "demonstration material," as a resource for its reinscription. It is this material demonstration which enables the setting into operation of any citational procedure. In this way the instant replays of plagiaristic activity recall the dynamics and graphics of the signature and its permeable effects.

All of the strange dialectics of truth or lie, of plagiarism or copy, dissolve with the lending system mapped out, marked out, and signed out under the signature of Moholy. The new vision entertained by Moholy's production-reproduction, marked with its warning signs against the author, the "keyword," and the "catchword," disavows the concept, plagiarism, and gives the right to copy—the copy. Both the moral connotations that indict the plagiarizer as well as all defensive reactions disappear at this point too. There would be neither moral valuation nor means of defense for doubling, taken for, as, the signature forging its course, as a matter of course.

To avoid the fall into another dichotomy or binary opposition, there is no claim that the forging of the signature heralds the triumph of a new order and founds the new principle of ——— (writing in a new name for what used to be called plagiarism). There is no principle of the double, substituted. The contaminants also spread in the attempt to describe the rather messy relations between an artist who works across many disciplines and a poseur or a dilettante. The shadow of the doubling dilettante hangs over Moholy's head throughout the span of his artistic trajectory. "This is the 'Information Please' culture where the participants shine in admirable versatility. . . . In reality those participants represent only encyclopaedic symbols. They personify an auxiliary instrument functioning with the *semblance* of a meaningful scheme."[22] Given the above quotation, it becomes

next to impossible to situate Moholy's position on this matter. On the one hand, he seems to speak from a moral position and for the reality in which authors replace symbols, semblances, and auxiliaries with the assurances of presence, originality, and meaning. Moholy's comments then would constitute a critique of the dissemblers. However, given other shreds of evidence wherein Moholy's writings affirm the noncreative aesthetics of the forging of the signature and the undermining of the originality of the author, he might just as well be talking of or to himself. These statements certainly mime those representations directed against the plagiarizer, the dilletante, and the bold-faced liar.

As the strategic practice delimited as plagiarism journeys in the space open to the replicating graphics of the signature and its effect of doubling, these writings declaim the right to copy these words in assuming that Moholy would not care to check the claim and fling far and wide certain suggestions that he tossed out into the artistic arena. Following Moholy in these matters, they have taken these liberties for the ruses of the copy and the double, for the impostures of the dilletante shadowing the calling of intermedia artist, and for the forging of the signature, these auxiliary instruments that function against certainty, with the "*semblance* of a meaningful scheme" and that in addition, scheme in deed.

■

*Laszlo*

*Moholy-*

*Nagy*

Now that the thesis of production-reproduction and the plague of plagiarism have been brought to bear upon Moholy's biographical writing, it is time to turn to another angle of vision that shows a Moholy immersed in the problems of artistic signature. At the outset, one sees that the title of this chapter is not phrased, "He Works." The third-person impersonal pronoun that titles this chapter (It) insists as much upon the operations of the signature *it*self in the production of Moholy's artistic works. In the case of Moholy, this can take multiple shapes from the way in which the signature is graphically affixed in a work to the visual signing of the artist via works of self-portraiture. All in all, this chapter reviews the putting to work of the signature in Moholy's artistic practice.

### Moholy-Nagy: The Graphic Works

In works of visual art, the signature usually appears in the bottom right-hand corner of the painting.[1] The assignment of the signature in painting constitutes one of the hallmarks of the rhetoric of individual style in the visual arts. An authentic signature accords value, guarantees the work, and makes it legitimate. It establishes a relationship of authority between the painting and the creative artist. In no uncertain terms, the signature signifies the author of the work. Inside the frame but framing the work of art by assigning it to the author, the classical signature is a writ of authorization. If one were to overlay the terms of Lacanian psychoanalysis

to the scene of artistic inscription, the signature might be seen as the authoritarian invasion of the symbolic realm into the imaginary in order to ground the play of the imaginary within the symbolic and its laws, codes, and authorities.

The inscription of the individual signature "Moholy-Nagy" provides an opportunity to review a number of autographic tactics that put this authorizing relationship into play. These particular works of art subvert Moholy's status as an author and the status of the author in general. By bringing the graphics of the signature into the forefront, Moholy's works of and about his signature break any automatic linkage between the signature and the biographical subject. The signature "Moholy-Nagy" will be studied in its delegitimizing aspects through a number of works that deploy the proper name in this material manner. In other words, Moholy's graphic works will be treated in detail.

### Re-placing the Signature

Calling attention to the question of enframing, Moholy-Nagy's placement of his signature on a painting or a photograph has much to say about the effect of the artistic composition. A move from the conventional bottom right hand corner can put a new slant on things.[2] In the same way that the photographing Moholy moves his body around in order to shoot the "steep" perspectives in line with the new vision, he is no stranger to moving his signature around the photographic frame. The effect is one of driving the reader of the print to distraction and disorientation. This displacement in writing institutes a disturbing, almost Brechtian, alienation effect in reading when the artist signs the print upside down. In this ("unusual") position, the disoriented viewer is forced to subject the conventions of reading to a rigorous questioning. Caroline Fawkes describes an instance of how "Moholy-Nagy" pens in a nude photograph from a missionary position and how this constitutes an unnatural as well as a denaturalizing act. The positive and negative contrast further multiplies this dislocated signing ceremony: "In his juxtaposition of a positive and a negative print of a woman's body (or rather, a partial view of her lying in bed, seen from above), Moholy has actually signed the print upside down. The signature (unusual on the front of his photographs) presumably serves to confirm the orientation which most effectively disturbs an uncritical natural reading of the space."[3]

*The Name Up In Lights*

In a frame from Moholy's typo-photo filmscript *Dynamic of the Metropolis* (1921), the signature has moved from its usual fringe position to the center of the action, thereby becoming a major attraction.[4] While this instance does not constitute a work in and of itself, the image-text in question institutes an alternative deployment of the artistic signature within a combinatory typo-graphic-photographic work that demands attention. Whether the script itself is seen as the finished work of art or whether it is projected as an unfinished film in the making, this particular frame has no other ostensible purpose than to display the signature of Moholy — to put Moholy's name up in lights. In literal terms, "Moholy" has been turned on and turned into a piece of light-art in the middle of an electronic urban cityscape. In neon writing, electric signs pulsate letters which spell out MOHOLY — with a few added attractions ("Y . . . MOH"). The typo-scripted signature reads, "YMOHOLYMOH."[5]

How does one read this luminous writing (*Lichtschrift*) or illuminate its meaning? The possibilities flash on and off, vanishing and reappearing like the sign itself. They move like the flashing headlights of *Dynamic of the Metropolis* wherein "the cars [move] ever more swiftly, soon giving rise to FLICKERING."[6] On one level, this piece of light-writing works like the conventional signature. Like an electronic billboard, it identifies and announces Moholy as the author of the *Dynamic* and as the proper name who created it. Hearkening back to Kemeny's critique of the Moholy self-propaganda machine, this is clearly a case of self-promotion and the text itself calls it a "Lichtreklame mit verschwindender und neuerscheinender Lichtschrift [a light advertisement with disappearing and newly appearing light-writing]."[7] However, it seems odd that this sign-off would be placed one-third of the way into the work. It raises the question of whether what follows belongs to Moholy. On this level, up above that it is, the replacement of the signature functions like the writing on the print of the nude. Another way to read the signature "YMOHOLYMOH" would be as the signified itself, i.e., as the subject of the work. The light display displaces the signature by reciting and resighting it as subject matter. Giving it an egomaniacal twist, one can imagine this sign as subject to a vision in perpetual motion in the shape of some electronic news ticker in the middle of Times Square placing the name of Moholy on an infinite loop.

Flickering, this reading of the sign soon vanishes. Another current flows back to the mobile status of the sign in the age of electronic media and this switch prevents any simple hermeneutic reading of the sign. A type of alternating current, a sign signals two ways of seeing and reading. The latter, or graphic portion of this flashcard, focuses on how writing, though luminous, stops or shorts the circuit of thinking. The digitalization of the everyday life flips attention to the perforations and graphics which constitute the biographical subject (Moholy, or in this case "YMO-HOLYMOH") as light-writing, or what in earlier chapters has been called, the signature effect. When Moholy, the subject "in solid form," first saw the neon mecca of metropolitan New York, he was impressed by its millions as a dematerializing fantasyland of dissolves. This flickering switches the subject from a solid urban citizen to a piece of light-writing, a technological effect of the graphics of the signature. In reviewing Moholy's reflections on his first impressions of the society of the electro-spectacle, one notes the similarities to the flickering language describing the name up in lights in *Dynamic:* "A million lights perforated the huge masses — switching, flickering — a light-modulation dissolving the solid form."[8] An electro-Moholy works the slippery terrain between the visual and verbal perception of the sign. In the dynamic space between literature and the visual arts, the autobiographical sign of *Dynamic of the Metropolis* is blinking — on the blink, with the blink.

*The Signature on Exhibit*

The textual dynamics on display in the light-writing of "YMO-HOLYMOH" are played out in a number of pieces written in Moholy's own hand as well. These graphic works concern the Moholy retrospective exhibition sponsored by the Cincinnati Modern Art Society shortly before the artist's death in 1946. Corresponding with Chairperson Marion Becker about its planning, Moholy takes part in the coordination and installation of the show in the long-distance way he has about such matters. In one particular letter, Moholy submits the sketch of a proposal for a work that would frame his signature and the entire exhibition. Moholy sketches in the details: "As you well see from the sketch, I am proposing a big black surface at the entrance with a photostat (negative) of my signature and a photogram self-portrait (framed) above it."[9] According to Moholy's plans in the above letter, the "(negative) . . . signature" and the "photogram . . . (framed)"

would stand at the entrance of the show to enframe it as Moholy's. But other pieces of evidence, most of them also signed by Moholy, frame it and him otherwise. The graphics of these signatures carry away any intentions on the part of their signifieds (i.e., Moholy-Nagy) to the contrary or, in the work itself, to the negative. In other words, Moholy seems to be framed by his own photogram, his own signature, and his own writing.

Exhibit A, written in Moholy-Nagy's hand, appears to be a draft or a Xerox copy of the signature (the photostat negative) to be used in the exhibition and contains a number of possible specifications for its framing. This immediately raises a number of questions for identity. What is the difference between a draft of a signature and an actual signature? Is a photostat negative of a signature an authentic signature? Is it another signature? Moholy-Nagy makes no mention of this draft (inscribed as "Moholy= Nagy") in his correspondence to the Modern Arts Society.

This intricate drafting and preparation supports a rethinking of the signature as an object of art historical interest in itself or as a genuine submission to the Moholy-Nagy retrospective. This practice signature on 8½ by 11 inch paper lists a number of dimensions scribbled at the bottom of the page for other possible inscriptions so that it appears as if Moholy were making a practice of his signature. But if these "Moholy-Nagy" signatures were reinscribed as specified in 45 by 60 inches, 3¾ by 5 feet, or 38 by 27 inches on other sheets or mounted as other works of art, they would constitute other graphic works. If each signature achieves the status of a graphic work of art, then the identity of the signature — every one standing unproblematically for its author — is undermined in these undersignings. Nevertheless, this does not mean — does not signify — that these unhinged signatures achieve object status. For the graphic works against this reading.

The graphic (i.e., the actual sketch) brings other signatures and questions in its wake. In the first place, it illustrates the letter with a blowup of the entrance space that shifts the sense of proportion. The signature "Moholy-Nagy" appears in white writing and (to its upper left) an empty space has been left for the insertion of the photogram (to be framed). Naturally, given the abstract light-writing of the photogram self-portrait, there is no certainty that this piece signs or frames Moholy either. An arrow points from the empty space to Moholy's bold black writing: "here the photogram self-portrait with white frame." Reversing the usual size relations and exposing this artistic convention, it is as if the self-

portrait signs the photostat signature. This inversion confuses the authorizing relationship between the signature and what it signs.

Another arrow points from the white-on-black signature to some other remarks below which are handwritten by Moholy-Nagy in lighter black print: "photostat of signature — Moholy-Nagy." What is the difference between the signature to the left and the one to the right, the white-on-black "Moholy-Nagy" and the black-on-white "Moholy-Nagy," the positive and negative images? Is the black-on-white an authorizing explanation of the white-on-black, a graphic work which does something other than signify the author? Is the white-on-black an authorizing illustration for the black-on-white which does something other than signify the author? Why the need for two signatures if each one indicates the same identity? Through photographic doubling (one positive and one negative), the same writing ("Moholy-Nagy") has produced two different signatures whose precise functions are unclear. An identity crisis has seized the autographic function and the change is graphic. In addition, there is more handwriting below — not in Moholy's script but perhaps still printed by him — which duplicates in essence the first Moholy-Nagy message ("photostat negative of signature suspended") but with this difference: the lack of "Moholy-Nagy." But despite all the traces of these signatures, the only missing piece in the archive is a photographic reproduction of the sign itself which was to be posted at the retrospective. While there are photographs of the show, not one shot frames the signature exhibited there.

Through an act of suspension, the characters spelling Moholy-Nagy have raised questions about the identity of the signature, or to use a chiasmus, the signature as an identity. The Cincinnati scenography returns to the scene of inscription for any text. Moholy-Nagy's maneuvers mark the graphic inscription of each signature and the nonidentity of every mark as mark. The play of these graphic signatures has moved from the personal signature of Moholy's retrospective accounting to a fracturing of impersonal signs suspended in a future anterior tense. From draft to sketch, letter to hanging, positive to negative, smaller to larger, illustration to explanation, right to left, the graphic works against the same and adds other dimensions.

## Typographics

In another type of graphic work called *typographics,* Moholy plays with and displays the letters of his name. There is one ex-

plicit work in the genre that bears the self-referential title: "*Typographical painting spelling out MOHOLY, 1921*. Oil on burlap"[10] (Figure 8, also known as *Yellow Disc*). However, upon closer inspection, the painting does not spell this outright. An *H*, an *O*, an *L*, and then what? Literally, there are typos or holes in the semes of this particular typographic. The mixing of two shades of color provides something that borders on an *M* (like a moustache), and the bottom right of the painting leaves it to the imagination to turn three interlaced rectangles into a kind of *Y*. And even if these borderline shapes form the letters which constitute the proper name, it still would be necessary to double the *O* to spell out "MOHOLY."

It is to be assumed that this solitary *O* stands as metonymic substitution for the monocle of the bespectacled man with the Moholy moniker. The shape of the letter *O* functions visually and symbolically as the aid to vision. As an aside, there is a striking similarity between this circular image and a photographic illustration that appears in the margins of a Moholy text published in 1927 in *i 10*. As graphics editor to this journal, Moholy selected three *Mechanische Fantasien* (mechanical fantasies) by the photographer Peer Bucking to accompany his remarks. The second photograph shows a distorted portrait that transforms and implodes a bespectacled face into a monocled cyclops, and this gesture in the photographic medium recalls the singular vision of the MOHOLY *Typographical painting*.[11]

This offers just one example of how the letters are beginning to blur in the painting. For "MOHOLY" plays a double game, suggesting and withholding the name and the self simultaneously.[12] The letters resist being spelled out. An arsenal of constructivist devices are employed in the service of the "surface treatment" (*faktur*) beyond the meaning of the letter — circles (masquerading as O's), lines (as in the *L* of "MOHOLY"), and oblong rectangles, intersections, and overlappings. Other lines no longer signify any letters at all and seem to operate on an order other than the alphabetical. Fancy forms encased in other forms go sideways (what borders on the *Y*) and some lines go off on tangents that render definition opaque. "MOHOLY" factors in the construct of *facture*. This is an attention given to the material or the assurance that the surface has received the treatment that it is due. It works through the scratch of pigment, the cut of the knife, and the mixing of the graphite — "anything," even if the object has been disregarded — but only so long as the "shimmer" of the signifier

8. Laszlo Moholy-Nagy, *Yellow Disc,* 1919–20, oil on canvas, 51 x 66 cm.
(Courtesy Davis Museum and Cultural Center, Wellesley College)

colors the experience of reading and overreaches it. Moholy—speaking in the third person for "MOHOLY"—pinpoints how *The New Vision* writes out a "new typography" in works like *Typographical painting spelling out MOHOLY:*

> His discoveries of surface treatment [*fakturerfindungen*] overreach one another. He uses the brush, the palette knife; he combs or scratches the pigment; he mixes it with sand, cement, or graphite. He introduces new materials: corrugated cardboard, wire mesh, etc. Anything—in order to attain the shimmering color experience of the inner and outer light phenomena, and no longer the objects [*das schillernd farbige erlebnis der inneren und äusseren lichterscheinungen—und nicht mehr die gegenstände—festzuhalten*].
>
> The structure, texture, and surface treatment values . . . became, for instance, the stimulus for a new typography.[13]

Sibyl Moholy-Nagy sees extra senses in the typographical medium. While one can take issue with her conclusion of a composed entity ("Constructivist" or otherwise), her synaesthetic analysis does spot an additional collage element—in the way of hearing—in the typographical painting. Free-associating with "sound experience," she poses and transposes the following insights:

> . . . or in painting, where typographical elements added visual and chromatic association to the two dimensional plane. The letters F, N, and O worked into a collage or a canvas represented curved or angular forms, but they also produced an associative sound experience in the spectator who not only saw but also "heard" the picture. One of the most ingenious of these experiments is Moholy's canvas *Gelbe Scheibe, 1921 (Yellow Disc, 1921)* in which the letters of the name *Moholy* are composed into a Constructivist entity.[14]

In these ways, the piece entitled otherwise as *Spelling out MOHOLY* brandishes the materiality of the signature in resistance to meaning and communication. To equate "the letters of the name Moholy" with this painting or to translate the visual and the verbal without remainder remains an impossibility. Moholy had written of "the new typography as a simultaneous experience of vision and communication."[15] Reworking Moholy in the light of the "MOHOLY" typographics, the viewer/listener must insist upon an association that continues to separate and divert in lay-

ers of sub- and supersonics. Moholy's transpositional effects problematize any clear-cut translation between the aural, verbal, and visual media in the arts. In other words, he makes the grammatical text a question for the purity of visual experience (e.g., photogrammatology) and the aleatory vision a problem for verbal meaning (e.g., typographics). The uneasy simultaneity of this latter experiment yields a visual surplus of communication. This surplus is associated, it must be argued, with the inscription of every graphic work surpassing the meaning of the biographical subject on the reproductive disc, *Yellow Disc*.

Lighting the way, Apollinaire's calligrams demonstrate this practice through a concrete poetics.[16] The calligraphic innovation in illustration is openly acknowledged in word and image in *Vision in Motion*. The sounds and visions of Apollinaire's typographic experiments supplement each other. The music of the word and the feast for the eyes induce aleatory effects. Through this sharp maneuver, the simultaneity of "the new typography" brings to the textual material, in the "normally printed text," an "unusual" combination so that "a visual [or sonic] dimension is added." The visual and sonic surplus of the graphics of the sign language ("distorted, etc.") sizes up the standard of an impossible exchange rate for words, even at a loss for them.[17] "While a normally printed text is usually read by the eye, yet it has only been conceived of as a sign language for the ear. By exchanging the visual appearance of the words, by printing them in unusual shapes, larger, smaller, distorted, etc., a visual dimension is added; one perceives the words with a combined sharpness of the eye and the ear."[18]

The sharp eye will observe that there is yet another barely legible signature in the right-hand corner of *Yellow Disc*. It is the signature of Moholy-Nagy authorizing the *Typographical painting spelling out MOHOLY* as his own. It stands as a countersignature that corroborates the authenticity of this graphic work. It seems to indicate the difference between a painting of a signature and a signature signing a painting. However, this signature cannot hide its status as a graphic work (like "MOHOLY") and, as such, at the (conditional) limit of Moholy's biographical meaning. It marks this countersignature as always already another typographical painting spelling out Moholy. The authorizing relation between signature and painting cannot function properly when the painting is another signature and when the signature is about to become another painting, i.e., another graphic work. It

is in this way that the vicious circles of *Yellow Disc* point the way to the formation of Moholy's counter-discourse.

### Facing Moholy: Mask/Self-Portrait(s)

His existence defines the black space that lies between the mask and the face it hides. — Michel Foucault, *Death and the Labyrinth*

With the self-portrait, an artist represents himself. He signs himself visually. He portrays himself to himself and to the world. Or, in a self-portrait, he faces his artistic public by facing himself. Like many artists, Moholy begins his career painting self-portraits according to a representational model. *Self-Portrait* (1919) provides an early example of this form of self-expression in line with the tenets of a Van Gogh or of contemporary Expressionism. In conventional terms, the heavily lined and furrowed brow depicts the withdrawn introspection of the artist deep in thought. But this is the last to be seen of an unproblematic self-presentation in a representational format for Moholy. For abstraction liberates the signifiers of painting to the point where they resist the representation of the author. Moholy's abstract paintings, the so-called *transparent pictures,* provide a "liberation from the necessity to record."[19] Paradoxically, Moholy's transparencies bring opacity into play and lose the record of the author.

This section reviews Laszlo Moholy-Nagy's series of self-portraits in the photogrammatical medium. Here, Moholy repeatedly employs strategies to efface, erase, or deface himself. He frustrates the viewer's attempts to come face-to-face with him. A mask or a black space intervenes between Moholy and his viewing public, or between Moholy and himself. And from this obstructed point of view, one can no longer be sure that it is Moholy whom one is seeing or about whom one is speaking. Moholy's abstract self-portraits play hide and seek or put on masks. They raise questions: What does an abstract self-portrait really look like? What is an abstract self-portrait and how do I identify it as such, as an "I"? In these ways, the photogrammatic self-portrait becomes the staging ground for Moholy to posit the conditions and limits of an economy of representation. Given these evasions of identity, one wonders whether to call them self-portraits at all. To repeat, these same doubts expose the risk of counterfeiting at the basis of abstraction. Without a system of representation to

provide validation, who is to say that this is or is not Moholy's self-portrait? In fact, if they resemble anything at all, these abstract self-portraits, as veiling and countervailing forces, function like signatures unhinged from meaning.

From another viewpoint, these abstract photogrammatical experiments blur the distinction between the face and the mask. In Greek rhetoric, this defines the central trope of autobiographical writing: *prosopon poien* — to bestow a face or a mask upon oneself or to make oneself out as a persona. Therefore, the photograms are not merely self-portraits in search of a subject or author. They are emblems of the autobiographical activity itself, the activity of donning a mask or face to generate photogrammatical effects and to become oneself in the process.

The photogrammatical procedure exposes objects to light-sensitive paper and records the results. Better said, it exposes objects as abstract effects. Moholy puts himself into the spotlight, exposes himself as a light effect, and displays the results of these experiments under the title of self-portraits. Moholy calls the photogram a frontier zone, a bridge, or a threshold space and one notes the wavering space (between object and effect) in which these photogrammatical self-portraits float.[20] This is reflected in the doubly slashed titles of the two most important works, *Photogram: Self-Portrait Profile* (Figure 9) and *Mask (Self-Portrait)*.[21] On the one hand, the viewer wants to read these works as profiles that stand for the author of the work. In a way, he wants to read them as he reads and understands the title *Self-Portrait Profile,* and these Moholy photograms expose that desire as the representational expectations of reading.

On the other hand, these abstract photograms, alienated from definition, resist a reading that would link up with the Moholy object. The abstract photo-writing moves vision from a representation of objects to a performance of effects. In the blink of a photo-eye, Moholy himself has been transmuted into a light-writing effect, "translated . . . in an almost immaterial substance."[22] These photograms disembody the identity of the object or the self-portrait and the results resist classification. As the photogram is written, "Through the elimination of pigment and texture it has a dematerialized effect. It is a writing with light."[23] What had seemed like Moholy's Pinocchio-shaped nose is a lie. Through the liberation of abstraction, it starts to dissolve into smoke. The hair, too, turns gaseous before the gaze. And this birthmark might

9. Laszlo Moholy-Nagy, *Photogram: Self-Portrait Profile*, 1922, gelatin silver, 37.4 x 27.4 cm. (Courtesy George Eastman House, Rochester, New York)

be a spot or a dust particle which slipped into the photogrammatical apparatus or the developing solution.

And yet, if one looks long enough at this photogrammatical self-portrait, one begins to fantasize, to imagine, to wish upon a star — to wish upon a moon or a half-moon. It seems as if man is becoming half-moon for a mask self-portrait or a photogram self-portrait. What appeared as a representational profile in the light of day becomes a half-moon crescent shining in the evening.

Technically, this is a lovely gesture because it sets up an analogical relationship that mimes the structure of the photogram itself. For the sun is to the moon as the light source is to the face (which is not). As a tele-directed thinker of the "new vision" and its technologically spaced-out scenario, it should not be surprising to learn that Moholy believes that the moon was within the reach of mankind. In "Geradlinigkeit des Geistes — Umwege der Technik" ("Directness of Mind — Detours of Technology"), Moholy reviews a series of technological extensions (e.g., camera, telescope, microscope) that have shortened the circuits and have bypassed the detours or have enabled mankind to overreach distances and to transform natural human scale. The astral navigator concludes his teleportation tour by shifting technological desire from the farthest reaches of the ground (i.e., Cape of Good Hope) to the starry heavens. Thus, "The next station will be the moon."[24] Keeping these considerations directly in mind, one might want to read *Photogram: Self-Portrait Profile* as the attempt to employ the camera — the tele-directed device that delivers more than the eye can see — to draw down the moon and generate a satellite picture in the form of a new type of self-portrait.

There is a strategy of masking the man in every photogrammatical self-portrait, in the light of its abstract writing, that removes the self from the portrait, that removes both the man and the moon as the subject of the photogram. In the meantime, the reader may still reflect in an anthropomorphic way that there is a man in the moon. Given the lunacies of anthropomorphism, one may wish upon this photographic star in imagining a Moholy in the moon.

Thus, when it comes to the *Mask (Self-Portrait),* Lucia Moholy continues to treat these pictures as works of self-portraiture, as strict representations of her husband and herself. She cannot face any possibility that would deface or efface the one who shares her proper name. She pays no attention whatsoever to the catastrophic effects of the abstract photogram in relation to the self. In this familial way, Lucia refuses to undertake Laszlo's experiment in estrangement. In her *Marginalien zu Moholy-Nagy,* she argues for an identity principle ("the same") in the study of both the author and the subject matter:

> At the same gallery I found, described as a "photocollage," a variant from a series of earlier photogram profiles we had made, which had meanwhile undergone a transformation by

a chin being stuck on [*durch Aufkleben einer Kinnpartie*]. A little later, a correspondingly reworked variant appeared at the Eindhoven Retrospective in 1967. This time, it was listed as *Mask* [*Maske*] and not *Self-Portrait* [*Selbstbildnis*] as in Munich and it was taken in among the photograms. . . . Neither the names of the lenders nor the formats being the same, it would appear that more than one copy of this reworked version [*überarbeitete Version*] had been in circulation.[25]

This passage raises questions about the identity behind this *Mask (Self-Portrait)*. Lucia is stuck on the fact that an authentic Moholy *Self-Portrait* has been vandalized and transformed into *Mask* by the hand of another through the addition of a chin later on. It implies that the photogram could act in another way such that the original self-portrait could properly belong to Moholy as the autobiographical author and the subject matter of the work.

But rather than the *Mask* spoiling Moholy's *Self-Portrait,* this brilliant reinscription (Moholy's or not) of a piece of cardboard masking paper (photographed or not) brings another layer of doubt to the photogrammatical self-portrait in general. It questions the ability to call this a representation or a work of Moholy — "neither the names of the" authors nor the subject matter "being the same" (*ungleiche*). This collage addition puts it one step ahead or one chin up on the original photogram and its masking devices. It cautions the reader not to constitute the mask as another identity. It calls attention to the extra protection which a mask generates and to the photogrammatical self-portrait as a space for pseudonym that exceeds any recognizable and delimitable biographical subject.[26] The photogram would then define its problematic existence as the black space that lies between the mask and the face it hides, or the space that divides *Mask (Self-Portrait)*.

It would appear that the photogrammatical structure has duped Lucia Moholy into believing that these masks are self-portraits in the first place or even when they have undergone some defacement. With this manner of feigning identity, feigning it through a most effective and brilliantly crafted deception, there is no way to identify the simulacra that pass themselves off as self-portraits — to call them Moholy's or even anybody else's. In reading them as representational and authoritative objects, Lucia Moholy has been duped by the drastic play of the photogram whose effects

bring an infinite risk to the notions of the truth or the identity of the self.

This study in deception looks like something one would cut out and wear to a festival, a masquerade ball, a Halloween party, or a carnival celebration. This raises an interesting piece of cultural history. For many years after Moholy's death, there occurs at the Institute of Design in Chicago a memorial celebration to honor the founder of the New Bauhaus. In a "bizarre resurrection," students mask Moholy and mime his deceptions (of himself). If the reader would try on this *Mask (Self Portrait)*, then he or she would be ready to join in the festivities. "Every year at Halloween at IIT's campus, the Institute of Design students still send out invitations, paste up posters, don Moholy Masks and celebrate a bizarre resurrection of Laszlo Moholy-Nagy, followed by a wedding with Moholy and an all-night *Deception*."[27] They celebrate the master by putting on Moholy masks. And by putting on Moholy masks, they multiply the identity of the unidentifiable photogram self-portrait even further.

With his *Vision in Motion,* in the guise of a twentieth-century literary critic, Moholy cites Hugo Ball's *Dada Diary* in the "Literature" chapter of his textbook. In the light of the photogram and its evasions of identity through the strange and deceptive powers of its abstract writing, he seems to be speaking of himself, the photogrammatical dissemblances of himself. This can only be referred to as a masquerade ball. "Every kind of mask is therefore welcome to him, every play at hide and seek in which there is an inherent power of deception."[28]

Even in the filmscript medium, there is this obsession of Moholy with masking. As soon as one enters *Once a chicken, always a chicken,* "inside is the man with the mask."[29] Indeed, the man with the mask (*der mann mit der maske*) is one of the leading characters in this story. As the plot of the filmscript unrolls, there is the recurrence of a masked man — a masked man who multiplies himself ten times and makes the question of identity doubly problematic, once on account of his mask and twice and many more times on account of his doubles. The riddle of the *Mask (Self-Portrait)* ("Is the mask a self-portrait?") appears in the filmscript version in a different form ("Is the 'man' a cinema actor?").[30]

The script has been constructed so that the reader is put in the position of the "chick" who pursues the masked men in the story. The narrative stages a comic chase in pursuit of an identifiable object amid the confusion of the effacement. The woman is sitting

in a cafe when "at this moment ten men with similar masks pass outside. Nine of them are relatively blurred." In this mad pursuit, a question has been added in the text which mocks the representational economy that would overlook the play and display of masks. Facing the men with the masks, the text doubts its own proper identity: "Is this '*the*' man?" It suggests that the search for Moholy's true identity has been working with dummy constructs from the very beginning. Thus, the following scene in the filmscript assumes an allegorical significance: "She knocks at the door of a flat. A woman opens it — shakes her head. Inside, a shadow appears (the man with the mask?). The girl pushes the woman aside and rushes toward the 'man.' A dressmaker's dummy [*eine modellpuppe*]!" The singular chase after the biographical subject has been translated into a movement of shadows, an abstract display of masks, and a dressmaker's fashioning with dummies. The final revelation of the dummy recalls an argument between Moholy and Lothar Schreyer about the future of the theater. In this debate, Moholy takes the technological part of the dummy. "You are wrong. The automaton, as you call it, is the motor and the form of our time. It is everything."[31]

There is another multiple exhibit of an abstract photogram that masquerades as a *Self-Portrait,* if it is possible to recognize it as such through the ruses of its signature(s). This is a rather lengthy treatment, a treatise even, full of twists and translations, reprints and versions, and metamorphosis:

> In the same way, the starting point for a metamorphosis occurred with a photogram done in 1922 (dated c. 1924 by Wingler). Reproduced upright in the first edition of *Malerei, Photographie, Film* (1925), it was published in a reversed position [*als Umkehrung*] in the second edition, subsequent reprints, and the translated version. Nevertheless, it appeared on the book jackets as originally intended. The identical photogram [*identische Photogramm*], enlarged to a format of approximately 64 by 94 cm., later supplied the image background for a new work. A wooden frame and other three-dimensional objects were knocked into the surface, converting it into a kind of relief-assemblage. Reproduced in "Abstract of an Artist" (1946), it was defined as a photogram-montage and dated 1922, the year applied to the initial photogram. In the Eindhoven Retrospective of 1967 and in the collage exhibition in Zürich, the whole thing was de-

scribed as a relief-montage on a photogram and listed as *Self-portrait* (1922–1926). In summary, it seems odd that the developments leading up to the spectacular result of this unusual metamorphosis [*ungewöhnliche Metamorphose*] have left no trace whatsoever in my memory [*keine Spur in meiner Erinnerung hinterlassen hat*].[32]

This *Self-Portrait* cannot keep its identity straight. Given the permutations of its name over a twenty-five year period, there is the question of what to call it — abstract photogram, relief-assemblage, photogram-montage, or relief-montage. The object, as well as the possibility of its original intentions (the "originally intended"), have undergone alterations through additions and reinscriptions of form — of a "wooden frame and other three-dimensional objects" added on to the "original photogram." But through all of these transformations, the results leave "no trace whatsoever" in the memory banks of Lucia Moholy. As with *Mask (Self-Portrait)*, Lucia Moholy has been framed by the drastic play of the trace structure of the photogram and these other forms of abstract writing. It appears as if she has been tricked by the advances of these masks which subvert the structure of identity, still-life, and a portrait of the self by adding on the possibility of an extra frame. This has even contested the authorship of the work, Moholy versus Moholy. While Laszlo later signs in for the collage additions of the abstract photogrammatical *Self-Portrait* with "Abstract of an Artist," Lucia disavows her former husband's authorial involvement in the making of the end product.

The version/revision illustrated in the autobiographical "Abstract of the Artist" shows how the question of the enframing of the subject appears on the surface of the work. By constructing this extra (wooden) frame, Moholy demonstrates the manner through which constructivist montage-assemblage masks identity and reframes the self-portrait. This display of signatures yields a spectacular spectacle and a carnival of masks so that the photogram dissembles itself from one viewing to the next. In the *Self-Portrait* of the "Abstract," these montage elements work against the empiricism of the three-dimensional object. By linking the extra frame with the light-writing effects of the abstract photogram, Moholy unhinges the fixed object status of the frame. Both are effects of framing — effects that open the space for the representation of objects. Moholy's tactics resituate the subject of an autobiographical self-portrait as an effect of enframing. The ob-

10. Laszlo Moholy-Nagy, *Self-Portrait, Photogram with Torn Paper,* 1924, gelatin silver, (Courtesy George Eastman House, Rochester, New York)

ject is knocked — "knocked into the surface, converting it." The object of study — the self-portrait (frame included) — and the author are converted into free-floating materials which are about to splinter off for yet another bit of enframing.

In another example, *Self-Portrait, Photogram with Torn Paper* (Figure 10), there is the temptation to read the piece as a representation of Moholy's face, especially as the pose affords more outline than some of the other photograms. But closer inspection reveals a double chin (two chin lines). The wavering of the line re-

calls the effects of light cast over space and time. Like the pseudo-chin that hangs out in *Mask,* another layer of material covers over the face in spots. It papers over the signified and defaces it (masking paper). *Torn paper* tears apart representation and rips it to shreds. It is the decomposition of the self-portrait as a life image. Like the double frame of the abstract photogrammatical self-portrait, this paper works what might be termed the double bond of composition. While the frame of representation lures the reader to Moholy as the signified of the paper, the materiality of the composition works in a more abstract way against an unproblematic biographical self-portrait. Paper, the surface for inscription, marks. It works like the Moholy photogram that experiments with paper — crumpling paper, its texture, and rewriting it (the object) as "a diagram of forces" or as a textual and light-writing effect. The English text on the back sheet of the photogram named *Diagram of Forces* in the handwriting and signature of L. Moholy-Nagy is transcribed as follows: "A light-sensitive paper / was made wet, squashed / and exposed to light. / This result is a 'diagram of forces' projected on / the flat sheet / by L-Moholy=Nagy >(for the cut maker)."[33]

To shred the biographical self and squash the self-portrait as autobiographical work, one leaves it to the writing of/on the photogram or to any light-sensitive paper. One takes the subject, the self-portrait, or the object, to the "cut maker." In admiration for the new vision of the Cubists, Moholy writes, "Thus he [insert 'Moholy' as one possible subject, keeping in mind the effects of such a quotation upon the status of the subject/object] began to peel off the surfaces of the object, to disintegrate it."[34] In an abstract musing, one that would follow the collogic of this photogrammatical practice, it is appealing to imagine that after making this cut he would find *Mask (Self-Portrait),* another photogram, as its underface.

■

**Knowing the Name: Autobiographical Photomontage**

The problem of the Moholy signature also finds expression in a group of autobiographical photomontages. Like the photogrammatical self-portraits, these works involve strategies that undermine or "misrecognize" their autobiographical subject. These playful montage pieces foreground the difficulties involved in "getting at" Moholy, in really knowing him or even his name,

and they set up numerous obstacles to autobiographical self-knowledge.

The inquiry into knowing the name in general and of knowing Moholy's name in particular begins with two biographical passages. In the first case, an overly ambitious Hungarian youth wants to make a name for himself. He dreams in his diary of a future time when his name will achieve fame and global significance. "My soul knows that a time will come when people's scorn will hurt no more, when my head is high and my spirit free because my name is known to the world."[35] In this romantic vision of renown, a naive Moholy equates worldly fame with spiritual freedom and a proud posture in the uncritical desire of a self-centered subject. But one notes how spiritual freedom has been written over as an antidote and an anesthetic to the pain of being scorned by others and the ensuing internalized self-contempt. The aestheticized name and its fame rest on the numbing of indifference.

The narrative of the name and the quest for recognition is taken up at the second juncture in a very different manner. This biographical incident takes place when the youth, now a man, meets the woman who is to share his name and its fame. Sibyl Moholy-Nagy recounts the encounter and its ramifications:

> As he handed the card to me, explaining how the mirage would work, I saw the name LASZLO MOHOLY-NAGY.
>
> "Oh, it's you; you're Moholy-Nagy," I said, and his face, which had been serious in its intense concentration, lighted.
>
> "You know my name? How nice" — as if everyone with an interest in modern art did not know who he was. But it was not an affected delight. It was genuine surprise, the joy of a child being recognized. He never lost it, and even the incredulous intonation remained unchanged to the end of his life. "You really know my name?" floated gaily through the darkened hospital room during his last sickness fifteen years later, when an orderly turned out to be a former student at Black Mountain College.
>
> I had known his name for ten years, I told him.[36]

The above narrative cuts up the biographical subject through the insertion of cinematic devices. The possibility of unified action begins to waver and to float in the flashbacks, cutaways, and fast forwards instituted from the hospital bed that remind

the reader of the scenography of TV soap operas. While written three years after Moholy's death, the story scuttles back and forth and recalls other times, places, and names. It replaces linear biographical narrative with a montage sequence that foregrounds again and again a scene of re-cognition and recognition ("who he was"). The play opens at the time when Sibyl recognizes Laszlo Moholy-Nagy or, at least, his signature ("I saw the name LASZLO MOHOLY-NAGY"). It moves forward fifteen years to the time when this now well-known name is recognized on his deathbed by the hospital orderly. Finally, it flashes back another twenty-five years to the point when Sibyl first hears of her future husband's name ("I had known his name for ten years, I told him").

In contrast to the initial scene and its soul searching, this narrative is fashioned according to a different set of nomenclatures. Throughout every point in this abridged version of Moholy's life, there is an obsession with the name, with recognition, with knowing "LASZLO MOHOLY-NAGY." At first glance, these anecdotes seem to affirm the impression that an affected or narcissistic Moholy desires to become famous, or even a household name. This interpretation would make Moholy-Nagy the artistic subject who wants to be known, who wants recognition, who wants to have his name, and therefore himself, pass through the world as knowledge, and even "well-known."

But there is another way of constructing the biographical scenographics so that the signature and who or what it signifies — as well as the self and the others — shift positions. At each break in the narrative, the reader notes that it is Moholy who is asking questions in a rather "incredulous" manner. This interrogation puts Moholy in the role of the psychoanalyst. The underpinnings of this alternative analysis take their cue by fast-forwarding to a basic idea from the writings of Jacques Lacan. In the foundational essay "The mirror stage as formative of the function of the I" (1934), Lacan argues that the constitution of the subject takes place when the child mistakenly identifies his mirror image as himself. In other words, the representative of the self is mistaken for the represented self, or the sign for what it signifies. In psychoanalytic parlance, this is called the scene of the misrecognition or the misconstruction of the self.[37] It is the scene of misknowing in the "me's knowing" — the "*méconnaissance* that constitutes the ego." This French word, *méconnaissance,* points out that the scene by which the subject obtains a knowledge of himself as an

ego identity is of necessity a misknowing and a mistaking of the self. The scene of misrecognition paradoxically gives the subject knowledge of himself by showing him how he has been constituted as an effect of a process of naming. It is the function of the analyst to interrogate the subject or to point out how he or she has been constituted by language.[38]

In the context of this biographical analysis, there are the persistent questions "You know my name?" and, "You really know my name?" It is as if Moholy wants to turn the issue back on the other — onto the subject who claims to know and be known — in order to show him or her how the "mirage" works, i.e., how the subject is constituted as a signature effect. It is as if he wanted to arrest the certainty and security of self-knowledge in the name of the signature. And it is interesting to note that he performs his grand graphic gesture by presenting the (visiting) card with the writing, with the inscription of the subject, "LASZLO MO-HOLY-NAGY."

His is the "genuine surprise" of the child or the constantly regenerating naivete of one who acts as if he would look through the looking glass or the subjection of the mirror even upon "being recognized." He does not invest in the subject in any unproblematic way, but rather exposes how the knowing subject is a misnomer, or rather a misknower, who is constituted within the bounds of naming in the expanded field of un-knowledge. This is how the mirage works: Whenever the subject is called into language, whenever the name is claimed, he must resist concentration as a subjective entity or as an ego identity. And so, when he is hailed as a subject through the use of the second person pronoun in the scene of misrecognition that has been set up by his future wife ("Oh, it's you; you're Moholy-Nagy."), one sees Moholy's "lighted" face in the acknowledgement of the mechanics of the scene played out before his eyes so that he responds with a pleasantry ("How nice"). The metaphor here is one of a child at play with the universe, full of wonder and surprised by life. This links up with a remark made by Walter Gropius in his eulogizing of the biographical subject: "His was an attitude of an unprejudiced, happy child at play, surprising us."[39]

Moholy once asks this rhetorical question, "Now shall I help them out when they simply *have* to know my first name?"[40] This question is posed for the subject who wants to know or who wants the reassurances of the origin in the "first name." But perhaps the teacher is setting a trap for his pupils in order to ex-

pose them to the expectations set up in their desire for knowing a name. It is as if he were to show them the lack or hollowness (*Hohlheit*) around which the subject of knowledge has been constituted. All intentions, desires, and claims to self-knowledge aside, this trap is posed by the signature which inscribes the subject who wants to know or be known.

The problematics of misrecognition also delineate the shifts in the signatures which form Moholy's own name(s). In addition to its most recognizable form, a whole series of variants and deviants opens this speaking subject to dispossessions of the name and, therefore, to the mechanics of name (mis)recognition. A genealogical inquiry suggests that there is even the chance that Moholy is a supplement added on to the name much later. When it comes to Laszlo Moholy-Nagy, the multiplying effect of the name-calling prevents the conversion of Moholy into a fixed identity and, moreover, the name of Moholy has been staged as a fabulous construction. It is also significant to note that Moholy assumes the famous name just about the time (i.e., at War's end) that he begins to practice in the name of art. The mysterious matter of (im)proper names and their origins traces Moholy's decidedly splitting genealogy.

> It is not exactly clear how young Laszlo came to have the surname Moholy-Nagy. By one recent account the family name was Nagy, and Moholy was later added to the name. It was derived from the name of a village, near which the family once lived. In another recent account, the artist's original name was Laszlo Weisz, but the last name was changed in favor of that of his lawyer uncle, whose last name was Nagy; in 1918, Moholy was added. It has become customary when not using his full name, to refer to him simply as Moholy. This usage began when the artist was still living.[41]

Given Moholy, it is rather difficult to mistake his name for himself or to enact the scene of misrecognition for once and for all (i.e., to forget about it) when he and his signature have been displaced and disposed of by language in so many ways and amid so many self-contradicting narrations.

In two photomontages of the mid-1920's, Moholy inscribes the autobiographical subject in the field of un-knowledge. Both of these pseudo-self-portraits, *Mein Name is Hase* and *Der Trottel,* stage the subject as a signature effect. They illustrate the paradoxical scene of misrecognition by which the subject (Moholy) has

been constituted and has received a (mis)knowledge of himself. *Mein Name ist Hase. Ich weiss von nichts.* That is the name of a Moholy photoplastic self-portrait that has to do with nothing, with knowing nothing. It denotes an ignorant person or, paradoxically, one who might be able to affirm the effects of unknowledge which are implicit in the (mis)recognition of the self. As the name of a photomontage self-portrait by and of Moholy, it should say something (or nothing) of what Moholy thinks of himself and of his name. In other words, if one assumes that *Mein Name ist Hase* has something to do with Moholy in an autobiographical sense, then *Ich weiss von nichts* (I know nothing) states exactly his position on the status of the photoplastic self-portrait and himself. Following this German colloquial expression for the affirmation of ignorance, an unknowing Moholy inscribes himself through the scene of misrecognition as an effect of naming.

"My name is Hase. I know nothing." But who is named Hase? Who is the subject of this sentence? One wonders what an autobiographical self-portrait of Moholy has to do with Hase. There is one translator who says that Hase means "to have," the verb of possession — as in *"have* to know" — but the title emphatically states that Hase has nothing and that he has been dispossessed.[42] Now the German dictionary says nothing about Hase and "having." It defines Hase as a hare. In the difference of a letter, the signifier moves interlinguistically and slides in significance from Hase to "have" to "hare." Assuming that the actions of this name have significance, the reader would expect the word Hase to move around very quickly. And in fact, it leaps over to another synonymous signifier, a rabbit. The English version of Krisztina Passuth's *Moholy-Nagy* translates the title of the photomontage differently, *Rabbit is my Name and I Know about Nothing.*[43] With this translation, the colloquial expression *Mein Name ist Hase* has become literalized, and the new title suggests that the subject matter of the photoplastic is making a pun or a visual literalization out of the idiom as well. This entitlement guides the visual interpretation. With this revision, one is bound to look for a hare in the picture and to read the face in the foreground as a rabbit's stare. Passuth's translation gives the photoplastic a new identity. It shows how a verbal difference may have visual significance and alter cognitive perception. This rabbit gnaws (*nagt*) to take a bite out of the meaning; it too wants its share of Moholy-Nagy.

Now it is quite possible that Moholy identifies with the rab-

bit — if that is what it is — and places it into his autobiographical self-portrait to stand in for himself. First, there is the capacity of a rabbit to move very quickly from place to place and to have vision in motion. Furthermore, there are etymological similarities between Moholy and those members of the parasitic rodent family which suggest more than a passing interest. Laszlo Moholy-Nagy might then be perceived as turning himself and his proper name over to the impersonality of language. In other words, Moholy's peculiar fascination with moles, burrows, rabbits, rodents, and guinea pigs might be lodged within the signature which structures the course of his biography. In this way, he turns self-knowledge over to language and he turns himself into a signature effect. For what is called a *Nagetier* in German is called a rodent in English. To strengthen the case for the significance of the signature as passed through the German linguistic register, there is written evidence that mole Moholy identifies his pioneering artistic practice with the activities of the animal underground, with the ones who, as he says, "are often compelled to take refuge in 'catacombs' in order to preserve their pioneer efforts."[44]

While it may seem absurd compared to forms of rational explanation, a series of interactions between Laszlo Moholy-Nagy and the Merz Dadaist Kurt Schwitters supports the case of the significance of the signature as it is applied to Moholy's relation with the *Nagetier* and its existence in caves. As both constructing subject and as constructed object, Moholy-Nagy plays an instrumental part in the construction of the *Merzbau* architecture in the home of Kurt Schwitters in Hannover up until 1930. The documentary source material for these revelations is not derived from books about Moholy, but rather from the memoirs of Schwitters's friend Käte Steinetz. Here, we learn of Schwitters's passion for guinea pigs, and one photograph shows a rodent sitting on the *Merzbau* during an early stage of its construction. When Schwitters decides to domicile these gnawing varmints, he calls for the expert technical assistance of his friend Moholy-Nagy to help him construct it. "The Guinea-pig House, or White Palace, was constructed by Kurt Schwitters and Moholy-Nagy about 1930 as part of Schwitters's experiments with the mechanical room."[45]

Schwitters's *Merzbau* is an intricate series of abstract caves and grottos in which biographical, topographical, and symbolic details are compounded in the design of an abstract architecture. Appropriately enough, among those dedicated to other abstract pioneers such as Naum Gabo, Hans Arp, and Piet Mondrian, one

of the caves of friendship and of hero worship (*Höhlen der Freundshaft und der Heldenverehrung*) is dedicated by Schwitters to Moholy-Nagy (*eine Moholy-Nagy Höhle*).[46] In other words, the man with the hollow signature is converted into a cave. According to published reports, this cave contains a pair of old, hole-ridden socks that Moholy had discarded and which Schwitters decides to make the fetishistic centerpiece of the Moholy cave.[47] But while this analysis has sought to optimize the Merzian logic intrinsic in this series of convergences between name and deed, a contrasting point of view would argue that the arbitrariness of the signature gnaws away at the possibility of its significance for Moholy.

To return to the specific autobiographical photomontage title lacking in knowledge, one sees that Hase has been capitalized. If this were in English, there would be no doubt that this is a proper name and that it denotes a person and not a rabbit. But one can never tell the difference in German where every noun has a capital letter. But there is evidence for considering this particular Hase as a proper name. Once upon at time, there was a famous German theologian by the name of Karl von Hase. This Hase wrote many interdenominational texts on religious subjects including the comparative treatise entitled *New Testament Parallels in Buddhistic Literature*.[48] Paradoxically, Moholy-Nagy may be alluding to or identifying with this old-timer (what is called in German, *alter Hase*) because the theologian pursued a parallel logic of emptiness in order to dispossess his own subjectivity and identity.[49]

What happens if one turns to the visual elements of the photomontage for more clues about the secret identity of this humble *Hase* who appears to know nothing? Many lines and parallel bars run up and down the montage in a diagonal manner with a child entangled in its web and a baby, hanging on by a thread, perched precariously over the void. On the right, there seems to be a blank-faced mime in whiteface staring out. It is nothing but a top hat, a face, and two hands crossed in an oblique expression of disengagement. It is difficult to figure out the gender or ethnic characteristics of the mime — whether it is a man or a woman, Occidental or Oriental, etc. It might be one of these types posing as the other or perhaps (putting on another *Mask/Self-Portrait*) it is a mime posing as a rabbit (following Passuth's Hase). Blank spaces occupy the areas which ought to contain the rest of the body parts. Like the mime and its gestures, the photomontage is

silent and inert. It gives out nothing definitive. Or, as it says, it knows nothing. In so many ways, the photomontage self-portrait *Mein Name ist Hase* works like an elaborate ruse designed by Moholy — and designing Moholy — in order to keep the viewer (and himself) from constituting him as an autobiographical or biographical subject of the work, and perhaps, only in this manner, to acknowledge the "I know nothing" of its title. Turning on the signified subject, the "I know nothing" of *Mein Name ist Hase* returns to the scene of the inscription of the subject of knowledge as a signature effect in the field of un-knowledge. *Mein Name ist Hase* is constructed like an elaborate puzzle in the pursuit of *Ich weiss von nichts*.

There is another part to add to what might be called this "know nothing party." During the same period (1925–26), Moholy-Nagy did another photomontage self-portrait entitled *Der Trottel*, or *The Fool*. This pseudo-self-portrait is another variant on the deviant *Hase* who knows nothing, for the one who plays the fool is *said* to know nothing. The etymological roots of *Mask* also enter into this self-portrait because it involves playing the fool. In fact, in Arabic *maskara* means a buffoon. The mask is worn by the buffoon and the fool for purposes of ridicule and satirical disguise.

Like *Hase*, there is not much to speak of with *The Fool*. The photo-plastic consists of three cutouts which are empty silhouettes (of a negative) of an official photograph of Moholy at the Bauhaus in his monteur's overalls taken by Lucia Moholy. Sabotaging the biographical project, Moholy has voided this documentary portrait of himself. He has fooled around with it and has become empty-headed in the cutting and pasting process. It is important to recall that this depiction of foolish empty-headedness (*Hohlköpfigkeit*) plays out another hollow connotation in the mid-section of the Moholy signature as it is inscribed in the German language. Three times (*X*'s) in a row, Moholy marks himself as the dispossessed subject of the work. The blanks and hollows of Moholy's former person mirror the emptiness outside of the frame. What remains? Two pairs of feet are crossed in a ridiculous fashion below the first two cutouts and a headless runner moves like a rabbit out of the frame behind the third cutout whose face has been masked and screened from view. His cutout existence defines the white space which lies between the photomontage and the face it hides. But the first alteration is not fixed

since Moholy's feet seem to have undergone a sex change, confusing the issue of gender when compared with the *Jealousy* photomontage which uses some of the same graphic materials.

There is this paradoxical wisdom in the gestures of *The Fool* as he misrecognizes the traps of his embodiment as a subject — what comes from knowing a name, or the act of forgetting which makes it stay in place. Like the dynamics of *Hase,* this is a self-portrait which sets up snares for anyone who would locate or know its subject, with Moholy as its subject.

*Der Trottel* can also be translated as "one who is lacking in concentration." This definition denotes another aspect of the Moholy lack in the German linguistic register. This usage mimes El Lissitzky's derogatory description of Moholy as the man without a proper calling and Kemeny's negative designation of Moholy as an eclectic. Nevertheless this lack of concentration makes him an inter-media artist. This does not just mean that Moholy accomplishes a variety of things because he has no field of concentration. For whatever he knows, Moholy's artistic practice acknowledges the surplus of the mean(ing)s — the *inter-* of *media.* He stages his works in the name of signature effects which lead unto un-knowledge. He removes himself for these nothing terms standing in for the biographical inscription of the subject.

This describes an intersection which the humanist ideal does not cross. It is the staging of a play, the working of a decentered machine called language, or a *Mechanized Eccentric.* There are no actors nor any place for human concentration in Moholy's play of this name. Moholy writes about the philosophy behind the staging of his play. Its purpose is to undermine the human as an ideal phenomenon of mind and spirit. "Man, who no longer should be permitted to represent himself as a phenomenon of spirit and mind [*geistiges Phänomen*] in his intellectual (logical/ thought) capacities, no longer has any place in this concentration of action."[50]

At this juncture marking the limits of the human as both a theatrical entity and as a knowing being, it is appropriate to incorporate a passage from the French philosopher of play, Georges Bataille, on the problem of un-knowing, and to set it in confrontation with the "I know nothing" in the name of *Hase:* "When I now speak of un-knowing, I mean essentially this: I know nothing, and if I continue to speak, it is only insofar as I have knowledge which leads me to *nothing.* This is particularly true of that

sort of knowledge which I am now considering before you, since it is in order to set myself before this *nothing* that I do talk of it, to set both myself and my listeners in confrontation with this *nothing*."[51]

At the limits of thinking and meaning as well as of intellectual and spiritual capacities, in playing *The Fool,* in confronting "nothing," or at least in acknowledging its effects, the biographical subject (Moholy) returns to the signature effect in writing, *Mein Name ist Hase. Ich weiss von nichts.* He exposes himself to the ruses of the negative which come from knowing nothing or of making something out of nothing. Moholy confronts the impossibility of thinking the impossible except perhaps when marked as a fool, as Hase, or as a *dummy construct* (a misconstruction). Avoiding substantiation at each turn, the ruse of the negative returns to the mark of the signature to make the nothing ring hollow (*hohl*) or sound dull — an empty gong in the cavity of a cave (*Höhle*) of Moholy's un-knowing. The ridiculous binds, the dummy constructs, and the impossible projects set up for the biographical subject and for biographical writings seeking to acknowledge these effects make the signature of unknowing a source and resource for laughter. But, to return to Bataille's dictum, it is only "perhaps in that un-knowing which I have here presented that we can win the right to ignorance."[52] In this way, like Moholy, one wins the right to write upon or to know *Der Trottel* or *Mein Name ist Hase,* or instead, to ignore them.

### Assignment: Mistaking Identity

The 1984 exhibition catalogue, *Bauhaus Photography,* numbers six works by Laszlo Moholy-Nagy. An itemized list follows: photomontages *How I Remain Young and Beautiful* (*Wie bliebe ich jung und schön*), *Jealousy* (*Eifersucht*), and *Mother Europe Cares for her Colonies* (*Mutter Europa pflegt ihre Kolonien*); the book cover to Ida Bienert's *Die Sammlung* (*The Collection*); the photogram entitled *Portrait of Rudolf Blumner;* and an untitled photogram (a part detached from one of Moholy's triptychs). Rudolf Blumner is the third man in on the artistic deal whereby both Moholy and Schwitters share studio space in Berlin in the early 1920's. But despite this example of historical exactitude, the assignment of this section will be to reexamine the identification of the Moholy's in this catalogue. It is about the assigning of such works, the signing of such works — the impossibility of identi-

*Laszlo*

*Moholy-*

*Nagy*

**108**

fying same without making mistakes and what these mistakes *mean,* or in turn, how they mark the limits of meaning at the level of the material inscription of the signature and in terms of the logic of collage. This cross-examination of cataloguing procedures has nothing to do with the condemnation of any curators for not doing their jobs properly. It is rather to look again at what are normally considered to be irrelevant or inconsequential errors in detail. These mistaking matters call into question the economy of identification and the underlying conditions of possibility for modern(ist) museum-making in its exclusion of collogic and the manner in which it cuts into the identical. Indeed, this section reviews how the mistaking of identities calls into question the author of a collage, the subject matter of an abstract self-portrait, and the identity of works about identity.

There are two particular photographs in the aforementioned catalogue upon which attention will be focused—one attributed to Moholy's hand and one assigned to another. But with the mistaking of identity at issue, these two photos will lead to double visions. "Number 79. Laszlo Moholy-Nagy, Portrat Rudolf Blumner, o.j., Foto No. 4 aus der Mappe-Bauhaus-Archiv 1979. . . . Number 101. Marianne Brandt, Metallwerkstatt, Collage (aus Neun Jahre Bauhaus). 1928. Repro-Foto, Bauhaus-Archiv."[53]

The first photogram is also reproduced in Sibyl Moholy-Nagy's *Experiment in Totality.* There is no debate about the authorship of the photogram. Both reproductions assign the photogram to Moholy's hand, but Sibyl Moholy-Nagy's caption of entitlement indicates that the signator is inside the frame as well. According to Sibyl's biographical narrative, this is another Moholy self-portrait rather than a portrait of Rudolf Blumner. The *Experiment* catalogues, "Figure 12. *Photogram* (cameraless photo), showing Moholy lighting a cigarette, ca. 1922."[54] The discrepancy in the naming of these two identical pieces cannot be cleared up through a closer inspection of the abstract subject matter. Sibyl Moholy-Nagy is convinced that Moholy is lighting his own cigarette, but perhaps this is Blumner lighting up instead. In fact, a number of alternative possibilities on the matter of the subject in the photogram present themselves. It could be the hand of Moholy, but the mouth of Blumner (or vice-versa). It could be Blumner lighting a cigarette for Moholy while Moholy takes his picture or while they both share a smoke waiting for the light-writing to develop. Or vice-versa, it could be a depiction of Moholy lighting up for Blumner (Figure 11).

■

*It*

*Works*

**109**

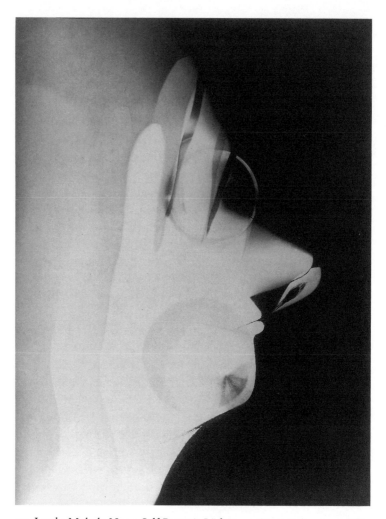

11. Laszlo Moholy-Nagy, *Self-Portrait Lighting a Cigarette*, 1924, gelatin-silver, print, 37 x 27.5 cm. (Collection George Eastman House, Rochester, New York)

But the question of the subject must be filtered through the peculiar logic of the photogram. One cannot infer that "whoever" lights a cigarette (ca. 1922) because the photogram dwells in a space that makes the attribution of actions dematerialized or perhaps even immaterial. Here, the assignment of identity has become a dead issue. The abstract photogram liberates the signifying materials from the field of representation in a conjuring act designed to displace identity. As Moholy writes, "The photogram conjures up as many interpretations as it has viewers."[55]

The search for the identity or subject of the photogram makes no sense when its abstract writing questions the representational object itself. Following photogrammatical logic, the viewers—each with his or her own interpretation on the subject—will not be able to tell the difference between Laszlo Moholy-Nagy and Rudolf Blumner.

The other works bring another set of questions related to entitlement—i.e., what belongs to the subject, to the one who would say "I" or "me." The photocollage *Metallwerkstatt* was part of the *Nine Year Bauhaus* portfolio (1928) that was presented to Walter Gropius upon his departure as Bauhaus director.[56] While the catalogue calls it *Metallwerkstatt* (translated, *Metal workshop* or *Mw* for purposes of abbreviation in this section), there is another version which appears in *Experiment in Totality* under the title of *Me*. Is this another shorthand way of writing the same work merely by taking the first two letters of *Metallwerkstatt*? This is certainly one possible scheme. However, Sibyl Moholy-Nagy offers a more definite explanation for the origin of this title. These two letters, *M* and *e*, add up to something which belongs to her husband. This piece is nothing other than an original self-portrait authored by Laszlo Moholy-Nagy. The first person objective pronoun signifies Moholy as a speaking and photographing subject. Sibyl Moholy-Nagy places the title into the context of Moholy's personal linguistic history and his knowledge of the English language. The graphics of the signature ("me") are subjected to a singular biography recalling a fragmented implementation of a trans-Atlantic foreign language (*Fremdsprache*) to make its linguistic user part of a "me generation." Sibyl recounts, "In a photomontage called *Me,* which was the only English word he had learned from an American visitor, Moholy has portrayed himself with his master students: Marcel Breuer, Hin Bredendieck, and others."[57] The caption to the illustration also assigns *Me* to him as both author and partial subject matter. The description is written in the form of a personal photo album. "Photocollage, ME, Bauhaus, Dessau, showing Moholy (top, wearing glasses) and master students, 1925."[58] In contrast to the Bauhaus photography catalogue, Sibyl Moholy-Nagy's reading constitutes a systematic repression which omits any connection between the photo-collage and Marianne Brandt (abbreviated in this study as MB) or to *Mw*.

In *Mw* one reads the letters *ME* inscribed two times over. One ME shadows the other in a type of double printing, a superim-

■

*It*

*Works*

position, a superimpression, or a macula. Both of these *ME*'s work as simulacra for the other photocollage, i.e., the one named *Me*. The pronoun ("me"), designed for defining identity, has multiplied identity and itself. In terms of subject matter, layout, and even typography, these two works shadow each other, bleed into each other, and confuse their own identities. The collages use some of the same portraits and architectural photographs. Reinscribing the same signifying materials, these collages offer slight shifts in the placement of the same compositional elements — like the blurred relation between the two ME's in *Me*. *Mw* puts its *ME*'s on a diagonal left, *Me* puts its own on the top right. Other elements have been added in one and not the other. The light fixtures also have undergone a switch. *Mw* has more light, not in terms of the brightness in the reproduction of the print, but in numerical terms — three columns compared to the one in *Me*.

It would be wonderful to find some obvious way to resolve this identity crisis — something in writing to clear up the confusion or some sort of identity card similar to the wartime postcard portrait sketch that Moholy had sent from the front that provides information about the subject of the representation with a written explanation and denial on its front: "Scribbled on it is: 'This isn't me. Love. [signed] Laci Nagy.' "[59] Unlike Moholy-Nagy's (abbreviated as MN) definitive renunciation of identity ("This isn't me") on the postcard, things are more confusing in the *ME* photocollages. *Me* and *Mw* appear to be two works by two different authors, MN and MB, dated three years apart, which are so close in their identity that the viewer is lured into identifying them as two variants of the same work by the same author. Ironically, *Me* (as well as *Mw*) is constructed to confuse the identities of MB and MN. It works like a plot designed by MN and MB to construct a collage that would employ strategies to call into question the construct of identity and the assignment of the identity of the work of art. They are superimposing on each other and plotting the subversion of their own subjectivities. With its capacity for reinscription, the photocollage risks their sense of self and authorship, their status as a "me," their stake in "me," or — to invert the latter phrase and to invent a neologism or a graphic demonstration quite similar to the mistaking effects of these works — their *me's stake*. As Jeannine Fiedler has tentatively concluded in a close reading of *Mw* in the *Experiment Bauhaus* catalogue, "Indeed, the riddle about the authorship of these two montages

might never be resolved completely."[60] In its own way, this tale of mistaken identity replays the scene of the misrecognition of the subject. For *Me* calls attention to the inscription of the signature through which the subject is constituted. The *ME*'s which inscribe these collages institute a gap between work and author such that there is no way for either Moholy or Brandt to claim, for either of these works, "That's me," or to appropriate the work for and as themselves. Stenographically, it is a game played both to pose and break identification with *ME* coming to stand between MB and MN.

But the work of *ME*'s mimesis raises other problems. Both versions which inscribe *ME* include others as well. Subverting the individual sense of a self-portrait, they move either from Moholy or from Brandt to each other, then to other classmates depicting different students in each picture, and then to the Bauhaus buildings occupied by countless others. They move from one identity to another. This series of multiplying names, it must be emphasized once again, undermines the logic of identity and identification. It seems impossible to stop the proliferation of identities connected to the taking of the collage picture.

In an analogous manner, it is most difficult to prevent the Bauhaus name (lent by Gropius) from acquiring a collogical association with Moholy's New Bauhaus, and later on in America, with the Institute of Design (nicknamed and abbreviated as the I.D.). The overlaying of the collage materials and their names (of the Bauhaus and the New Bauhaus) generates difficulties for the delimitation of a collective identity. In this somewhat embarrassing letter on the proliferation of names and the possibility of guilt by association after the close of the New Bauhaus in Chicago, Moholy appropriately and ironically turns to Gropius. As Moholy quotes him, the old Bauhaus director attempts to salvage the situation and to protect his and Moholy's good (institutional) names: "None of us relish the idea of having our name connected with a school that is forced to close after one year of rather brilliant success due to the work of Moholy and his staff. I hope this will help to stop unjustified rumours and misinterpretations."[61]

In contrast to Gropius's concluding hope to having put an end to misinterpretations about the quick demise of the New Bauhaus, there is no return to a stable difference between Moholy-Nagy and Marianne Brandt amid their identity crisis when, within their senses of self — the *ME* collages — each has inscribed the other. For these two have called for misinterpretations of the

"me's" interpretation. In fact, misinterpretation itself appears to be an improper way to name this interpretative strategy which follows from the collogic that reinscribes the identity of the self as a patchwork of mobile signs. The *ME* collages, as collages, have cut a moving intersection to cross up the sense of identity. They have connections (MB and MN) but they have become misconnected from fixed identity and from each other, from the *ME*'s connection — correction, misconnection.

In an attempt to avoid the network of dispersions instituted by this collage problematic, Lucia Moholy's study of Moholy translates the problematic into "Documentary Absurdities" (*Dokumentarische Ungereimheiten*).[62] In a somewhat pedantic tone, Lucia Moholy insists on what really happened, the truth of Moholy's career, as methodically, one by one, she dispels innumerable mistakes made by a variety of Moholy scholars about the identification of his works. In fact, she devotes an entire section of her *Marginalien* to the curatorial questions of "Attribution and Identification:"

> Reading in "Abstract of an Artist" about the history of the origin [*Entstehungsgeschichte*] of a "still life" depicted there which dates back to 1920, one can not help wondering — the more so if one happens to be a witness from those days — how it came about that this picture, which the artist never wanted to represent as a cyclist, as he himself writes [*wie er selbst schreibt*], ultimately made its appearance as *Radfahrer* at Eindhoven in 1967, as *Bicyclist* in Chicago and New York, 1969/1970 and as *The Motorcyclist Speeding* in a publication of the Institute of Design, not dated, but presumably, published in 1946.[63]

Lucia Moholy trusts her sources and returns to the origin of the work of art and its history. A biographical instance is evident in the overseeing of the eyewitness who looks over the status of the "I." The nostalgia for proper assignment is betrayed by a linking of the author with correct works and dates. But this overlooks how the play of the signifier "me" has managed to subvert identity in Moholy's own work, or in this case, how the movement of the still life and the transformative history of its reception overrides "what he himself writes." These other readings (*Bicyclist* or *The Motorcyclist Speeding*) make their way into the publication, the reprinting of the I.D. materials (Figure 12).

The same nostalgia is evident in the biographer's indignant

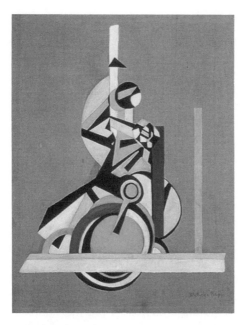

12. Laszlo Moholy-Nagy, *Bicyclist,* 1920, oil on canvas, 95 x 76 cm. (Caracas, Venezuela, private collection)

expression about changes in the identification of the dates and titles of paintings; in numbers, letters, and figures that somehow manage to slip through a proper accounting. Like the *ME* photocollages, things become very confusing and are inscribed in gray areas:

> A black-and-white reproduction of the same as tempera, named *A II,* 1924 may be found in the catalogue of the London Gallery, where a Moholy-Nagy exhibition was opened on 31 December 1936. Shortly before, the picture was shown in *Telehor,* the date being the same, but the title was quoted as *a 20. Telehor* also published, with the title *a 2* and dated 1926, a painting which in the catalogue of the Kunsthalle Mannheim (1961) and the book *Maler am Bauhaus* by Eberhard Roters (1965) — in the latter subject to a rotation of 90 degrees — was named *A XX* and dated 1924. If in the catalogue of the travelling Bauhaus exhibition [*Bauhaus-Wanderausstellung*] the title was changed to *a xx,* this was probably due to the typographical arrangement, using lowercase letters [*Kleinbuchstaben*] throughout, except for the Roman figures.[64]

Lucia Moholy cannot harness the play of signification, the violence of the letter, or the effects that occur on the level of graphic inscription and collage manipulation. Her biographical account cannot overcome these oversights or blindspots for the signified object. She may try to recuperate the difference as "typographical arrangement" or as mere appearance, but such is the design of the signature which opens the space for meaning. No matter how hard she tries to document and make sense of her former husband's *oeuvre* and biography, the marginal shifts of the signifying materials — that which escapes the collected works — come back to haunt or arrest her — a 90 degree turn, a letter (between *a* and *A*), an extra number (between 2 and 20), a shift in symbol (between II and XX), a change in a year or two (1922, 1924), the difficulties of identifying one painting or two (a XX vs. a 20). These signifiers are meant to identify the object, but instead, in a virtual sense, they object. Collogic delimits identity and the biographical subject as inscriptions which are part of a wandering exhibition of graphic differences. Beyond the control of its author, *Marginalien* demonstrates the absurdity of the documentary and the subversive power of such marginalia.

These effects demonstrate in action the very experimental techniques deployed by Moholy and his (and her) generation. After all, one of the sections of *Marginalien* is entitled "Photoplastic — Collage — Montage — Assemblage."[65] As this study has demonstrated, these techniques contest the logic of identity and write out the challenge to the authority of bearing witness to the signing of a painting. The shifts of these signature effects confound the cataloguer's attempts to assign things a proper order — even to such an extent that one cannot be sure whether there are six or seven Moholys in this travelling show of *Bauhaus Photography*.

The displacements and the movements of the speeding *Bicyclist* (misidentified) race to a vision in motion that re-marks times, dates, names, and places, as well as still-life. Mutilating and turning things around or upside down, the cuttings and pastings of collogic make every point a point of and for departure. As the history of reception works against the author's original intentions, this re-naturalization demonstrates in turn another instance of collogic through the act of mutilation. In other words, this is how Moholy cuts: "I took scissors. Cutting away some parts of the drawing, and turning it at an angle of ninety degrees I was satisfied. When the remnants were pasted on a new sheet, the whole had little similarity to the still-life which I had chosen as the point

of departure. People, accustomed to naturalistic schemes, insisted that this 'still-life' mutilated and turned upside down looked like a rider on a motorcycle."[66] At this point, under the knife of the scissors and the departure of the fixed biographical subject, one takes the workings of the collages which inscribe *ME* in accordance with the transformational grammar of *The Bicyclist*. The goal is not to detract from Lucia Moholy's or any curatorial account so much as to reframe this biographical project and the unproblematic field of historical representation through the give and take of the scissors's cut. It is to recall how the curatorial world vision is rooted in the habits and conventions of more "naturalistic schemes" of representation antithetical to the doctrines of vision in motion. Because if one follows the biographical path of *The Bicyclist,* paved as it is in collage and montage practices, one encounters materials that are in the process of losing their fixed object status, that constitute bifurcating pieces ready to be pasted over and recycled.

The eyewitness also notices that the collages of the *ME* bear no signature. This absence of authorization illustrates how collogic dislodges the signature from the logic of identity. This is what separates representational painting and its logic of identity from the collogic of the transmuting cut found in abstract photograms (like *Portrait of Rudolf Blumner* or "*Photogram* [cameraless photo], showing Moholy lighting a cigarette, ca. 1922") and photocollages (like *Me* or *Mw*). For collage, each instance of "you" or "me" will not mistake itself as an identity but will acknowledge an exteriority of self and the possibility of *mis-takings*. In other words, in moving from the one to the other, the picture changes, the self-portrait is altered, and the text is rewritten. As Robert Rauschenberg put it, "If I had a painting, I'd want to be sure it would stay the way it is; this one is a collage and would change."[67] This is the end of assignment. With this change in (and out of) place, the *ME* collages expose the mistaking of identity, and their transformations put at risk the structure of identification, of "you" and "me."

■

*It*

*Works*

4

## The Telephone Paintings: Hanging Up Moholy

> I was not afraid of losing the "personal touch," so highly valued in previous painting. On the contrary, I even gave up signing my paintings. I put numbers and letters with the necessary data on the back of the canvas, as if they were cars, airplanes, or other industrial products. — "Abstract of an Artist"

A number of paradoxes tie up this scene of resignation. An identifiable subject speaks of his loss, of becoming anonymous. In an autobiographical narrative, he writes of his artistic techniques for losing himself, for losing his signature, the loss of assignment to a signature. In this manner, the text written as "Abstract of an Artist" registers the abstracting of an artist. In place of the identity of the author, one reads an impersonal product label — numbers and letters of a computer bar-coded system stamped onto the back of a canvas in order to provide the "necessary data" in the age of mechanical production and reproduction. But at the point of this abstracting gesture, one reads about an "I" who returns to assign each of the acts of resignation to himself. What of the "I" who refrains from the personal touch, who has given up signing "my paintings," who puts numbers and letters on the back of the canvas or on the front of the graph paper, who has treated himself and his productions like impersonal models — cars, airplanes, guns, or even telephones? Who, if and when anonymous?

13. Laszlo Moholy-Nagy, *Telephone Picture EM 3,* 1922, porcelain enamel on steel, 47.5 x 30.1 cm. (Courtesy of The Museum of Modern Art, New York, Gift of Philip Johnson in memory of Sibyl Moholy-Nagy)

One sees the difficulties which a standard biography (fore-grounding an unproblematic "I") might have in writing about someone who would give up his authorizing authority and employ strategies of unnaming, who would live "in a spirit of self-sacrifice,"[1] and who would become "an anonymous agent."[2] However, the present study welcomes this problematic position and writes at the peculiar crossroads and strange exchange where the personal signature exposes itself to an anonymous hand writing and where biography touches impersonally upon the graphic in order to present a graph paper and a life of writing. It thrives and survives out of this self-sacrificing spirit and this anonymous agency in marking the becoming-anonymous of the subject as the underside of each registration of the authorizing "I."

While it should not make any difference—in the difference of the anonymous—who says this, the particular "I" who gives up, and who is given up for dead, belongs to Laszlo Moholy-Nagy. By giving up and resigning the "I" that signs the painting, Moholy, or whoever, has crossed out the "I" who writes (i.e., the subject of the enunciation) so that the material shifts to the "I" who is written (i.e., the subject of the enunciated). These are the basic dynamics and mechanics of the unsigning "I." Its inscription converts all of the "necessary data" into an unhooked generation, of numbers and letters, anonymous, unlisted, or unnameable which hang up on Laszlo Moholy-Nagy.[3]

This is the impossibility of making the proper connections, of hooking up with the receiver at all or once and for all. With these qualifications, these disclaimers and dispensations of the anonymous hand that get the speaking subject off the hook, so to speak, one follows it through another passage, one that almost immediately follows the other quotation. This enters as another specific instance of the resigning of the signing of the work of art and is called the telephone picture (Figure 13).

■

In 1922 I ordered by telephone from a sign factory five paintings in porcelain enamel. I had the factory's color chart before me and I sketched my paintings on graph paper. At the other end of the telephone, the factory supervisor had the same kind of paper, divided into squares. He took down the dictated shapes in the correct position. (It was like playing chess by correspondence.) . . . Thus, these pictures did not have the virtue of the "individual touch," but my action was directed exactly against this overemphasis. I often hear the

criticism that because of this want of the individual touch, my pictures are "intellectual."[4]

This paragraph also employs the use of the first person pronoun to play out other paradoxes. It is a four-fold authorial "I" who orders from and dictates to a sign factory, sketches on graph paper, studies, plays, and hears criticism. But if this is the same "I" — another "I" — who gave up signing, who prefers anonymity, who wants the virtues of the "individual touch," then who is there to talk about, or in the case of the telephone pictures, who is there to talk to? Who is on the other end of the line if the "I" is put on the line?

Like Duchampian readymades, the gesture which orders up art via the mediation of modern telecommunications technology has become an infamous modern art experiment. In short or long distance, it places into operation the telephonic solicitation of the author and of the production of works of art in general. He (the authorial "I") still employs terms of mastery and authority, but he is caught unaware in the work carried on by the fine print of the telephone directory which detaches him from his signature in these unsigned works. The telephone pictures would be the connecting, and consequently, the disconnecting link between Laszlo Moholy-Nagy and his passing away into anonymity. From dictating to dispatching and transmitting signals, with the dispensing of the author, the Romantic conception of the artist has been put at risk. Smoothly, facilely, with the greatest of ease, the telephone has turned Moholy into an operator for feeds and feedback. The concepts of the creative genius and original artist have also been put into question.

These art exchanges, telephone exchanges, make the Bauhaus master quite common — a common house painter, a common name, a bedroom farce, a simpleton, or even a nobody. Published a few years after Moholy's art by telephone experiment, another version of this remote-control, lazy, bedroom scenario is provided in Arp and El Lissitzky's compendium of avant-garde art, *Die Kunstismen: The Isms of Art*. Under the heading of "Suprematism" — the same movement under which *Das Kunstblatt* had categorized Moholy the previous year — one reads the following Moholyesque prescription for artistic production: "Given the inflation of the square, the art markets have procured the means for everybody to carry on art. Now the production of works of art is sensibly so facilitated and simplified that nobody can do better

than order his works by telephone from his bed, from a common painter."[5]

There is an amusing photograph that Moholy snapped with the title *Painter's Works in Switzerland* (1925) that enacts the basic elements of this facile scenario. The image puts the telephone and the common painter into the proximity of the call. Playing on the double meaning of the craft, Moholy's revaluation elevates the "common painter" to the highest possible level. While the house painter finishes off his work in progress, one notes the telephone lines below him, or the grid which allows for the institution of the telephone picture as artistic experiment.[6]

This mode of production from a sign factory charted on graph paper has sketched a network that questions the structure of the sign. The telephone paintings set up static in the lines, on the graph paper, in the sign factory, in the final product, a buzzing for telecommunications and for communication in any form. With the gesture of the dialing or button pushing hand that generates art by telephone, it is the impersonality and anonymity of the language machine or of the telephone machine which has gone into a remote-control reproduction. Keeping these technological variables in mind, it is necessary to take issue with any analysis that places control squarely in Moholy's hands. In his authoritative review of the arts of the twentieth century, Peter Selz speaks of the telephone paintings in the rhetoric of a naive artistic mastery over technology: "In 1922, therefore, [Moholy] dictated a number of paintings to the foreman of a sign factory by telephone, making use of a standard color chart and graph paper as in *Telephone Picture EM 2*. A new cool art, based on a different kind of information or communication, was suggested, as well as the possibility that the artist could control technology by this strategy."[7] Yet, this masterful analysis represses the flip side of the signature effect, or how the strategies of the anonymous hand wrest control from the artistic producer by generating a reproductive practice governed by technological considerations in order to achieve this "different kind of information or communication."

A related text in the signature of Moholy-Nagy also suggests the difficulties for the delineation of the author who gets himself on the telephone line and in the way of the (tele)visual recording apparatus. For Moholy's *Dynamic of the Metropolis* (1921) records a scene where a telephoning face gets defaced, even blotted out, by a phosphorescent intervention that renders him without a silhouette, if not already anonymous: "The FACE of the man tele-

phoning (close up) — smeared with phosphorescent material to avoid producing a silhouette — turns VERY CLOSE to the camera."[8]

In the middle of Moholy's discussion of the procedures for his anonymous production of the telephone paintings, an analogy or anomaly stands out in parentheses, "(It was like playing chess by correspondence)." In another move that removes, Moholy likens the distancing of the telephone paintings to a chess game played through the mails and at a distance. Moholy's move — dispensing with art by telephone and dispensing with himself as artistic signator — might be compared to a game of chess for the most impersonal of reasons. Drawing further analogies, it corresponds to Saussure's pairing of the text and chess as comparable systems of differences. Crosschecked in this way, Moholy crosses a telephone painting with a chess game to get to the anonymity of language. Or, the move might be compared with Norbert Wiener's cybernetic chess games that make the automated machine into an active player. This would recircuit Moholy's art by telephone gesture as Wiener's "automatization of the next move."[9] As in chess, the game of wits, where it is impossible for any player (whether man, machine, or man-machine) to foresee the extent of the effects of any of his moves, Moholy's telephone play, playing the art game by correspondence, also takes this chance.[10] It is an anonymous venture that exposes the artist to uncertain risks and to a loss of authorial control.

But even as it plays back, the effaced "I" of the telephone pictures does not like the sound of a certain criticism raised against "him." From where did this personal affront come and to where is it going? "I often hear the criticism that because of this want of the individual touch, my pictures are 'intellectual.'" In spite of the lack, the autobiographical accountant claims the pictures as his own through the most possessive of all the pronouns ("my pictures"). But, in stating his own reasons, a personal touch is missing. In this passage, it is important to point out how the terms "intellectual" and "individual touch" (a few sentences earlier) are indicated with quotation marks. They are marked off from the communication which surrounds the telephone pictures and deformed in their presentation. These acts of quotation serve to remove the communication from their authorial origin and place them in an anonymous hand. Perhaps these terms, and the direction of the criticism itself, have been effaced (like the "I" that resigns from signing the paintings) through their quotation and through the anonymous gesture of the telephone paintings.

One wonders what the pedagogical value of this telephone art production could be or even where its teacher will be found. Lucia Moholy can only decide this question by going back to the source, but she thereby overlooks the consequences which the telephonic action has upon this source. She argues that since Moholy *himself* did not talk about the telephone paintings in the posthumous text *Vision in Motion* or deal with their educational implications in the "Abstract," they are not intended to teach anything. Lucia Moholy offers a symptomatic reading of what is missing and gaping in Moholy-Nagy: "These are significant symptoms; for Moholy-Nagy's wisdom and circumspection as a teacher being of a high order, any gaps left in the didactic system must be understood as intention."[11] It is agreed in the present text that the telephone pictures do not serve to instruct, but not for the same reasons, nor for the sake of reason. The pictures do not circumscribe a didactic system of the highest order or of any kind. If these paintings do instruct, it is through the gaps, the holes, the patterns of interference they leave between the author and the work, between both of these and their significance, or between the "I" who writes and the "I" who is written — through the insertion of an anonymous hand dialing or a coin placed in the slot of a machine. The symptomatic reading of the scene places a technological long-distancing device — a telephone or a sign system — between the author and the production of the art work. This anonymous handwriting works to distance intentionality from the teacher and from the records.

The *Marginalien* of Lucia Moholy also offers some strong opinions on the place of the telephone in the pictures. Lucia disputes their removed origins. She would remove all remote-control devices from the picture, or transfer them onto Moholy's person. This institutes an example of the familiarizing tactics of Lucia Moholy as she tries to appropriate matters into the family circle. According to this Moholy, that Moholy did not really order them on the phone. This is a telephone prank, minus the telephone. In constructing a purely hypothetical scenario, Moholy is a faker and a *tele-phonie*. Later on, Moholy transforms the story in this game of telephone talk which goes in one ear and out the other. For he actually did the job in person.[12] Even though her memorial overhears the grain or materiality of a voice as if in a primordial telephone conversation, Lucia turns the crank when she recalls, "I distinctly remember the timbre of his voice on this occasion — 'I might even have done it over the telephone.'"[13] Removing the

telephone from the stage scenery, Lucia Moholy invokes the format of a personal memoir in order to speak with an authoritative voice about Laszlo Moholy-Nagy as an authoritative voice. But, in this act of quotation, an indistinct overtone slips into this memorable occasion through the wavering of the "I might have done it over." In spite of the pure description, the telephonic logic spreads a series of rumors for which there is no easy answer — did he or did he not pick up the telephone? — but which Moholy-Nagy would acknowledge in any case in his recording of the telephonic event in the terms of the future conditional tense. In this case, the remounting of remembering has afforded another detaching possibility of the anonymous hand which blurs the borders of fact and fiction.[14]

Lucia Moholy's attempt to demystify the telephone pictures moves over to more elementary matters. The name, telephone paintings, is a misnomer. She insists that these works that border on the namelessness of anonymity are originally named the enamel paintings — *Email* for one, *Emaille* for plural, or simply *Em*, in Moholy's abbreviated style of naming, and numbered from one to five. She insists that the enamels are intended only to experiment with the effects of color in relation to the size of their reproduction, and that is the sole reason Moholy orders them in the first place. But with the logic of the dispatch in the production and reproduction of the paintings, something has been lost in the mails and later recalled, that is, the telephone paintings. Through a later call, the telephone pictures receive another calling. This is emblematic of the secondary role of a biographic writing practice which assumes a reality of its own and which estranges an artwork or its author from an original entitlement. Speaking against herself, Lucia Moholy senses how the margins creep into her notes through the telephonic reconsideration of the author. This traces the technological and rigorous play of the anonymous hand. "The role played by industrial technology, a secondary consideration for him to start with, gradually assumed in his mind a reality of its own, the metaphor [*Anrufung*] of the telephone becoming the emblem of the day."[15]

*Telephone becoming*, recalled as metaphor, rewires the signals from message unit to message unit. The "assumed" character of the graphics that later rewrite the history of art carries over to the point where, according to some critics, Moholy becomes the primary source for conceptual or telephone art, ideas which were not on his mind at all. Again, this regrafting operation of *telephone*

*becoming* surpasses intentions, hand executions, ideas, even what Moholy, in person, dubs the "mental process of the genesis of the work" (*geistigen Prozess des Werkenstehens*).[16] Lucia Moholy argues that Moholy could not have had anything to do with the thought of Concept Art and its thinking: "It is, however, erroneous to think of Moholy as the precursor of those movements."[17] But, at another point, certainly unintentionally, she acknowledges the unintended consequences of *telephone becoming,* of a production in reproduction, outside of the power of intentions of the author of the artwork. The anonymous hand pushes the present argument apart and makes way for the new movement and medium. "The present argument apart: the notion *Telephone Art* might, in the computer age [*Computer-Zeitalter*], take on a new meaning with connotations of a very different nature hardly foreseeable today."[18] With the processing of this new piece of computerized information in the databanks, technology has switched tracks again. In the slip of a disk or on the tape of a telephone answering machine, this talk doubles back for Moholy and produces doubletalk, i.e., statements which take on a new meaning with connotations of a very different nature hardly foreseeable today.

For *telephone becoming,* very different from nature, the redialings of the telephone game, takes and transforms. Present and future arguments aside, it can give new meanings to anything Moholy might have said about it—especially when he who executes the anonymous telephone pictures has given up his signature, that which attaches something to himself. But this inability for one to trace the call would not have been fostered in service of meaning. *Telephone becoming,* to cite a phrase, takes away from authorial intentions—puts meaning on hold—only through an anonymous handwriting, the "I" that is written and rewritten. It reproduces every autobiographical statement in an anonymous hand, unnaming it with an anonymous hand.

All of these telephonic switches raise a chorus. It is an affirmation that rises to ever new heights, higher and higher, again and again. It is the party line of the dispatching signature taken up by different voices and different timbres. Amid the din, a voice distinguishes itself. It has been recorded: "So they came to a new device of the literary expression—to a crisscrossing, zigzagging thought-pulsation of as many currents and messages as could be transmitted at the same time. We have an analogy in the synchronous multiplex telegraphy and in the coaxial cable system."[19]

With these technological reflections, Moholy returns yet again

to the metaphor of the telephone — to the super-syncretistic science of "synchronous multiplex telegraphy" — as the means to describe contemporary literary and artistic production in tune with a different type of cybernetic beat. These are the crisscrossing telegraphic writing practices which he sends through the wires and which send him through the wires. At this juncture and with this device, in the space of "literary expression" where the history of ideas gets tangled up in the materials and materiality of writing, this crisscrossing and zigzagging of thought, of its currents and messages that put the term of the intellectual in a marked form, in the intertwining of the lines, the patterns of interference, the static of this dispatch network, the systematic overloads of the coaxial cable system, this long drawn out death sentence, the telephone rings, sounds and resounds with the death knell of the author.

This scenario posits a world where an anonymous phone call, a telephone painting, or a biographical experiment in defamiliarization — and the risks which they pose to authority — would not automatically be called a practical joke nor considered obscene.

It resembles the H-U-M of a dial tone, of an anonymous phone call, Hanging Up Moholy.

### The Shooting Practice

The shooting practice is designed to give Moholy his best shots. He may choose from a wide variety of weapons — a firearm, a favorite Leica camera, an airbrush, a spraygun, a toy pistol, or he can even borrow a rifle from one of his photomontages. He may use as much ammunition as he wants and take as many shots as he wants. Whether objectively valid or not, this is how Moholy formulates his desires for an art designed to shoot (beyond) the self. He aims for anonymity by removing the identity of the author of the art work. "My desire was to go beyond vanity into the realm of objective validity, serving the public as an anonymous agent. An airbrush and spraygun, for example, can produce a smooth and impersonal surface treatment, which is beyond the skill of the hand. I was not afraid of losing the 'personal touch,' so highly valued in previous painting."[20]

Like the telephone paintings, the shooting practice begins with these autobiographical statements of resignation from "Abstract of the Artist." In a similar fashion, they work through the double space of an identifiable subject losing himself to the anonymity

of the signature. This means that when Moholy shoots, he is in effect aiming to shoot the self, and consequently, to put himself out of the picture. The shooting practice is designed to bring death to the author and impersonality or anonymity in its wake. Moholy becomes the anonymous hand aiming to hit the mark. Whether using camera or gun, the shooting practice records an ongoing attempt aimed at becoming anonymous or detaching from authorship.

In the next sentence of this quotation, Moholy — or perhaps through this statement he will have acquired the name reserved for a masked outlaw or a secret agent (i.e., Mr. X) — makes the anonymous move. The signature effect goes into reverse with this abstaining gesture: "On the contrary I even gave up signing my paintings." He removes his signature, the link between the painting and its author, the identity of the author. As anonymous hand, he, who was the author just a moment ago, has now lost touch with his signified, his personal touch, his hand, or even his "his."

Moholy attempts to enter the neutral space of a writing where the "personal touch" has been replaced by the *impersonal he*. For the anonymous hand is writing — that which remains after its author has passed away, that which passes away before the author. The anonymous hand (writing) turns the subject over to the impersonal space of the inscription of the signature and poses the death of identity. But there must be a vigilance against a certain danger when it comes to the shooting practice and its problematic meaning. It is a guard comparable to one kept at the tomb of an unknown soldier. How can one avoid the conversion of the shots into concepts or properties? How can one continue to mark the shooting of identity? This problematic opens the space for these remarks on Moholy who, as "anonymous agent," speaks and speaks removed, in the space where " 'he' is rather a kind of void in the work — the absence-word 'a hole-word, hollowed out in its center by a hole, by the hole in which all the other words should have been buried.' "21

It is the return of the "hole-word" that haunts the signature of Moholy in both German and English. This is what he shoots for — to excise that (missing) part of himself so that he can write and paint anonymously or even absent-mindedly. To pick up or to expand this point by quoting the "Abstract": "This is the place where I may state paradoxically that, in contemporary art, often the most valuable part is not that which presents something new,

but that which is missing."[22] With such a statement, Moholy shifts the terms of avant-garde artistic value from the modernist rush of the forever new (a la Baudelaire) to the problematic presentation of what is missing—from something new to something removed.[23] This shift also has its authorial repercussions. Looking at these matters with the assistance of contemporary art, the name of Moholy might acquire value only when each usage of identity is reinscribed within the veil of anonymity, "that which is missing," or that which absents the name from itself.

With this theoretical framework on the becoming anonymous of the shooting subject and of the anonymous hand in place, a biographical incident stages how Moholy puts himself in the middle of the crossfire and risks his subjectivity. In the role of filmmaker, our anonymous agent wants to be in the middle of the shooting. When Moholy arrives to shoot the documentary film *Gypsies* (1932), the stars shoot back. The encounter between the film director and his shooting star is documented by Sibyl Mohol-Nagy in the following dramatic manner:

> As Moholy focused his camera at him a sharp whistle stopped him. On the top of one of the adjoining brick houses stood a Gypsy, pointing a gun.
> "Leave or be dead," he said in the impressive Gypsy lingo.
> . . . This was the chance for a panorama shot of the Gypsy community he had been waiting for. Forgetting the man on the roof, he started to move his camera slowly from window to window. There was a whizzing sound. A bullet streaked only a hand's width from his shoulder and struck the sand. . . . Moholy went on with his pictures. The man on the roof seemed dismayed. He filled the air with such a detonation of profanity that Moholy took the camera from his eyes and looked up, smiling admiringly. . . . Swiftly Moholy took up his camera again but the man on the roof was just as fast. He shot again, this time striking a wooden bucket which splintered noisily. A minute later there was a click in the camera, indicating that all the film in the magazine had been exposed. Unhurriedly, Moholy put his camera in its leather case and walked across the yard to the footpath where I waited with the car. I noticed how white he looked as we drove away. A few minutes later I had to stop because he became sick.
> "Why didn't you leave when you saw the man on the roof meant business?" I asked, feeling annoyed at his bravura and

irritated by my own agonizing fear. "Do you really think those film shots are more important than your life?"[24]

This drawn out story stages the scene of a shootout between Moholy's camera and the gypsy's gun, but one linguistic utterance stands out. It is the death sentence, or the threat of death decreed by the gypsy: " 'Leave or be dead,' he said in the impressive Gypsy lingo." Unmoved, Moholy remains to shoot and be shot at, even when a bullet strays only a hand's width away. Now this anecdote is not to be interpreted in the light of the Romantic hero who braves death in the pursuit of his art. After all, a disgusted Sibyl recalls how Moholy, for all his "bravura," turned as white as a ghost and became very sick immediately after the incident. This kind of fable never ends with the hero vomiting over the back seat of the car. The moral of the story lies in the rhetorical question left hanging: "Do you really think those film shots are more important than your life?" Moholy's shots gyp life because photographic inscription is linked to a violence that deals in death, or as close to it as an anonymous hand's width away. It is a shooting practice that puts the subject of life into question. The film shots are not more important than life so much as they point to a photographic dimension and "detonation" that simulates something other than life. All in all, the firing of these shots opens the space for anonymity, for what's his name.

But this is not the only anecdote in the archives that brings Moholy into close range of the shooting practice. For the first unfavorable impression that Moholy was to make upon his Bauhaus colleagues in Weimar relates to a paranoid story told in a broken and comical German about being in the line of fire of a shooting practice. Occurring one decade earlier than the gypsy's shots, the Weimarian sniper's incident offers a possible autobiographical rationale for the obsessive photoplastics which would follow. Lothar Schreyer returns to the scene of the crime:

> Unglücklicherweise hatte Moholy-Nagy Schwierigkeiten mit der deutschen Sprache. Das war so: In einer Abenddämmerung kam Moholy-Nagy atemlos, völlig aufgelöst ins Bauhaus und stiess einen Satz hervor, den wir mit Mühe enträtselten.
> "Ähr wollte mit dem Rävolvär berücksichtigen!"
> Er stellte sich heraus: Moholy-Nagy war auf dem kurzen Weg durch den Park zum Bauhaus gekommen und hatte sich

ernsthaft eingebildet, ein Mann mit einem Revolver habe ihm verfolgt und hätte ihn von hinten erschiessen wollen, in den Rücken "berücksichtigen." Wir lachten ingesamt. Diese Episode sprach sich leider sofort im ganzen Bauhaus herum. [Unfortunately, Moholy-Nagy had difficulties with the German language. It was thus: At dusk, Moholy came running breathlessly and completely distracted into the Bauhaus and he delivered a sentence that we were at great pains to decipher.

"He wanted to take me into consideration with a revolver."

It turned out to be this: Moholy-Nagy came to the Bauhaus via the shortcut through the park and he quite seriously imagined to himself that a man with a revolver had followed him and had wanted to shoot him from behind, in the back ("*in den Rücken*"), and thus, "*berücksichtigen*," to take him into consideration. We laughed in unison. Unfortunately, this incident immediately made the rounds around the Bauhaus.][25]

Moholy's comical misfiring in the German linguistic register transforms the cold-blooded "hitman" slang of being sighted in the crosshairs of the revolver and shot in the back into a formal expression for being taken into consideration (*berücksichtigen*). The unfortunate result of this incident was not only to make Moholy the butt of the joke; ironically, it also reveals how his Bauhaus colleagues did not care to take this peculiar fellow into consideration. The story underlines Schreyer's view of what a tough time Moholy — perceived as a foreign body — had at the beginning of his Bauhaus tenure. While Moholy avoided the (imaginary?) sniper's bullet in the Weimarian park, the shot did have personal repercussions.

At the other extreme, there is the tale told of Moholy as a bold, young, vanguard artist in Berlin hosting the famous art collector Julien Levy in the early 1920's. During their meeting, Moholy preferred to show Levy the bullet holes on the walls of the modern-design housing units rather than some of his own work to cover the walls of an art gallery. Levy recalls this Berlin wall and street art exhibition in his *Memoirs:* "Moholy wanted to show me the walls near his apartment in the district of the new, modern-design worker's housing units. They were marked with bullet holes. Some weeks before, a demonstration against workers liv-

ing there had turned into a riot, suppressed with bloodshed."[26] On the surface, this appears to be a most peculiar way for an artist to entertain or to impress a gallery agent. But at a time when the "politicization of the aesthetic" was already making its rounds, could Moholy have left a clue for Levy on the new constitution of the art gallery? For the units marked with bullet holes would demonstrate the operation of the photomontage effects of the shooting practice. They provide a more concrete instance of the riotousness of reinscription which opens identity to the remarkings of the anonymous hand. This capacity for cutting and hole making would serve as the point of departure for the shooting practice.[27]

Switching roles from tour guide to photo monteur, Moholy produces a photoplastic a few years later which brings the bullets back into the art gallery. It is called *Innovations in Museums: The picture goes to the best shot* (*Neue Einrichtungen in Museen: Jeder kann sich sein Bild schiessen*) or alternatively, *The Shooting Gallery* (1927).[28] This work conjures a metaphorical displacement in its words and images from the rifle range to the art museum. In this turn, the art gallery has been transformed into a shooting gallery as shadowy marksmen dressed like secret agents take target practice at the works on the walls and on the floor down the line. In the figurations of this animal fable, the montage depicts fantastic beasts that bring associations of the hunter and the game. For the purposes of the shooting practice, many aspects register the scene as an exhibit for the becoming anonymous of the subject and the author of the artwork. *Innovations in Museums* transposes the evaluation of the artwork from the content of the picture or the intention of the author to its viewer who takes the offensive. The writerly spectator wields the gun and has the power to shoot. Therefore, the piece can be read as an allegory of the demand and critical risks of reading in the constitution of artistic meaning. In *The Shooting Gallery*, the reader shoots, rends, and renders anonymous the work and the author. In this way, Moholy's photomontage, *The Shooting Gallery*, stages his own removal as author. It offers one possible interpretation as to why Moholy no longer sees the need to sign his paintings.

But there is another twist in this tale of the hunter and the dynamics of capture. This particular photomontage remounts El Lissitzky's constructive ideas about the multi-dimensional *Proun* room and the state-of-the-art exhibition space of the 1920's. Like

El Lissitzky, Moholy's partitioned space compartmentalizes the target practice of *The Shooting Gallery*. In a sense, Moholy's adaptation puts into practice the productive-reproductive capacities of the photoplastic — i.e., the very traitorous traits for which El Lissitzky had cited Moholy as a plagiarizer. But, in a way, Moholy is only following what El Lissitzky had suggested in his own writings. He assumes the active role and plays the marksman in El Lissitzky's design by setting up his own picture zoo that takes on the thousand roaring art beasts. In this substitution, the active man of the following remarks by El Lissitzky becomes the anonymous hand of Moholy's shooting practice: "The great international picture-review resembles a zoo, where the visitors are roared at by a thousand different beasts at the same time. In my room the objects should not all suddenly attack the viewer. In previous occasions in his march-past in front of the picture-walls, he was lulled by the painting into a certain *passivity*, now our design should make the man *active*."[29]

This is not the only instance of the gun in Moholy's photomontages of the 1920's. There is a whole series of such shots that revolve around each other and the question of identity. They follow in chronological order: *Love Your Neighbor* (*Murder on the Railway Line*) (1925) (Figure 14), *Jealousy* (1925), *Jealousy* (variant, 1927), and *In the Name of the Law* (1927) (originally titled in English). To continue our line of argument and fire, *Jealousy* stages the attempted murder (or suicide) of autobiographical authority. A markswoman shoots from the empty shell of a Moholy cutout towards the negative image of a Moholy who is shot in the back with the bullet which then hits a bathing-suited beauty caught in the line of fire. Moholy has taken the cutouts of *Der Trottel* — already an autobiographical self-portrait that questions the subject — and given these blanks a new life in order to be the death of him. There is an additional irony in the fact that the cutup photograph of Moholy was initially shot by his first wife, Lucia Moholy. Moholy remotivates the picture and this gesture brings a backhanded titling to the photoplastic. In a world of originals and copies, this act of borrowing might instigate some feelings of jealousy, even aside from the emotional entanglements that are depicted in this photomontage.

This photomontage and its variant have been interpreted as Laszlo Moholy-Nagy's attempts to work out his psychoanalytic problems on paper, or as image-condensations for his ailing relationship with Lucia Moholy. In a double-faced figuration, the

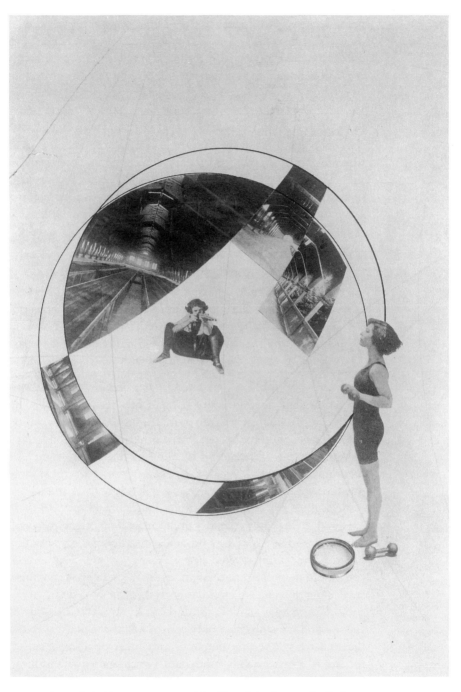

14. Laszlo Moholy-Nagy, *Love Your Neighbor* (*Murder on the Railway Line*), 1925, gelatin silver, 37.8 x 27.2 cm. (Collection of the J. Paul Getty Museum, Malibu, California)

markswoman can be read as a Cupid figure who shoots the victim of new love or as the jealous wife who shoots the new couple. In a sense, the montages enact the problems that arise from following the Christian dictum "Love thy neighbor" too closely or too close to the letter. As psychobiography, the works are said to mirror Laszlo's problematic relations with Lucia Moholy during their Bauhaus Dessau years together. The double and triple images and shadow plays of the males and females in the montages represent the transferences and counter-transferences of the interrelationships and ruses of their desires. The hurling of the projectiles is linked to the projections of these personae in pain. In *Marginalien*, Lucia refers to the inherent possibility of a cynical reading of the three stages of the *Jealousy* montage:

> Franz Roh published the three stages without date in 1930. Roh had previously spoken of the *"demonic-fantastic effect"* inherent in photomontage. If the 1927 dated version of *Jealousy*, in which the woman-chief carries along a powerful man-eating shadow with her were to have come to his attention, he would hardly have resisted the temptation to pass some profound observation tinged with cynical humour.[30]

Here, one stands in the middle of an emotional crossfire of personal fears and overladen desires, and of a reading that would valorize a psychohistory as the source of inspiration and creation behind these photomontages. While both Roh and Moholy had spoken of the fantastic effect of photomontage as a source for humor in their advocacy of the "New Vision," Lucia Moholy does not appear to be taking things too lightly in these comments.

Nevertheless, the anonymous hand does not want to let these personal feelings get in the way of the analysis. Nothing personal, but while *Jealousy* may be read in a selfish manner, the shooting practice can be interpreted just as easily as part of an overall programming in the service of anonymity. These photomontages stage a death scene which is designed to silence the desire of the subject, or to take a shot in the dark, to show that the identity of the self and his desires are only constituted through the work of that generous donor, the unnamed and impersonal sniper called, for lack of a better name, anonymity. For to again quote Moholy, with excisions, "My desire was ... as an anonymous agent."

To demonstrate that *Jealousy* does not belong to a specific biographical subject, neither to Moholy nor to Lucia, the tables (of *The Pool,* another variant name for this montage) are turned a

few years later in the divide of a different continent. This involves a transmutation of the technological media from photomontage to something between film and poetry in motion. As part of a workshop class at the Institute of Design in Chicago, Moholy's students reinscribe the *Jealousy* montage in a new piece with the rather ironic title *Do Not Disturb* (1945). For no matter what the medium, the shooting practice disturbs and redistributes. The disturbances point to the work of alteration and unnaming in the signature which belongs to no one. In the first scene of *Do Not Disturb,* the students-actors theatricalize the photomontage. They reshoot the picture and assume the title roles. This is followed by a filmic narrative that enacts the thematics of the *Jealousy* photomontage in the lives of the student body. The final sequence of the film-poem cuts into the structure of the sign with a pair of scissors wielded by the anonymous hand cutting into the identity of the filmic subject. The script reads:

> *Do Not Disturb* hanging on tree blown by wind.
> Sign flies through the air—
> Sign on asphalt moving, flying, resting, flying.
> Autos run over it.
>
> . . . .
>
> Scissors cut the film.[31]

Thus runs the hanging of the sign—flying, resting, flying. Thus moves the sign *Jealousy.* The autos literally run over autobiographical meaning in a disturbing return to the drift of the anonymous sign which opens upon the asphalt of concrete identity.

Last but not least, *In the Name of the Law* is the name of the most curious of the shooting gallery of photomontages (Figure 15). First, there is the question of its proper name. While this singular title is in English, it is the third of a series of photoplastics which Moholy entitled *Der Eigenbrötler.* This is a term for an odd or eccentric person who prefers to remain isolated and tend to his own interests in seclusion. This matches some of the characteristics of one who prefers to remain anonymous, or the so-called recluse. Irene-Charlotte Lusk interprets this photomontage as a Marxist class struggle in the making with the rebel woman of the lower class taking a shot at the middle-class male subject while the military-class representative overlooks the scene. She sees the photomontage as a political statement criticizing the exertion of power over submissive subjects.[32] But the case for anonymity reads something more generalized—something that insti-

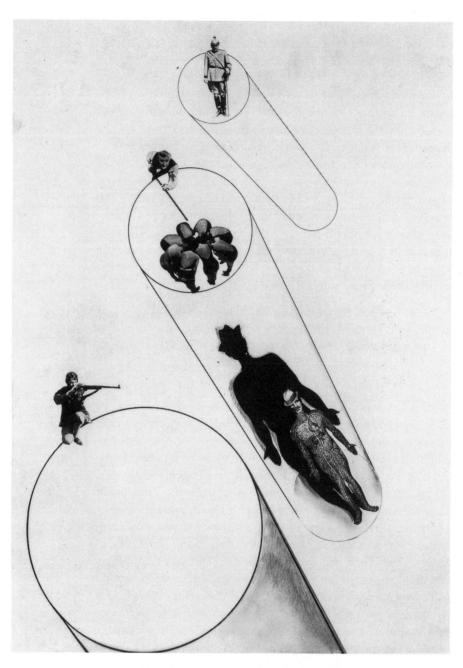

15. Laszlo Moholy-Nagy, *In the Name of the Law/Psychology of the Masses,* 1927, gelatin silver, 20.6 x 15.6 cm. (Collection of the J. Paul Getty Museum, Malibu, California)

tutes the general and every classification. This returns to the sheer violence of naming, in the name of the law and in the law of the name. Whether the weapon employed is a gun, a pen, or a camera, the act of naming and enframing institutes an irreducible violence upon the world. As a primal shooting scene, *In the Name of the Law* enacts the violence unleashed in the founding and naming of the biographical subject in the symbolic order. It punctures, makes a hole, and leaves a mark. It is the hole that pricks Moholy, that both inscribes and punctures his status as an identity.

For the camera is a gun and its writing (shooting) is violence. The juxtaposition of the camera and the gun in this programmatic way is not a mere analogy nor just a metaphor. An investigation of the history of photographic equipment in the second half of the last century reveals a wide variety of cameras designed to hunt and shoot. The camera takes the form of the weapon in design and in function. Whether one sets one's sights on Enjabert's Photographic Revolver (1882), E. J. Marey's Photographic Firearm (1882), or Lechner's Gunman Camera (1891), one finds that these photographic technologies are modelled upon the arsenal of contemporary military weaponry.[33]

In his famous dictum, Moholy prophesies that the camera as weapon will carry equal weight compared to other educational implements in the future. This points out how the pedagogical imperative of the "New Vision" will be photogrammatical in nature. "The illiterate of the future will be the person ignorant of the camera as well as the pen."[34] The future demands a new type of visual literacy in the form of the fanatical snapshooter versed in the violence of inscription in the graphic arts. This would bring a reverse angle to the theme of ignorance and the anonymity of Moholy (alias *The Fool*) snapping away at himself and others. "The fanaticism typical of today's ubiquitous snapping away seems to indicate those ignorant of photography will be the illiterate of tomorrow [*dass der fotografieunkundige der analfabet der zukunft sein wird*]."[35]

The invocation of Moholy's photographic catchphrase brings the discussion into the intertextual folds of Weimarian cultural criticism and surrealist artistic practice. In his essay "A Short History of Photography," Walter Benjamin deploys Moholy's dictum in the form of a paraphrase that leads to a becoming anonymous. Moholy's maxim has taken on a life of its own and this linguistic effect sets a minimum value on the subjective signature and a maximum value on an impersonal graphics ("as one has

said"). Benjamin reworks the adage with the insertion of a double negative: "As one has said, not he who is without knowledge of writing but rather of photography will be the illiterate of the future."[36]

Even as Benjamin deploys Moholy's photographic dictum (though without any personal acknowledgement), one might speculate that the shooting practice owes some of its theorizing to the writings of Walter Benjamin in "The Work of Art in the Age of Mechanical Reproduction." In his classic technological treatment, Benjamin insists upon the figures of the shooting practice when describing the shock tactics of dadaist photographic practice. The mechanics of dadaist photomontage followed the terminology of "ballistics" technology. It mattered and it hurt. It worked as "an instrument of ballistics. It hit the spectator like a bullet, it happened to him, thus acquiring a tactile quality. . . . The spectator's process of association in view of these images is indeed interrupted by their constant, sudden change. This constitutes the shock effect."[37]

In *Vision in Motion,* Moholy's theory of dadaist photomontage also focuses on the shock technique which exposes the violence of photographic inscription and generates a type of visual poetry which produces a poetic revolution and reevaluation of the visual arts. In contrast to Benjamin's, Moholy's shock analysis exchanges gun for knife in the strategic arsenal of his graphic description. "They glued photographs together in order to shock the public or to demonstrate their ideas in creating a visual poetry. The Dadaists, having a contempt for any kind of illusion, exhibited brutally the torn and divided photographs, the rough cut of the scissors."[38] In this alternative use of the anonymous hand, the anonymous sniper has become the anonymous snipper. Moholy reviews the manipulations of dadaist photomontage as follows: "These pictures were far from pretending to be real, they showed brutally the process, the dissection of single photos, the crude cut made by scissors."[39] The photomontages openly display how the concept of identity is stitched or pieced together — the cuts, lines, shots, holes, and seams are showing. The subject matter is torn to pieces becoming a fragment of its former self.

Moholy's "Surrealism and the Photographer" details the photographic conditions of Surrealism in a similar manner.[40] Moholy links the automatic writers of Surrealism with the men with automatic cameras. Following this trajectory, it is fascinating to recall that *both* Man Ray and Moholy acted as photo-mediums in

the programming of photograms (without a camera) which de-materialize a hand-held revolver in the early 1920's. The light-written revolver of photogrammatology stands in the place of the missing camera-gun. The shooting practice of the surrealist photographer exposes the transparency of the real as a signifying practice of the reel and recreates the field of vision by redirecting or "re-trajecting" (misspelling) the bonds between words. The model for photography's shooting practice lies in automatic writing as a form of the fertile play recoining signatures. "The expressive character of the automatic writings, as employed by surrealistic authors — with the new and fertile bonds between worn out, tired words, through misspelling and the recoining of idiomatic expressions — gives a good analogy to the new use of the photographic means."[41]

These writers deploy words as automatic weapons. After all, André Breton points out the aesthetic qualities of the man with the gun who fires into the crowd. *Vision in Motion* quotes Breton's "The White-Haired Revolver" (1932) as well as Dadaist Huelsenbeck's definition of literature, "I wanted to make literature with a revolver in my pocket."[42] Surrealist film adds further fuel to the firepower. For instance, Hans Richter's film *Ghosts Before Breakfast* (1927) features a moving target practice sequence. There is also the firing of the shotgun in Francis Picabia's *Entre'acte* (1924)[43] — between the acts (cf., inter-media) and the sights — as the spectator looks right into its barrel.[44] Even the American hero of technological slapstick, Buster Keaton, got himself into the act with the film *The Cameraman* (1928) in which he plays a "would-be newsreel photographer."[45] In the climactic scene of the movie, racing reporter Buster uses his camera-gun to document the shoot-out in Chinatown and get the exclusive story.

These are well-known vanguard parallels on the becoming anonymous of the subject through the associations generated by the word *shoot*. It cross-checks Moholy's shooting practice with the art-technological problematics of an extensive discursive network. Moholy's analysis and the above citations demonstrate how the shooting practice entered into the productions of Dadaists, Surrealists, and Constructivists alike as part of a strategic shift that made language a central problem for the visual arts. The gun or camera fired by an anonymous hand (i.e., the shooting practice) became an exemplary site to foreground the act of un-naming the real, or of pointing to the real as an effect of naming. In his writings on the ready-made, Marcel Duchamp invoked this

strategy with the photographic twist of the *snapshot effect*. This is the process implicit in the shooting practice wherein the real is reinscribed as an effect of a signifying practice. The ready-made provides the perfect example of this phenomenon in that it re-motivates the banal and everyday object as a work of art through the very act of naming. Duchamp found this same procedure in the exposure of the photograph and the photogram. These are indexical signs which put the real in quotation marks. Like the anonymous hand, the indexical act of the snapshot effect has the capacity to turn reality into a simulacrum of itself. The snapshot (or signature) effect enables the various practices of the anonymous hand — photogrammatology, photomontage, and art by telephone. These shooting practices invoke another formulation of the sign that takes aim at any unproblematic bond between names and things or between language and reality. The shooting practices mark their subjects by exposing them to the risk that they are mere sleights of an anonymous hand or its signatures.

But the egalitarian thrust of Moholy's *Vision in Motion* does not stop with a person of the caliber of Breton or Huelsenbeck. The bullet ricochets to a group poetry session which is structured like a surrealist *exquisite corpse* event. Not only does this collective poem breed anonymity, it also marks the creation process as well. The poem begins with a bang: "an antiaircraft gunman makes Z Z Z O O O M  B A N G we S H O T the mark again."[46] In the light of the shooting practice, this shooting of the mark would trigger babble and noise at the limits of linguistic meaning.

The bullets of *Vision in Motion* then strike the writings of an anonymous child prodigy whose poetry Moholy quotes extensively in the chapter on "Literature." In 1945 this child, too, is involved in the funny game that has been called, rather technically, the shooting practice. Imagining a life during wartime, the reader witnesses the fun of the gunplay through the intense desiring of a nameless child who shoots for anonymity in terms of his nuclear family while playing at high modernist poet.

What I Want for Christmas

I like a rifle because I can play guns because I like to play guns it is fun to play guns you hide in bush I like to play guns you hide I will find you it will be fun to play guns. Guns is fun to play guns is a funny game you have to hide when you play guns.[47]

One wonders if Moholy shares the fantasies of this trigger-happy third-grader. They certainly resonate with his own gun-slinging tendencies.⁴⁸ But the anonymous hand shoots down the authority of biographical intentions in this war-torn economy. The shooting practice switches attention from the subject of the enunciation (the "I" who likes "to play guns") to the subject of the enunciated (the becoming anonymous of the subject of the violent gunplay). Like the little boy says and teaches, the subject hides when he plays guns. He hides himself in the play of the anonymous signature, leaving only a hand exposed, cocked, and ready to shoot or write. For he is about to confront death, or at least, to photograph it. The photographic rifleman stands ready to acknowledge the becoming anonymous of the subject as a signature effect through the shooting practice.

### The Detached Hand

Who waits for you at the end?

No one.

Your name has folded over on itself like the hand on the white arm. — Edmund Jabes, *Return to the Book*

Moholy's programming and sequencing in *Painting, Photography, Film* announce the shift from personalized handwork to impersonalized technology, or from the hand-held use of pigment to the anonymous handwritings of photography, film, and light display. The acknowledgement of the shift from the manual to the mechanical arts becomes a constant refrain in the Moholy text. Moholy recalls, "In the age of new technological and design possibilities, it appeared senseless to me to work with antiquated means which were insufficient for the new tasks."⁴⁹ As already outlined, the hand reaches for the camera-gun in the shooting practice and it becomes a prosthetic touch-tone instrument for dialing in the case of the telephone pictures. As in Moholy's mechanized rhetoric for these technological times, the construction of the mass-market economy depends upon technical instruments and anonymous resources. "With the aid of machine production, with the aid of exact mechanical and technical instruments and processes [*mechanisch-technischer Instrumenten und Verfahren*]

(spray-guns, enamelled metal, stencilling) we can today free our-
selves from the domination of the individual hand-made piece
[*manuell hergestellten Einzelstücks*] and its market value."[50]

But in spite of the critique of the handmade article and manual
painterly techniques, one finds the repeated photographic depic-
tion of the hand in *Painting, Photography, Film* and in many of
his pieces of this period. These appearances and apparitions indi-
cate that the hand has not been banished nor censored in Mo-
holy's iconography. It is only a matter of its functioning. Indeed,
the hand can serve as an emblem for anonymity as long as it
assumes a detached status and a cutoff format.[51] This transmuta-
tion replaces the intimate expression and integrity of the painterly
hand with an anonymous body part as dematerialized abstrac-
tion, as shadow player, as montage fragment, as prosthetic de-
vice, or as attachable/reattachable appendage.

In the second paragraph of the introduction to *Painting, Pho-
tography, Film,* Moholy writes specifically about the new capaci-
ties of photography which supercede the manual modalities and
question their means of design in the arresting terms of the snap-
shot effect and the fragment: "No manual means of design (pen-
cil, brush, etc.) is capable of arresting fragments [*Ausschnitte*] of
the world seen like this; it is equally impossible for manual means
of design [*Gestaltungsmittel*] to fix the quintessence of a move-
ment."[52] To return to the hand lent by the theory of language that
guides these biographical writings, the detached hand would play
the part of the fragmenting signifier caught in the act of cutting off
from the referent. In other words, the detached hand would seek
the vertiginous point at which its signified drops out and ano-
nymity reigns, its name a blur.

The dropping off or out of the detached hand opens the space
for a biographical writing practice that exposes itself to the risk of
detaching from the subject at hand. Having gotten so far in name-
dropping Laszlo Moholy-Nagy, it seems as if the detached hand
risks dropping him as well. The detached hand recalls the point of
disengagement of the author from the work of art. Like the shoot-
ing practice, it is designed to bring the death of the author so that
he, too, will drop out of hand and out of sight. In accepting this
anonymous hand (out), Moholy risks being removed. Through
this turning of the tables, the author will be exposed as an ef-
fect of the inscription of an anonymous hand. It is time to let
these hands speak for themselves, to let them speak in a sign lan-

guage through the gestures, movements, and motions of the puppet show of language.

The abstract film *Light Display: Black, White, and Gray* can serve as an opening instance of the staging of the signature effect in the shadow of the anonymous hand. At the start of the performance of the *Light Space Modulator* in this film, Moholy has been projected in the form of the reflected shadows of anonymous hands which are in the act of cutting and splicing the film. At the borderline of projection and identification, the film presents the authorial signature in terms of an emulsional investment into the shadow play and display of detached hands and filmic fragments.[53]

As already remarked, the removal of the artist's hand does not mean the loss of the hand from Moholy's editorial choice of photographic cuts. If one reviews the visual evidence of *Painting, Photography, Film*, the detached hand plays a doubly illustrative role in the photographic means of presentation. The first shot delivers an X-ray vision of the anonymous hand. It is a Röntgen photograph from a medical textbook with six skeletal hand fragments cut to the bone pointing towards an empty pictorial center. The second shot, entitled *Tischrücken* (*Table Turning*), is a still frame of a haunting film scene from Fritz Lang's *Dr. Mabuse* (1922) with occult overtones. In this evocative invocation (a raising of the dead, perhaps), twenty-two cut-off hands are depicted in close-up around the seance table during a mysterious rite. Moholy's underlying description points out how the art-historical problem of the detached hand is involved in the move from a painterly mode of expression to the fracturing and fragmentation of the photo image in the psychoanalytic seance: "The psychological problem of the hands. The goal of many painters since Leonardo is captured in a fraction [*Bruchteil*] of a second."[54]

Dropping off the body, the detached hand invokes a vision of an "acritical" apprehension of artistic production. In the unpublished and unsorted papers of Moholy, fragments to himself, one finds the following freak occurrence linked to the detached hand (hand) written on a page with the warning assertion "never criticism." The anthropologist of art takes these field notes: "to KEEP the creative existence of the child . . . in new guinea the boy born with navel cord around the neck becomes artist. (The boy, whose right hand was cut down . . ."[55] In this clipped inscription, Moholy leaves out the second (right) parenthesis in an unconscious

simulation of the loss of the boy's right hand. In their attempts at overcompensation, these monstrous instances of an exotic artistic production remove the direct link between the artistic appendage and the work of art. The outcome of this loss comes out as an anonymous handout.

This does not mean that Moholy is calling for the severing of an ear or a hand for a more complete artwork. Rather, the removal of this boy's hand touched Moholy and his own problematics. It evoked resonance with the research program of the anonymous hand in the move away from the manual and personal touch and the loss of control over the hand as well as in the McLuhanesque move towards technological extensions as prosthetic substitutes. Even after the youthful influence of Vincent Van Gogh and that infamous artistic gesture involving the severing of a body part, the image of the detached hand haunts Moholy's vision of artistic production. Acting independently, it withdraws from the analysis of the author and his identity. Like signatures gone mad, deranged from intention, the anonymous hand draws out of the control of the speaking and writing subject. Writing from the body, these signatures have become a matter of marked lines. In the "Abstract," Moholy recalls his first feeble attempts to master representational art in a rather clumsy scenario that involves a slip of the hand: "I tried to analyze bodies, faces, landscapes with my 'lines' but the results slipped out of my hand."[56]

Indeed, the rhetoric of the hand's detachment is also embedded in the conceptual strategy whereby Moholy de-privileges hand execution as an essential component of the genesis of the artwork. It is with such logic regarding the hand and its execution that one is led to designs such as the telephone paintings. "People believe that they should demand hand execution as an inseparable part of the genesis of a work of art. In fact, in comparison with the creative **mental** process of the genesis of the work, the question of its execution is important only in as far as it must be *mastered.*"[57]

Both the mastery in execution and the practice of detachment require a strict self-discipline. It may seem like an impossible mental exercise for one to continue to employ his hand and the use of the first person pronoun (i.e., "my") but in an impersonal or an anonymous way that refuses to bind the name to the thing. To mark the difficulties, Moholy's (self) description combines the self-abnegations of the ascetic adept and the lurking undertones of the smooth operator. Putting himself in this problematic space,

the subject speaks of renunciation and restraint as he describes the impersonal discipline instituted by an anonymous handling: "This was emphasized by my smooth, impersonal handling of pigment, renouncing all texture variations. This involved ascetic restraint."[58]

Moholy's emphatic desire for ascetic restraint traces every upraised hand as a call to halt. In his photographs, the detached hand acts as a stop sign to stop the normal functioning of the sign and put into question any theory of signification which would overlook the materiality of language that breeds anonymity or the graphic inscription that poses the dispossession of signifier from signified. In the undated *Self-Portrait* that signs on the work in progress, it is a hand in the face that blocks and prevents the passage to the autobiographical subject and/or author of the photograph. On the surface, this blocking hand subverts the representational frame and poses the question of anonymity. It prevents the simple move from signature to signified, from work to author, from picture to thing, from writing to representation, or from gesture to meaning.

Even in the rare cases when the hands are not detached from the rest of the anatomical structure, they stop the process of identification. The photoplastics *The Law of the Series* are a series of publicity posters to promote the Schocken Department Store in Nürnberg (Figure 16). Lighter or darker, smaller or larger, deformed or transformed (cf., *The Transformation*), the repeated figures put up hands to glass, enacting the signature gesture of Moholy's arresting self-portrait or of the upraised palm in the School of Design catalogues. The posters hold up a double gesture. In a commercial sense, they are designed to bring in business, to make the consumer stop and shop. But given the multiplying law of the series, they stop the action, or at least, insist on double takes. Even in the absence of any question marks, the interrogative text of the poster involves a second guessing or the experience of deja vu: "*HALT! Waren Sie schon im Kaufhaus Schocken* (HALT! Were you in Schocken Department Store already)." In this poster, two pair of halting hands rise up before the viewer meets an indexical arrow which points in the direction of the store. But it is not certain that the hands which signal a stop are only there to encourage the customer to follow the indexical arrow into the store. For this interpretation leaves the double edge of the indexical sign out of the picture.

The double role of the index in the work of Marcel Duchamp

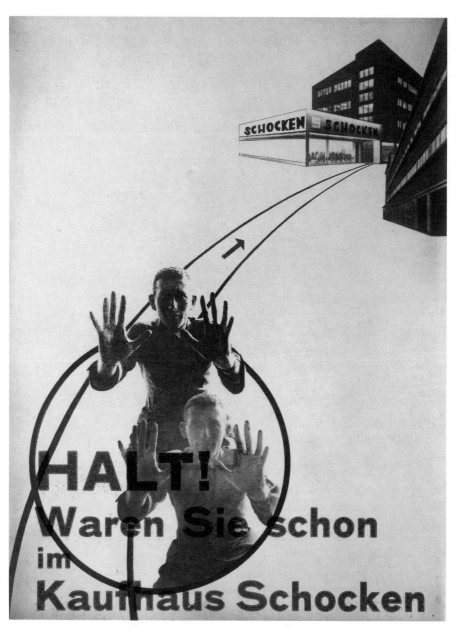

16. Laszlo Moholy-Nagy, *Poster for Schocken Department Store*, 1927, gelatin silver, ink, 21.6 x 16.2 cm. (Collection of the J. Paul Getty Museum, Malibu, California)

may be examined as a comparative model. One might say that the index in Duchamp plays the same function as the anonymous hand in Moholy. In other words, these artists use the anonymous hand and the index to stage the problem of signification for painting. In turn, their artistic practices reflect upon themselves as indexical or anonymous handwriting. Duchamp's *Tu m'* (1918) is an unusual painting that displays a number of his ready-mades — the three standard stoppages, the bicycle wheel, the hatrack, etc.[59] These ready-mades were projected on the canvas and the shadows cast were traced in pencil. Therefore, the traced forms bear an indexical relationship to the shadows of the ready-mades. To read the titular sign, they are their tombs. But the ready-made also poses the indexical relationship by which the real is constituted as a simulacrum of itself in an act of signification. Thus *Tu m'* stages a triple indexing procedure and sets off a signifying chain. From the perspective of the index, these links will no longer be viewed as natural or even as ready-made. Duchamp's practice further recalls the index as the procedure by which painting names (language) or pencils in. Like Moholy, he does this in his *Tu m'* through the emblem of the detached hand.[60] In the middle of the canvas, there is the hand which is literally pointing at shadows. This is the indexical hand separating and connecting signifier and signified. Coincidently, this indexical hand was not painted in by Duchamp's hand. Its generation bears a similar relationship to the soundings made by the anonymous hand in the telephone paintings. The description reads, "The hand was painted by a professional sign painter who signed in pencil, A. Klang."[61]

Both the anonymous hand and the index are well-positioned for this holding action as a cut between the author and the work of art. As a hinge or a pivot, this cut constitutes a hyphenated site that connects and breaks. It sits like the signature tied to the author who signs the work and yet free to act on its own behind the author's back. Painting, the hand connects the work to the author's person. But by detaching the hand, rending it and rendering it disjointed, Moholy and Duchamp stage a series of tactics that break with the author.[62] Given the indexical act, one can talk about the telephone paintings in another way. Moholy's telephone paintings and Duchamp's ready-mades act as indexes because both of them deliver the snapshot effect. Acting with an anonymous hand, the ready-made involves an act of inscription which makes the real a simulacrum of itself, folding over on itself

and in quotation marks: "*to inscribe* a readymade.' . . . The important thing then is just this matter of timing, this snapshot effect, like a speech delivered on no matter what occasion but at *such and such an hour.*"[63] They shoot for the empty sign and deliver the act of signification by which art/life is constituted. It no longer matters what finds its way into the viewfinder, what the photogram or photograph frames. What matters is the indexical gesture, the wave of the anonymous hand, the time and manner of its performance — of Duchamp inscribing the shovel, of Moholy inscribing the dimensions for the telephone pictures — that delivers the name of life and art.

Many of Moholy's photograms hold up the detached hand as this broken-handed, indexical specimen. These ready-made hands have become dematerialized and unattached through the photogrammatical process so that one does not know to whom or even how the hand belongs. The use of the detached hand as the "subject matter" of the photogram becomes a paradoxical emblem for the photogrammatic technique that leaves a print or trace by detaching a hand. Indefinitely formed and ghostlike photograms include a hand with a hole burned through its palm captioned "Phantastic forms obtained by laying hands on sensitive paper," the backside of a hand interlaced with a snake-like thread that ties it up; the black shadow of a hand covered over with black dot-like formations; and a double-handed photogram of an inverted pairing.[64] All of these photograms demonstrate how the action of the anonymous hand, taken as a light-writing effect, raises the dematerialization of the ready-made object as its issue.[65]

The photogrammatical procedure stages the hand as refuse or discard at the point of detaching from the author. For the photogram does not demand any expert handicraft on the part of the author. It is an automatic process or photocopying with no operator at the controls. Andreas Haus relates how a number of photograms employing the "silhouette of his [Moholy's] hand" (*Schattenriss seiner Hand*) offer this "gesture at the intersection" (*Haltung im Schnittpunkt*). The open hand of anonymity transforms Moholy's status as a centered artistic subject.

> In the silhouette of his hand, the automatic process of creation [*automatische Enstehungsprozess*] is shown as inactive, just as in an imploring gesture at the intersection of spatial lines, and without holding any tool — in contrast to

the famous hand montage by Lissitzky which shows a hand holding a pair of compasses. Moholy used this hand-photogram a second time, this time in a manner even more closely reminiscent of Lissitzky but at the same time decisively distanced from him: Lissitzky's montage includes a lively looking, active eye at the center of the active hand; the pair of compasses, the hand and the eye, technical-scientific, manual and intellectual-artistic work, refer to each other. Moholy includes at the same spot in the passively open hand, the automatic *photo-eye*.[66]

While one has to remain cautious of Haus's use of the term "creation" to discuss a photogrammatical effect, the analysis hits the mark in revealing how the "automatic *photo-eye*" rewrites the active and centered author in control of the work of art. The anonymous hand poses its two intersecting lines at the crossroads of the passive and active voices. The hand of the active author creates the photogram; the photogram puts the author in the space where he encounters passivity and inactivity and where he is turned into an effect of the light-writing of the photogram. This intersection charts the reaction of the hand, transformed into action, merely through the laying on of hands on the photo-writing machine. Haus points out how El Lissitzky, the *Self-Constructor*, traps himself in the rhetoric of the mastery of the hand and ruler in the construction of the photogrammatical self. Meanwhile, Moholy's techno-mystical restaging of the automatic photo-eye as organ transplant or implant within the detached hand provokes another kind of opening.

Like the graph paper backdrop of El Lissitzky's *Self-Constructor*, Moholy's two hand photograms inscribe a textual grid. This coincidence becomes more meaningful when one charts the genealogical and intertextual linkages between the "silhouette" and the photogram cover of *Foto-Qualität*. Moholy chose the earlier photogram (the "silhouette") as the first illustration in his important theoretical essay "fotografie ist lichtgestaltung" ("Photography is Light Design") in the Bauhaus magazine (1928), referring to it as a "primitive form of the photogram."[67] Through an act of (re)production, the primordial photogram became the basis for the photo-eye-in-hand version which graces the cover of the *Foto-Qualität* magazine (1931) where it appears as a reversed impression with the addition of the tabloid text. Through the intersection of the anonymous writing hand and the parallel lines of the

textual grid, the works of the detached hand delineate photo-grammatical technology as a writing system which organizes light and inscribes a system of graphic differences. The recurrence of this juxtaposition between anonymous hand(s) and textual grid in other photogrammatic and typo-photo versions (e.g., the book cover for Guido Bagier's *Der Kommende Film*) indicates the fascination which this linkage held for Moholy and in which this held Moholy.[68] These reprintings extend the pedagogical demand of photographic literacy to the media technology of the photogram.

In addition, there are certain photograms of the same type which portray the grid network by means of the interlocking of two dematerializing and detaching hands.[69] They detail, in black and white, the superimposition of two hands held up to weave the photogrammatical gesture as a grillwork. As a differentiated system of light traces, the photogrammatical hands are folding over and crossing out the object at hand. In an unconscious manner, this work recalls the biographical account in *Experiment in Totality* of Moholy folding over and crossing up his hands upon his initial meeting with Sibyl Moholy-Nagy, indeed even crossing himself out for unknowing anonymity's sake.[70] Moving over to the typographic media, this particular crossover turns up again in the prospectus for the School of Design in Chicago. As one turns the pages of the school catalogue, the detached hands turn up in graphic form. This enters the record as a kind of handshake signifying and sealing the school pact. Within an illustration of the crossed hands of the grill network, the course program of the School of Design is advertised in an elliptical space: "paper cuts . . . metal cuts . . . hand sculpture . . . lettering . . . philosophy . . . life drawing."[71]

In this accumulation of body parts, the piling up of Moholy's detached hands demands some type of cutoff point. For our purposes, this will come in the emblematic abstract photogram "self-portrait" that stages a becoming anonymous via the light-writing of a detached hand and a printed signature. The flip sides of the signature effect — naming like a self-portrait and unnaming without even a titular trace — accompany the dual titling of a detached-hand photogram alternatively named *Autoportrait* and *Ohne Titel*.[72] But instead of demanding the proper name of the photogram, it might be better to review how an indecision and a wavering is essential to this deployment of the photogram as an autogram. This is a picture-perfect selection because it traces the

remains of both the verbal artistic signature and the visual detached hand within the same framework. Nevertheless, there is a definite ambiguity in the hermeneutic reading of this image, or in the decision of how to hold it. According to the Neusüss catalog, the twisting, white-handed ghost appears from stage right in what might be interpreted as a grabbing gesture with the signature right side up.[73] According to the catalog at the Pompidou Center, the hand is held up in the conventionally detached manner with the signature running down the hand's lifeline. In either case, it appears as if an attempt has been made by an author to tie this hand to himself through the superimposed and black, bold-faced inscription of the signature (MOHOLY) at the thumbprint. But the floating signature and the detached or folded hand turn towards the apparitional when the autobiographical name is cast into the flames of an abstract light-writing and under the spell of dematerialization. Both the printed autogram and the disembodied hand have been caught up in the light and shadow play of the photogrammatical trace.

Between its French and German entitlements, *Autoportrait/ Ohne Titel* reinscribes the epigraph of "The Detached Hand" with a few minor revisions. It is possible to imagine the epigraph of Edmund Jabes in the negative as addressed to Moholy, to the self-portrait and its becoming-anonymous: Who waits for you at the end? No one. Your name has folded over like the [detached] hand on the black backdrop.

### Anon: Anonymous Post-Scripting

He . . . cared for the sick anonymous stranger. — Sibyl Moholy-Nagy, *Experiment in Totality*

Marcel Duchamp, Man Ray, and Katherine Dreier founded Société Anonyme in 1920 for the promotion of modern and abstract art through exhibitions, lectures, and publications. According to Duchamp, the Society's collection was to be organized as a "sanctuary of [art of] esoteric character, contrasting sharply with the commercial trends of our time."[74] The contrast to commerce becomes quite confusing when one recalls that the term *Société Anonyme* (abbreviated S.A.) stands, in French, for the corporate insignia of a Limited Company. As in so many Duchampian wordplays, it is quite difficult to hold to the legal limits of the enti-

tlement of this corporate entity. Following the call of the anonymous hand, there is the temptation to interpret matters literally here and to take the corporation as the Anonymous Society. In a chapter reviewing Moholy's anonymous hand that includes comparisons with Duchamp's index, it seems appropriate to end with a consideration of the Société Anonyme. For Laszlo Moholy-Nagy's own election into this esoteric collection and collectivity brings to the forefront the paradoxical twists and turns involved in writing a biography about a subject whose artistic practice seeks anonymity.

From the start, the concept of an anonymous society is rife and rifled with impossible ironies and ruses in regards to the question of its beginnings as well as the mode of selection and composition of its membership. In passing, Duchamp writes of the origin of the company's generic label: "Incidently, the name 'Société Anonyme' was suggested by Man Ray, who has been an active member from the start."[75] Duchamp's historical account assigns the name of the nameless to the pseudonymous Man Ray enamored with suggestion and mystery. But even more puzzling — how does one become an active member of that organization which removes activity, identity, and membership? Such an anonymous association can only elicit a participation without belonging. This is the only type of membership compatible with the anonymous or with a signing on to the anonymous. In signing on to this corporation, Moholy enters the register book as both a patron of the arts and an anonymous donor.

While Moholy's work was on display at the collection's center at Yale University in New Haven, the inscription of Moholy into the permanent catalogue of the collection did not take place until 1950.[76] It happened anon, as a postscript, later on, posthumously — an appropriate nomination only when he had attained the status of a non-entity. The inauguration committee used the eulogy that Walter Gropius read over Moholy's grave as documentary indoctrinating material. This speech is riddled with the traditional rhetorical platitudes which laud the artistic genius.[77] Indeed, there are Goethean overtones in Gropius's praise of the multifaceted talents of Moholy as he ventured into "all realms of science and art to unriddle the phenomena of space." In this context, it does well to remember the connections between the two ambitious Bauhaus masters who pursued the total work of art and technology with the Weimarian intellectual giant. Indeed, Hans Finsler once satirized the overarching pretensions of our dynamic

duo with a photomontage entitled *Sachte Neulichkeit* (1927–28) that substitutes the heads of Gropius (playing Goethe) and Moholy (playing the supporting role of Schiller and adorned with his floppy hat) for the heads in the famous monumental sculpture that stands in front of the Weimar State Theater.[78] While Finsler's photomontage gives Gropius the leading role, Gropius's eulogy switches sides in its unconscious identification of Moholy with the Goethean part.[79]

In contrast to any Faustian claims, this chapter has suggested that Moholy poses the space of the anonymous subject throughout his life in the telephone paintings, the shooting photomontages, and the detached hand photograms. As Moholy writes, "My desire was to become an anonymous agent. . . . On the contrary, I even gave up signing my paintings." Unlike Gropius's eulogy, these remarks are made in Moholy's lifetime, but judging from their character, this agency is the pre-recorded voice of someone already playing dead. It is an abstract artist beginning his own eulogy or inaugurating himself in Société Anonyme in a foreshadowing of his own subsequent election and demise. Moholy's membership drive into S.A. closes in on the divided identity of the biographical writings — the becoming anonymous of the self, the subject carried away as a signature effect.

Contrasted with Gropius's remarks and their unqualified apologizing of Moholy and his individual creativity, Moholy's remarks are open to the space of anonymity that haunts identity or the signature effect that writes in the subject to deliver the curious conscription ticket that admits one into Société Anonyme. For anonymity leaves departing with riddles. The abstract artist of the anonymous hand spends his entire artistic career in the pursuit of this death in life but does not receive the rank until after death in a paradoxical postmortem nomination. Like the biographical writings, the script of selection counterposes the dated identity of the memorialized subject with his removal in the form of an anonymous epitaph. It has been set onto a page of the Société Anonyme as each side plays off the other. The caption reads, "Laszlo Moholy-Nagy (1895–1946), Member, Société Anonyme."

## Introduction

"Moholy: The Significance of the Signature" rekindles the traditional controversy arising out of the textual analysis of the significance of proper names. In Plato's *Cratylus*, Hermogenes argues for the arbitrary character of the signature. A proper name — any name — is the result of convention and continued habitual use. This book of ancient wisdom is rather straightforward on the question of name-calling: "Then every man's name, as I tell him, is that which he is called." If all of us agreed to exchange the names of horse and man, it would not make one bit of difference. There is neither a natural linkage nor a mimetic relationship between the word and the thing. Meanwhile, Cratylus takes up the contrary position that the signature bears a motivated relationship to that which it names. Socrates provides this motto in an invocation of nature: "For as his name, so also his nature."[1] Much of the dialogue of *Cratylus* demonstrates how the names of the Greek gods and heroes suit their natures in essence.[2] Cratylus's position sets up the signature as a genealogical programming for the writing of life.

This chapter takes the terms *ho, holy, whole, hole,* and the hyphen of Moholy and imagines, with Cratylus, that these words organize the life of the subject who bears this name. In other words, that the proper name bears a motivated relationship to the meanings of the common nouns which constitute it and is genetically prescriptive. These terms write Moholy's biography

and direct his poetry, his artistry, his teachings, and his visions. This staged play entertains the hypothesis that things happen to people according to the promptings of the signature as it modulates and props up the action. Autobiography follows from the autograph.

While the textual analysis of this chapter is concerned for the most part with Moholy's relationship to the English language, his second artistic language (German) does not lag far behind owing to the shared etymology of the two languages. As already indicated at strategic points in this study, such hole-ridden terms as *hohl* or *Hohlheit* (emptiness, hollowness) and *Höhle* (hollow, hole, cave) matter to Moholy's biographical trajectory across the German linguistic landscape. And in the section on his autobiographical photomontages, there was an attempt made to trace the significance of the second half of Moholy-Nagy's signature — in the form of *nagen* (to gnaw) and *Nagetier* (rodent) — for his artistic practice, and indeed, for the entire avant-garde rhetoric with which he is associated.

Nevertheless, Hermogenes's position regarding the arbitrariness of language underwrites this entire debate and puts Cratylus's analysis into question whether the terms are German, English, Hungarian, or even Greek. From this perspective, one must read "Moholy: The Significance of the Signature" with reservations and suspicions in mind — that these links are superficial plays on words which are the results of arbitrary graphic accidents, that they only provide forced and stupid jokes devoid of meaning, or that they convert proper names into common nouns into order to conjure an easy laugh. These reservations raise the arbitrary nature of the signature in another form. Paradoxically, the Hermogenic programming would show how *ho, holy, hole in whole,* and the hyphen underwrite things for Moholy-Nagy in such a way as to break attachment to the significance of the signature. With the terms of this double relationship in the (in)significance of the signature set up, this scene becomes an unresolvable meeting between the arbitrary and the motivated, between chance and necessity, between the graphic and biography.

**Holy**

But when the light-prop was set in motion for the first time in 1930, I felt like the "sorcerer's apprentice." The mobile was so startling in its coordinated

motion and space articulation of light and shadow sequences that I almost

believe in magic. — Laszlo Moholy-Nagy, "Abstract of an Artist"

Four magical symbols spell out Moholy's link to the sacred. These four letters make Moholy a holy man. The rhetoric of the vision and that of the visionary constitute a very intimate coupling in the texts of Laszlo Moholy-Nagy. It is in this light that one recalls the volumes devoted to *The New Vision* and *Vision in Motion*. As Moholy once described it, his artistic practice "emanated from an inner vision."[3] The *holy* of Moholy affords the chance that the common noun and proper name that constitute the signature are thinking for themselves. If such is the case, it is necessary to follow the magic lead of the signature all the way — or in Moholy's case, the whole way — for a writing that "programs the whole scenario."[4] According to this particular genetic program, this graphic plant — *holy* — grows for Moholy. For there is evidence that those in contact with Moholy make the connection between the signature and his character. Given the mysticism of the proper name, these people might be viewed as stage props, robots, or showroom dummies in the service of the signature of Moholy-Nagy which authorizes their statements. The language reserved for Moholy consists of a panoply of words associated with his holiness. As an educator, he is described as a magician in the transmission of mind. Who can resist the contagious teachings of this dynamic guru figure who sets minds spinning? Gropius figures Moholy's *Light Space Modulator* as a magical device in pedagogical terms: "What more can true education achieve than setting the student's mind in motion by that contagious magic?"[5] (Figure 17). As an artist, Moholy is compared to a sorcerer who experiments with new materials and has the capacity to transmute the means at hand in an instant. Gropius stands, suddenly amazed at Moholy's magical powers at construction: "It was like a sorcerer's miracle to find suddenly that elaborate exhibition put up in a jiffy."[6] And even in the public at large, the *Light Space Modulator*, the great kinetic sculptural work of the self-professed sorcerer's apprentice (whether of Goethean or Disneyan inspiration), is hailed as "cosmic in conception."[7]

A survey of gallery-goers to Moholy's exhibitions reveals a following of the same sacred script. In the catalog to the Guggenheim show, an anonymous signature catches the spirit affirming Moholy's "intuitive insight into the realm of the spirit."[8] After the Cincinnati retrospective exhibition, one student praises the

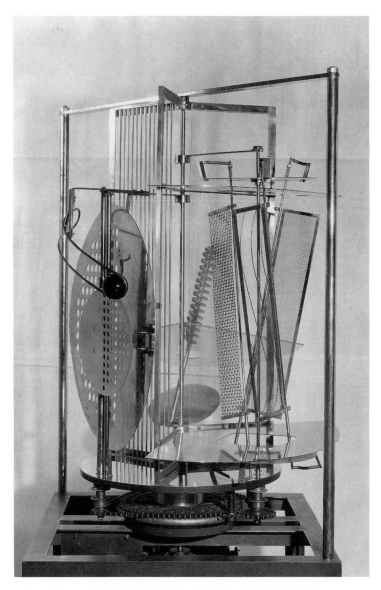

17. Laszlo Moholy-Nagy, *Light Space Modulator*, 1921–30, kinetic sculpture, 151.1 x 69.9 x 69.9 cm. (Collection of The Harvard University Art Museums)

teacher for his performance with some high-flying metaphysical language: "We were amused and mystified by your magic production of the pictorial impossibility."[9] This is a striking account — mixing up mystification and mysticism, linking magic and holiness to pictorial impossibility. It suggests that the production of

the holy seeks and depends upon something impossible. One recalls Moholy's own slogan on the matter, "Directness of Mind, Detours of Technology." In linking the holy and the impossible, this passage suggests that there will be detours (*Umwege*) along the way in the quest for and on account of the holy grail.

Even with his early poem "As a Telegraph Wire of Alien Secrets" (1918), Moholy tunes in to this more esoteric aspect of the holy. The title is a brilliant condensation and constellation of Moholy's techno-occultist concerns foregrounding the network of occlusion, alterity, cryptography, wiring, and telegraphy. This is how Moholy sets himself up as a medium or channel to become holy writ. Indeed, Siegfried Giedion argues for the importance of *The New Vision* precisely because it gives Moholy the chance to act as a prophetic medium pronouncing upon the new alliance of art, science, and magic: "The close concatenation between the artistic evolution of our age and the occult forces of the *zeitgeist* which permeate our daily lives has rarely been so impressively demonstrated as in this book."[10]

The occlusion of the holy opens an impossible abyss — to find holiness is to have it hidden again; to lose holiness is to already have found it again as occluded. Given the excessive character of the holy, this amusing or laughable logic of the impossible makes the holy man's practice always a going beyond and a starting over, again and again. So one returns to the epigraph and reads that Moholy *almost* believed in magic or that he felt *like* the sorcerer's apprentice. These words, slightly removed, register a resistance for the holy seeker. This occluding logic also suggests that the holy demands shifting in the field of significance. As such, the play of the holy signature and of Moholy's signature has been staged diacritically between the arbitrariness of the signature and its significance, between the holy's removal of Moholy as subject and the holy quest of the subject Moholy. If Moholy sees the light, it is important to recall that this always involves a display of differences (e.g., photogrammatology). Moholy was one of the first to see that light is structured like a language and that it is never a clear-cut matter of absence and presence. Light traces its effects in a differentiated manner. "If light is completely absent, that is, in blackness, we are unable to distinguish objects as in the case of its total presence, that is whiteness (dispersion)."[11]

Therefore, Moholy's illuminations are filtered through a series of intricate apparatuses as "the play of light [writing] . . . open[s] up new joy in life."[12] The experience of the holy demands new me-

dia and new intermediaries. It requires means for attainment, the "unusual" writing machines, and what Moholy calls the "other forerunners of a light-graphic."[13] He relies upon the technologies of screens, clouds (of unknowing), and dreams to get his light visions into gear. "I dream of a light-apparatus, which might be controlled either by hand or by an automatic mechanism by means of which it would be possible to produce visions of light, in the air, in large rooms, on screens of unusual nature, in fog, vapor, and clouds."[14]

The relationship between Moholy and the holy institutes a wavering motion that projects the ceaseless blur of a moire effect between the authorizing control of the signature in the subject's life and the automatic constitution of a signature effect that disperses significance. As the message (or medium) exposing the holy's super-abundant signature, light acts according to a logic of the threshold. According to one anonymous source, his medium is "his message of light. His treatment of light designs is of ethereal genre. . . . He seems almost to cause the observer to become a filter through which a slender shaft of light enters the human soul. He is the threshold to a whole new world of awareness for the discerning."[15] As spiritual intermediary, Moholy uses the medium of light to turn the observer into "a filter through which a slender shaft of light enters the human soul." Through the interactions of these media, the (holy) light breaks through to illuminate the subject. Pursuing the logic of the liminal, Moholy crosses "the threshold" — another interzone — "to a whole new world of awareness" which some viewers might even dare to call holiness. Autobiography follows the autograph. But one must also take the risk that comes with this shaft or light hole that arrives with an expanded awareness. Miming photogrammatology, this holy practice disperses or empties the significance of the biographical subject as an unmotivated light-writing effect. Vision in motion works "on the threshold of dream and consciousness, a tumultuous collision of fantastic details."[16] This collision is a friction of proper and common, profane and sacred, named and unnameable, of the significance and the arbitrariness of the signature, of Moholy and the holy.

Following the calling of his name, Moholy begins to sing the praises of the signature as a poetic medium quite early. Writing in his diary, the medium inscribes odes to holy light. The light mystic seeks to name the holy and the holy name. With a "paper heart" burning with enthusiasm, he writes "Love and the Dilletante Art-

ist." In the second phrase, Moholy anticipates the charges to be used against him in his forging ahead. In the fiery forging of the signature, Moholy appears as the burnt subject wearing a paper heart on his sleeve, a wondrous gift of holy light (writing). In the noisy rush of sound and light waves, a young artist already desires transformation into an ecstatic, photogrammatological subject.

> Longing for the old ecstasy — light.
> The waves rushed against each other
> And my paper heart filled with wonder.[17]

At the age of twenty-two, Moholy writes his most famous light-mystical poem with the insistent title "Learn to know the light-design of your life." Looking over the holy scenario and its scripting of the subject, it is as if the signifiers (holy and light) are speaking and writing through him, passing through him like light through a filter for a telegraphic transmission of the sacred. In this particular light verse, the holy empties the subject in a purification by firelight, a ferocious burning that almost blinds Moholy into oblivion and spreads like wildfire. "Come over me, proud light, fierce light, burn deep. Ferocious light spread through me, cleanse my eyes." Reviewing these poems and the constant obsession that light holds for him throughout his artistic career, certain critics have invented new terms to refer to Moholy's artistic practice. This seeker after artistic illumination is described as a "Lichtner" (light designer) or a "Luminarist" (luminator).[18]

At the Guggenheim show, another deeply impressed spectator defines Moholy's dematerializing designs as the writing of the interval that opens the space for the subject and his significance. "You *feel* the space, the interval . . . the 'shadow' designs . . . and through the wonder of embracing substance, light and shadow, Moholy-Nagy . . . is known to have Vision." While there is a temptation to render "Vision" with a capital *V,* the practice of the interval remains an art of revision, working through, to cite Moholy's student Richard Koppe, "the interzones of experience." The quest for the holy — as the "interzone" between the arbitrary signature and its significance — motivates Moholy. Koppe begins his tribute to the master with a series of "early Chinese quotations" from the *Tao te King.* Whether intended for Moholy or not, the essay begins with the ancient maxim on a questionable interzone, the use of the useless: " 'Therefore, just as we take advantage of what is, we should recognize the utility of what is not.' " Then Koppe makes his move (beyond the strictly positive)

from the *Book of Changes* to *Vision in Motion:* "It is not only in the many positive aspects of his life and work but also in the numerous areas in between and in combination that his greatest contribution lies for present and future generations. Moholy opened many doors and broke down many barriers for those who would follow."[19]

While there are no specific writings in which Moholy charts his relationship to Buddhism or Taoism, a number of biographic incidents provide points of comparison between Moholy and the holy practices of the Buddhist masters. They involve a shared use of pedagogical devices such as koans, diagrams, riddles, puzzles, shock tactics, and a sense of humor to expose the paradoxes of the significance of the signature and its relation to a mysterious logic of emptiness. In terms of Koppe's analysis, the breaking down of these barriers and the opening of these doors could be another knocking at a gateless gate of Enlightenment in quest of what lies "in between."[20] Like the Zen master who meditates under his gnarled tree, the Bauhaus master dubbed "Holy Mahogany" is of a mind to pursue the mindless and to use the useless. At home in the Institute of Design, the man of the crossover builds the perfect borderline checkpoint — a doorless door that stumps the enterer or that provides the knock of Enlightenment. With its strings attached, Moholy's design predates the hip counter-cultural styling of the 1960's. This is how the journalist Robert Yoder handles his problematic assignment:

> A Door that is Not a Door. Leading into the workshop is a large door. When closed, this shuts off the breeze. But when open, it used to attract visitors who would wander into the shop instead of going on down the hall to the office. Moholy-Nagy solved this by suspending a half-dozen pieces of string in the doorway. It makes only the sketchiest suggestion of a door, but works like a charm. Visitors halt as obediently as if confronted with solid oak.[21]

Meanwhile it might take a Buddhist sage to figure out or translate for the reader what is being stated in Kent Sagendorph's essay "Functionalism, Inc." It is the breaking point for logic that the Zen master hopes to coax with a koan, a gesture, a demonstration, a different point of view, an edge or a threshold where "a" and "not a" are about to cross borders and the impossible logic of the holy signature might be glimpsed or laughed at. In these holy matters, the language turns to a declassifying description that

marks an unlocatable surplus. But whether overly charged with significance or of complete insignificance, it is hard to say. Sagendorph piles on the Zen paradoxes to the point of dysfunction by constructing a set of attributions where nothing appears to be what it really is. "A chair that doesn't look like a chair—a wall that doesn't look like a wall—these are products of this school that doesn't look like a school."[22] The rhetoric of reversals even reaches over into the avant-garde aesthetic of the "beyond of painting." These uncarved blocks are taking their cues from the declassifying master of the school who has so mastered the art of painting that he paints by not-painting. "A painter of the most advanced type—so far ahead of the rest of the class that he is working happily on a plan whereby it may not be necessary to paint at all."[23]

At this crossroads of Moholy and the holy, things lighten up and empty out. The holy logic of emptiness hollows out the self from the heavy baggage of attachments. In turn, the subject is inscribed as a light-writing effect. It functions like a perpetual motion machine wherein the aspiring adept constantly attempts to throw off the weights and the traps of desire. This holy lightening also engenders laughter and amusement in what might, facetiously or not, be seen as the ho of Moholy. In terms of the play of the holy signature, lighter means a loss of gravity. It describes the architecture of a mouth opening with laughter. As Moholy stresses in another context in *Vision in Motion,* "The development of the *opening.* . . . Architecture became *lighter,* seemingly less bound by the forces of *gravity.*"[24] Moholy's demonstration of the loss of gravity and the lighter wave of the future has a delivery that is comic in conception. Over and over again, he tells his standing joke or riddle about the chair of tomorrow, "a seat on a compressed air jet." Moholy performs it, setting it up with the proper props. Pointing his air gun, he lets out a stream, a burst supporting a chisel. Not playing the straight-faced comic, Moholy smiles at his own show. " 'That's fun,' he grins, 'It's a stunt to show the buoyancy of air. Who knows? Maybe someday we will have chairs without legs — springed on columns of compressed air like this. Some day —.' "[25]

On the air of WGN radio in Chicago, Moholy's speculative stunt headlines *The World of Tomorrow* program. In their "Scripteaser" Moholy tells the one about stripping down to nothing in a new light. This one-liner about the need for a crash diet after lunch recalls the Zen master's riddle about three pounds of flax[26]

with one difference, "For me, I would need 170 pounds pressure, and after lunch two pounds more"—and it brings a burst of laughter for his free lunch.[27]

With all these indications, an early collage in the name of "Moholy-Nagy" can be read as a Zen diagram on the problematic of emptiness.[28] To add more circumstantial evidence to this reading, it should be pointed out that this piece was personally dedicated to the dadaist ringmaster Tristan Tzara who was to deliver an important lecture-performance on the relations between Dadaistic and Buddhistic practices during his visit to the Bauhaus in Weimar in late September of 1922 at the time of the Dada-Constructivist Congress.[29] In this Moholy collage, a holy man, looking very much like a Buddha, levitates in a seated position upon a row of corn and meditates, gazing into space. Across the line of vision from our budding Buddha is a giant *Y*. Is Moholy speaking silence, saying his mantra to himself, the end result of his name, of the holy—not *OM*, not *MO*, but *Y*? The contemplating figure is surrounded by a number of windmills—machines designed to blow air around. The *Y* collage depicts how the cycling of these great wheels of the desiring machine generate the investment in the biographical subject which it is the practice of meditation to still and empty. Below the seat of the sage, there is an Aladdin's lamp, or maybe a Bunsen burner, which looks as if it could have fabricated the whole scene so that the Buddha and everything would have been sprung from this magic lantern of continuous recreation as in a dream or as a veil of Maya. This could offer another version of the compressed air joke on the largest scale imaginable. It would project the shadow play of rebirths, of Moholy becoming Maya and of signatures becoming substance. As Moholy writes elsewhere, "And this despite our knowledge since the first *Laterna Magica* that light is continuous creation."[30] Through a simple manipulation of switches, this *Y* lamplight reads like one of the "multicolored floodlights" of Moholy's visions of the future which "will project a constant flow of immaterial, evanescent images into space by the simple manipulation of switches."[31]

In the light-writing of the photogram *Telegraphed Cinema*, Moholy enacts the holy's occlusion as his own occultism. This is a singularly clipped autographic photogram. In the center, a mystical spiral symbol is enframed in a rectangular fashion. Above this framing device, one reads the letters *OW*. If this were to be flipped over backwards, it would become a Buddhist meditative aid. If

turned upside down, it spells the first two letters of Moholy's name in light-writing and casts a type of halo as one reading of the print shadows the other. The spiral film reel and the long distance writing machine come together in holy matrimony under the instigation of MO. The shock tactics of this flipped-out reading strategy follow Moholy's lead when, as already alluded to, he resituated the photographic works of Edward Weston in the flip of the print. Beaumont Newhall recounts the annoying encounter: "I was an onlooker. Moholy kept finding in the photographs hidden and fantastic forms, which were often revealed when to Weston's obvious, but politely hidden annoyance, he turned the print upside down."[32]

Neither here nor there, the holy word is occluded in the *Telegraphed Cinema* photogram. Yet, if one must seek to lose face, self, and name's sake to become holy, then perhaps Moholy has succeeded in his failure and performed the amusing logic of the impossible in this (loss of a) material gesture. In meditating on the occlusion of the holy and the removal of himself, the Mo-holy of *Telegraphed Cinema* may just have pulled off a magic trick in the light-writing of this photogram.

### The Hyphen

The painter with the strange and double name, Moholy-Nagy. — Elisavietta

Richie, "Memories like fireflies, fleeting"

Taking a short break or graphic interlude from all these words, a mark in Moholy's signature remains after all the twenty-six letters have been used up. It is the horizontal line placed halfway through the type and sliding somewhere in between. A slice to connect and divide (*Bindestrich*), and a perforating slash — this spells out the status of the hyphen in and for Moholy-Nagy. The hyphen follows a supplementary logic that shifts perspectives. (1) It divides a word down the middle. (2) It joins two fragments into one name. (3) It demonstrates that something extra must be added for the completion of the name. Continuing with the hypothesis of the autograph as the arbitrator of meaning and significance for autobiography, then it is the interruptive force of the hyphen that led Moholy-Nagy to inter-media artistry. The hyphen, or the mark of inter-media, led him on.

But from the other extreme of the unmotivated graphics of the

signature, this split would only be a matter of some spilt ink or some marks on paper which are barred from significance. This hyphenated slit would only be a stain in need of wiping away; thus, it would not mean a thing. In this manner, Hermogenes mediates Cratylus. Structured like a hyphen, the reading and writing of "The Significance of the Signature" operates in this space that plays between the chance and the necessity of these encounters between the graphic and biography or between significance and the signature.

From the time the hyphen claims him at the start of his artistic career (1918) until his death, Moholy invokes the force of this sign and makes its meaning his life writing. One might argue that the significance of the signature manifests itself even as it marks and tattoos the body. About the time that the hyphen appears in the signature, there is also a change in Moholy's material makeup, his physical constitution, and being. Sibyl Moholy-Nagy recalls, "After two years in the front lines, a snow-white streak divided his black hair."[33] Sibyl draws a causal connection between the front lines and the hairline. But according to the significance of the signature, harebrained though it may appear to any conventional theory of the linguistic sign, this is the physical sign that Moholy has been placed under the mark of inter-media or the guiding light of the hyphen. Indeed, it is exactly the time when Moholy produces his first sketches as an artist. This part in the middle divides the forehead and the signature like the third eye of Buddhist wisdom. This streak of snow-white on black and later mixed with gray will remain as such till the end of his life — up to and after the time that he constructs one of his last modulating pieces, *Space Modulator with Hairlines* (1946).

But something else steps in to test this single-minded and quasi-mystical explanation. It lodges in the formal characteristics of the hyphen. For turning to a sample of Moholy-Nagy's signature, this hyphen has doubled over. This might be an optical art puzzle or sleight of hand that the master kineticist has performed for his spectators. Empirical research documents dozens of these specimens. The painter with the strange and double name — Moholy= Nagy — always signs his name with a double mark.

Along the conceptual lines of the signature in the design of biography, this extra turn does not spell a snag. In fact, it motivates an arithmetic reading of the hyphen in which both marks, "-" and "=," would count as mathematical symbols that help account for Moholy as an adept geometrician of form. It lends

support to the art historical view that Moholy is a leader in the constructivist movement referred to retrospectively as *geometric abstraction*.[34] Barring El Lissitzky, Moholy-Nagy does about as much as any constructivist artist to bring the minus and equal signs as well as the compass and ruler back to the artistic drawing board. Perhaps this dilemma could be resolved if the hyphen were to equal "=" in either Hungarian or German. Then, simply put, one could ascertain that this Hungarian or German national signs his name in a conventional manner. However, "the equal sign" does not signify "the hyphen" in either language. Then how does he become Moholy=Nagy? How does he become Moholy-Nagy, for that matter? It starts, as already documented, with the tacking on of Moholy to Nagy as the original addition or first edition and the one that will dominate his calling. The genealogist Laszlo Peter documents this breakthrough without the break: "This was the first time in April 1918 that he used the name Moholy — but without the hyphen."[35]

But when does the break, that is, the first hyphen, occur? When does Moholy Nagy become Moholy-Nagy? While there is no exact date, Moholy-Nagy's relative, Levante Nagy (who lacks the famous name) has researched the signatures affixed to Moholy's paintings between 1918 and 1921 and has traced a pattern of development in the staging of Moholy's signature. The first paintings which incorporate two names are signed diagonally, "Moholy Nagy." Then the same signature appears in a straight line. At some undetermined later point, a hyphen is added. He becomes Moholy-Nagy. Finally, an extra flourish is inscribed. He becomes Moholy=Nagy with the hyphen set (doubly) in place.[36] He lets himself be taken in or disposed of by language in a new way.

In Moholy (-, =) Nagy, the hyphen might be read as a personal affectation written in a private language that makes it quite difficult for others to read him. It raises questions. Does Moholy-Nagy = Moholy=Nagy? Does - = = ? Something might have been subtracted (-) or added (+) in moving from the first symbol to the second symbol. This type of inquiry may seem quite marginal but such a production, from - to = or from hyphen to hyphen, suspends the logic of identity which would gloss over such differences. According to this logic, a signature signed "Moholy-Nagy" or one signed "Moholy=Nagy" refer to the same person. A reference to "Moholy-Nagy" and another to "Moholy=Nagy" on the same piece of paper refer to the same entity and to the same biographical identity. But in the biographical writings of a graphic

artist like Moholy whose artistic practice incorporates a display of signature effects, this graphic difference *matters*. The common-sensical explanation ignores the material production and the inscription of a text in each of its marks. It overlooks the pseudonymous staging of Moholy and his signature, or Moholy (-, =) Nagy's staging of himself and his signature, as a possible strategy for unnaming himself. No rules govern the use of this fleet and fleeting hyphen. It is the signature divider in (between) words or appearing and disappearing at the end of lines. Comings and goings, additions and subtractions, the hyphen generates a significance that risks significance with each inscription. To return to the poetic epigraph, it may look like a firefly's writing as it lights up the sky and then blinks.[37]

So divided he stands — Moholy=Nagy, Moholy-Nagy. For Moholy, these signatures are joined and divided like the hyphens which compose them. Interspaced in the middle, the hyphen operates not unlike the bar between signifier and signified. The intervention of the hyphen splits the subject right down the middle or, in this case, splits him twice over — Moholy-Nagy from himself, Moholy=Nagy from himself.

**Ho**

Ha he hi ho

— James Joyce, *Finnegans Wake*

*Ho,* a word to call attention to, acts more like an exclamation, something more, an interjection. Ho! This exclamation appears when people or things break into laughter. It marks an excess of explanation that brings joy in its wake. Bursting with meaning, it discharges with emotion in a release that may reach down to the belly and bears a similar structure to Moholy's laugh meter, *The Large Emotion Meter*.[38] This was the device that *Time* magazine called a "meaningless 'machine of emotional discharge,' which he designed for laughs."[39] Would the *ho* of this signature be enough to mean something or to make Moholy a funny man? Would it convert him into a deviser of strategies to amuse via a series of these guttural utterances?[40] Or would this be too much to ask of *ho* and of him, of Moholy and his signature? This meeting of *ho* and Moholy repeats the meeting of Hermogenes and Cratylus. It stages two simultaneous scenarios — the biographical necessity of

this linkage (i.e., *Nomen est Omen*) and its graphic insignificance (i.e., mere wordplay), the natural and the conventional theories of the proper name and its meaning.

The writing of the pun attends to the material makeup of the signature by nature. Rather than standing in for a thing, the pun inverts and exposes the other side that language tries to hide. It organizes things around the arbitrary similarities in the material design and finds meaning therein. It subjects the sign to design, the signified of biography (Moholy) to the graphics of signature (*ho*) and provokes a disappearance of the subject in the play of language. Straining and stressing, things show their semes. Confounding the arbitrariness of the signature and the necessities of significance, the pun opens the impersonal space of the ready-made, of a language already writing itself.

In his writings on literature, Moholy draws attention to the materiality of language that the pun foregrounds. These punishing outbursts break up the word itself into its sonic microparticles. The pun pulverizes, fragments, punctures. It matters even "to the point where word relationships [*Wortbeziehungen*] are transformed into exclusive phonetic sound relationships [*Tonbeziehungen*] thereby totally fragmenting the word [*die vollkommene Auflösung des Wortes*] into logically-conceptually [*logisch-gedanklich*] disjoint vowels and consonants."[41] Cast as avant-garde literary critic, it is Moholy's opinion that the "isms of art" — whether spelled out as Futurism, Expressionism, Dadaism, or Merz — share the same literary program, one involving a radical shift from the level of conceptualization and meaning (semantics) to the level of the letter (phonetics), from word to sound relationships. As Moholy comments upon "The Theater of Surprises," "From this premise the FUTURISTS, EXPRESSIONISTS, and DADAISTS (MERZ) came to the conclusion that phonetic word relationships [*phonetischen Wortbeziehungen*] prevail in meaning over the other literary means of design, and that the logical-intellectual content of a literary work was far from the primary aim."[42]

This attention to the level of the letter and to the disjointed fragmentation and cutting up of the word generates the twistings of the tongue that tie up meaning. *Ho* initiates the sophisticated teaching of the Hottentot. In the quoted saying that follows, exotic rhythms and nonsense verses demonstrate how the fortuitous convergence of the phonetic materials matters more than any principle of semantic meaning or linguistic identity. After the

tongue- and ear-tickling onslaught of the phonetic powers, this direct supersonic hit totters the teachable — an end to thought, ending with taught. While one may object to the underlying colonizing approach taken in relation to the Hottentots, given the semantic content of this verse in terms of its moral and pedagogical overbearingness, the faster the nonsense verse is said, the harder it will become to appropriate this "elementary" and "primitive" tongue twister. "Such sound rhythms were preceded long ago by tongue twisters. Their value lies in their elementary phonetic power and their primitive directness as tongue and ear ticklers. 'If a Hottentot taught a Hottentot tot to talk ere the tot could totter, ought the Hottentot tot be taught to say ought or naught or what ought to be taught 'er.' "[43]

In concrete form, Moholy begins to write the literature of the future — the omnidirectional, multidimensional literary history of the future, gung-ho for things that will be organized around the associations of such data gestures. Popping the question "How to Create Total Theater?" Moholy offers this response: "The literature of the future — dispensing with musical-acoustical effect — will develop language primarily in accordance with its own basic data. (Through association, its data branch out in many directions.) This will surely also affect the presentation of word and thought on stage."[44]

With *Vision in Motion*, Moholy branches out to the texts of James Joyce in support of an excessively playful view of language. In the "Literature" chapter, Moholy entitles him to two sections of the analysis — both "James Joyce" and "Finnegans Wake." For Moholy, Joyce's literary significance depends upon the ability to capitalize upon the surplus of linguistic associations and send the reader into transports. The pun is at the root of why the data branch out in so many directions. Joyce hones his hobby, writing, and it sets up so much more, "but beyond that, of the 'plus' which turns writing into literature."[45] While the + effect performs the surplus of the literary conversion experience (or even what Joyce dared to call the "epiphanic"), it is rather difficult to define this phenomenon within the limits of the logical-conceptual. Moholy describes the matter graphically and leaves the metaphysical question hanging: "With Joyce's language one can see 'more.' [new paragraph] But what is this 'more?' "[46]

Moholy evades an answer to this question as quotation marks get raised for "more" in a performative gesture that repeats the same signature ("more," that is) as something else again.[47] This is

what comes to matter as the linguistic materials link up and the pun displaces control over language from the scriptor in order to relocate the significance of the signature as a series of chance meetings on the level of the letter in an outpouring of humor. Given these intricate textual encounters or homophones, lo and behold, they bring forth multiple connotations. They touch off "liberating explosions" and "flashing sparks." The superficiality of the surface assumes deep significance as the pun pushes language to the experience of limits. The French might prefer to call such textual intercourse *jouissance*. "The peculiarity of Joyce's language is its multiple meaning. . . . In this way situations — old and new — words and sentences are recast and shifted to unexpected connotations, cunning, intricate, pouring out humor and satire. Flashing sparks from the subconscious, mixed with trivialities of routine talk, sharp tongued gossip illuminate hidden meanings. Puns are of deep significance, touching off liberating explosions."[48]

Moholy looks at Joyce's manipulation of the graphic materials and he laughs at a specific instance of the playful logic of the letter wherein the branchings of the data, of language, the tree house of being, will not be taken for granted. " 'Tree taken for grafted' indicates 'taken for granted'; but here is 'grafted' which may be taken as implied in the process of 'grafting a tree,' but also as political 'graft.' "[49] There is no argument with Moholy's political or horticultural connotations, but for the man nicknamed Holy Mahogany, there is more than meets the eye on the surface where "one sees 'more.' " Exceeding the mastery of the biographical subject, the signifying materials will be called upon for more, to be remounted again and redrafted, the regrafting of the graph, its *regraphting*.

Joyce grafts words and crosses over on the level of the letter for a generalized linguistic incest. "Tree taken for grafted" is a less pronounced case as "granted" and "grafted" play off of each other in the same idiomatic slot. More to the effect, what might be termed the "rejoyce" effect, collides and concatenates. It brushes words up against one another in order to breed hybrids. As Moholy comments, "His humor grows beyond the obvious in the word combinations with their ambivalent or multiple meanings. He speaks for example about the '*panaroma* of all flores and speaches.' "[50] These composites of words folded over, whatever their part of/in speech or of senses — what Moholy later recasts as "manifolded word agglutinations" — concoct an assemblage of

language and languages which grow on one like the flowers of rhetoric.[51]

At this point, it does well to interject a visual-verbal graft of Moholy's own making. Also published in Werner Graeff's photographic compendium, *Here Comes the New Photography*, this sight gag appeared in *Painting, Photography, Film* to illustrate the comic capabilities of the photograph. While the source of the photograph is the Keystone View Co., London, Moholy writes his own caption to the graphic. In fact, the title offers two choices, *Der ÜBERMENSCH oder der AUGENBAUM* (The *Superman* or the *Eye-Tree*). Cast in cyborgian terms, this technological monstrosity comes bearing a tree of (electronic) eyes grafted one on top of the other. With such oversight, its surveillance program follows the labyrinthine *regraphtings* of the graph, its infinite branching and cuttings.

Moholy senses that "Joyspeak" plays inter-media art after his own heart as the languages rub up against each other and produce frictional effects in the spaces between. Reading through Joyce's gay science, Moholy rejoices: "The gaiety, implicit between the lines, between the words, and *within* the composite words, makes one feel happy."[52] Juggling languages, Moholy gets one between Hungarian, German, and English that seems written especially for his phonetic amusement. He " 'takes a szumbath for his weekend and wassarnap for his refreskment.' . . . But nap is in Hungarian also 'sun' so that at the end Joyce produces a most elegant pun, a crosswise identity — sunbath-waternap."[53] Here Moholy's reading of Joyce surpasses the bounds of nationality as a crossed up identity is lodged in the name to produce a quite elegant interlinguistic "pundemonium."

While Moholy obviously did not produce a *Finnegans Wake* in his lifetime, he did put the pun into practice in a more modest way in his photoplastic experiments. For these visual works of the cutup are punctuated and structured like puns. Like the linguistic concatenation of the pun, the photoplastic offers a "visual synopsis of a number of events" or a "multiple image condensation fixed in a single frame."[54] Deploying visual puns, his photomontages also challenge the strict division of words and things. To point out how *Vision in Motion* (reread "distortion") relies upon shock aesthetics, Moholy draws on Salvador Dalí and the case of the jest in the chest of drawers: "Literary distortion (in the visual arts) counts on the intellectual shock deliberately produced . . . as in caricature or visual puns, for instance showing a man's chest as

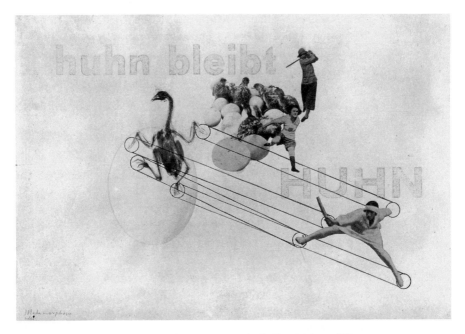

18. Laszlo Moholy-Nagy, *A Chick Remains a Chick; Poeticizing of Sirens,*
1925, gelatin silver, 11.0 x 16.4 cm. (Collection of the J. Paul Getty Museum,
Malibu, California)

a chest of drawers."[55] Taking the visual and the verbal to the limit
or crossing them over, the "joke of the future" will involve the lit-
eralization of idiomatic expressions to get the pun across. Mo-
holy offers his prolegomena to any future joke book in the form
of the photoplastic: "Photo-plastic is often the expression of an
intellectually hardly comprehensible variety of connections [*ver-
bindungen*]. It is frequently a very bitter joke, often blasphe-
mous. . . . The joke of the future will probably not be illustrated
graphically but by means of photoplastics."[56]

The joke of the future becomes the yolk of the future in *Huhn
bleibt Huhn* (1925) (Figure 18). This is a photoplastic in which
Moholy lets the pun run afoul. It translates as *A Chick Remains a
Chick* or *Once a Chicken, Always a Chicken.* Is this a verbal
tautology? But chicks do not only come in poultry form when they
cross the road. In the web of language and in the slang of its sense,
this is also meant to signify a "little chickadee." Moholy's photo-
montage stages it as a big linguistic joke in order to visually il-
lustrate this connection as a network of lines crosses over and con-
nects the chicks and the eggs laid above crack open to release two

species. As published in Moholy's *60 Fotos,* the caption reads, "Correspondence of action and position in space." This visual pun splits the word open. One variant of the photomontage spells it out even as it marks this difference, *huhn bleibt HUHN.* In this manner, with this concrete typo-photo gesture, Moholy returns to the meat of the pun — the chance meeting in the signifying materials that doubles over meaning. Listening to the subtext of this plastic, Moholy voyages again with Ulysses via an image condensation of "the poeticizing of sirens" (*Sirenenverdichtung*), which is the subtitle of the 1927 version. The piercing tones involve the punning condensation of the linguistic material which sounds awful for identity. From the alarming perspective of the materiality of language, *huhn bleibt HUHN* might then sound off like "Ho, ho, ho!" — the cackle and cacophony of the chicken clucking away in its phonetic terms.[57]

Moholy extends his chicken and egg research in a number of directions.[58] Here are some data. As an afterthought to this montage, Moholy writes the filmscript entitled *Once a chicken, always a chicken.* As previously discussed, this peculiar inter-media work remains a self-contained shooting script for a film that is never shot. But that is not all. As this network cuts across, it weaves an irregular intertextual web that asks where this plot could have been hatched. Moholy throws eggs into the light with photograms that dematerialize the egg from the shell of meaning or that employ an eggbeater to demonstrate light modulation. Or Moholy undertakes poached experiments to test the crushing limit of an eggshell.[59]

The filmscript *Once a chicken, always a chicken* follows the silent film tradition of a Keystone Kops comedy. In terms of its merzian origins, the structure of the filmscript owes much to Kurt Schwitters's *Auguste Bolte* (1923). Moholy borrows the digitalized permutations of Schwitters's narrative action that starts from a ratio of one to ten and then splits itself sequentially by subdivisions down to a one on one confrontation. In Moholy's parallel action, a woman who has sprung from a shell pursues ten masked men through the maze of the city until she catches one. *Huhn bleibt HUHN* also features an elaborate chase scene as the scrambling eggs pursue the populace and one masked man (Moholy's anonymous point of identification) in particular. The film scenario also pranks with bits of slapstick violence — a girl hit with a bucket of water from a washerwoman above, a postman flinging the girl into a notice board. There are other scenes of acrobatic

juggling and egg breaking. Throughout the script, one witnesses the cycles of rebirth and the dissemination of the eggs as these signifying materials roll along. The script enables Moholy to enact his punning equation in a visual literalization. Like Clark Kent into Superman, the egg enters a hotel room and checks out as a superchick, flicking "broken shells from her dress."[60]

Autobiographically speaking, back to the days of his youth, Moholy offers a "Confession" which sheds further light on this punning equation animating the photomontage and the filmscript. The question runs, "Why would you change places with any other human being?" Moholy responds by means of the photoplastic adage: "When I was a child I thought that I was a king's son, who had been exchanged for another, but who later would come into his own. Today I know that one is what one is . . . chicken stays chicken."[61] Despite Moholy's assertion of self-knowledge, this simple equation (i.e., one is what one is, chick = chick) — a seeming identity in the semes — substitutes. Some graphic and temporal difference slips into the equation so that "I" is "exchanged for another." In losing the fixed identity of the biographical subject, *A Chick Remains a Chick* adds something extra (i.e., remains). For a change, another version of this photomontage has the moving inscription "metamorphosis."

Moving from land to sea, many of Moholy's jokes happen aquatically. This serves as the photoplastic medium for transmutation and the quick liquification of the language. In the essay "Theater, Circus, Variety," Moholy poses a number of theatrical strategies for further exploration. He calls for "comic-tragic, grotesque-serious, minor-monumental, recurrent hydraulic spectacles [*wiedererstehende Wasserkünste*], acoustic and other pranks."[62] To draw a direct line of comparison, these hydraulic pranks are Moholy's version of Joyce's "wassarnap."

Subject to a play on words, myth is inverted in *Leda and the Swan* (subtitled *Der umgekehrte Mythos*). The usual form that the story (and Zeus) takes is of a swan who comes to earth to lie with Leda and to crossbreed both Helen and Pollux. In Moholy's (in)version, Zeus is climbing the walls and ducking out of the way of a lady (presumably Leda) who is swan diving her way downwards.[63] Judging from the lower part of the plastic, this swan dive transforms her literally as she touches bottom in the form of this most poetic bird and wordplay.

Another bucket of water to the head, *The Hydrocephalus* (*Der Wasserkopf*) brings another example of these hydra-headed hy-

19. Laszlo Moholy-Nagy, *The Hydrocephalus,* 1925, gelatin silver, 12.9 x 17.9 cm. (Collection of the J. Paul Getty Museum, Malibu, California)

draulic visual-verbal punning monstrosities (Figure 19). The German word means diver, or he who plummets down to the depths of the sea. Along the way, it stands for divers other things for which, if the English word waterhead is used, there is no room to speak about. For *Wasserkopf,* unfortunately, also refers to a childhood disease in which fluids accumulate in the cranium. This expands the skull and induces memory lapses or a failure in the mental faculties. Thus, the stream of *The Hydrocephalus* (unconsciously) runs through to the photomontages *Der Trottel* and *Mein Name ist Hase: Ich weiss von nichts.* They link up as those autobiographical works of the hollowing out (*Hohlheit*) of Moholy where he plays the fool and loses his head, himself.[64] Moholy casts himself into a diver's suit and helmet, a few of its screws loose, in order to have water on the brain.

Not to be drowned out with laughter, there is another undersea exploration to be added to this aqueous exhibition which has the alternative title of *Unterseeboot* (Figure 20). This denotes the usage of the submarine underseeing the situation. The star fish of

20. Laszlo Moholy-Nagy, *City Lights*, n.d., gelatin silver, n.s. (Collection of the J. Paul Getty Museum, Malibu, California)

this story is slapstick comedian Charlie Chaplin, and this work must be seen as Moholy's homage to the laugh master of modern times. There he stands helpless (Title 2: *Da stehst du machtlos vis à vis*) in a typical Charlie Chaplin stance. But something is underfoot. There is an undertow or a catch which causes a sudden reversal. With a trick of projection, the perspective shifts and the tiptoeing low chap on the totem pole with the big shoes has made the fat ladies the butt of the joke. In spite of his low position, it turns out that Charlie's hustle has given him the best view in the city. Through these circus acrobatics, the boylike man finds a peephole. Given this new vision perspective, Moholy shows how *ho* deflates, inverts, or even perverts myth. In the vein of the photoplastic named *City Lights,* this becomes a golden rush of streaming laughter.[65]

Given the grafts of language, the inexhaustibility of signs meeting up and the jokes they exchange, James Joyce, unbeknownst to himself, offers an homage to Holy Mahogany in *Finnegans Wake* as a hi or hello to *ho.* "(The meeting of mahoganies, be the waves . . . and his two nurserymen advisers suggested under genus Inexhaustible.)"[66] This parenthetical statement suggests the writing of/on the pun as a ceaseless practice of chance meetings squaring off the significance of the signature with the arbitrariness of its graphic inscription. It risks the subject to language, inscribes the subject "under genus Inexhaustible." It converts proper names for improper usage, of *ho* for Moholy's sake, of *joy* for Joyce's sake. In arranging a number of meetings among these "nurserymen advisers" of visual/verbal homophonic languages, it is hoped this writing, too, by waving (to) both, will have encountered or acknowledged that excessive labor.

### Hole in Whole

*Laszlo Moholy-Nagy*
**180**

Openings and boundaries, perforations and moving surfaces carry the periphery to the center, and push the center outward. A constant fluctuation, sideways and upwards, radiating. — Laszlo Moholy-Nagy, *The New Vision*

The pronunciation of the middle three letters of the Moholy signature yields two proper spellings, *hole* and *whole. H-O-L* divides Moholy through a homonyn of contradictory meanings. Like inter-media, the midsection of Moholy's signature plays between the meanings. *H-O-L* spells out a homonymic word asso-

ciation which upsets and which will not be stomached whole. If autobiography follows the autograph, this complication in the communication should split the subject and his artistic practice between two opposite goals — for totality *and* for cutting up. With this dislocating fracture, this perforated boundary, the signature performs a juggling act, juggling the body of autobiography. Given this chance, half a chance, the autograph doubles over and splits its sides, so to speak, sliding in this schizophrenic schism, a constant fluctuation sideways between *hole* and *whole*. Openings and boundaries. *Hole in Whole,* the slip of the signature radiates and writes a duelling *duo-biography.* From the point of view of the biographical subject, the desire to live up to the demands of the signature and in the service of its split might be quite maddening or upsetting. Confirming the infirmity to the letter are the words of one European commentator reviewing Moholy's artistry, " 'Don't be taken in by the fact that this young painter makes excellent use of color. He's crazy.' "[67] At first, one might also render this judgment upon an analysis that poses the significance of the relationship between the autograph and autobiography. But the biographical writings must take this risk, given these chance/necessary meetings, this double cross of the *hole in whole* and Moholy. It runs with it, slipping and sliding with the signature or its significance, flipping back and forth between the signature external to meaning and meaning in the service of the signature.

In letting out this leak, the anonymous European critic remains an exception. For the history of Moholy criticism, particularly when it concerns the question of inter-media artistry, ties everything together into a coherent and rational whole. The analysis excludes the possibility of any madness in the method or of anything which would escape accounting. The critics have gathered together to gather together Moholy and his wide range of experiments in order to encompass and to enclose, to control Moholy as a closed identity and as a fixed or identifiable biographical object of study. These containing critics have carried the peripheral and the marginal — every opportunity for spillage or displacement — to the center, to a core of the matter through which all of Moholy's activities have then been read, and through which biography has been understood. But like good critics, they cannot agree on the centerpiece of the story. For one writer, the self-defining discipline is photography. Photographs and secondarily photograms give a "sense of primary identity . . . central to his aes-

thetic."[68] Another critical voice shifts the center to painting and dubs it "the vital thread linking all his manifold activities."[69]

For Walter Gropius, too, Moholy's "manifold activities" push outward from a powerful painting center. Gropius expresses great anxiety regarding the dissemination of Moholy's artistic powers (a "mistake to imagine"), a practice of spillage and seepage that loses or diminishes the biographical subject along the way in the "manifold" play of the signature (e.g., of hole in whole) folding over on the man and ruining the "whole work." Therefore, the Bauhaus director must reclaim every "by-path" or "indirection," every road not taken, every possibility for wasting effort. They must be brought back into line and onto the road that masters and conquers the whole. Gropius's version of Moholy's artistic career fights for the new vision in the name of the whole.

> It would, however, be a mistake to imagine that the man-
> ifold activities of Moholy in the spheres of photography,
> the theatre, the film, typography and advertising art must
> have diminished and disseminated the powers of Moholy the
> painter; on the contrary, all his successful efforts in these
> spheres were merely indirect but necessary by-paths on the
> road to his conquest of a new conception of space in paint-
> ing. . . . His whole work is a mighty battle to prepare the way
> for a new vision.[70]

In spite of Moholy-Nagy's edges and the stress on "perforated boundaries," the critics cling to a unity of purpose and subordinate "all his activities" to a larger end or direct them "to the same goal."[71] The critical language always institutes totalizing terms to take on Moholy. The goal is the "unity of life,"[72] the "unity of all things in relation to life,"[73] "a totality of vision,"[74] and "a holistic vision."[75] If pressed on the matter, they will admit (reluctantly) that Moholy was an artistic adventurer or an eclectic who sought variety—but just so long as the spice of his life is tempered, so that it all adds up to a coherent object of study, the *ouevre* of Moholy-Nagy, in conformity with a *logos* and *telos* which under-lies it all. As Richard Kostelanetz concludes, "He was the best kind of eclectic, which is to say, someone whose various choices are informed by an underlying purpose, a coherent logic."[76]

This coherent logic of the whole and of the total man does not restrict itself to critical accounts of Moholy. It must be admitted that the desire for the whole and the lure of totality inform the word choices that constitute Moholy's manner of speaking about

his own work, "a blending of independent elements or events into a coherent whole."[77] In this piece of writing, impersonal and independent elements, whole and Moholy's signature, are blending together, if not forming a coherent whole. In fact, the whole plays its part to the fullest in a range of instances throughout Moholy's writings. Moholy desires it all: "the conscious organization of the whole of life,"[78] "to master the whole of life."[79] These terms track a superlatively speaking logic of domination and mastery with the whole of life as its object. Moholy is "pointing through each function to the wholeness of the solution."[80] The total demand of his signature must be kept.

This holistic approach would provide an interpretative framework for Moholy's association with and departure from the Bauhaus. A review of the initiating Bauhaus program from 1919 reveals a rhetoric that strives for a unity of *all* specialized artistic disciplines. To recall these aims, "The Bauhaus strives for the collection of all artistic creation; the unity, the reunification of all artistic disciplines — sculpture, painting, arts and crafts, and handicraft."[81] Indeed, it is the move towards specialization at the Bauhaus and the departure of Gropius that force Moholy to hand in his resignation. His letter protests that which "overlooks the development of the whole."[82] Following the logic of mastery and domination, Moholy believes that the whole will regulate the future of the arts as well. Following Gropius's rhetoric of the architectural *Einheitskunstwerk,* all the pieces of the scheme must fit together: "The future conception of architecture must consider and realize the whole." "All the functional parts taken together must be conceived in the whole" — and there's more — "as a whole."[83]

Nevertheless, these statements point to some cracks in the logic of the whole and its functioning. For instance, one might become suspicious of all the repeated calls for that which should be complete in and of itself, once and for all. Furthermore, Moholy often projects things into the future when he speaks of the whole. These reservations would make one believe that something is missing, that the whole is only make-believe. The rhetoric of the whole offers a thin cover for a brand of Utopian idealism which operates in a future perfect tense whose "architectural" blueprints will always have fallen short of their presentation. The teleological tonality of the whole is underwritten by a lack which is projected into the future and it spells out Utopia.[84]

There is a loophole in the whole, a hole in the one. This is

its silent partner that registers a pronounced difference. It is a shadow in the whole that haunts it, appearing only when it gets written out — a silent *w* as in writing. While the logic of the whole involves full meaning, the hole lodged within the whole provides something else which is missing. Employing a silent writing, the hole charts its responses *in absentia*. The hole must not be read as a thing or concept, but rather as an effect of displacement, that which opens the space for such things. For this is how the hole works itself (out). Missing in their actions and meanings, Moholy's holes show what "overlooks the development of the whole," why there is always a need for more "through each function," why there is always more than the whole can contain. With these abstentions and displacements, the signature hole gives space to the dissemination of Moholy's powers so feared by Gropius. The hole gives way to the confounding of the biographical subject as a fixed identity.

Every Moholy space modulator works out of the void, *Warping the plane by the locomotion of points,* for instance, or *Space Modulator in Cork* (1935). In the *Light Space Modulator,* the machine most attached to Moholy's name, the hole at the front leads to an "electric glow" illumination. A spot for blinding light as well as a blindspot, the graphics of the signature hole open the space for the visible, as the space in which the whole of meaning will have been inscribed and mounted. The aperture, its spacing, allows for the staging of the design. Here is an attempt at its description: "The model consists of a cubical box, measuring 120 x 120 cm., with a round hole (stage aperture) at the front. Around the hole there are yellow, green, blue, red, and white electric glow lamps mounted on the near side of the plate."[85]

It must be recalled that every modulator or light box necessitates cutting out the hole for its operation. "If now you cut or tear a hole near one corner as in Figure 5, you can observe the change in light and shadow."[86] Though nothing in and of itself, the hole carves out the modulating play of light and shadow. Writing on modern sculpture, Moholy speaks for himself, for the modern sculptor, and for the writing of a bilingual signature effect: "He dares to proceed more drastically: to make huge indentations, holes, 'hollow spaces.' "[87] The plasticity of the space of modern sculpture modulates the signature hole. With a daring and drastic gesture, displacing and spacing (out) the biographical subject, the cut of these signatures (holes and hollow spaces) opens the possibility for Moholy's reinsertion some space else. Moholy lists

any number of these space displacers — "the negative volume, the void, the hole, the opening" — as "outstanding plastic elements" which stand out by standing out and even risk sending him away.[88] Like hole in whole, it is difficult to perceive the presence of this absence, or the lack of this black. For what is black? What is the other of light itself? Attentive to the hole's evasion of objecthood, Moholy can only "pin-point" it — humorously, in this demonstration, responding to a voice up front, "a pin-point hole in a box," that is about as black as it is possible to get:

> *Voice from the Audience:* A hole in a box lined with black.
> *Mr. Moholy-Nagy:* The gentleman out in front is correct. You put a pin-point hole in a box that is lined with black velvet and this is as black as it is possible to get.[89]

For Mr. Moholy-Nagy, the play of the signature hole will not be pinned down as an essence or a substance — to be boxed in or pigeonholed. This evasive and evading stipulation spills over to an experiment carried out by two of Moholy's old associates, Kurt Schwitters and Raoul Hausmann. In 1946, the year of his death, Moholy acts as the intermediary or dispatcher who sends Schwitters's new address to Hausmann. Thanks to this avant-garde act of networking, the other two men begin working on a pen-pal project, *PIN,* shorthand form of Pinhole (a collection of pieces) as a shared statement of pricking purpose. PIN is an acronym where "Poetry Intervenes Now," an intervention of presence. Like a light box made for looking or for creeping through, project PIN prints VOID. It punctures holes, in effect, for the whole of art, for all that it is about. The signature, PIN, is designed to put out the "pinhole" that moves people around. According to the *PIN* manifesto, " 'Pin' is the hole people have to creep through in order to see what art is all about."[90]

There is no doubt that Moholy's name could be lent as a contributing editor to this interlinguistic project quite easily. And it is important to recall, not only how the pinhole impacts upon Moholy-Nagy, but, moreover, how the pin, in German translation, has been implanted into the second part of his signature as well. In this way, the significance of the second half of the artistic signature in the German linguistic register resonates with a common noun that pegs or nails him (i.e., as *Nagel,* peg or nail) and that enters into his artistic practice. As a supplement to *PIN,* or somewhere in the body of its text (e.g., next to the illustration of the riveting stigmatic photogram of a nail in an anonymous

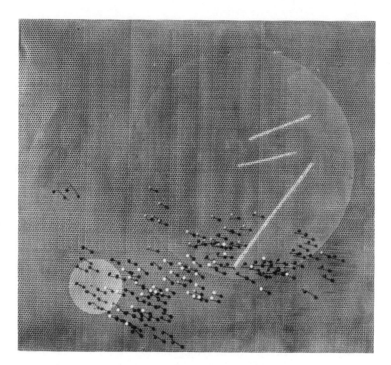

21. Laszlo Moholy-Nagy, *Space-Modulator L3,* 1936, oil on perforated zinc and composition board, with glass-headed pins, 43.8 x 48.6 cm. (Courtesy of The Museum of Modern Art, New York)

hand), Moholy's *Space-Modulator L3* (1936) would fit right in with its pins and pinholes, the shadows cast by the pins (Figure 21). This piece is subtitled by Moholy-Nagy "Deformation of a surface by the displacement of points." And, in the letters to the editor section of this imaginary volume of *PIN,* one would make a point of documenting the 1943 correspondence which reviews the offer made to Laszlo Moholy-Nagy, alias "Holy Mahogany," to undertake a commercial project to design wooden dowel pins for the J. G. Edelen Company.[91]

However, the reader is warned of the dialectical traps which threaten analysis — of conceptualizing hole in whole or of pairing off the whole and the hole. This threatens to set up a greater indivisible whole — even as Moholy writes — through the "combined use of both as mutually interdependent components of an indivisible whole."[92] But the split of the subject will not be solved if and when whole + hole = Moholy. When Sibyl Moholy-Nagy interprets Moholy's sign of the cross — the gesture of the grill — to

gain a better understanding of collage, she adds things together, whole and hole. The analysis brings this symbol into line with a unity of purpose, the "drive toward integration," the symbolic order, and a greater whole: " 'I could make your father understand a collage,' he said. 'I'm sure I could. If I had a chance to explain the basic idea to him—the overlying planes and the relationship of color and texture.' He crossed his spread fingers in the form of a grill, a gesture which I later came to accept as the most characteristic expression of his drive towards integration."[93]

But the grill performs a (double) gesture that exceeds this logic of totality. In the interspace of ten fingers folded over, *hole* in *whole* crosses up for a spread that risks full meaning in a return to the signature, its chance or its removal. It offers a different collage picture than the one that Sibyl believes Moholy has intended for her father. Instead, the graphic hole-ridden excesses of collogic— its "*over*lying planes [my italics]"—takes each and every element as another addition, the chance for the inscription of another signature effect. From this angle, the whole itself may be read as an incomplete addition which has been grafted upon a locally constituted site. *New Vision* introduces "massing" (*häufung*), that which disorganizes the organism, turns the arrangement into synthetic matters of addition and subtraction: "In the mass arrangement of surface units there are no organic relations, the whole often being not synthesis, but mere addition."[94]

Given this particular arrangement of the textural material, the whole object, the objectification of the critical whole-mongers, has been translated into something else, to be called a *totality-effect*—"not synthesis, but mere addition," a play on the signature, a hole displacing itself, a " 'part' bigger than itself," the *(w)hole*.[95] Returning to the epigraph, this remarking makes for constant fluctuations and reformulations of the biographical text—of openings and boundaries, perforations and moving surfaces, moving the periphery to the center, or with another addition or a strange subtraction, transforming the center outward.

Through the use of other figures, Moholy registers the totality effect that comes (w)holesale. The possibility of mere addition, the chance for something else, "and so on," gives 100% and an incalculable return, "what-not." Though Moholy was educated as a lawyer, with the law's rules and regulations, his dabbling cuts across a terrain that tests the whole and experiments with totality. This equation combines one-fourth scholarship, three-fourths artistry, and something extra: "I love to dabble.

That is what made me what I am today. I was educated as a lawyer, but because I dared to dabble with plastics and wood and so on, I gained a wide experience. . . . Today I am 25% scholar, and 75% an artist and a what-not."[96]

This doubling and dabbling writing of whole and hole has been brought to bear on the profession of art history for the scholar, for the artist, and indirectly, for the what-not. Richard Kostelanetz's "A Mine of Perceptions and Prophesies" offers a starting point; but in the course of digging, his "Mine" is dynamited by the doubled signature effect. In this war of the words, slipping in the trenches of his signature, as if in the Great War all over again, Moholy takes more shots to his midsection. Kostelanetz writes, "Moholy possessed the art historian's competence for discerning the character and drift of the whole."[97] As it adds praise to Moholy's character, it hones in on the problem of *Hole* in *Whole* in discerning "the drift of the whole." It works the split and the slip which the signature has set up for Moholy. How can one ever be sure that the "whole drift" has not already begun to shift or to drift, to spring a leak or a hole where all has become lost? For Moholy's sake, the "drift of the whole" might be termed "vision in motion."

What of the drift and how to catch it? How to speak it? The problem for contemporary art history is how to catch the drift and its works . . . (w)hole. Following the currents of this drift, the art historian must be willing to undertake an experiment in totality that, in the service of the whole of meaning, flows with the drift of the signature effect. In this way, *Hole* in *Whole* would delineate a writing practice which questions any historical closure of the subject and its demand for totality. This writing practice gives the graphic back to biography, to Moholy's character, to the (w)hole story, to his story.

■

**After Words**

"The Significance of the Signature" has reached a rest stop. It has demonstrated how certain of the words and word particles which constitute the nickname and the signature of Moholy play a vital role in shaping his life's work. To repeat the graphic formula, autobiography has followed the autograph. Following Cratylus's position, this procedure has provided an alternative way to understand biography: the meaning of one's life is motivated or written by the common nouns that constitute his or her signature.

*Ho* leads Moholy to play with puns in his photoplastics and to privilege Joyce's writing. *Holy* enmeshes Moholy in a spiritual quest for an art of holy light-writing effects. The hyphen turns Moholy into an inter-media artist. The pairing of *whole/hole* divides his life between the demands of totality and cutup. This strategy of biographical writing has inverted the standard practice where the signature of the subject is merely an arbitrary convention and where the significance of a man's life is to be found in a history unmediated by language. In other words, it has flipped the locus of significance from the historical subject to the linguistic signature.

But "The Significance of the Signature" has not stopped with this inversion. In a countervailing movement, one has witnessed how the "meaning" of each of these signatures risks significance and displaces Moholy's status as a fixed biographical subject. Each term has opened the space of the arbitrariness of the signature. With *ho,* he hits the materiality of puns that turn him over to chance meetings, to the impersonality of language, and to condensed meaning explosions. With *holy,* he institutes a practice that empties or removes the self as a signified subject. With *hole in whole,* he encounters the signature hole that enables or exceeds the whole of his meaning. Through the hyphen of inter-media, Moholy-Nagy is disposed by the mark of a graphic inscription that moves him between the artistic means. Therefore, in each of these ways, these signatures have brought displacement and exteriority to bear upon the status of the biographical subject and his significance even while they have posited the significance of Moholy's life as determined by these signatures. All in all, one might conclude that these linkages and these breaks are effects of the biographical writings.

# Signature's Postscript: Moholisch/Like Moholy

In a eulogistic letter, Xanti Schawinsky imparts a piece of information about his friend's monstrous relationship to the German language. "Some of his German writings are almost incomprehensible, their writing so complicated that '*moholisch*' has become a new term in the German vocabulary, just like '*faustisch*.' "[1] This exaggeration brings a happy endnote for biographical writings preoccupied with the problem of writing for the subject of biography. A man devoted to the problems of artistic signature becomes embodied as a new linguistic sign. Thanks to an adopted signature, his name detaches from himself and becomes a part and piece of language. Moholy achieves eternal life in the chains of signification, while the legendary Faust suffers infernal and eternal damnation. He crosses over the threshold and into the line of writing as his proper name becomes a common noun.

Indeed, the ruses of the signature multiply even further. Even though Moholy does not achieve German citizenship, the language naturalizes him. The proper name is reprocessed as an idiom. It is put into common use and achieves a life of its own. The German language makes this foreign body, Moholy, a favorite son on account of his relation of *exteriority* to that language. On account of Moholy's non-mastery of the language, the German reader stumbles over his reading and can neither settle down to meaning nor account for his words. And for that reason, they honor his name. It is quite a paradoxical operation, this *moholisch*. Schawinsky's definition shows how the complicated or

the almost incomprehensible establishes part of Moholy's legacy. While it has not been the goal of this study to overcomplicate matters or render incomprehensible in the name of Moholy, this definition points out some of the obstacles in the way of a completely comprehensive and comprehensible account of the biographical subject.

*Laszlo Moholy-Nagy: Biographical Writings* has tried to be worthy of this name. This translates as "moholyish." It hopes to have stood on the side of the signature that it has put into play and that has put it into play — *moholylike*, like Moholy.

■

# Notes

## Introduction: Signing on Moholy

1  Stephen Bann, ed., *The Tradition of Constructivism* (New York: Viking, 1974), p. xviii. This book was part of The Documents of 20th-Century Art series (edited by Robert Motherwell) which was so formative in shaping the textual canon of Modernism.

2  Laszlo Moholy-Nagy, *Vision in Motion* (Chicago: Paul Theobald, 1946), p. 12.

3  Ibid.

4  Moholy reproduces this astounding photograph and cartographical key on facing pages of *Vision in Motion*, pp. 314–15. In his analysis of the event, one might think that the old Constructivist as art historian protests too much in hindsight. The photograph shows otherwise. It should also be noted that, while absent from the photo, Kurt Schwitters also attended the meeting.

5  For a fuller discussion of the fascinating intersection between Dadaism and Constructivism, see the exhibition catalogue *Dada-Constructivism: The Janus Face of the Twenties* (London: Annely Juda Gallery, 1984).

6  History's debt to the writing of the signature is conveyed by Jacques Derrida along the following lines: "That history is tied to the possibility of writing; to the possibility of writing in general, beyond those particular forms of writing in the name of which we have long spoken of peoples without writing and without history. Before being the object of a history — of a historical science — writing opens the field of history — of historical becoming. And the former [*Historie* in German] presupposes the latter [*Geschichte*]." In *Of Grammatology*, trans. Gayatri Chakravorty Spivak (Baltimore: Johns Hopkins University Press, 1976), p. 27. More attuned to the writing of the present story — a biography of Moholy that acknowledges and records the possibility of writing in general — the final sentence might read, "The former, biography, presupposes the latter, the *graph* (Writing)."

7  For an exemplary engagement of the questions of writing and the graphic dimension for history, see the texts of Michel de Certeau, particularly, *The Writing of History*, trans. Tom Conley (New York: Columbia University

Press, 1989). A number of de Certeau's historiographical selections are translated in *Heterologies: Discourse on the Other,* trans. Brian Massumi (Minneapolis: University of Minnesota Press, 1986).

8  For historical and archival details on this chapter of the Bauhaus, see Peter Hahn, "Kunst und Technik in der Konzeption des Bauhauses," in Helmut Friedel, ed., *Kunst und Technik in den 20er Jahren* (Munich: Stadtische Galerie im Lenbachhaus, 1980), pp. 138–48.

9  Here, Derrida reads Freud's (grand)child's play of *fort/da* in *Beyond the Pleasure Principle,* "according to the supplementary necessity of a parergon, as an autobiography of Freud." Jacques Derrida, "To Speculate on Freud," in his *Post Card: From Socrates to Freud and Beyond,* trans. Alan Bass (Chicago: University of Chicago Press, 1987), p. 303.

10  In speaking of *Ulysses,* Derrida admits, "if its analysis is not exhausted by any of the forms of knowledge available precisely because it laughs at knowledge and from knowledge, then laughter bursts out in the event of signature itself." This outburst of laughter in the face of knowledge will be reactivated in the "Ho" section of "Moholy: The Significance of the Signature" in the tele-programming of a certain Joycean laughter in the event of the Moholy signature itself. See Jacques Derrida, "Ulysses Gramophone: Hear Say Yes in Joyce," in Peggy Kamuf, ed., *A Derrida Reader: Between the Blinds* (New York: Harvester/Wheatsheaf, 1991), p. 590.

11  Jacques Derrida, *Glas,* trans. John P. Leavey, Jr. and Richard Rand (Lincoln: University of Nebraska Press, 1986), p. 4.

12  Ibid.

13  Peggy Kamuf, *Signature Pieces: On the Institution of Authorship* (Ithaca and London: Cornell University Press, 1988), p. 13.

14  Jacques Derrida, *Signéponge/Signsponge,* trans. Richard Rand (New York: Columbia University Press, 1984), p. 56.

15  Derrida, *Glas,* p. 19.

16  Jacques Derrida, "Signature Event Context," in his *Margins of Philosophy,* trans. Alan Bass (Chicago: University of Chicago Press, 1982), pp. 328–29.

17  Derrida, *Signéponge/Signsponge,* p. 64.

18  Ibid.

19  See Jacques Derrida, "Parergon," in *The Truth in Painting,* trans. Geoff Bennington and Ian McLeod (Chicago: University of Chicago Press, 1987), pp. 15–148.

20  Gregory L. Ulmer, *Teletheory: Grammatology in the Age of Video* (New York and London: Routledge, 1989), p. 162.

21  Derrida, *The Truth in Painting,* p. 18.

22  Jacques Derrida, "Otobiographies: The Teaching of Nietzsche and the Politics of the Proper Name," in his *The Ear of the Other: Otobiography, Transference, Translation,* ed. Christie V. McDonald, trans. Peggy Kamuf and Avital Ronell (New York: Schocken, 1985), p. 5.

23  For a discussion of these issues, see Hayden V. White, "The Burden of History," in *Tropics of Discourse* (Baltimore: Johns Hopkins University Press, 1979), especially pp. 27–28, 43–44.

24  The German text reads, "Da geschah es nun, dass mit Moholy-Nagy eine neue, uns ganz fremde Welt in das Bauhaus kam, die uns zu bedrohen schien." In Lothar Schreyer, *Erinnerungen an Sturm und Bauhaus* (Munich: Albert Langen, 1956), p. 238.

25  As for the original German, "Die massgebenden Lehrlinge und Gesellen Weimars lehnten Moholy-Nagy ab, nicht als Künstler, sondern als Menschen. Es ist furchtbar, das zu sagen." In Schreyer, *Erinnerungen an Sturm und Bauhaus,* p. 238.

26  For a discussion of homonymy as a signature strategy of applied grammatology in "directing the relation of the proper name to common nouns," see Gregory L. Ulmer, *Applied Grammatology: Post(e)-Pedagogy from Jacques Derrida to Joseph Beuys* (Baltimore and London: Johns Hopkins University Press, 1985), pp. 26–29.

27  Laszlo Moholy-Nagy, *Painting, Photography, Film,* trans. Janet Seligman (Cambridge, Mass.: M.I.T. Press, 1969), p. 21.

28  Sibyl Moholy-Nagy, *Experiment in Totality* (New York: Harper and Row, 1950), p. 202.

29  Peter Galassi, "Laszlo Moholy-Nagy" is the electronic entry in the *Academic American Encyclopedia* (n.p.: Grolier Electronic Publishing, 1993).

30  Werner Spies, *Victor Vasarely* (New York: Abrams, 1971), p. 20.

31  Gaston Diehl, *Vasarely,* trans. Eileen B. Hennessy (New York: Crown, 1973), p. 8.

32  Otto Stelzer, postscript to *Painting, Photography, Film,* by Moholy-Nagy, p. 145. The inserts are taken from the German version, *Malerei, Fotografie, Film* (Munich: Albert Langen, 1925), p. 143.

33  See the exhibition catalogue *ZERO Bildvorstellungen einer europäischen Avantgarde 1958–1964* (Zurich: Kunsthaus Zürich, 1979).

34  For the range of connections between Moholy and Group ZERO, see the work of Hannah Weitemeier, "Schatten einer Lichtvision," in the exhibition *Vision und Bewegung: Werke aus der Sammlung Lenz Schönberg* (Munich: Städtische Galerie im Lenbachhaus, 1988), pp. 21–41.

35  For illustrative purposes, see *Groupe de Recherche d'Art Visuel 1960–1968* (Milan: Electa, 1985).

36  Gregory L. Ulmer, "Op Writing: Derrida's Solicitation of *Theoria,*" in *Displacements: Derrida and After,* ed. Mark Krupnick (Bloomington: Indiana University Press, 1983), pp. 38–39.

37  Ibid., p. 40.

38  In Andreas Papadakis, Catherine Cooke, and Andrew Benjamin, eds., *Deconstruction,* Omnibus vol. (London: Academy Editions, 1989), p. 7.

39  James Wines, "The Slippery Floor," in *Deconstruction,* ed. Papadakis, Cooke, and Benjamin, p. 138.

40  See "Jacques Derrida in Discussion with Christopher Norris," in *Deconstruction,* ed. Papadakis, Cooke, and Benjamin, p. 70.

41  See, for instance, Derrida's speculations upon the work of Tschumi in the piece "Point de folie—Maintenant l'architecture," in *AA Files* (London) 12 (summer 1986): 65–75.

42  Papadakis, Cooke, and Benjamin, *Deconstruction,* p. 76.

43  Laszlo Moholy-Nagy, *The New Vision and Abstract of an Artist* (New York: Wittenborn, 1947), p. 59.

44  Ulmer, "Op Writing," p. 41.

45  Laszlo Moholy-Nagy, *Vision in Motion,* p. 150.

46  Ibid., p. 160.

47  For more of Derrida's writing on/of the *double band,* see *Dissemination,* trans. Barbara Johnson (Chicago: University of Chicago Press, 1981).

48 Laszlo Moholy-Nagy, *The New Vision*, p. 86.

49 Ibid.

50 Jacques Derrida, *The Archaeology of the Frivolous*, trans. John P. Leavey, Jr. (Pittsburgh: Duquesne University Press, 1980), p. 133.

51 Kurt Schwitters, "Merz (1920)," trans. Ralph Manheim, in *The Dada Painters and Poets*, ed. Robert Motherwell (New York: Wittenborn, Schultz, 1951), p. 60.

52 See S. Moholy-Nagy, *Experiment in Totality*, pp. 22–27.

53 Kurt Schwitters, "Mein Merz und Mein Monstre," *Der Sturm* 17 (1926–27): 106. The German text reads: "Vor einigen Jahren hiess es noch: 'Kandinski, Klee, Kokoschka,' alles mit K. Davor hiess es Lissitzky mit L. Wir machen eben das ganze ABC der Entwicklungen durch. Heute ist nun die Mode bei M angelangt, weil eben das Alphabet so weitergeht. Und eines Tages, wenn die Entwicklung bis S gekommen sein wird, heisst es plötzlich: 'Schwitters.' Ja, ja, Kunst ist Mode."

54 L. Moholy-Nagy, quoted in S. Moholy-Nagy, *Experiment in Totality*, p. 106.

55 Laszlo Peter, "The Young Years of Moholy-Nagy," *The New Hungarian Quarterly* 13, no. 46 (1972): 63.

56 The upraised palm also can be read like a stop sign, and this call to halt may be indicative of the writing of the signature.

57 Laszlo Moholy-Nagy, "Dynamic of the Metropolis," in *Painting, Photography, Film*, by Moholy-Nagy, p. 132. The original reads, "Grossaufnahme. NUR die HAEnde mit den Kugelhandschuhen."

58 School of Design in Chicago catalogue, p. 15, Illinois Institute of Technology Archive, Chicago.

59 School of Design in Chicago catalogue, p. 9, Hattula Moholy-Nagy Archives, Ann Arbor, Michigan.

60 Ferdinand Ostertag, "Laszlo Moholy-Nagy Horoscope," December 1, 1946, Hattula Moholy-Nagy Archives.

61 Laszlo Moholy-Nagy, quoted in S. Moholy-Nagy, *Experiment in Totality*, p. 106.

## 1 Production-Reproduction

1 Laszlo Moholy-Nagy, "Directness of the Mind; Detours of Technology," *Bauhaus* I (1926; rpt. in Richard Kostelanetz, ed., *Moholy-Nagy* [New York: Praeger, 1970], p. 188). I have altered Sibyl Moholy-Nagy's translation somewhat based upon the original text of "Geradlinigkeit des Geistes-Umwege der Technik."

2 Tilman Osterwold, in *Moholy-Nagy*, ed. Wulf Herzogenrath and Hannah Weitemeier (Stuttgart: Verlag Gerd Hatje, 1974), p. 127. The German text runs as follows: "Der Künstler, wie zum Beispiel, Moholy-Nagy, revolutioniert zwar die Medien inhaltlich, in dem er seine ungenutzten Möglichkeiten freilegt — unten dem Einsatz von Phantasie, Ideen, Gefühl, Intellekt — verändert aber nicht die Funktion des Massenmediens."

3 Laszlo Moholy-Nagy, "Produktion-Reproduktion," *De Stijl* 5, no. 7 (1922): 97–101 (rpt. and trans. as "Production-Reproduction" in Krisztina Passuth, ed., *Moholy-Nagy* [New York: Thames and Hudson, 1985], p. 289).

4 In *Grammophon Film Typewriter* (Berlin: Brinkmann and Bose, 1986), Friedrich Kittler grooves to the beat that converts an avant-gardist Moholy

into mass cultural king and pop of hip-hop. A New York DJ adds this track to the mix: "*Bis noch die Disc Jockeys von New York aus den esoterischen Graphismen eines Moholy-Nagys den Alltag von Scratch Music machen.* (Until when the Disc Jockeys from New York make the everyday scratch music out of the esoteric graphism of a Moholy Nagy.)" (p. 79).

5   See Laszlo Moholy-Nagy, "Production-Reproduction" (rpt. in Andreas Haus, *Moholy-Nagy: Photographs and Photograms,* trans. Frederic Samson [New York: Pantheon Books, 1980], p. 47).

6   For the discussion of "bricolage" as a reinscriptive technique, see Claude Levi-Strauss, *The Savage Mind* (Chicago: University of Chicago Press, 1966), pp. 16–20.

7   Laszlo Moholy-Nagy, "Neue Gestaltung in der Musik: Möglichkeiten des Grammophons," *Der Sturm* 14, no. 7 (July 1923): 104 (rpt. as "New Forms in Music. Potentialities of the Phonograph," in Passuth, *Moholy-Nagy,* p. 291).

8   L. Moholy-Nagy, "Production-Reproduction," in Haus, *Moholy-Nagy,* p. 47.

9   Laszlo Moholy-Nagy, "From Pigment to Light," in *Telehor* 1, 1–2 (February 28, 1936): 34. This special double issue was devoted to Laszlo Moholy-Nagy and all future citations will be to this particular issue.

10   Laszlo Moholy-Nagy, *Painting, Photography, Film,* p. 21.

11   Laszlo Moholy-Nagy, *Vision in Motion,* p. 98.

12   This alphabetical grab bag finds support in Kittler's view that Moholy's scratch writing allows for the "unrestrictive transposition from medium to medium." See his *Grammophon Film Typewriter,* p. 74.

13   Laszlo Moholy-Nagy, "New Forms in Music," pp. 291–92. The German inserts are culled from "Neue Gestaltung in der Musik," p. 104.

14   Laszlo Moholy-Nagy, "Production-Reproduction," in Haus, *Moholy-Nagy,* p. 46.

15   Laszlo Moholy-Nagy, "Problems of the Modern Film," in *Telehor,* p. 39.

16   Laszlo Moholy-Nagy, *Vision in Motion,* p. 277.

17   The writings of Michel Serres are relevant here. For a discussion of noise in language, see his "Origin of Language: Biology, Information Theory, and Thermodynamics," in *Hermes: Literature, Science, Philosophy,* ed. Josue Harari and David F. Bell (Baltimore: Johns Hopkins University Press, 1981), pp. 71–84. For a discussion of noise and interference within the productive-reproductive strategies of the parasitic double, see *The Parasite,* trans. Lawrence R. Schehr (Baltimore: Johns Hopkins University Press, 1982).

18   Laszlo Moholy-Nagy, quoted in S. Moholy-Nagy, *Experiment in Totality,* p. 68.

19   The signature of this cross-breed or this crossed-out construct crosses up the photogram with another practice, a head-on collision that may derail it in the intersection of its writing. For the second part of this term is borrowed from the highly approximate science of writing, *Of Grammatology,* which put the name of Jacques Derrida on the map and in the text.

20   Laszlo Moholy-Nagy, "Photography is Creation with Light," *Bauhaus* 2, no. 1 (1928) (rpt. in Passuth, *Moholy-Nagy,* p. 303).

21   For an extended discussion of the sovereign as the imperative form of heterogeneous existence, see Georges Bataille, "The Psychological Structure of Fascism," in *Visions of Excess: Selected Writings 1927–1939,* trans. Allan Stoekl (Minneapolis: University of Minnesota Press, 1985), pp. 145–49.

22 Laszlo Moholy-Nagy, "Space-time and the Photographer," *American Annual of Photography* 57, no. 52 (1943) (rpt. in Passuth, *Moholy-Nagy,* p. 352).

23 Laszlo Moholy-Nagy, "Production-Reproduction," in Passuth, *Moholy-Nagy,* p. 290.

24 Lyonel Feininger to Julia Feininger, February 11, 1925, "From Letters to Julia Feininger, February and March 1925," in *The Bauhaus: Weimar Dessau Berlin Chicago,* ed. Hans Wingler, trans. Wolfgang Jabs and Basil Gilbert (Cambridge, Mass.: M.I.T. Press, 1969), p. 97.

25 See, of course, Walter Benjamin, "The Work of Art in the Age of Mechanical Reproduction," in *Illiminations,* ed. Hannah Arendt, trans. Harry Zohn (New York: Schocken, 1968).

26 The original German reads: "So kurze Zeit ich am Bauhaus bin, habe ich doch schon erkannt, dass Sie alle hier an Romantik und Naturalismus kranken. Das sollte doch längst der Vergangenheit angehören und ich habe nicht erwartet, gerade am Bauhaus, diese, wie ich meine, längst überwundene Welt zu finden." See Schreyer, *Erinnerungen an Sturm und Bauhaus,* pp. 241–42.

27 For the photograph and its flanking by six variations, please refer to the design layout in Herbert Bayer, Walter Gropius, and Ise Gropius, eds., *Bauhaus 1919–1928* (New York: Museum of Modern Art, 1938), pp. 198–99.

28 W. Benjamin, "Work of Art," p. 224.

29 See also Jacques Derrida, "Freud and the Scene of Writing" (in *Writing and Difference,* trans. Alan Bass [Chicago: University of Chicago Press, 1978]) for the deployment of similar figures in order to discuss the productive-reproductive operations of the scratch pad, the Mystic Writing Pad. With the aid of this photocopying machine, Moholy is read "against the writing by which the 'subject' is himself threatened as he lets himself be written: *as he exposes himself*" (p. 224).

30 Laszlo Moholy-Nagy, "New Instrument of Vision," in *Telehor,* p. 36. This quotation, verbatim, can be found again in "Photography in a Flash," *Industrial Arts* (London) 1, no. 4 (winter 1936): 294–303.

31 This follows the same logic as the statement "He invented deconstruction" in the caption to a photo-reproduction of Derrida in Colin Campbell, "The Tyranny of the Yale Critics," *New York Times Magazine,* February 9, 1986, p. 21.

32 Laszlo Moholy-Nagy, "New Instrument of Vision," p. 35. The German asserts this point in terms of an independence from the camera, "unabhängig von jeder camera." See *Telehor,* p. 120.

33 For the most thoroughgoing review of the photogram including reprints of primary documents, analytical essays, and hundreds of abstract specimens, see Floris M. Neusüss, *Das Fotogramm in der Kunst des 20. Jahrhunderts: Die andere Seite der Bilder — Fotografie ohne Camera* (Cologne: Dumont, 1990).

34 S. Moholy-Nagy, *Experiment in Totality,* p. 27. Other debaters include Andreas Haus in the section, "On the origins and technique of the photograms of Moholy-Nagy," in *Moholy-Nagy,* pp. 13–20; and Lucia Moholy, *Marginalien zu Moholy-Nagy/Moholy-Nagy, Marginal Notes* (Krefeld: Scherpe Verlag, 1972), p. 59.

35 El Lissitzky to Mutti, September 15, 1925 (rpt. in Sophie Lissitzky-Kuppers,

*El Lissitzky: Life, Letters, Texts*, trans. Helene Aldwinckle and Mary Whittall (London: Thames and Hudson, 1968), p. 67.

36  S. Moholy-Nagy, *Experiment in Totality*, p. 44.

37  Laszlo Moholy-Nagy, *Vision in Motion*, p. 187.

38  Laszlo Moholy-Nagy to Beaumont Newhall, April 7, 1937 (rpt. in Kostelanetz, *Moholy-Nagy*, p. 57).

39  Laszlo Moholy-Nagy, *Vision in Motion*, p. 190.

40  For a discussion of how the problematics of the significance of the signature affect Moholy and his life, the reader is referred to chapter 5 of this study.

41  S. Moholy-Nagy, *Experiment in Totality*, p. 27.

42  Laszlo Moholy-Nagy to Beaumont Newhall, April 7, 1937.

43  But following the significance of the signature, it seems that Schade should have done the christening.

44  Richard Kostelanetz, "Moholy-Nagy: The Risk and Necessity of Artistic Adventurism," in his *Moholy-Nagy*, p. 7.

45  This is the very term which Moholy uses as another way to talk about vision in motion.

46  Man Ray, *Self-Portrait* (London: Andre Deutsch, 1963), pp. 128–29.

47  Originally written in French, this text was translated into the German by Dr. Walter Benjamin and published as "Photographie von der Kehrseite: Man Ray" (Backsided Photography, perhaps) in the periodical *G* (August 1922): 39–40.

48  Tristan Tzara, *Seven Dada Manifestos and Lampisteries* (New York: Riverrun Press, 1981), pp. 99–101. In the German text of the magazine *G*, see p. 40.

49  These words paraphrase the interventions of the ghost of Moholy's Weimarian contemporary investigator into the "mechanization of the intelligence," Walther Rathenau, as transcribed in the posthumous seance conducted by Thomas Pynchon in *Gravity's Rainbow* (New York: Viking, 1973), p. 167.

50  S. Moholy-Nagy, *Experiment in Totality*, p. 27.

51  See the discussion in Andreas Haus, *Moholy-Nagy*, pp. 13–20.

52  Many of the strategies which organize this section address the problematic of *iterability* in Derrida, "Signature Event Context," and in "Limited Inc abc," *Glyph* 2 (1977): 162–254.

53  The term "testamentary" is derived from a paradoxical practice of the signature, "otobiography," which through the twisting of the letter and the sound of things maintains an open ear for autobiographical studies. Constructivism lends an ear to the following text: "It is rather paradoxical to think of an autobiography whose signature is entrusted to the other, one who comes along so late and is so unknown. But . . . this testamentary structure doesn't befall a text as if by accident, but constructs it. This is how a text always comes about." See Derrida, "Otobiography," p. 51.

54  *Time*, February 18, 1946.

55  Laszlo Moholy-Nagy, *Von Material zu Architektur* (Munich: Albert Langen, 1929), p. 75. The German text reads here as follows: "was an ihm noch gestern den menschen bizarr und sinnlos schien, enthüllt sich heute als ein teil des weges zu den grossen zusammenhängen unserer in wandlung begriffenen lebensform."

56  Ibid., p. 77. The German text reads here as follows: "es entstanden bilder, in welchen selbst die in der stereometrie gebunden gegenstände verzerrt dargestellt waren."

57  See Roswitha Fricke, ed., *Bauhaus Fotografie* (Dusseldorf: Marzona, 1982), nos. 330, 337, and 339. These are beach photos shot by Irene Bayer-Hecht on the Elbe between 1926 and 1929.

58  As one typical example in the series of books on Fotoreisen, see Hein Gorny and H. E. Trieb, *Fotoerfolg am Badestrand* (Halle: Verlag Wilhelm Knapp, 1937).

59  Roland Barthes describes the haunting terms of the trace structure of the photograph that shifts the tenses in this way: "on the one hand 'it is not there,' on the other 'but it has indeed been.' " See *Camera Lucida: Reflections on Photography*, trans. Richard Howard (New York: Hill and Wang, 1981), p. 115.

60  Laszlo Moholy-Nagy, *Painting, Photography, Film*, p. 61. In the German, one notes that Moholy uses the term *Verzeichnung* rather than *Verzerrung* in the (mis)registration of the meaning of distortion.

61  See Beaumont Newhall's reflections in Leland Rice and David W. Steadman, ed., *Photographs of Moholy-Nagy from the Collection of William Larson* (Claremont, CA: Trustees of Pomona College, 1975).

62  Siegfried Giedion, introduction to *Telehor*, p. 29.

63  Laszlo Moholy-Nagy, quoted in Haus, *Moholy-Nagy*, p. 70. The German text reads here as follows: "Ich habe fast nie einen vorbedachten Plan bei meinen Fotos. Sie sind aber auch nicht Zufallergebnisse. Ich habe — seitdem ich fotografiere — gelernt, eine gegebene Situation rasch zu erfassen" (p. 95).

64  Laszlo Moholy-Nagy, *Vision in Motion*, pp. 221, 117, 128, in order of their appearance.

65  Laszlo Moholy-Nagy, *The New Vision*, p. 36.

66  Laszlo Moholy-Nagy, *Vision in Motion*, p. 116.

67  Ibid., pp. 256, 118, 120, in order of their appearance.

68  Ibid., p. 130.

69  Ibid., p. 134.

70  This quotation has been cited, with slight emendations, from Laszlo Moholy-Nagy, *The New Vision*, p. 51. The German inserts are taken from *Von Material zu Architektur*, p. 178.

## 2  Forging Ahead: The Plague of Plagiarism

1  Montaigne, "Of Pedantry," in *The Selected Essays of Montaigne*, ed. Lester G. Crocker, trans. John Florio (New York: Pocket Library, 1959), p. 71. I have taken much from Tom Conley here. See "Institutionalizing Translation: On Florio's Montaigne" (in *Glyph Textual Studies I* [Minneapolis: University of Minnesota Press, 1986], pp. 45–61) for an analysis of "the graphics of translation" (p. 57), of languages "slipping over each other in order to open upon an infinite multitude of virtual meaning" (p. 50). To translate, this has similarities with our inquiry into the graphics of the forged signature.

2  The original reads: "das erlebnis eines kunstwerks kann niemals durch schilderung zum besitz werden." Laszlo Moholy-Nagy, *Von Material zu Architektur*, p. 12.

3  Laszlo Moholy-Nagy, *The New Vision*, p. 67.

4  This is written even more belatedly, the attempt of the autobiographical "Abstract of an Artist" to construct the narrative, in good order, a personal history, that follows.

5   Laszlo Moholy-Nagy to Antal Nemeth, July 18, 1924, in Hattula Moholy-Nagy Archives.

6   Laszlo Moholy-Nagy to Ivan Hevesy, May 26, 1921 (rpt. in Passuth, *Moholy-Nagy*, p. 389). The letter reads: " 'It is exasperating that you are so susceptible to every kind of influence.' . . . Yes this was perhaps valid in the past, when I was still a receptacle of a man. When I did not say a word or think a thought, for example, if not under your influence. But that was at a time when with an unbelievable thirst for knowledge I woke up to the emptiness of previous years. You had to evoke the possibility in individual thinking in me, so that I could be somebody, a personality. . . . As for my other things, let me say this much, there is not a trace of alien influence to be found in my work; on the contrary, today, in May 1921, I stand alone in the whole European — let alone in the Hungarian — painting. One day you too are going to realize this."

7   Laszlo Moholy-Nagy, "In Answer to Your Interview," *The Little Review* 12, no. 2 (May 1929; rpt. in Kostelanetz, *Moholy-Nagy*, p. 17).

8   Paul F. Schmidt, "Der Konstruktivismus," *Das Kunstblatt* 8, no. 3 (1924): 84. The German takes the following shape: "der Suprematismus, den inbesondere Moholy-Nagy vertritt, arbeitet mit farbigen Lichtspielen auf weisser Fläche und sucht sich die Techniken des Kinos wie der Elektrizität dienstbar zu machen."

9   Alfred Kemeny, "Comments," *Das Kunstblatt* 8, no. 6 (1924): 192. Except for one alteration (substituting "hollowness" for "sterility"), the English text has been taken from Passuth, *Moholy-Nagy*, pp. 394–95.

10  Laszlo Moholy-Nagy, quoted in S. Moholy-Nagy, *Experiment in Totality*, pp. 43–44.

11  Hans Richter, "An den Konstruktivismus," *G* (June 1924): 72. The German text follows: "Solange das Schlagwort Mode ist. Es scheint übrigens damit schon wieder vorbei zu sein, wenigstens lässt sich der Schnelläufer Moholy-Nagy der für solche Dinge eine feine Nase hat im Kunstblatt z.Z. als Suprematist ausrufen; vielleicht hat er dabei mehr Glück als mit den weiland Konstruktivisten."

12  El Lissitzky to Mutti, September 15, 1925 (rpt. in Lissitzky-Kuppers, *El Lissitzky*, p. 66).

13  Ibid.

14  Xanti Schawinsky to Sibyl Moholy-Nagy, August 25, 1948, in Hattula Moholy-Nagy Archives.

15  C. L. Morrison, "Chicago Dialectic," *Artforum* (February 1978): 32.

16  Roland Barthes, "On *S/Z* and *Empire of Signs*," in *The Grain of the Voice: Interviews 1962–1980*, trans. Linda Coverdale (New York: Hill and Wang, 1985), p. 79.

17  Terence A. Senter, "Moholy-Nagy's Works," in *Moholy-Nagy*, ed. Krisztina Passuth and Terence A. Senter (London: Institute of Contemporary Art, Arts Council of Great Britain, 1980), p. 35.

18  Laszlo Moholy-Nagy, lecture notes, in Hattula Moholy-Nagy Archives.

19  S. Moholy-Nagy, *Experiment in Totality*, p. 42.

20  Ibid., pp. 42–43.

21  This document, in the handwriting of Laszlo Moholy-Nagy, was in the private collection of the late E. Ray Pearson, Chicago, Illinois.

22  Laszlo Moholy-Nagy, *Vision in Motion*, p. 22.

## 3 It Works

1 The reader is referred to Michel Butor, *Le Mots dans le Peinture* (Switzerland: Albert Skira, 1969) for excellent discussions of a number of issues pertinent to a chapter on the signature in Moholy's works. In the section entitled "La grammaire des signatures" (The Grammar of Signatures), Butor calls for a new graphology in order to study the signature in painting. "The signature in painting requires a graphology . . . and a special chapter ought to be reserved to what one could call monogrammatical expressivity" (p. 102, my translation). It is hoped that "Moholy-Nagy: The Graphic Works" contributes to the graphology of the signature called for by *Painting Words*.

2 On the conventions of the marginal place of the signature in painting, see the section, "La lieu du sigle" (The place of the sigil), in Butor, *Le Mots dans le Peinture*, pp. 103–5. "A normal place for the signature ought to go in the bottom right corner, therefore it would be in the most inferior part of the rectangle" (p. 104, my translation).

3 Caroline Fawkes, "Photography and Moholy-Nagy's Do-It-Yourself Aesthetic," *Studio International* 190 (July–August 1975): 24.

4 It has come to my attention that German filmmaker Jürgen Sascha Hardt adapted the *Dynamic* filmscript in 1988. Having not seen the film, one can only speculate how it plays out the autobiographical neon sign and the authorial name up in lights.

5 Laszlo Moholy-Nagy, "Dynamic of the Metropolis," in *Painting, Photography, Film*, p. 129. For the German version, see "Dynamik der Grossstadt," in *Malerei, Photographie, Film*, p. 127.

6 Ibid., p. 125. The German version is a bit glitzier (*flimmern*) in its portrayal, "und die Autos immer rascher, so dass bald ein FLIMMERN ensteht" (p. 123).

7 Laszlo Moholy-Nagy, "Dynamik der Grossstadt," p. 127. The English translation here is my own.

8 Laszlo Moholy-Nagy, quoted in S. Moholy-Nagy, *Experiment in Totality*, p. 143.

9 Laszlo Moholy-Nagy to Marion Becker, January 28, 1946, Cincinnati Modern Art Society Papers, University of Cincinnati Archives, Cincinnati, Ohio.

10 S. Moholy-Nagy, *Experiment in Totality*, p. 10.

11 For the abstract photos that mime the typographic painting, see Laszlo Moholy-Nagy's contribution to the "Diskussion über Ernst Kallai's Artikel 'Malerei und Fotografie,'" in *i 10: International Revue* 1, no. 6 (1927): 233–34.

12 Just as in the layout of the letters, one can imagine the *O* as a monocle or mistake the *M* for a moustache to make out of these letters the beginnings of a face for a self-portrait in letters.

13 I have revised the terms of the translated version found in Laszlo Moholy-Nagy, *The New Vision*, p. 36. The German inserts are taken from *Von Material zu Architektur*, p. 85.

14 S. Moholy-Nagy, *Experiment in Totality*, p. 24.

15 Laszlo Moholy-Nagy, "The New Typography," in *Staatliches Bauhaus Weimar 1919–1923* (Munich and Weimar: Bauhaus Verlag, 1923; rpt. in Kostelanetz, *Moholy-Nagy*, p. 75).

16 For Apollinaire's discussion of these effects, the reader is referred to his 1917

essay "The New Spirit and the Poets," in *Selected Writings of Guillaume Apollinaire,* trans. Roger Shattuck (New York: New Directions, 1971). Moholy's typographics review Apollinaire's writings on this issue in so many words: "Typographical artifices worked out with great audacity have the advantage of bringing to life a visual lyricism" (p. 228).

17 There is an uncanny convergence of photographs which document the imagined exchange of an eye for an ear and an ear for an eye. See George Morris's *Shifting with Prisms* photograph (1943) in Laszlo Moholy-Nagy, *Vision in Motion,* p. 204. Moholy's caption asks: "Can you see with your ear? or hear with your eye?" The same attempt at conversion of senses can be seen in a fantastic photograph that features John Cage — a one-time musical employee of Moholy at the Institute of Design — in another exchange of an eye for an ear. See Marshall McLuhan, *The Medium is the Message* (New York: Random House, 1967).

18 Laszlo Moholy-Nagy, *Vision in Motion,* p. 301.

19 Laszlo Moholy-Nagy, "Abstract of an Artist," p. 75.

20 See, for instance, Moholy's article "Fotogramm und Grenzgebiete" (Photogram and frontier zones), *i 10: Internationale Revue* 21/22 (1929): 190–92.

21 For four versions of these works back to back, see Floris M. Neusüss, *Das Fotogramm,* p. 126. See Jeannine Fiedler's detailed description of the makings of *Mask (Self-Portrait),* in *Experiment Bauhaus* ed., Magdalene Droste and Jeannine Fiedler (Berlin: Kupfergraben, 1988), pp. 181–82. Fiedler concludes her analysis with an acknowledgement of the technology of the signature effect in photogrammatology: "*Es ist das Profil Moholys, das gleichsam als 'Signatur' die Technik des Fotogramms für sich reklamiert* (p. 182; It is Moholy's profile — as if the photogrammatical technique reclaims the 'signature' for itself").

22 Laszlo Moholy-Nagy, "Photogram and Frontier Zones" (rpt. in Passuth, *Moholy-Nagy,* pp. 305–6).

23 Laszlo Moholy-Nagy, quoted in S. Moholy-Nagy, *Experiment in Totality,* p. 27.

24 In de-capitalized German, "die nächste station wird der mond sein," in Laszlo Moholy-Nagy, "Geradlinigkeit des Geistes — Umwege der Technik," *i 10: Internationale Revue* I/1 (1927): 35.

25 See Lucia Moholy, *Marginalien zu Moholy-Nagy.* The German of the bilingual text is on page 72. I have amended the English translation (on p. 30) accordingly.

26 In "Otobiography," Jacques Derrida's writing of/on Nietzsche affords a parallel to mask (self-portraits) where he "puts his body and his name out front even though he advances behind masks or pseudonyms without proper names. He advances behind a plurality of masks or names, that, like any mask or even any theory of the simulacrum can propose and produce themselves only by returning a constant yield of protection, a surplus value in which one may still recognize the ruse of life," p. 7.

27 Morrison, "Chicago Dialectic," p. 34.

28 Laszlo Moholy-Nagy, *Vision in Motion,* p. 317.

29 The English quotations in the next two paragraphs are taken from Laszlo Moholy-Nagy, "Once a chicken, always a chicken" filmscript (1925–30) in *Vision in Motion,* pp. 285–88. The German citations are from "huhn bleibt huhn" as published in the Moholy *Telehor* issue, pp. 128–31.

30  The parenthetical cinematic question and the question in the next paragraph ("Is this 'the' man?") are popped only in the *Vision in Motion* version. It appears as if Moholy's self-interrogation on the question of identity increases in these later additions to the screenplay.

31  Schreyer, *Erinnerungen an Sturm und Bauhaus,* p. 243. The text reads: "Sie irren. Der Automat, wie sie es nennen, ist der Antrieb und die Form unserer Zeit. Er ist alles."

32  Again, I have adopted a new English translation based on the German text in Lucia Moholy, *Marginalien zu Moholy-Nagy,* p. 31.

33  Laszlo Moholy-Nagy, printed on the back of the photogram *Diagram of Forces* (n.d.), in Rice and Steadman, *Photographs of Moholy-Nagy,* p. 35.

34  Laszlo Moholy-Nagy, *The New Vision,* p. 35. The German reads: "er begann also, das objekt abzuschälen, auseinanderzulegen," in *Von Material zu Architektur,* p. 83.

35  Young Laszlo, quoted in S. Moholy-Nagy, *Experiment in Totality,* p. 6.

36  S. Moholy-Nagy, *Experiment in Totality,* p. 59.

37  This is quite apt for the constructivist Moholy, or, in this case, Moholy the *mis-constructivist.*

38  See Jacques Lacan, *Ecrits,* trans. Alan Sheridan (New York: Norton, 1977), pp. 1–7. This section proposes that Moholy's autobiographical photomontages, *The Fool* and *I Know Nothing,* also stage the scene of the misrecognition or misknowing of the subject.

39  Walter Gropius, preface to *Experiment in Totality,* by S. Moholy-Nagy, p. viii.

40  Laszlo Moholy-Nagy, quoted in S. Moholy-Nagy, *Experiment in Totality,* p. 144.

41  Lloyd Engelbrecht, "Moholy-Nagy in Chicago," in Rice and Steadman, *Photographs of Moholy-Nagy,* p. 10.

42  Julie Saul, "Social and Political Themes," in her *Moholy-Nagy Photoplastiks: The Bauhaus Years* (New York: Bronx Museum of the Arts, 1983), p. 48. I believe that within these scenes of misknowledge, misinformation, and misrecognition, this definition can be judged a mistranslation.

43  See Passuth, *Moholy-Nagy,* fig. 96.

44  Laszlo Moholy-Nagy, *Vision in Motion,* p. 62.

45  Käte Steinetz, *Kurt Schwitters: A Portrait from Life* (Berkeley and Los Angeles: University of California Press, 1968). See the illustration opposite p. 67.

46  This is taken from the shorter German version of Steinetz's work entitled *Erinnerungen aus den Jahren 1918–1930* (Zurich: Verlag der Arche, 1963), pp. 145–46.

47  Harriet Janis and Rudi Blesh, *Collage: Personalities, Concepts and Techniques* (Philadelphia: Chilton, 1962), p. 63. Sibyl Moholy-Nagy recalls the case of the holy socks: "Mme. Moholy-Nagy has related the fantastic architecture was subdivided into plaster grottos dedicated to Schwitters's friends. She remembered an occasion when her husband discarded a worn pair of socks. Schwitters retrieved them, dipped them in plaster of Paris, and added them to the Moholy grotto."

48  Karl von Hase, *New Testament Parallels in Buddhistic Literature* (New York: Eaton and Mains, 1907).

49  For other possibilities in the "Hase" family, see Irene-Charlotte Lusk, *Mon-*

tagen ins Blaue: Laszlo Moholy-Nagy, Fotomontagen und -collagen 1922–
1943 (Berlin: Anabas Verlag, 1980), p. 110. Lusk tells the story from the
perspective of Victor von Hase, as related by his brother Karl. Oddly enough,
this story is also one of mistaken identity. It appears that in 1855 the young
Victor had lent his I.D. card to a student to help him escape from an impend-
ing duel in Heidelberg. When the card was found, the lawyer, Hase, denied
all complicity during the investigation with the words, "Mein Name ist Hase.
Ich verneine die Generalfragen. Ich weiss von nichts." This response soon
spread into the general idiom.

50  Laszlo Moholy-Nagy, "Theater, Circus, Variety," in *The Theater of the Bau-
    haus,* by Laszlo Moholy-Nagy, Oskar Schlemmer, and Farkas Molnar, trans.
    Arthur S. Wensinger (Middletown, Conn.: Wesleyan University Press, 1961),
    p. 52. The above is a slightly altered version of this translation. For the
    German original, see his article in *Die Bühne im Bauhaus* (Munich: Albert
    Langen, 1925), p. 47.

51  Georges Bataille, "Un-knowing: Laughter and Tears," *October* 36 (spring
    1986): 95.

52  Ibid., p. 102.

53  Wulf Herzogenrath, ed., *Bauhaus Photography,* trans. Ellen Martin (Stutt-
    gart: Institute for Foreign Cultural Relations, 1983), pp. 50–51, 66–67.

54  S. Moholy-Nagy, *Experiment in Totality,* p. 29.

55  Laszlo Moholy-Nagy, *Vision in Motion,* p. 188.

56  To learn more about the details of its composition, see Fiedler's analytical
    description in *Experiment Bauhaus,* p. 189.

57  S. Moholy-Nagy, *Experiment in Totality,* p. 38.

58  Ibid., p. 40.

59  Laszlo Peter, "The Young Years of Moholy-Nagy," p. 68.

60  Fiedler, *Experiment Bauhaus,* p. 189. The German text reads: "Das Rätsel
    über die Urheberschaft dieser beiden Montagen wird wohl nie ganz geklärt
    werden können."

61  Laszlo Moholy-Nagy, letter to the Editor, *New York Times,* January 1, 1939.

62  Lucia Moholy, *Marginalien zu Moholy-Nagy,* p. 89.

63  Ibid., p. 74. I have slightly altered the English translation of the German text
    found on p. 32 of the bilingual edition.

64  Ibid., p. 69. This text has been subject to slight alterations as adapted from
    the German text found on pp. 26–27 of the bilingual edition.

65  Ibid., pp. 69–74.

66  Laszlo Moholy-Nagy, *The New Vision,* p. 71.

67  Robert Rauschenberg, quoted in John Cage, "Robert Rauschenberg, Artist,
    and his Work," in his *Silence* (Cambridge, Mass.: M.I.T. Press, 1966), p. 102.

### 4 The Anonymous Hand

1  Laszlo Moholy-Nagy, quoted in S. Moholy-Nagy, *Experiment in Totality,*
   p. 30.

2  Laszlo Moholy-Nagy, *The New Vision,* p. 79.

3  For an anecdote that links Moholy's numerical practices and the technologi-
   cal extensions of American jazz and industrial culture where "the numbers
   took over the place," see media guru Marshall McLuhan, *Understanding
   Media: The Extensions of Man* (London: Routledge, 1964), p. 109.

4 Laszlo Moholy-Nagy, *The New Vision,* pp. 79–80.

5 "Suprematism," in *Die Kunstismen: The Isms of Art,* by Hans Arp and El Lissitzky (Erlenbach-Zurich: Eugen Rentsch Verlag, 1925), pp. X–XI. Given certain reservations regarding the English in this polylingual text, I have generated a new version based on the German text: "Die Kunstbörsen haben durch die Inflation des Quadrates jedem die Mittel gegeben, Kunst zu treiben. Die Herstellung von Kunstwerken ist nun einsichtigerweise so erleichtert und vereinfacht, dass man seine Werke am besten telephonisch, vom Bett aus, bei einem Anstreicher bestellt."

6 For another reading and signature effect, see Andreas Haus on the dematerialized nature of this photograph, which has been entitled alternatively *Entkörpertes Haus* (Disembodied House). Haus adds this mysterious touch to the lines: "The telephone lines and their shadows form unreal lines in space." See Jeannine Fiedler, ed., *Photography at the Bauhaus* (Cambridge, Mass.: M.I.T. Press, 1990), p. 16. The photo appeared as fig. 59 in Laszlo Moholy-Nagy's *60 Fotos,* ed. Franz Roh (Berlin: Klinkhardt and Biermann, 1930).

7 Peter Selz, *Art in Our Time: A Pictorial History 1890–1980* (New York: Abrams, 1981), p. 267.

8 Laszlo Moholy-Nagy, "Dynamic of a Metropolis," p. 125.

9 Norbert Wiener, *God and Golem, Inc.* (Cambridge, Mass.: M.I.T. Press, 1964), p. 19.

10 Like the dada jesters and matchmakers Man Ray and Marcel Duchamp, Moholy played chess, matching his wits with his benefactor and friend, Walter Paepcke. In correspondence with Paepcke (file 79, Institute of Design Archive), Moholy delivers suggestions for the writing of a new chess book, one where the moves of the master might be checked at his own game through other moves, moves that "use his wit" and that outwit, out of hand. "I also thought one could publish such a chess book in which the new steps are always on the other side of the page, so that one could play along with such a book and use his wit — then be able to check his moves with the master's moves. I have two solutions for such a book — one which saves paper — and one that wastes paper." This book, put into print, would publish "new steps" on the other side — "always on the other side of the page" — the flip of an anonymous hand lurking, ready to spring forth to make the next move, to jump him (for a dummy).

11 Lucia Moholy, *Marginalien zu Moholy-Nagy,* p. 79.

12 The move that debunks the long-distance legend in line with Lucia Moholy's official account also finds its way into the historical recitation of Caroline Fawkes. See "Photography and Moholy-Nagy's Do-It-Yourself Aesthetic," pp. 19–20.

13 Lucia Moholy, *Marginalien zu Moholy-Nagy,* p. 76. The German version of this bilingual account inserts the memory-trace into the aural organ itself. Lucia Moholy recalls, "ich habe den Ton seiner Stimme noch im Ohr — Das hätte ich sogar telephonisch machen können!" (p. 34).

14 For a rumor-ridden account of telephone logic at the limits of truth-telling and at the borders of philosophy and literature, the reader is routed to Avital Ronell, *The Telephone Book: Technology, Schizophrenia, Electric Speech* (Lincoln: University of Nebraska Press, 1989).

15 Lucia Moholy, *Marginalien zu Moholy-Nagy,* p. 77.

16 Laszlo Moholy-Nagy, "Domestic Pinacotheca," *Painting, Photography,*

*Film*, p. 26. The German is from "Haus Pinakothek," *Malerei, Fotografie, Film*, p. 24. Moholy's emphasis upon conceptual process has been taken as his articulation of an aesthetic practice conducive to the production of the telephone paintings involving the mastering of limits and the limits of mastery. To quote, "in Wahrheit ist neben dem schöpferischen **geistigen** prozess des werkenstehens die ausführungsfrage nur insofern wichtig, als die bis auf äusserste beherrscht werden muss. ihre art dagegen — ob persönlich oder durch arbeitsübertragung, ob manuell oder maschinell ist — gleichgültig." [In fact, in comparison with the inventive *mental* process of the genesis of the work, the question of its execution is important only in so far as it must be mastered to the limits. The manner, however — whether personal or by assignment of labour, whether manual or mechanical — is irrelevant.]

17  In the pursuit of the "movement," I have given a new twist in English to the original German of Lucia Moholy, *Marginalien zu Moholy-Nagy*, p. 36. "Es ist jedoch irrig, Moholy-Nagy als Vorläufer jener Bewegung zu bezeichen . . ."

18  Ibid., p. 79. Lucia Moholy refers to the 1969 exhibition at the Museum of Contemporary Art in Chicago which was entitled *Art by Telephone*.

19  Laszlo Moholy-Nagy, *Vision in Motion*, p. 314.

20  Laszlo Moholy-Nagy, *The New Vision*, p. 79.

21  Maurice Blanchot, "The Narrative Voice," in his *The Gaze of Orpheus*, trans. Lydia Davis (Barrytown, N.Y.: Station Hill, 1981), p. 141. Blanchot quotes Marguerite Duras, *The Ravishing of Lol V. Stein*, trans. Richard Seaver (New York: Grove Press, 1966), p. 38.

22  Laszlo Moholy-Nagy, *The New Vision*, p. 79.

23  This does not seem to be so far removed from the insistence of Jean-François Lyotard regarding the postmodern demand to play out the Kantian project of the representation of the unrepresentable in all its sublime effects. See his "Sublime and the avant-garde," in *A Lyotard Reader*, ed. Andrew Benjamin (Oxford: Basil Blackwell, 1989), pp. 196–211.

24  S. Moholy-Nagy, *Experiment in Totality*, pp. 81–82.

25  Schreyer, *Erinnerungen an Sturm und Bauhaus*, pp. 238–39.

26  Julien Levy, *Memoirs of an Art Gallery* (New York: G. P. Putnam's Sons, 1977), pp. 65–66.

27  This touches upon many of the aesthetical-political motifs of the most important dada photo-monteur of the Weimar period, John Heartfield. One of his infamous calls to rally the anonymous-handed worker to communist action finds its expression in the eye-grabbing poster *The hand has five fingers*. In another emblematic work, the monteur is depicted with his scissors as weapon in the act of chopping off the head of the Berlin chief of police. Finally, for the purposes of this section, the reader is reminded of the book cover designed by Heartfield for Franz Jung's *Die Eroberung der Maschinen* (The conquering of the machine), published in 1924, which features an anonymous hand brandishing a pistol perched in between the wheels of some modern machinery. The book was advertised on p. 34 of the same issue of *G* in which Hans Richter denounced Moholy in 1924. For a recent collection of some of his violent inscriptions, see the centennial celebration catalogue edited by Peter Pachnicke and Klaus Honnef, *John Heartfield* (Cologne: Dumont, 1991).

28  The first title literally means that everyone can shoot his picture for himself. The back of the original collage contains the following cryptic caption: " 'lass

dem kinde die bulette' oder besuch in einer gemäldegalerie 1927" ('give the kid the bullet' [sic] or visit in a painting gallery 1927).

29 El Lissitzky, "Exhibition Rooms," in Lissitzky-Kuppers, *El Lissitsky*, p. 362.

30 This is a new version of the "demonic-fantastic" translation in Lucia Moholy, *Marginalien zu Moholy-Nagy*, p. 72. For the German, see p. 30.

31 Laszlo Moholy-Nagy, *Vision in Motion*, p. 290.

32 Irene-Charlotte Lusk, *Montagen ins Blaue*, p. 88.

33 For a complete description and linguistic analysis of camera and gun in the history of photography, see Thilo Koenig, " 'Die Kamera muss wie eine nimmer fehlende Büchse in der Hand ihres Herrn liegen': Gedanken zu einem medienspezifischen Sprachgebrauch," in *Fotogeschichte* 8, no. 30.

34 Laszlo Moholy-Nagy, *Vision in Motion*, p. 208.

35 Laszlo Moholy-Nagy, "Contribution to the Debate on the Article 'Painting and Photography' by Erno Kallai," *i 10: Internationale Revue* 6 (1927): 233–34 (rpt. in Passuth, *Moholy-Nagy*, p. 301).

36 The original reads: "Nicht der Schrift-, sondern der Photographieunkundige wird, so hat man gesagt, der Analphabet der Zukunft sein." See Walter Benjamin, "Kleine Geschichte der Photographie" (1931), in his *Das Kunstwerk im Zeitalter seiner technischen Reproduzierbarkeit* (Frankfurt: Suhrkamp, 1963), p. 67.

37 W. Benjamin, "Work of Art," p. 238.

38 Laszlo Moholy-Nagy, "Surrealism and the Photographer," *The Complete Photographer* 9, no. 52 (1943): 3341.

39 Laszlo Moholy-Nagy, "Photography is Manipulation of Light" (rpt. in Haus, *Moholy-Nagy*, p. 49). The original German reads: "diesen bildern lag einen wirklichkeitsvortauschung fern, sie zeigten brutal den entstehungsprozess, die zerlegung von einzelphotos, den rohen schnitt der schere."

40 Both the title of the essay and its emphasis on the exteriority of the photographic image in the dissecting space of anonymity might be compared with Rosalind Krauss, "The Photographic Conditions of Surrealism," in her *The Originality of the Avant-garde and Other Modernist Myths* (Cambridge, Mass.: M.I.T. Press, 1986), pp. 87–118. Krauss concludes her article with a citation from *Vision in Motion* that involves seeing the world with a different set of eyes.

41 Laszlo Moholy-Nagy, "Surrealism and the Photographer," p. 3334.

42 Laszlo Moholy-Nagy, *Vision in Motion*, pp. 336, 311, in order of their appearance.

43 One recalls Moholy's high praise for the film in the preface to "Dynamic of the Metropolis." Here, Moholy lauds its implementation of the possibilities of the camera and its "*Bewegungsdynamik*" (movement dynamic). In Laszlo Moholy-Nagy, *Malerei, Fotografie, Film*, p. 120.

44 In *The Case of California* (Baltimore: Johns Hopkins University Press, 1991), Larry Rickels points out how primal film theorist Hugo Münsterberg in *The Photoplay: A Psychological Study* (1916) was into the shooting practice as and at the shocking origin of the cinematic event: "Münsterberg shares his insights at gun point: the use of a pistol on stage cannot compare in shock value to the close-up of a gun pointed at the movie audiences: 'Here begins the art of the photoplay.' (37)" (p. 348).

45 Buster Keaton and Charles Samuels, *My Wonderful World of Slapstick* (New York: Da Capo, 1982), p. 207.

46  Laszlo Moholy-Nagy, *Vision in Motion*, p. 356.

47  Ibid., p. 325.

48  Hattula Moholy-Nagy states that one of the most indelible memories of her life with father was going to the movies to watch the weekly Westerns which Moholy loved so well. Interview with Hattula Moholy-Nagy, Ann Arbor, Michigan, July 31, 1986.

49  Laszlo Moholy-Nagy, "Brief an Fra. Kalivoda," *Telehor*, p. 115. This translation is my own.

50  Laszlo Moholy-Nagy, *Painting, Photography, Film*, p. 25. The German inserts are taken from *Malerei, Photographie, Film*, p. 23.

51  For a spread of seven detached-hand photographs including a Moholy *Self-Portrait* and a photogram of hands displayed as crossed-up light effects, the reader is referred to Andreas Haus's photo-essay, "Photography at the Bauhaus: Discovery of a Medium," in *Photography at the Bauhaus*, ed. Fiedler, pp. 138–39.

52  Laszlo Moholy-Nagy, *Painting, Photography, Film*, p. 7. I have altered the translation a bit based on the inserts included from the German ed., p. 5.

53  This offers a very different reading from Vlada Petric who recently restaged the film in the testamentary form of *Light Play: A Tribute to Moholy-Nagy* (1990). Imposing his own authorial voice upon the detached hands, Petric loses track of the monster question of the non-human unconsciously wrought by the anonymous hand in his very personal overdubbing. The author speaks up: "At one point, however, a human voice is included which to my satisfaction coincides with the appearance of Moholy-Nagy's own hands — the only human element in the film. Actually the voice is mine . . ." Text taken from a handout, Arsenal Kino, Berlin, June 4, 1991.

54  *Op. cit.,* p. 87.

55  Laszlo Moholy-Nagy, unpublished papers in Hattula Moholy-Nagy Archives.

56  Laszlo Moholy-Nagy, *The New Vision*, p. 68.

57  Laszlo Moholy-Nagy, *Painting, Photography, Film*, p. 26.

58  Ibid., *Film*, p. 79.

59  The title of *Tu m'* almost delivers the French pronouns for *you* and *me*. Like Moholy's autobiographical painting *Me, Tu m'* points to the indexical status of the subject constituted as an effect of the process of naming.

60  For the staging of another anonymous hand, one should also look at the poster for the exhibition *Editions de et sur Marcel Duchamp* at the Galerie Givaudan, Paris, June 8–September 30, 1967. This edition features a detached hand holding a cigar between index and middle finger and some smoke drawn in and rising up. This anonymous hand brings many of the terms of these biographical writings to light — the enigmatic signature of the halting/inviting upraised palm as well as the smoke that signals the signature's threat to the signified thing.

61  In *Marcel Duchamp*, ed. Anne D' Harnoncourt (New York: Museum of Modern Art, 1973), p. 284.

62  The indexical signs of photograph, photogram, and ready-made point both to the referent and themselves as traces or ghosts of the referent. Here, one has the referent only when it is removed. In that removal, the index, like the footprint or the upraised palm, delivers the materiality of the signature. In this way, the index and the anonymous hand become two registers to demonstrate how things are effected by naming.

63 Marcel Duchamp, *Salt-Seller,* ed. Michel de Sanouillet and Elmer Peterson (London: Thames and Hudson, 1975), p. 32.

64 For the last impression, see Gerhard Glüher, *Laszlo Moholy-Nagy: Frühe Photographien* (Berlin: Nishen, 1990), pp. 78–79.

65 For a discussion of the photogram and Duchamp's art as indexical procedure, see Rosalind Krauss, "Notes on the Index: Part I," in *The Originality of the Avant-Garde,* p. 203.

66 Andreas Haus, *Moholy-Nagy,* pp. 19–20.

67 Laszlo Moholy-Nagy, "fotografie ist lichtgestaltung," in *Bauhaus* 2, p. 2. The translation is my own.

68 For a spread of four photogrammatical detached hands interwoven with textual grids, see Floris M. Neusüss, *Das Fotogramm,* p. 124.

69 See Fiedler, *Photography at the Bauhaus,* p. 139.

70 As Sibyl Moholy-Nagy recounts, "He crossed his spread fingers in the form of a grill, a gesture which I later came to accept as the most characteristic expression of his drive toward integration," in *Experiment in Totality,* p. 60.

71 School of Design in Chicago catalogue, p. 14, Illinois Institute of Technology Archive.

72 For the untitled German, see Floris M. Neusüss, *Das Photogram,* p. 130. For the autobiographical French, see the 150th anniversary of photography catalogue at the Georges Pompidou Center in Paris, *L'invention d'un art* (1989).

73 A negative image of the detached hand (black on white, and left-to-right) also appears in the form of a space modulator at the outset of Moholy's autobiographical essay, "Abstract of an Artist." See *The New Vision,* p. 66.

74 Marcel Duchamp, *Salt-Seller,* p. 148.

75 Ibid., pp. 152–53.

76 For instance, there is an invitation to an exhibition of the collection at the Yale University Art Gallery on January 13, 1942, which features a Moholy woodcut on its cover. In terms of biographical convergences, one might also recall Moholy's introduction to Katherine Dreier's art portfolio entitled *1 to 40 Variations* (Springfield, Mass.: Pond-Ekberg, 1939).

77 For example, "We see at all times he was successful as a thinker and inventor, as a writer and teacher. That seems almost too vast a field for one man to till but this abundant versatility was uniquely his." Or Gropius writes, "He commanded his genius to venture into all realms of science and art to unriddle the phenomena of space." Walter Gropius, "Laszlo Moholy-Nagy (1895–1946)," in *Moholy-Nagy,* ed. Passuth, p. 432.

78 Finsler's photomontage from 1927–28 is reproduced in Lusk, *Montagen ins Blaue,* p. 188.

79 Lusk also includes Moholy's photomontage homage to the Goethe year (*Goethejahr*) published in *Die Neue Linie* in 1932. The bust of Goethe is superimposed over the hustle and bustle of a dynamic metropolis taken from an aerial perspective. Ibid., p. 189.

5  **Moholy: The Significance of the Signature**

1 Plato, *The Dialogues of Plato,* vol. 1, trans. B. Jowett (London: Oxford University Press, 1931), p. 323; p. 337. For an excellent discussion of the regeneration of the *Cratylus* in the poetry of Valery and Mallarme, see Gerard Genette, *Mimologiques* (Paris: Seuil, 1976).

2  A similar Cratylism motivates the study of Hebrew proper names throughout the tradition of Biblical interpretation. Here the proper name invokes the direct word of God. In his *Etymologies and Genealogies: A Literary Anthropology of the French Middle Ages* (Chicago: University of Chicago Press, 1983), R. Howard Bloch reviews how the Alexandrian exegete Jerome upheld the significance of the signature in the study of the shifts in the names of such figures as Abraham and Sarah. "For Jerome, in particular, the derivation of a divinely given name becomes genetically prescriptive. He maintains that a proper appellation is equivalent to a genealogical program, and its alteration is tantamount to a prophetic rewriting of the future" (p. 35). For Saint Augustine, "Language constitutes, in this respect, a kind of genetic code in which the future in germ is inscribed but which remains indecipherable until its genesis has become historically realized" (p. 37). This "future in germ" interpretation of the terms of the signature may signal to this Moholy case study where a part of the significance of the signature does not become historically realized until he adopts this nickname in the 1920's and the English language in the last dozen years of his life.

3  Laszlo Moholy-Nagy, *Vision in Motion,* p. 142.

4  Jacques Derrida responds during the "Roundtable on Autobiography" in *The Ear of the Other* and the significance of the signature writes itself as follows: "Thus, the proper name is at play and it's meant to play all by itself, to win or lose the match without me. This is to say that, at the furthest limit, I no longer need to pull the strings myself, to write one way or another. It is written like that by itself. When it comes to names, the relation between the proper and common already programs the whole scenario" (p. 77).

5  Walter Gropius, preface to *Experiment in Totality,* by S. Moholy-Nagy, p. viii.

6  Walter Gropius to Moholy-Nagy, n.d., attached to another letter, Laszlo Moholy-Nagy to Walter Paepcke, March 14, 1942, Institute of Design Archives.

7  "Public Comments," in *In Memoriam Laszlo Moholy-Nagy* (New York: Solomon R. Guggenheim Foundation, Museum of Non-Objective Painting, 1947), p. 30.

8  Ibid., pp. 30–31.

9  Anonymous student, quoted in Raymond Barnhart to Laszlo Moholy-Nagy, March 16, 1946, Modern Art Society Papers, University of Cincinnati Archive, Cincinnati, Ohio.

10  Siegfried Giedion, introduction to *Telehor,* p. 24.

11  Laszlo Moholy-Nagy, "Contemporary Typography — Aims, Practice, Criticism," *Offset-, Buch-, und Werbekunst* 7 (1926): 375–76 (rpt. in Passuth, *Moholy-Nagy,* p. 294).

12  Laszlo Moholy-Nagy, "Light Architecture," *Industrial Arts* 1, no. 1 (September 1936) (rpt. in Kostelanetz, *Moholy-Nagy,* p. 159).

13  Laszlo Moholy-Nagy, *Vision in Motion,* p. 166.

14  Laszlo Moholy-Nagy, "Light Architecture," in *Moholy-Nagy,* ed. Kostelanetz, p. 156.

15  "Public Comments," p. 30.

16  Laszlo Moholy-Nagy, "Surrealism and the Photographer," p. 3341.

17  Laszlo Moholy-Nagy, quoted in S. Moholy-Nagy, *Experiment in Totality,* p. 8.

18  The first phrase is from art historian Andreas Haus's informative introductory essay in his *Moholy-Nagy: Fotos und Fotogramme* (Munich: Schirmer-Mosel, 1978), p. 9. The second phrase comes from original Bauhaus Archiv director Hans Wingler's remarks ("Ausschnitte aus einem Lebenswerk") in the exhibition catalogue of the same name at the Bauhaus Archiv in Berlin in February–March 1972.

19  Richard Koppe, "Laszlo Moholy-Nagy and His Visions," *Art International* 13 (December 1969): 46.

20  One of the most famous collections of Zen koans and stories is entitled the "Mumon-koan" ("The Gateless Gate"). For one translation, see Paul Reps, *Zen Flesh, Zen Bones* (New York: Anchor, n.d.).

21  Robert M. Yoder, "Are You Contemporary?" *Saturday Evening Post,* July 3, 1943, p. 16.

22  Kent Sagendorph, "Functionalism, Inc.," *Coronet,* October 1941, p. 107.

23  Yoder, "Are You Contemporary?" p. 16. Many of the stories in the *Diamond Sutra* are structured like this sentence. For instance, "What has been taught by the Tathagata as the possession of marks, that truly is a no-possession of no-marks" (p. 28), in Edward Conze, *Buddhist Wisdom Books* (London: George Unwin, 1958).

24  Laszlo Moholy-Nagy, *Vision in Motion,* p. 102.

25  Sagendorph, "Functionalism, Inc.," p. 109.

26  This is a riddle in the "The Gateless Gate": A monk asked Tozan while he was weighing some flax, "What is Buddha?" and Tozan replied, "Three pounds of flax."

27  *The North Loop News,* June 13, 1946.

28  The graphic *Y* (1919) was published for the first time ever (catalog no. 8) in a recent Moholy retrospective exhibition catalogue which toured Europe in 1991. See Renate Rüdiger, Monika Göbel, and Veit Loers, ed., *Laszlo Moholy-Nagy* (Kassel: Verlag Gerd Hatje, 1991).

29  Tristan Tzara, "lecture on dada," in *Seven Dada Manifestos,* pp. 107–12. After all, "Dchouang-Dsi was as dada as we are" (p. 110). The piece was first published in French in *Merz* 2, no. 7 (January 1924). While the talk was delivered before Moholy's arrival at the Bauhaus, it would not be surprising if he attended since he was at the conference in Weimar. The talk was later described in the Red Issue of van Doesburg's *Mecano* (1922) as "The injection of the Virgin Dada Microbe into Weimar and the people of the Bauhaus."

30  Laszlo Moholy-Nagy, "Directness of Mind," in *Moholy-Nagy,* ed. Kostelanetz, p. 188.

31  Laszlo Moholy-Nagy, "From Pigment to Light," in *Telehor,* p. 34.

32  Beaumont Newhall, quoted in *Photographs of Moholy-Nagy,* ed. Rice and Steadman, p. 7.

33  S. Moholy-Nagy, *Experiment in Totality,* p. 6.

34  See, for example, Moholy's *Yellow Circle* (1921) which was mounted as the poster for the Museum of Modern Art exhibition *Contrasts of Form: Geometric Abstract Art 1910–1980* held from October 7, 1985 to January 7, 1986.

35  Laszlo Peter, "The Young Years of Moholy-Nagy," p. 70.

36  Interview with Hattula Moholy-Nagy.

37  But Cratylus's voice can no longer refrain from doing its double duty in the memory of the strange (and double-named) destiny which calls him, Moholy-Nagy.

38 This work is also known as *The Great Wheel* (*Das Grosse Rad*). In Buddhistic terms, one imagines the *Dharma-ho* law as one that cycles and siphons off desires.

39 *Time*, February 13, 1946.

40 This imagines Moholy as a Santa Claus figure, the jolly gift-bearing roly-poly one who says, "Ho!" and whose toying around has the same effect on others. It places Moholy at the Institute of Design with his students-children-elves-patients designing inter-media experiments under the sign of the crossover. In "Are You Contemporary?" Yoder observes, "It looks like a cross between kindergarten, Santa's toy shop, and an institution for occupational therapy" (p. 17).

41 Laszlo Moholy-Nagy, "Theater, Circus, Variety," p. 52. The German inserts are from "Theater, Zirkus, Varieté," in *Die Bühne im Bauhaus*, p. 47.

42 Laszlo Moholy-Nagy, "Theater, Circus, Variety," p. 52. I have slightly altered the original translation based on *Die Bühne im Bauhaus*, p. 46.

43 Laszlo Moholy-Nagy, *Vision in Motion*, p. 326.

44 Laszlo Moholy-Nagy, "Total Theater is the Theater of the Future," *Dokumentum* (March 1927): 6–7 (rpt. in Passuth, *Moholy-Nagy*, p. 300).

45 Laszlo Moholy-Nagy, *Vision in Motion*, p. 351.

46 Ibid., p. 344.

47 The footnote to the previous quotation continues, "A little child, painting a horse, showed the picture to his older sister who burst into laughter. 'Why do you laugh?' asked the child indignantly, 'do you not see that it is more horse than a horse?' " A horse? Of course. The repetition of the horse operates like the repetition of the pun that demonstrates *more*, the materiality of a signature that folds over on itself in excess of identity and of meaning. It is more than a horse, "more horse than a horse." Furthermore, *ho* is in hobby horse, the child would tell her Dada.

48 Laszlo Moholy-Nagy, *Vision in Motion*, pp. 341–42.

49 Ibid., p. 348.

50 Ibid., p. 349.

51 Ibid., p. 350.

52 Ibid., p. 349.

53 Ibid.

54 Ibid., p. 53.

55 Ibid., p. 118.

56 Laszlo Moholy-Nagy, "Photography is Manipulation of Light," (rpt. in Haus, *Moholy-Nagy*, p. 49).

57 Or in this egg show, the web of language, the cackling wobbles over to the fowl friends in the photoplastic *Structure of the World*. These are the super-geese who see *more* and mock the monkey up above. In *Vision in Motion*, Moholy writes of "the quack-clacking super-geese (pelicans) who discovered the simplicity of the world constructed as a leg show" (p. 212).

58 For an extension of the problematics of chicken and egg as applied to the practice of 1920's photography in general, see Louis Kaplan, "Foto-Ei," in *Photography at the Bauhaus*, ed. Fiedler, pp. 254–63.

59 Laszlo Moholy-Nagy, *Vision in Motion*, p. 53.

60 Laszlo Moholy-Nagy, "Once a chicken, always a chicken," in *Vision in Motion*, p. 286.

61 Laszlo Moholy-Nagy, "In Answer to Your Interview," in *Moholy-Nagy,* ed. Kostelanetz, p. 17.

62 I have translated here from Laszlo Moholy-Nagy, "Theater, Zirkus, Varieté," p. 52.

63 This dredges up another Moholy photomontage, *Zeus Has His Troubles Too.* This is probably one of them. In a more general sense, Zeus's problem inscribes the death of his godlike status and the troubles arising when signatures are unleashed from under the control of the transcendental subject.

64 At the other end of the scales or from its bottomless depths, Moholy's *hydrocephalus* (which is how it was entitled at a recent exhibition) and *eyetree* join Bataille's *acephalus* and the Nietzchean *superman* as other laughable visions of the monstrous.

65 For an analysis of *Die Lichter der Stadt* (1926?) citing the silent film *Circus* at the root of its clowning, see Fiedler, *Experiment Bauhaus,* pp. 183–84.

66 James Joyce, *Finnegans Wake* (New York: Penguin Books, 1967), pp. 169–70.

67 Yoder, "Are You Contemporary?" p. 16.

68 Fawkes, "Photography and Moholy-Nagy's Do-It-Yourself Aesthetic," p. 18.

69 *Bloomington Pantagraph,* October 22, 1944.

70 Walter Gropius, quoted in *New Bauhaus Catalogue* (Chicago: Association of Arts and Industries, 1937), p. 9.

71 Lloyd Engelbrecht, "Laszlo Moholy-Nagy: Perfecting the Eye by Means of Photography," in *Photographs of Moholy-Nagy,* ed. Rice and Steadman, p. 10.

72 Charles Morris, quoted in *New Bauhaus Catalogue,* p. 10.

73 Leland Rice, introduction to *Photographs of Moholy-Nagy,* ed. Rice and Steadman, p. 4.

74 Hilton Kramer, "A Utopian Vision of the Arts," *New York Times,* June 8, 1969.

75 Steven Mansbach, *Visions of Totality: Laszlo Moholy-Nagy, Theo van Doesburg and El Lissitzky* (Ann Arbor: UMI Research Press, 1978), p. xi. The quoted phrase has already begun to betray the whole.

76 Richard Kostelanetz, "Moholy-Nagy: The Risk and Necessity of Artistic Adventurism," in his *Moholy-Nagy,* p. 3.

77 Laszlo Moholy-Nagy, *Vision in Motion,* p. 252.

78 Ibid., p. 66.

79 Laszlo Moholy-Nagy, "Education and the Bauhaus," *Focus* 2 (winter 1938) (rpt. in Passuth, *Moholy-Nagy,* p. 348).

80 Laszlo Moholy-Nagy, *Vision in Motion,* p. 187.

81 I have translated here from Hans Wingler, *Das Bauhaus* (Cologne: Verlag Rasch, 1962), pp. 38–39.

82 Laszlo Moholy-Nagy, quoted in S. Moholy-Nagy, *Experiment in Totality,* p. 47.

83 Laszlo Moholy-Nagy, "Modern Art and Architecture," *Journal of the Royal Institute of British Architects* 44, no. 4 (January 1937): 210–13 (rpt. in Passuth, *Moholy-Nagy,* pp. 342, 341, in the order of their appearance).

84 For a discussion of Moholy's Utopian preoccupations on paper, see the essays of Wulf Herzogenrath in his exhibition catalogue, *Bauhaus Utopien: Arbeiten auf Papier* (Stuttgart: Cantz, 1988).

85  Laszlo Moholy-Nagy, "Light-Space Modulator for an Electric Stage," *Die Form* 5, nos. 11–12 (1930) (rpt. in Passuth, *Moholy-Nagy*, p. 310).

86  Laszlo Moholy-Nagy, "Make a Light Modulator" (rpt. in Kostelanetz, *Moholy-Nagy*, p. 103).

87  Laszlo Moholy-Nagy, *The New Vision*, p. 42. In the German text, one reads the following concatenation in the hollowing out of the Moholy signature: "er erfindet methoden, findet neue werkzeuge; wagt fester zuzugreifen; löcher, höhlungen zu machen."

88  Laszlo Moholy-Nagy, *Vision in Motion*, p. 241.

89  Laszlo Moholy-Nagy, "Information Please!" *The Printing Art* 68, no. 3 (1944): 25.

90  Raoul Hausmann and Kurt Schwitters, *PIN* (London: Gaberbocchus, 1962), pp. 18, 25.

91  Laszlo Moholy-Nagy to J. G. Edelen Co., June 22, 1943, file 86, Institute of Design Archives.

92  Laszlo Moholy-Nagy, *Vision in Motion*, p. 252.

93  S. Moholy-Nagy, *Experiment in Totality*, p. 60.

94  Laszlo Moholy-Nagy, *The New Vision*, p. 24.

95  "But if the formula for this absolute knowledge can be thought about and put in question, the whole is treated then by a 'part' bigger than itself; this is the strange subtraction of a *remark* whose theory is borne by dissemination, and which constitutes the whole, necessarily as a *totality-effect*," in Jacques Derrida, "Outwork," in *Dissemination*, p. 54.

96  Laszlo Moholy-Nagy, quoted in S. Moholy-Nagy, *Experiment in Totality*, p. 242.

97  Richard Kostelanetz, "A Mine of Perceptions and Prophesies," in his *Moholy-Nagy*, p. 206.

#### Signature's Postscript: Moholisch/Like Moholy

1  Xanti Schawinsky to Sibyl Moholy-Nagy, August 25, 1948.

■

*Notes*

# Selected Bibliography

## Collections of Documents and Private Papers

Bauhaus Archive, Berlin. Collection of papers and photographs of Laszlo Moholy-Nagy.

Cincinnati Modern Art Society Papers. University of Cincinnati. Catalogued collection of papers, correspondence and press clippings.

Crane Collection. J. Paul Getty Museum. Santa Monica, California. Collection of photographs and photomontages of Laszlo Moholy-Nagy.

Hattula Moholy-Nagy Archives. Ann Arbor, Michigan. Uncatalogued collection of papers, correspondence, and press clippings of Laszlo and Sibyl Moholy-Nagy.

Illinois Institute of Technology Archives. Chicago. Uncatalogued collection of papers, correspondence, and press clippings including the New Bauhaus Scrapbook.

Institute of Design Archives. University of Illinois, Chicago. Catalogued collection of papers, correspondence, and press clippings. Files 79–86 on Laszlo Moholy-Nagy.

## Works by Laszlo Moholy-Nagy

(Note: Order is chronological)

*Books*

With Lajos Kassak. *Buch Neuer Künstler* (Book of new artists). Vienna and Budapest: Aktivista Foliorat, 1922.

With Oskar Schlemmer and Farkas Molnar. *Die Bühne im Bauhaus*. Munich: A. Langen, 1925. Trans. Arthur S. Wensinger as *The Theater of the Bauhaus*. Middletown, Conn.: Wesleyan University Press, 1961.

*Malerei, Fotografie, Film*. Munich: A. Langen, 1925. Trans. Janet Seligmann as *Painting, Photography, Film*. Cambridge, Mass.: M.I.T. Press, 1969.

*Moholy-Nagy, 60 fotos*. Ed. Franz Roh. Berlin: Klinkhardt and Biermann, 1930.

*Von Material zu Architektur*. Munich: A. Langen, 1929. Trans. Daphne M. Hoff-

man as *The New Vision: From Material to Architecture*. New York: Breuer
Warren and Putnam, 1930. Rev. and exp. ed. *The New Vision, And, Abstract
of an Artist*. New York: George Wittenborn, 1947.
*Vision in Motion*. Chicago: Paul Theobald, 1947.

*Articles*

With Raoul Hausmann, Ivan Puni, and Hans Arp. "Aufruf zur elementaren
Kunst." *De Stijl* 4 (October 1921): 156. Translated as "Manifesto of Elemen-
tal Art." In *Moholy-Nagy*, ed. Krisztina Passuth. New York: Thames and
Hudson, 1985.

"Produktion-Reproduktion." *De Stijl* 5 (July 1922): 98–101. Trans. Frederic
Samson as "Production-Reproduction." In *Moholy-Nagy*, ed. Andreas Haus.
New York: Pantheon, 1978. Also translated in *Moholy-Nagy*, ed. Krisztina
Passuth. New York: Thames and Hudson, 1985.

"Az új tartalom és az új forma problémájáról." *Akaszott ember* 3–4 (1922): 3.
Translated as "On the Problem of New Content and New Form." In *Moholy-
Nagy*, ed. Krisztina Passuth. New York: Thames and Hudson, 1985.

With Alfred Kemeny. "Dynamisch-konstruktives Kraftsystem." *Der Sturm* 13
(December 1922): 186. Translated as "Dynamic-Constructive System of
Forces." In *Moholy-Nagy*, ed. Krisztina Passuth. New York: Thames and
Hudson, 1985.

"Light—A Medium of Plastic Expression." *BROOM* 4 (March 1923): 283–84.
Rpt. in *Moholy-Nagy*, ed. Krisztina Passuth. New York: Thames and Hud-
son, 1985.

"Neue Gestaltung in der Musik: Möglichkeiten des Grammophons." *Der Sturm*
14, no. 7 (July 1923): 102–6. Translated as "New Forms in Music. Poten-
tialities of the Phonograph." In *Moholy-Nagy*, ed. Krisztina Passuth. New
York: Thames and Hudson, 1985.

"Die neue Typografie." In *Staatliches Bauhaus Weimar 1919–1923*. Munich and
Weimar: Bauhaus Verlag, 1923. Trans. Sibyl Moholy-Nagy as "The New
Typography." In *Moholy-Nagy*, ed. Richard Kostelanetz. New York: Praeger,
1970.

With Erno Kallai, Alfred Kemeny, and Laszlo Peri. "Nyilatkozat." *Egység* (1923).
Translated as "Manifesto." In *Moholy-Nagy*, ed. Krisztina Passuth. New
York: Thames and Hudson, 1985.

"Das Bauhaus in Dessau." *Qualität* 4, nos. 5–6 (May–June 1925): 81–88. Trans-
lated as "The Bauhaus in Dessau." In *Moholy-Nagy*, ed. Krisztina Passuth.
New York: Thames and Hudson, 1985.

"Bauhaus und Typografie." *Anhaltische Rundschau* (September 14, 1925). Trans.
Wolfgang Tabs and Basil Gilbert as "Bauhaus and Typography." In *Moholy-
Nagy*, ed. Richard Kostelanetz. New York: Praeger, 1970.

"Ismus oder Kunst." *Vivos Vocos* 5, nos. 8–9 (September 1926): 272–77. Trans.
Sibyl Moholy-Nagy as "Isms or Art." In *Moholy-Nagy*, ed. Richard Kostel-
anetz. New York: Praeger, 1970.

"Geradlinigkeit des Geistes—Umwege der Technik." *Bauhaus* 1 (1926): 5. Pub-
lished also in *i 10: Internationale Revue* 1 (1927). Trans. Sibyl Moholy-Nagy
as "Directness of the Mind; Detours of Technology." In *Moholy-Nagy*, ed.
Richard Kostelanetz. New York: Praeger, 1970.

"Zeitgemässe Typographie—Ziel, Praxis, Kritik." In *Offset-, Buch-, und Wer-*

*bekunst* 7 (1926): 375–76. Trans. Wolfgang Tabs and Basil Gilbert as "Contemporary Typography — Aims, Practice, Criticism." In *Moholy-Nagy*, ed. Krisztina Passuth. New York: Thames and Hudson, 1985.

"A jövö szinháza a teljes szinhaz." *Dokumentum* (March 1927): 6–7. Translated as "Total Theatre is the Theatre of the Future." In *Moholy-Nagy*, ed. Krisztina Passuth. New York: Thames and Hudson, 1985.

"Diskussion über Erno Kallai's Artikel 'Malerei und Fotografie.'" *i 10: Internationale Revue* 6 (1927): 227–36. Translated as "Contribution to the Debate on the Article 'Painting and Photography by Erno Kallai.'" In *Moholy-Nagy*, ed. Krisztina Passuth. New York: Thames and Hudson, 1985.

"Fotografie ist Lichtgestaltung." *Bauhaus* 2 (1928): 2–8. Translated as "Photography is Creation with Light." In *Moholy-Nagy*, ed. Krisztina Passuth. New York: Thames and Hudson, 1985. Translated as "Photography is Manipulation of Light." In *Moholy-Nagy*, ed. Andreas Haus. New York: Pantheon, 1978.

"Fotogramm und Grenzgebiete." *i 10: Internationale Revue* 21/22 (1929): 190–92. Translated as "Photogram and Frontier Zones." In *Moholy-Nagy*, ed. Krisztina Passuth. New York: Thames and Hudson, 1985.

"The Future of the Photographic Process." *Transition* 15 (Feb. 1929): 289–93.

"In Answer to Your Interview." *The Little Review* 12, No. 2 (May 1929): 54–56. Rpt. in *Moholy-Nagy*. Ed. Richard Kostelanetz. New York: Praeger, 1970.

"Scharf oder unscharf." *i 10: Internationale Revue* 20 (1929): 163–67. Translated as "Sharp or Fuzzy?" In *Moholy-Nagy*, ed. Krisztina Passuth. New York: Thames and Hudson, 1985.

"Lichtrequisit einer elektrischen Bühne." *Die Form* 5, nos. 11–12 (1930): 297–99. Translated as "Light-Space Modulator for an Electric Stage." In *Moholy-Nagy*, ed. Krisztina Passuth. New York: Thames and Hudson, 1985.

"Fényhäték-film." *Korunk* 6, no. 12 (1931): 866–67. Translated as "Light Display Film." In *Moholy-Nagy*, ed. Krisztina Passuth. New York: Thames and Hudson, 1985.

"A film új lehetöségei." *Munka* 5, no. 24 (1932): 685–87. Translated as "New Film Potentialities." In *Moholy-Nagy*, ed. Krisztina Passuth. New York: Thames and Hudson, 1985.

"Festészet és fényképészet." *Korunk* 7, no. 2 (1932). Translated as "Painting and Photography." In *Moholy-Nagy*, ed. Krisztina Passuth. New York: Thames and Hudson, 1985.

"Uj filmkisérletek." *Korunk* 8, no. 3 (1933): 231. Translated as "New Film Experiments." In *Moholy-Nagy*, ed. Krisztina Passuth. New York: Thames and Hudson, 1985.

"An Open Letter to the Film Industry." *Sight and Sound* 3, no. 10 (1934): 56–57. Rpt. in *Moholy-Nagy*, ed. Krisztina Passuth. New York: Thames and Hudson, 1985.

"From Pigment to Light." *Telehor* 1, 1–2 (Brno, Feb. 28, 1936): 32–34.

"Letter to Kalivoda." *Telehor* 1, 1–2 (Brno, Feb. 28, 1936): 30–32.

"Light Architecture." *Industrial Arts* 1, no. 1 (spring 1936): 15–17. Rpt. in *Moholy-Nagy*, ed. Richard Kostelanetz. New York: Praeger, 1970.

"A New Instrument of Vision." *Telehor* 1, 1–2 (Brno, Feb. 28, 1936): 34–36.

"Once a Chicken, Always a Chicken." *Telehor* 1, 1–2 (Brno, Feb. 28, 1936): 43–45.

■

"Photography in a Flash." *Industrial Arts* (London) 1, no. 4 (winter 1936): 294–303. Rpt. in *Moholy-Nagy*, ed. Richard Kostelanetz. New York: Praeger, 1970.

"Problems of the Modern Film." *Telehor* 1, 1–2 (Brno, Feb. 28, 1936): 37–40.

"Subject without Art." *The Studio* 12 (November 1936): 259. Rpt. in *Moholy-Nagy*, ed. Richard Kostelanetz. New York: Praeger, 1970.

"Supplementary Remarks on the Sound and Colour Film." *Telehor* 1, 1–2 (Brno, Feb. 28, 1936): 41–42.

"Modern Art and Architecture." *Journal of the Royal Institute of British Architects* 44, no. 4 (January 1937). Rpt. in *Moholy-Nagy*, ed. Krisztina Passuth. New York: Thames and Hudson, 1985.

"Light Painting." In *Circle: International Survey of Constructive Art,* ed. J. L. Martin, Ben Nicholson, and Naum Gabo. London: Faber and Faber, 1937.

"Moholy-Nagy, Picture Hunter, Looks at the Paris Exposition." *Architectural Record* 82 (October 1937): 92.

"The New Bauhaus and Space Relationships." *American Architect and Architecture* no. 151 (December 1937): 23–28. Rpt. in *Moholy-Nagy*, ed. Richard Kostelanetz. New York: Praeger, 1970.

"Paths to the Unleashed Color Camera." *Penrose Annual* 39 (1937): 25–28. Rpt. in *Moholy-Nagy*, ed. Richard Kostelanetz. New York: Praeger, 1970.

"Education and the Bauhaus." *Focus* 2 (winter 1938): 20–27. Rpt. in *Moholy-Nagy*, ed. Krisztina Passuth. New York: Thames and Hudson, 1985.

"From Wine Jugs to Lighting Fixtures." In *Bauhaus 1919–1928,* ed. Herbert Bayer, Walter Gropius, and Ise Gropius. New York: Museum of Modern Art, 1938.

"Why Bauhaus Education." *Shelter* 1 (March 1938): 8–21.

"Light—A New Medium of Expression." *Architectural Forum* 70 (May 1939): 388–92. Rpt. in *Moholy-Nagy*, ed. Richard Kostelanetz. New York: Praeger, 1970.

"Painting with Light—A New Medium of Plastic Expression." *Penrose Annual* 41 (1939): 25–31.

"Make a Light Modulator." *Minicam Photography* 3, no. 7 (March 1940). Rpt. in *Moholy-Nagy*, ed. Richard Kostelanetz. New York: Praeger, 1970.

"Better than Before." *Technology Review* 46, no. 1 (November 1943): 45–48.

"Space-time and the Photographer." *American Annual of Photography* 57, no. 52 (1943). Rpt. in *Moholy-Nagy*, ed. Krisztina Passuth. New York: Thames and Hudson, 1985.

"Surrealism and the Photographer." *The Complete Photographer* 9, no. 52 (1943): 3337–42.

"Design Potentialities." In *New Architecture and City Planning,* ed. Paul Zucker, 675–87. New York: Philosophical Library, 1944. Rpt. in *Moholy-Nagy*, ed. Krisztina Passuth. New York: Thames and Hudson, 1985.

"Photography in the Study of Design." *American Annual of Photography* 59 (1944): 158–64.

"In Defense of Abstract Art." *Journal of Aesthetics and Art Criticism* 4, no. 4 (1945): 74–76. Rpt. in *Moholy-Nagy*, ed. Richard Kostelanetz. New York: Praeger, 1970.

"On Art and the Photograph." *Technology Review* 47, no. 8 (June 1945): 491–94.

"New Education — Organic Approach." *Art and Industry* 40 (March 1946): 66–77.

"Art in Industry." *Arts and Architecture* 64, no. 1 (September 1947): 30, and (October 1947): 28–33. Rpt. in *Moholy-Nagy*, ed. Krisztina Passuth. New York: Thames and Hudson, 1985.

*Letters*

Letter to Ivan Hevesy, April 5, 1920. In *Moholy-Nagy*, ed. Krisztina Passuth. New York: Thames and Hudson, 1985.

Letter to Antal Nemeth, July 18, 1924. In *Moholy-Nagy*, ed. Krisztina Passuth. New York: Thames and Hudson, 1985.

Letter to Herbert Read, January 24, 1934. In *Moholy-Nagy*, ed. Richard Kostelanetz. New York: Praeger, 1970.

Letter to Beaumont Newhall, April 7, 1937. In *Moholy-Nagy*, ed. Richard Kostelanetz. New York: Praeger, 1970.

*Films*

*Berliner Stilleben* (Berlin still life), 1926.
*Marseille Vieux Port* (The old port of Marseilles), 1929.
*Lichtspiel schwarz-weiss-grau* (Light display: black, white, gray), 1930.
*Tönendes ABC* (Sound ABC), 1932.
*Zigeuner* (Gypsies), 1932.
*Architekturkongress Athen*, 1933.
*Hattula*, 1933.
*Life of the Lobster*, 1935.
*Things to Come*, 1936. Special effects.
*The New Architecture at the London Zoo*, 1936.
*Do Not Disturb*, 1945.

## Works on Moholy-Nagy

*Books and Theses*

Caton, Joseph. *The Utopian Vision of Moholy-Nagy*. Ann Arbor, Mich.: UMI Research Press, 1985.

Engelbrecht, Lloyd C. "The Association of Arts and Industries." Ph.D. Diss., University of Chicago, 1973.

Findeli, Alain. "Du Bauhaus à Chicago." Ph.D. Diss., Université de Paris, VIII, 1989.

Haus, Andreas. *Moholy-Nagy: Fotos und Fotogramme*. Munich: Schirmer-Mosel, 1978. Translated as *Moholy-Nagy: Photographs and Photograms*. New York: Pantheon, 1980.

Janosi, Ilona. "Laszlo Moholy-Nagy: His Early Life in Hungary (1895–1919)." Master's thesis, Indiana University, 1979.

Kostelanetz, Richard, ed. *Moholy-Nagy*. New York: Praeger, 1970.

Lusk, Irene-Charlotte. *Montagen ins Blaue: Laszlo Moholy-Nagy, Fotomontagen und -collagen 1922–1943*. Berlin: Anabas Verlag, 1980.

Mansbach, Steven. *Visions of Totality: Laszlo Moholy-Nagy, Theo van Doesburg, and El Lissitzky.* Ann Arbor: UMI Research Press, 1978.

Moholy, Lucia. *Marginalien zu Moholy-Nagy/Moholy-Nagy, Marginal Notes.* Krefeld: Scherpe Verlag, 1972.

Moholy-Nagy, Sibyl. *Experiment in Totality.* New York: Harper and Row, 1950.

Passuth, Krisztina, ed. *Moholy-Nagy.* New York: Thames and Hudson, 1985.

Senter, Terence A. "Moholy-Nagy in England." Ph.D. Diss., Nottingham University, 1975.

Weitemeier, Hannah. *Licht-Visionen, Ein Experiment von Moholy-Nagy.* Berlin: Bauhaus Archiv, 1972.

## Articles and Studies

Davis, Douglas. "Mighty Machine." *Newsweek,* November 16, 1969.

Fawkes, Caroline. "Photography and Moholy-Nagy's Do-It-Yourself Aesthetic." *Studio International* 190 (July–August 1975): 18–26.

Galassi, Peter. "Laszlo Moholy-Nagy." In *Academic American Encyclopedia.* Grolier Electronic Publishing, 1993.

Giedion, Siegfried. Introduction. *Telehor* 1, 1–2 (Brno, Feb. 28, 1936).

Kirkpatrick, Diane. "Time and Space in the Work of Laszlo Moholy-Nagy." *The Hungarian Quarterly* 15 (1989).

Koppe, Richard. "Laszlo Moholy-Nagy and His Visions." *Art International* 13 (December 1969): 43–46.

Kovacs, Steven. "Totality through Light. The Work of Laszlo Moholy-Nagy." *Form* 6 (1967): 14–19.

Kramer, Hilton. "A Utopian Vision of the Arts." *New York Times,* June 8, 1969.

Moholy-Nagy, Sibyl. "Moholy-Nagy und die Idee des Konstruktivismus." *Die Kunst und das Schöne Heim* 9 (June 1959): 330–33.

Moholy-Nagy, Sibyl. "Constructivism from Kasimir Malevich to Laszlo Moholy-Nagy." *Arts and Architecture* 80 (June 1966): 4–28.

Morrison, C. L. "Chicago Dialectic." *Artforum* (February 1978): 32–39.

Newhall, Beaumont. "The Photography of Moholy-Nagy." *Kenyon Review* 3, no. 3 (1941): 342–51.

Passuth, Krisztina. "Debut of Laszlo Moholy-Nagy." *Acta Historiae Artium* 19, nos. 1–2 (1973): 125–42.

Peter, Laszlo. "The Young Years of Moholy-Nagy." *The New Hungarian Quarterly* 13, no. 46 (summer 1972): 62–72.

Piene, Nan. "Light Art." *Art in America* 55, no. 3 (May–June 1967): 24–48.

Reichardt, Jasia. "Moholy-Nagy and Light Art as an Art to the Future." *Studio International* 174 (November 1967): 150–52.

Richie, Elisavietta. "Memories like fireflies, fleeting, flitting." *Christian Science Monitor,* August 5, 1981, 20.

Rose, Barbara. "Kinetic Solutions to Pictorial Problems: The Work of Man Ray and Moholy-Nagy." *Artforum* 10, no. 1 (September 1971): 68–73.

Sagendorph, Kent. "Functionalism, Inc." *Coronet* (October 1941): 108–11.

Schmidt, Paul F. "Konstruktivismus." *Das Kunstblatt* 8 (1924): 83–85.

Senter, Terence A. "Moholy-Nagy's English Photography." *Burlington Magazine* (November 1981): 659–71.

Staber, Margit. "Medienforschung in den zwanziger Jahren. Laszlo Moholy-

Nagy, die konstruktive Kunst und die heutige Lage." *Kunstnachrichten* 12, no. 4 (1975).

Yoder, Robert M. "Are You Contemporary?" *Saturday Evening Post,* July 3, 1943, 13–16, 78–79.

*Catalogues*
(Note: order is chronological)

*New Bauhaus and Institute of Design Catalogues.* Chicago, 1937–1946.

*In Memoriam Laszlo Moholy-Nagy.* New York: Solomon R. Guggenheim Foundation, Museum of Non-Objective Painting, 1947.

*Laszlo Moholy-Nagy.* Chicago: Museum of Contemporary Art, and New York: Solomon R. Guggenheim Foundation, 1969.

*Laszlo Moholy-Nagy. Ausschnitte aus einem Lebenswerk.* Berlin: Bauhaus Archiv, 1972.

*Laszlo Moholy-Nagy.* Ed. Wulf Herzogenrath, Tilman Osterwold, Hannah Weitemeier. Stuttgart: Verlag Gerd Hatje, 1974.

*Photographs of Moholy-Nagy from the collection of William Larson.* Ed. Leland Rice and David Steadman. Claremont, CA.: Trustees of Pomona College, 1975.

*Laszlo Moholy-Nagy.* Ed. Krisztina Passuth and Terence A. Senter. London: Institute of Contemporary Arts, Arts Council of Great Britain, 1980.

*Bauhaus Fotografie.* Ed. Roswitha Fricke. Dusseldorf: Marzona, 1982.

*The New Vision. Forty Years of Photography at the Institute of Design.* Ed. Charles Traub. New York: Aperture Books, 1982.

*Laszlo Moholy-Nagy. ZIV, 1924.* Mannheim: Städtische Kunsthalle, 1983.

*Moholy-Nagy Fotoplastiks: The Bauhaus Years.* Ed. Julie Saul. New York: Bronx Museum of the Arts, 1983.

*Moholy-Nagy: Photography and Film in Weimar Germany.* Ed. Eleanor Hight. Wellesley, Mass.: Wellesley College Museum, 1986.

*New Bauhaus: 50 Jahre, Bauhausnachfolge in Chicago.* Ed. Peter Hahn. Berlin: Argon, 1987.

*Experiment Bauhaus.* Ed. Magdalena Droste and Jeannine Fiedler. Berlin: Kupfergraben, 1988.

*Laszlo Moholy-Nagy: Frühe Photographien.* Ed. Gerhard Glüher. Berlin: Nishen, 1990.

*Moholy-Nagy: A New Vision for Chicago.* Ed. Terry Suhre. Springfield, Ill.: n.p., 1990.

*Photography at the Bauhaus.* Ed. Jeannine Fiedler. Cambridge, Mass.: M.I.T. Press, 1990.

*Laszlo Moholy-Nagy.* Ed. Renate Rüdiger, Monika Göbel, and Veit Loers. Kassel: Verlag Gerd Hatje, 1991.

■

## Works on Twentieth-Century Art and Art Movements

Apollinaire. *Selected Writings of Guillaume Apollinaire.* Trans. Roger Shattuck. New York: New Directions, 1971.

Arp, Hans and El Lissitzky. *Die Kunstismen: The Isms of Art.* Erlenbach-Zurich: Eugen Rentsch Verlag, 1925.

Banham, Reyner. *Theory and Design in the First Machine Age.* 2nd ed. New York and Washington: Praeger, 1960.

Bann, Stephen, ed. *The Tradition of Constructivism.* New York: Viking, 1974.

Barrett, Cyril. *An Introduction to Optical Art.* New York: E. P. Dutton, 1971.

Bauhaus, *Staatliches Bauhaus in Weimar 1919–1923.* Weimar-Munich: Bauhaus Verlag, 1923.

Bayer, Herbert, Walter Gropius, and Ise Gropius, eds. *Bauhaus: 1919–1928.* New York: Museum of Modern Art, 1938; London: Secker and Warburg, 1979.

Benjamin, Walter. *Illuminations.* Ed. Hannah Arendt, trans. Harry Zohn. New York: Schocken, 1969.

———. "Kleine Geschichte der Photographie" (1931). In *Das Kunstwerk im Zeitalter seiner technischen Reproduzierbarkeit.* Frankfurt: Suhrkamp, 1963.

———. "A Short History of Photography." Trans. Phil Patton. *Artforum* 15, no. 6 (February 1977): 46–61.

Bois, Yve-Alain. "El Lissitzky: Reading Lessons." *October* 11 (winter 1979): 113–26.

Brett, Guy. *Kinetic Art: The Language of Movement.* New York: Reinhold, 1968.

Burnham, Jack. *Beyond Modern Sculpture.* New York: George Braziller, 1968.

Butor, Michel. *Le Mots dans le Peinture.* Switzerland: Albert Skira, 1969.

Cohen, Arthur A. *Herbert Bayer: The Complete Work.* Cambridge, Mass.: M.I.T. Press, 1984.

*Dada-Constructivism: The Janus Face of the Twenties.* London: Annely Judah Gallery, 1984.

Diehl, Gaston. *Vasarely.* Trans. Eileen B. Hennessy. New York: Crown, 1972.

Doesburg, Theo van. *Grondbegripper der nieue beeldende Kunst.* Nijmegen: SUN, 1983.

Droste, Magdalena. *Bauhaus.* Cologne: Benedikt Taschen, 1990.

Duchamp, Marcel. *Salt-Seller.* Ed. Michel de Sanouillet and Elmer Peterson. London: Thames and Hudson, 1973.

Fried, Michael. "Art and Objecthood." *Artforum* V, no. 10 (summer 1967).

Friedel, Helmut, ed. *Kunst und Technik in den 20er Jahren: Neue Sachlichkeit und Gegenstandlicher Konstruktivismus.* Munich: Stadtische Galerie im Lenbachhaus, 1980.

Graeff, Werner. *Es Kommt der neue Fotograf!* Berlin: Herman Reckendorf, 1929.

Gropius, Walter. *The New Architecture and the Bauhaus.* Trans. P. Morton Shand. Cambridge, Mass.: M.I.T. Press, 1965.

Hausmann, Raoul and Kurt Schwitters. *PIN.* London: Gaberbocchus, 1962.

Janis, Harriet and Rudi Blesh. *Collage: Personalities, Concepts and Techniques.* Philadelphia: Chilton, 1962.

Johnson, Philip and Mark Wigley. *Deconstructivist Architecture.* New York: Museum of Modern Art, 1988.

Karginov, German. *Rodchenko.* Trans. Elisabeth Hoch. London: Thames and Hudson, 1979.

Keaton, Buster and Charles Samuels. *My Wonderful World of Slapstick.* New York: Da Capo, 1982.

Kittler, Friedrich. *Grammophon Film Typewriter.* Berlin: Brinkman and Bose, 1986.

Krauss, Rosalind E. "Jump Over the Bauhaus." *October* 15 (winter 1980): 103–11.

———. *The Originality of the Avant-Garde and Other Modernist Myths*. Cambridge, Mass.: M.I.T. Press, 1986.

———. *Passages in Modern Sculpture*. New York: Viking, 1977.

———. "When Words Fail." *October* 22 (fall 1982): 91–103.

Lippard, Lucy, ed. *Dadas on Art*. Englewood Cliffs, N.J.: Prentice Hall, 1971.

Lissitzky-Kuppers, Sophie. *El Lissitzky: Life, Letters, Texts*. Trans. Helene Aldwinckle and Mary Whittall. London: Thames and Hudson, 1968.

Malevich, Kasimir. *Essays on Art*. vols. 1–4. Trans. Xenia Andersen, ed. Troels Andersen. Copenhagen: Borgen, 1978.

Man Ray. *Photographs*. New York: Thames and Hudson, 1982.

———. *Self-Portrait*. London: Andre Deutsch, 1963.

McLuhan, Marshall. *Understanding Media: The Extensions of Man*. London: Routledge, 1964.

Melville, Stephen. "Notes on the Reemergence of Allegory, the Forgetting of Modernism, the Necessity of Rhetoric, and the Conditions of Publicity in Art and Criticism." *October* 19 (winter 1981): 55–92.

Motherwell, Robert, ed. *The Dada Painters and Poets*. New York: Wittenborn, Schultz, 1951.

Neusüss, Floris M. *Das Fotogramm in der Kunst des 20. Jahrhunderts: Diè andere Seitè der Bilder — Fotografie ohne Camera*. Cologne: Dumont, 1990.

Pachnicke, Peter and Klaus Honnef. *John Heartfield*. Cologne: Dumont, 1991.

Papadakis, Andreas, Catherine Cooke, and Andrew Benjamin, eds. *Deconstruction*. Omnibus vol. London: Academy Editions, 1989.

Richter, Hans. "An den Konstruktivismus." *G* (June 1924).

Rickey, George. *Constructivism: Origins and Evolution*. New York: George Braziller, 1967.

Rotzler, Willy. *Constructive Concepts: A History of Constructive Art from Cubism to the Present*. Zurich: ABC Editions, 1977.

Schmalenbach, Werner. *Kurt Schwitters*. New York: Harry N. Abrams, 1967.

Schreyer, Lothar. *Erinnerungen an Sturm und Bauhaus*. Munich: Albert Langen, 1956.

Schwitters, Kurt. *Auguste Bolte*. Berlin: Verlag Sturm, 1923.

Selz, Peter. *Art in Our Time: A Pictorial History 1890–1980*. New York: Abrams, 1981.

Spies, Werner. *Victor Vasarely*. New York: Abrams, 1971.

Steinitz, Käte T. *Erinnerungen aus den Jahren 1918–1930*. Zurich: Verlag der Arche, 1963.

———. *Kurt Schwitters: A Portrait from Life*. Berkeley and Los Angeles: University of California Press, 1968.

Tzara, Tristan. "Photographie von der Kehrseite." *G* (August 1922).

———. *Seven Dada Manifestos and Lampisteries*. New York: Riverrun Press, 1981.

Weitemeier, Hannah. "Schatten einer Lichtvision." In *Vision und Bewegung: Werke aus der Sammlung Lenz Schönberg*. Munich: Städtische Galerie im Lenbachhaus, 1988.

Wick, Rainer. *Bauhaus-Pädagogik*. Cologne: Dumont, 1982.

———, ed. *Das neue Sehen. Von der Fotografie am Bauhaus zur Subjectiven Fotografie*. Munich: Klinkhardt and Biermann, 1991.

Wingler, Hans. *Das Bauhaus*. Cologne: Verlag Rasch, 1962.

———. *The Bauhaus: Weimar, Dessau, Berlin, Chicago.* Trans. Wolfgang Jabs. Cambridge, Mass.: M.I.T. Press, 1976.

Zhadova, Larissa A. *Malevich: Suprematism and Revolution in Russian Art.* Trans. Alexander Lieven. London: Thames and Hudson, 1982.

## Supplementary Texts

Barthes, Roland. *Camera Lucida: Reflections on Photography.* Trans. Richard Howard. New York: Hill and Wang, 1981.

———. *The Grain of the Voice: Interviews 1962–1980.* Trans. Linda Coverdale. New York: Hill and Wang, 1985.

———. *The Responsibility of Forms: Critical Essays on Music, Art, and Representation.* Trans. Richard Howard. New York: Hill and Wang, 1985.

———. *Roland Barthes.* Trans. Richard Howard. New York: Hill and Wang, 1977.

Bataille, Georges. *Death and Sensuality: A Study of Eroticism and the Taboo.* Trans. Mary Dalwood. New York: Arno Press, 1962.

———. "Un-knowing: Laughter and Tears." *October* 36 (spring 1986): 89–103.

———. *Visions of Excess: Selected Writings 1927–1939.* Trans. Allan Stoekl. Minneapolis: University of Minnesota Press, 1985.

Blanchot, Maurice. *The Gaze of Orpheus.* Trans. Lydia Davis. Barrytown, N.Y.: Station Hill, 1981.

———. *The Space of Literature.* Trans. Ann Smock. Lincoln: The University of Nebraska Press, 1981.

———. *The Writing of the Disaster.* Trans. Ann Smock. Lincoln: The University of Nebraska Press, 1986.

Bloch, R. Howard. *Etymologies and Genealogies: A Literary Anthropology of the French Middle Ages.* Chicago: University of Chicago Press, 1983.

Cage, John. *Silence.* Middletown, Conn.: Wesleyan University Press, 1961.

Certeau, Michel de. *Heterologies: Discourse on the Other.* Trans. Brian Massumi. Minneapolis: University of Minnesota Press, 1986.

———. *Writing History.* Trans. Tom Conley. New York: Columbia University Press, 1989.

Conley, Tom. "Institutionalizing Translation: On Florio's Montaigne." *Glyph Textual Studies I* (1986): 45–61.

Conze, Edward. *Buddhist Wisdom Books.* London: George Unwin, 1958.

Derrida, Jacques. *A Derrida Reader: Between the Blinds.* Ed. Peggy Kamuf. New York: Harvester/Wheatsheaf, 1991.

———. *Dissemination.* Trans. Barbara Johnson. Chicago: University of Chicago Press, 1981.

———. *The Ear of the Other: Otobiography, Transference, Translation.* Ed. Christie V. McDonald, trans. Peggy Kamuf and Avital Ronell. New York: Schocken, 1985.

———. *Glas.* Trans. John P. Leavey and Richard Rand. Lincoln: University of Nebraska Press, 1986.

———. "Limited Inc a b c. . . ." Trans. Samuel Weber. *Glyph* 2 (1977): 162–254.

———. *Margins of Philosophy.* Trans. Alan Bass. Chicago: University of Chicago Press, 1982.

———. *Memoires: for Paul de Man.* Trans. Cecile Lindsay, Jonathan Culler, and Eduardo Cadava. New York: Columbia University Press, 1986.

——. *Of Grammatology.* Trans. Gayatri Chakravorty Spivak. Baltimore: Johns Hopkins University Press, 1976.

——. "Point de folie — Maintenant l'architecture." *AA Files* (London) 12 (summer 1986): 65–75.

——. *The Post-Card.* Trans. Alan Bass. Chicago: University of Chicago Press, 1987.

——. *Signéponge/Signsponge.* Trans. Richard Rand. New York: Columbia University Press, 1984.

——. *The Truth in Painting.* Trans. Geoff Bennington and Ian McLeod. Chicago: University of Chicago Press, 1987.

——. *Writing and Difference.* Trans. Alan Bass. Chicago: University of Chicago Press, 1978.

Foucault, Michel. "What is an Author?" In *Textual Strategies: Perspectives in Post-Structuralist Criticism.* Ed. Josue V. Harari, 141–60. Ithaca: Cornell University Press, 1979.

Heidegger, Martin. *The Question Concerning Technology and Other Essays.* Trans. William Lovitt. New York: Harper and Row, 1977.

Joyce, James. *Finnegans Wake.* New York: Viking, 1939; New York: Penguin, 1976.

Kamuf, Peggy. *Signature Pieces: On the Institution of Authorship.* Ithaca and London: Cornell University Press, 1988.

Koenig, Thilo. "Die Kamera muss wie eine nimmer fehlende Büchse in der Hand ihre Herrn liegen." *Fotogeschichte* 8, no. 30 (1989).

Lacan, Jacques. *Ecrits.* Trans. Alan Sheridan. New York: Norton, 1977.

——. *The Four Fundamental Concepts of Psycho-Analysis.* Trans. Alan Sheridan. New York: Norton, 1977.

Levi-Strauss, Claude. *The Savage Mind.* Chicago: University of Chicago Press, 1966.

Lyotard, Jean-François. *A Lyotard Reader.* Ed. Andrew Benjamin. Oxford: Basil Blackwell, 1989.

Montaigne. *The Selected Essays of Montaigne.* Ed. Lester G. Crocker, trans. John Florio. New York, Pocket Library, 1959.

Nietzsche, Friedrich. *The Will to Power.* Trans. Walter Kaufmann and R. J. Hollingdale. Baltimore: Penguin, 1961.

Plato. *The Dialogues of Plato.* Vol. I. Trans. B. Jowett. London: Oxford University Press, 1931.

——. *Phaedrus and Letters VII and VIII.* Trans. Walter Hamilton. New York: Penguin, 1973.

Pynchon, Thomas. *Gravity's Rainbow.* New York: Viking, 1973.

Reps, Paul. *Zen Flesh, Zen Bones.* New York: Anchor, n.d.

Rickels, Laurence A. *The Case of California.* Baltimore: Johns Hopkins University Press, 1991.

Ronell, Avital. *The Telephone Book: Technology, Schizophrenia, Electric Speech.* Lincoln: University of Nebraska Press, 1989.

Serres, Michel. *The Parasite.* Trans. Lawrence R. Schehr. Baltimore: Johns Hopkins University Press, 1982.

Ulmer, Gregory L. *Applied Grammatology: Post(e)-Pedagogy from Jacques Derrida to Joseph Beuys.* Baltimore and London: Johns Hopkins University Press, 1985.

——. "The Object of Post-Criticism." In *The Anti-Aesthetic: Essays on Post-Modern Culture*. Ed. Hal Foster, 83–111. Port Townsend, Wash.: Bay, 1983.

——. "Op Writing: Derrida's Solicitation of *Theoria*." In *Displacements: Derrida and After*. Ed. Mark Krupnick, 29–58. Bloomington: University of Indiana Press, 1983.

——. *Teletheory: Grammatology in the Age of Video*. New York and London: Routledge, 1989.

Wiener, Norbert. *God and Golem, Inc*. Cambridge, Mass.: M.I.T. Press, 1964.

Won, Ko. *Buddhist Elements in Dada: A Comparison of Tristan Tzara, Takahashi Shinkichi and Their Fellow Poets*. New York: New York University Press, 1977.

■

*Laszlo*

*Moholy-*

*Nagy*

**228**

# Index

Abstract-Creation group, 2, 19
Activism, Hungarian, 66–7
Albers, Josef, 73
Anonymous hand, 8, 11, 28, 119–55,
  185–6
Apollinaire, Guillaume, 88
Arp, Hans, 4, 104, 122
*Autoportrait,* 152

Bagier, Guido, 151
Ball, Hugo, 94
Bann, Stephen, 2
Barthes, Roland, 1, 29, 63
Bataille, Georges, 37, 107–8
Baudelaire, Charles, 129
Bauhaus, 1–2, 4, 6, 12–3, 16–8,
  31, 39–40, 73, 106, 111–3,
  115–6, 131–2, 135, 151, 154,
  182–3
Bayer, Herbert, 15, 17–8, 73
Becker, Marion, 82
Benjamin, Andrew, 21
Benjamin, Walter, 39, 41, 139
*Bicyclist,* 114–7
Blumner, Rudolf, 108–9, 111
Bortynik, Alexander, 17
Brandt, Marianne, 109, 111,
  113
Bredendieck, Hin, 111
Breton, André, 140–1
Breuer, Marcel, 111
*Broom,* 46
Bucking, Peer, 85
Buddhism, 164, 166, 168

Calligraphics, 88
*Cameraman, The,* 141
Cezanne, Paul, 59
Chance vs. necessity in signification,
  9–13, 17, 22, 24, 44, 47, 58–9,
  105, 158, 161–2, 168, 170–1, 180–
  1, 188
Chaplin, Charlie, 180
Circle group, 2
*City Lights,* 178–80
Collogic, 59, 61–2, 98, 109, 116–7, 187
Concept Art, 126
Constructivism, 1–3, 14–23, 25–6,
  69–71, 75, 87, 133, 141
Copyright, 43–4, 46, 63–5
Cratylus, 157–8, 168, 170, 188
Cubism, 3, 54, 59, 61–2, 98

*Dada Diary,* 94
Dadaism, 1, 24, 94, 104, 139–41,
  166, 171
Dadaist-Constructivist Congress, 4–5
Daguerre, Louis, 49
Dalí, Salvador, 174
*Das Kunstblatt,* 68, 71–2, 122
Death of the author, 8, 11, 29, 74–5,
  127–9, 136, 144
Deconstruction, 15–17, 19–24, 26
Deconstructive architecture, 20–1
*Der Eigenbrötler,* 137
Derrida, Jacques, 6–10, 15–6, 19–21
*Der Sturm,* 71
Detached hand, 11, 142–52
*Diagram of Forces,* 98

Die Kunstismen: The Isms of Art, 122
Distortion, 23, 49, 54, 57–8, 61–2, 88
Diving Board, The, 56–57
Doesburg, Theo van, 4, 18
Do Not Disturb, 136–7
Double band, 7, 10, 20, 23–4, 29
Double bind, 8, 64, 98
Dr. Mabuse, 144
Dreier, Katherine, 153
Duchamp, Marcel, 4, 121, 141, 148–9, 153
Dynamic of the Metropolis, 26, 81–2, 123

Ear of the Other, The, 10
Earp, T. W., 15, 19
Edison, Thomas, 33, 45–6
Eggeling, Viking, 34
Einstein, Albert, 51
Eisenmann, Peter, 21
El Lissitzky, 4, 20, 25, 44–6, 50, 71–3, 107, 122, 133, 150–1, 169
Entre'acte, 140–1
Experiment in Totality, 15, 46, 50, 76, 109, 151, 153
Expressionism, 13, 89, 171

Facture, 85
Fawkes, Caroline, 80
Feininger, Lyonel, 39–41, 51
Fiedler, Jeannine, 112
Finnegans Wake, 170, 172, 180
Finsler, Hans, 154
Fool, The, 29, 106–8, 135, 139, 178
Footprints in the Mud, 56
Foto-Qualität, 151
Foucault, Michel, 89
Frank, Ellen, 58
Futurism, 3, 171

G, 71–2
Gabo, Naum, 104
Genet, Jean, 7, 9
Ghosts Before Breakfast, 140
Giedion, Siegfried, 58, 161
Glas, 7
Graeff, Werner, 4, 174
Gramophone, 31–3
Graphology, 26, 28–9
GRAV, 19
Gropius, Walter, 1, 6, 40, 101, 113, 154, 159, 182–3
Group Zero, 18–9
Gypsies, 129–30

Hase, Karl von, 105
Haus, Andreas, 46, 51, 150
Hausmann, Raoul, 45, 71, 140, 185
Here Comes the New Photography, 174
Hermogenes, 157–8, 168, 170
Hevesy, Ivan, 67
Ho, 9, 11, 157–8, 170–80, 189
Hole in whole, 9, 11, 41, 69, 129, 157–8, 180–9
Holy, 9, 11, 69, 157–67, 189
Homophonics, 13, 21–2, 24, 103, 180; and photogram, 48
Huelsenbeck, Richard, 24–5, 140–1
Hydrocephalus, The, 177–78
Hyphen, 9, 11, 46, 157–8, 167–70, 189

Index, 56, 58, 141, 148–9, 153
Innovations in Museums: The picture goes to the best shot, 132–3
Institute of Design, 74, 113, 136, 164
Intervention: of the photogram, 43–51
In the Name of the Law, 133, 137–8
In the Sand, 57–8
Invention: of the photogram, 43–51
Iterability, 8, 23, 59

Jabes, Edmund, 142, 152
Jealousy, 108, 133–7
Joyce, James, 171–4, 177, 180, 189

Kamuf, Peggy, 7
Kandinsky, Vassily, 25, 40
Keaton, Buster, 141
Kemeny, Alfred, 68–72, 81, 107
Kinetic Art, 18
Klee, Paul, 25, 40
Kokoschka, Oscar, 25
Koppe, Richard, 163–4
Kostelanetz, Richard, 182, 188

Lacan, Jacques, 79, 100
Lang, Fritz, 144
Large Emotion Meter, The, 170
Laszlo Moholy-Nagy (1925–26), 27–8
Lautreamont, Count de, 49
Law of the Series, The, 146
Leda and the Swan, 177
Leonardo, 145
Le Parc, Julio, 19
Levy, Julien, 132

*Light Display: Black, White, and Gray,* 144
*Light Space Modulator,* 18, 144, 159–60, 184
Light-writing, 4, 18–9, 28, 37–8, 44–5, 47, 49, 51, 81–3, 90, 109, 149–50, 152, 161–2, 165–7, 189
*Love Your Neighbor (Murder on the Railway Line),* 133–4
Lusk, Irene-Charlotte, 137

*MA,* 70
Malevich, Kasimir, 25, 69
Man Ray, 4, 43–50, 72, 140, 153
Marey, E. J., 137
*Marginalien zu Moholy-Nagy,* 92, 114, 116, 125, 135
*Mask (Self-Portrait),* 90, 92–4, 96, 98
McLuhan, Marshall, 32, 145
*Me,* 111–4, 117
Mechanical reproduction, 39–40, 51, 119, 139
*Mechanized Eccentric,* 107
*Mein Name ist Hase. Ich weiss von nichts,* 102–8, 178
Merz, 25, 104, 105, 171
*Merzzeichnung,* 25
Message in bottle, 52–59, 62
*Metallwerkstatt,* 111–4, 117
Misrecognition of the self, 98, 100–3, 107, 113
Mistaking identity, 11, 108–17
*Moholisch,* 191–2
Moholy, Lucia, 4, 92–3, 96, 106, 115–7, 124–6, 135–6
Moholy-Nagy, Sibyl, 44, 46, 48, 73, 75–6, 87, 99–100, 109, 111, 129–30, 151, 168, 186–7
Moire effect, 19, 22–3, 162
Mondrian, Piet, 1, 18, 25, 104
Monstructivism, 25–6
Montaigne, Michel de, 63–4
Morellet, François, 19
*Motorcyclist Speeding, The,* 114
Muche, Georges, 40
Multiples, photographic, 39–41, 43

*Nagetier,* 69, 102–4, 158
Nagy, Levante, 169
Naturalism, 40
New Bauhaus, 2, 74, 94, 113
Newhall, Beaumont, 46, 48, 167
New vision, 15, 21, 58, 77, 80, 92, 98, 139, 180, 182

*New Vision, The,* 87, 159, 161, 180, 187
Nietzsche, Friedrich, 10

*Ohne Titel,* 152
*Once a chicken, always a chicken,* 94, 175–7
Op Art, 18, 168
Ostertag, Ferdinand, 29
Osterwold, Tilman, 32

*Painter's Works in Switzerland,* 122
*Painting, Photography, Film,* 18, 57, 95, 143–4, 174
Palmistry, 26–9
Papadakis, Andreas, 20
Passuth, Krisztina, 103, 105
Phonograph, 6, 10, 33–5, 41, 45
*Photogram* (1927?), 38
Photogram, 6, 10, 31–2, 37–8, 41, 43–51, 72, 83, 92–3, 110, 117, 140–1, 149–51, 166–7, 181, 185; as frontier zone, 56, 90
*Photogram: Self-Portrait Profile,* 90–3
Photogrammatics, 43–7, 50–1, 72, 111, 139, 149–52
Photogrammatology, 4, 25, 37–40, 47, 88, 140–1, 161–3
Photogram self-portraits, 11, 82–4, 89–98, 109, 152
Photography, 8, 10, 31, 39–41, 49, 71, 80, 84, 130–1, 139, 142–3; beach, 55–9
Photomontage, 4, 11, 41, 76, 111, 128, 132–3, 135–41, 146, 154, 174–7
Photomontage self-portraits, 11, 29, 98–108, 158
Picabia, Francis, 140
Picasso, Pablo, 59, 61
*PIN,* 185–6
Plagiarism, 9–11, 63–78, 133
Plato, 157
*Play,* 59–60
Pollux, 177
Ponge, Francis, 8
*Portrait of Rudolf Blumner,* 108–11, 117
*Poster for Schocken Department Store,* 147
Production-reproduction, 6, 8, 10–11, 14, 17, 24, 29, 31–62, 63, 65, 70, 74–7, 79, 133

■

*Index*

**231**

Proper name, 1, 5–6, 8–11, 16, 43, 47, 80–1, 92, 105, 152, 157, 159, 171, 191
Puns, 171–80, 189

Rauschenberg, Robert, 117
Rayogram, 47–9
Readymade, 121, 141, 148–50
Richie, Elisavietta, 167
Richter, Hans, 4, 71, 140
Rodchenko, Alexander, 75
Roh, Franz, 135–6
Romanticism, 13, 40, 99, 122, 130
Roters, Eberhard, 115

Sachte Neulichkeit, 154
Sagendorf, Kent, 164
Schade, Christian, 44, 47–8
Schawinsky, Xanti, 73, 191
Schlemmer, Oscar, 40
Schmidt, Joost, 73
Schmidt, Paul, 68, 71
School of Design, 26–8, 74, 148, 151–2
Schreyer, Lothar, 12–3, 40, 95, 131–2
Schwitters, Kurt, 24–5, 46, 104–5, 108, 176, 185
Scratching, 43, 85; onto film, 6, 35–6; and phonographics, 31, 33–5
Self-Constructor, 71, 150–1
Self-Portrait, 89
Self-Portrait, Photogram with torn paper, 97–8
Selz, Peter, 123
Shadograms, 46–8
Shadows are becoming longer, The, 58
Shooting Gallery, The, 132–33
Shooting practice, 11, 128–144
Signature Pieces, 7
Significance of signature, 11, 12, 17, 22, 24, 47, 69, 104–5, 157–89
Signsponge, 8
Snapshot effect, 56, 141, 143, 149
Société Anonyme, 153–5
Socrates, 157
Sound ABC, The, 34, 36
Sowjetskoje Foto, 75
Space Modulator in Cork, 184
Space-Modulator L3, 186
Space Modulator with Hairlines, 168
Spies, Werner, 17
Spiral-bound Mobile Picture, 14–5
Stage Scene—Loud Speaker, 41–2

Stein, Gertrude, 61
Steinetz, Käte, 104
Stelzer, Otto, 18
Superimposition, 3, 15, 22, 112–3, 151
Suprematism, 68–71
Surrealism, 48, 139–41

Taoism, 164
Technology, 43, 143, 162; art and, 6, 39–41, 51, 69, 141, 154; media, 10, 32–3, 136; of photogram, 38, 44, 50–1; photographic, 137, 151; prosthetics, 145; and telephone paintings, 121–7
Telegraphed Cinema, 166–7
Telephone paintings, 11, 119–28, 143, 146, 148–9, 154
Telephone Picture EM 2, 121, 123
Telephone Picture EM 3, 120
Tradition of Constructivism, The, 2
Tschumi, Bernard, 20–1
Tu m', 148
Typo-photo, 81
Typographic painting spelling out MOHOLY, 85, 87–8
Typographics, 84–88, 151
Tzara, Tristan, 4, 50, 166

Ulmer, Gregory, 9, 19–20

Van Gogh, Vincent, 89, 145
Vasarely, Victor, 17–9
Vision in Motion, 2, 59, 61, 88, 94, 124, 139–42, 159, 164–5, 172, 174
Vision in motion, 2–3, 12, 14–5, 61–2, 81, 116–7, 162
Von Material zu Architektur, 64

Weininger, Andor, 17
Weston, Edward, 58, 167
Wiener, Norbert, 123
Wines, James, 20
Wolfe, Tom, 1, 14
Wordplay, 3, 15, 22, 24, 171, 177

Xerox, 39, 64, 83

Y, 167
Yellow Disc, 86–9
Yoder, Robert, 164

Zen, 164–6
Zeus, 172

Laszlo

Moholy-

Nagy

**232**

Louis Kaplan is a post-doctoral Research Fellow at the Franz
Rosenzweig Center for German-Jewish Literature and Cultural
History, Hebrew University of Jerusalem.

Library of Congress Cataloging-in-Publication Data
Kaplan, Louis, 1960-
Laszlo Moholy-Nagy : biographical writings / Louis Kaplan.
Includes bibliographical references (p.   ) and index.
ISBN 0-8223-1577-7. — ISBN 0-8223-1592-0 (pbk.)
  1. Moholy-Nagy, Laszlo, 1895-1946. 2. Artists — Hungary — Biography —
History and criticism. 3. Art, Modern — 20th century — Hungary.
4. Deconstruction. I. Title.
N6822.5.M63K36   1995
709'.2 — dc20   [B]   94-40315 CIP